NEGATIVE EXPOSURES

SINOTHEORY
A Series Edited by Carlos Rojas
and Eileen Cheng-yin Chow

DUKE UNIVERSITY PRESS
Durham and London 2020

NEGATIVE

✕
✕
✕

owing What **Not to Know** in Contemporary China

EXPOSURES

✕
✕
✕

MARGARET
HILLENBRAND

X

X

X

Printed and bound by CPI Group (UK) Ltd, Croydon, CR0 4YY
Designed by Courtney Leigh Baker
Typeset in Warnock Pro by Westchester Publishing Services

Library of Congress Cataloging-in-Publication Data
Names: Hillenbrand, Margaret, [date] author.
Title: Negative exposures : knowing what not to know in contemporary
China / Margaret Hillenbrand.
Other titles: Sinotheory.
Description: Durham : Duke University Press, 2020. | Series: Sinotheory |
Includes bibliographical references and index.
Identifiers: LCCN 2019047922 (print)
LCCN 2019047923 (ebook)
ISBN 9781478006190 (hardcover)
ISBN 9781478008002 (paperback)
ISBN 9781478009047 (ebook)
Subjects: LCSH: Photography—Political aspects—China—History—
20th century. | Altered prints—Political aspects—China. | Photography,
Handworked—Political aspects—China. | Official secrets—Social
aspects—China. | Propaganda, Chinese. | Collective memory—Political
aspects—China. | Nanking Massacre, Nanjing, Jiangsu Sheng, China,
1937. | China—History—Cultural Revolution, 1966–1976. | China—
History—Tiananmen Square Incident, 1989.
Classification: LCC TR184 .H55 2020 (print) | LCC TR184 (ebook) |
DDC 770.951—dc23
LC record available at https://lccn.loc.gov/2019047922
LC ebook record available at https://lccn.loc.gov/2019047923

Cover art by Courtney Baker, based on images from the
Chinese journal *Old Photographs*.

Duke University Press gratefully acknowledges KS Scholarship,
which provided funds toward the publication of this book.

TO TOM

×

×

×

×
×
×

Contents

Series Editor's Preface

In his 1925 essay "On Photography," Lu Xun recalls how when he was growing up in Shaoxing ("S City") during the final decades of the nineteenth century, locals were very apprehensive about the technology of photography that had begun to gain popularity around that time. In particular, he recalls that many of them resisted having their photographs taken on the grounds that "a person's spirit could be stolen by the camera." He further notes that a persistent rumor spread that foreigners would pluck out people's eyes and preserve them in brine so that the vestigial images preserved inside their pupils could then be used to make photographs. Lu Xun, here, is describing an early view that photography relied on a process of extracting and materializing a set of filmlike layers that are present in all material objects.

Pioneering early photographer Nadar similarly recounts how, in the age of the daguerreotype at the very dawn of photography, Honoré de Balzac once cited similar concerns to explain his reluctance to be photographed; he contended that "all physical bodies are made up entirely of layers of ghostlike images, an infinite number of leaflike skins laid one on top of the other. . . . Repeated exposures entailed the unavoidable loss of subsequent ghostly layers, that is, the very essence of life."

Today, of course, it is widely recognized that photographs are simply images produced after light strikes a photosensitive surface, and consequently they have no direct material connection to their referents. Nevertheless, the notion that photographs retain an intimate, almost magical link to the objects they depict remains surprisingly common even today. As a result, not only do photographic images contain verisimilar likenesses, they may also generate complicated layers of affect—even as the photographs themselves may become overdetermined objects of emotional investment in their own right.

In his 1931 essay "A Small History of Photography," Walter Benjamin suggests that photographs have the potential to reveal what he calls the optical unconscious—which is to say, those elements of the visual field that may be perceived subliminally but that, under ordinary circumstances, rarely rise to the level of conscious cognition. This is particularly true, Benjamin argued, for our perception of physical motion, in that photographs are capable of capturing and revealing individual components of what is normally perceived as merely a continuous movement.

Margaret Hillenbrand's *Negative Exposures* uses photographs—and more specifically a transmedial category that she calls the "photo-form"—to probe modern China's optical unconscious as it pertains not to physical motion but rather to the movement of history. In particular, Hillenbrand attends to the ways in which these photo-forms may offer a transformative glimpse into the legacies of traumatic events, and although the Chinese state has systematically attempted to suppress public discussion of these events, they nevertheless remain indelibly inscribed in the private memories of the citizens who lived through them. By examining how historical photographs from these earlier periods have been retrieved and remediated in "paint, ink, celluloid, codex, mural, fabric, sculpted matter, the digital image, even human skin," Hillenbrand treats these photo-forms as virtual windows into a set of traumatic legacies that, like the unconscious, are simultaneously invisible and ubiquitous.

This is the first extended study of this category of the photo-form in contemporary China, and Hillenbrand offers fascinating analyses of examples drawn from elite and popular art, public performances and private artifacts, as well as images produced by figures based both inside the People's Republic of China and throughout the world. In this respect, Hillenbrand's study replicates the function that she attributes to the photo-form itself, in that it similarly seeks to bring critical attention to a phenomenon that is both invisible (the category of the photo-form itself did not even have a recognized name prior to her study) yet at the same time universally recognized. And although she does not directly cite Benjamin's notion of the optical unconscious, Hillenbrand does engage closely with his notion of revelatory justice—the way in which a process of publicly disclosing something previously kept secret can contribute to the pursuit of justice. This volume examines an array of attempts to use the category of the photo-form in order to pursue revelatory justice, even as the study itself engages in a parallel pursuit of justice on its own terms.

Carlos Rojas

Acknowledgments

It is now nearly a decade since I first noticed the rich afterlives of historic photographs in China and began to wonder what these images might mean in the here and now, and why they have been repurposed in such profusion by makers of culture. The more I looked for these images, the more I found. But it took me some time to understand that the stories they told were essentially about those strange limbo histories that are remembered all too well but that people are not supposed to discuss. It was in many ways due to the insights of others that I began to make sense of this, and I am very happy to have the chance to thank those people now.

Several of the artists whose work I discuss in this book kindly submitted to my questions, and I am very grateful to Badiucao, Lily and Honglei, Sheng Qi, Xu Weixin, Zhang Dali, and the late Chen Shaoxiong for so freely sharing their thoughts with me. Those interviews were inspirational for me.

Many friends and colleagues invited me to give talks on parts of this book while it was in progress, and they offered feedback that was often transformative. I thank Kevin Cawley, K. C. Choi, Craig Clunas, Heather Inwood, Francesca Kaufman, Paola Iovene, Richard Howells, Erin Huang, Song Hwee Lim, Nikky Lin, Barbara Mittler, Ankhi Muhkerjee, Laikwan Pang, Carles Prado-Fonts, Carlos Rojas, Lionel Ruffel, Shu-mei Shih, Mark Smith, Hans van de Ven, and Julian Ward. Nicole Huang, K. C. Lo, Wang Youqin, and Wu Hung kindly gave me materials or put me in touch with artists. Tarryn Chun, Peter Ditmanson, Michel Hockx, Chloe Starr, and Patricia Thornton generously read parts of the manuscript and gave me illuminating comments. Many of these same people, as well as Chow Yiu Fai, Rossella Ferrari, Wendy Larson, Xiao Liu, Angus Lockyer, Chris Lupke, Jason McGrath, Xavier Ortells-Nicolau, Nicolai

Volland, and Jiwei Xiao, have offered me advice, kindness, and ideas both recently and over the years. My colleagues in Oxford, particularly Rosanna Gosi, Hu Bo, Pamela Hunt, Dirk Meyer, and Justin Winslett, have made our department a warm and collegial place. Jonathan Service very gently told me where I was going wrong with this book a few years back, and he has been an exceptional friend and confidant ever since.

I thank the Art and Humanities Research Council in the U.K. for a grant that supported both research leave and extensive fieldwork in China; the British Inter-University China Centre for funding two international conferences related to this project, one on "Photography and the Making of Modern Chinese History" in 2012 and the other on "Digital Culture in China, Hong Kong, and Taiwan" in 2015; and Rana Mitter, Director of the China Centre at Oxford, for providing support for several events connected to my research. An earlier version of chapter 4 appeared in the *Journal of Visual Culture*. I thank the publishers for permission to reuse that material.

At Duke University Press, Ken Wissoker has been an insightful, open-minded, and incisive editor, and Josh Tranen and Jessica Ryan have been exemplary in their efficiency and advice. I owe special thanks to Carlos Rojas, who as series editor really championed this book—putting it through his own remarkably rigorous review, zeroing in on problems, offering terrific ideas, and giving much-appreciated encouragement.

My close friends and family have sustained me during the time I have spent working on this book. Thank you to Andrew, Nick, and especially Batul for over four decades of friendship. Finally, I am more grateful than I can say to my parents and sister, Ruth, who have supported me without end; to my sons, Sam, Max, and Alex, who have given me so many happy distractions from this project; and to my husband, Tom, who has always had faith in me and who has been the best possible companion throughout. I dedicate this book to him.

Preface. Negative Exposures

The negative is the equivalent of the composer's score,
and the print the performance.
—ANSEL ADAMS, 1968

In the spring of 1989, Beijing-based photographer Xu Yong 徐勇 became caught up in the protest movement that was unfolding at speed across the capital. As he puts it, it was hard not to be swept along, since "time seemed to have stopped for all other activities in Beijing" (Lee 2015). He began going to Tiananmen Square every day, with his Konica, to photograph the swelling crowds who were demonstrating for change. "I believe," he said later, "that no one had ever seen such a spectacular protest in Mainland China" (Lee 2015). After the bloody crackdown on June 4, when tanks rolled in and mowed down thousands of protestors, Xu Yong hid in his archives the scores of 35 mm negatives he had taken, and turned his attention to other projects. The images stayed buried for twenty-five years, until they began to fade and yellow with age. Fearing their attrition, or perhaps to mark the quarter-century anniversary of the protests, Xu decided in 2014 to publish his record of those days in a remarkable photobook.[1] Entitled *Negatives* (*Dipian* 底片), the book is an elegant hardback; at first sight, it looks like standard coffee-table fare, encased in a clear cover artfully mocked up to look like a photographic transparency. Inside are sixty-four images, each 17.5 cm by 24.5 cm, selected from Xu's secret photographic cache. They are reproduced as color negatives, without captions or commentary, but with their trademark serrated edge clearly visible.

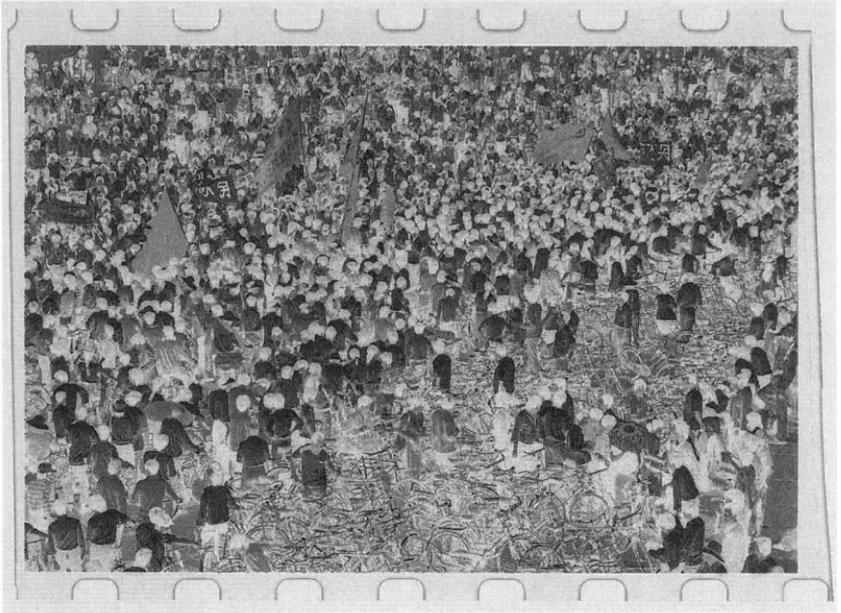

FIGURE P.1 Xu Yong, *Negatives*, 2014. Reproducing an image as a color-inverted negative makes an elegant pretense at secrecy.

The first image sets the tone for the collection (figure P.1). The immediate impression it delivers is of an abstract painting rather than a photograph, and it is only when the eye trains itself harder that the mystifying patterns of the negative begin to resolve into recognizable shape. The visual field is divided roughly into two diagonal halves: the left is populated by scores of small pale circles, which upon closer inspection are revealed to be the heads of the protestors, turned white as the tonal values of the image are inverted. The right half is thick with densely crosshatched shapes, which turn out to be bicycles. Flags are held aloft, splashes of malachite on the dark background; their Chinese characters appear as mirror images and are only partially visible. The image, in its chiaroscuro and chromatic inversions, is set up as a puzzle that the viewer must work to decipher. This provocation persists across each of the sixty-four images, whose very number is itself a kind of clue, as 6/4 is a source of euphemistic puns for the events that occurred in Tiananmen during the first week of June 1989. These encryptions are, obviously enough, a response to the status of the bloody crackdown as a forbidden thing in contemporary China—unsayable, unseeable, and so approachable only in "scrambled" ways. Yet flick back to the photobook's epigraph and it clearly flouts the

taboo, stating that "these photographic negatives were taken 26 years ago, in 1989." To this we might add that most people who purchase Xu's book already know exactly what it is about, and indeed, they have bought it precisely because of its subject matter. So why reproduce coded negatives instead of positive prints? Why telegraph the photobook's subject matter, only then to hide it via smoke and mirrors?

Xu Yong's *Negatives* is a photographic record of the Tiananmen protests, for sure. But he also intends it to be a photographic representation of their legacy, and as such, its mixed messages constitute its core meaning. They show the viewer, via their tactics of feint and counterfeint, that the June 4 bloodshed is something both very known and very secret. It is an event whose afterlives dwell in the space between taboo and totem: unspeakable, yet always looming at the edge of outcry, threatening to break into politically destabilizing speech. Like several other episodes in China's violent twentieth-century past that I discuss in this book, the June 4 protests are contained under a broad but fragile carapace. If enough people pretend they are not there—seared across China's collective consciousness of its past—they may disappear, like those brain-teasing, "spot the object" optical illusions in which hidden tigers slip in and out of camouflage. Xu Yong keeps up this idea of his photobook as a sort of ploy when he states repeatedly during interviews and press junkets that its guiding concept is not political.[2] Instead, he gambits, the book is intended as a meta-meditation on photography and its shift from analog to digital practices of image-making. Xu's argument here is the predictable one that negatives have a pristine quality that ramps up their documentary capacities in an age of ceaseless photographic dissimulation. But both these claims are strategically disingenuous. To publish a photobook on the Tiananmen Square protests and call it unpolitical is so patently implausible that Xu's political purpose merely shouts out all the louder. And sure enough, the book is banned in China. Xu is disingenuous here not in the hope of slipping through the net of censorship, but instead to mirror the strains of staying on message about June 4, of pretending that the matter of the protests has been cleanly resolved when everyone of a certain age in China knows very well that they have, rather, been rendered utterly unbroachable. What's more, any viewer of *Negatives* will also realize within seconds that it is not the apparently immaculate truth of the photographic negative that Xu is channeling in his book either. Instead, it is the status of this image prototype as photography's dark avatar, a space of the repressed and inadmissible, that *Negatives* persistently harnesses.

If photography has always had a whiff of the occult about it, then the negative occupies its most uncanny zone. The negative, as Oliver Wendell Holmes stated

in 1859, is "perverse and totally depraved," so much so that "it might almost seem as if some magic and diabolic power had wrenched all things from their proprieties, where the light of the eye was darkness, and the deepest blackness was gilded with the brightest glare" (741). Sigmund Freud, in "A Note on the Unconscious in Psychoanalysis" (2005), takes the analogy further, developing a linked metaphor that entwines the operations of the darkroom with the psychoanalytic process and the relationship between unconscious and conscious activity: "The first stage of the photograph is the negative; every photographic picture has to pass through the 'negative process,' and some of these negatives which have held good in examination are admitted to the 'positive process' ending in the picture" (139). Although Freud's focus here is on the "'positive process' ending in the picture,'" his analogy also figures the photographic negative—and the darkroom that some such images never leave—as the hinterland of the unconscious to which those things that have failed to "hold good in examination" are consigned. There they lie: undeveloped, unprocessed, a point that the Chinese term for "negative"—*dipian*, which literally means the "base" image—captures well. Negatives, by this logic, connote what the camera saw but what the photographer preferred not to look at, and their visual language of inversion and silhouette captures what Eviatar Zerubavel calls the "fundamental tension between knowledge and acknowledgment" (2006, 3).

It does so because this "perverse" play of light and shadow parlays with the viewer directly in the idiom of the ghost. Moving through the book, the spectrality of the images is almost overwhelming. Presented as negatives, Xu Yong's shots of the square seem to take place at night or in the gloaming; the bodies of the protestors are translucent, the shadows they cast lighter than they are themselves; their eyes become hollow sockets; and the trees, as they switch from green to purple—its complementary color—look like radioactive clouds. In fact, the sheer force of the sixty-four imprints, page after page, makes them look like more than simple negatives. They take on the air of repurposed or even doctored objects whose haunting shapes and colors are a deliberate aesthetic strategy that Xu's eerie mode of presentation enhances. Rather than serving as the blueprints for finished photographs, in fact, these ghostly, never-developed negatives seem to prefigure actual events, since some of the protestors who appear as wraiths may well have been captured by Xu Yong mere hours before their death. This point becomes menacing in the final image of the book, which shows the spectral, faded outline of a tank (figure P.2). As such, these pictures impart, despite their shadowy shapes, a hard solidity to the idea of the darkroom as a repository for those things that are documented all too well in many private minds but remain disowned in public

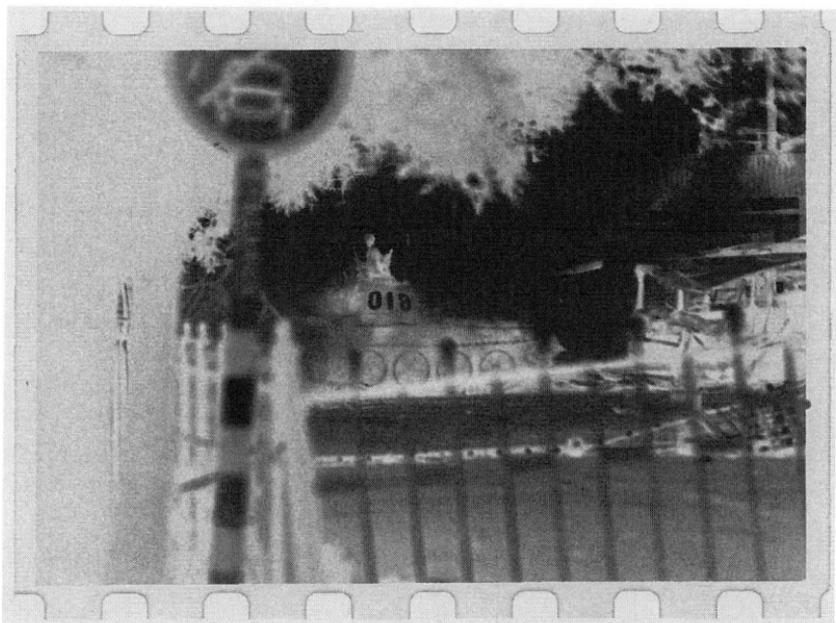

FIGURE P.2 Xu Yong, *Negatives*, 2014. *En marche* to the Square; or, Tank Man foretold.

culture. Their silhouettes stand for those troubled parts of China's modern history that a coalition of state and social actors have agreed not to develop into positive prints: those things that are at once both very known and very secret. And just as important, Xu's use of uncaptioned but eloquent images tells a necessary story about the role that visual culture—and photography, especially—come to play in arenas where powerful interdictions on certain acts of speech lie in place.

At the end of Xu's book, the viewer finds some instructions stenciled on the transparent back cover: "To interact with the works in *Negatives* with your iPhone or iPad, go to 'Settings' 'General' 'Accessibility' and turn on 'Invert Colors.' Then use the camera to reveal the positive images of the negative works. Other devices have similar functions, such as camera setting 'Color Effect—Negative.'" Inverting the colors is more difficult than these instructions suggest; it took me few minutes of fumbling with my phone to make the switch (figure P.3). Obviously, this heightens the moment of reveal—and the sense of spectatorial engagement. As the images flip from negative to positive through the camera function on a small handheld device, all the uncanniness vanishes like ghosts at daybreak (even as the skin tone of my own hand was ghosted to an X-ray-like blue-green as I turned the pages), and the iPhone becomes a time

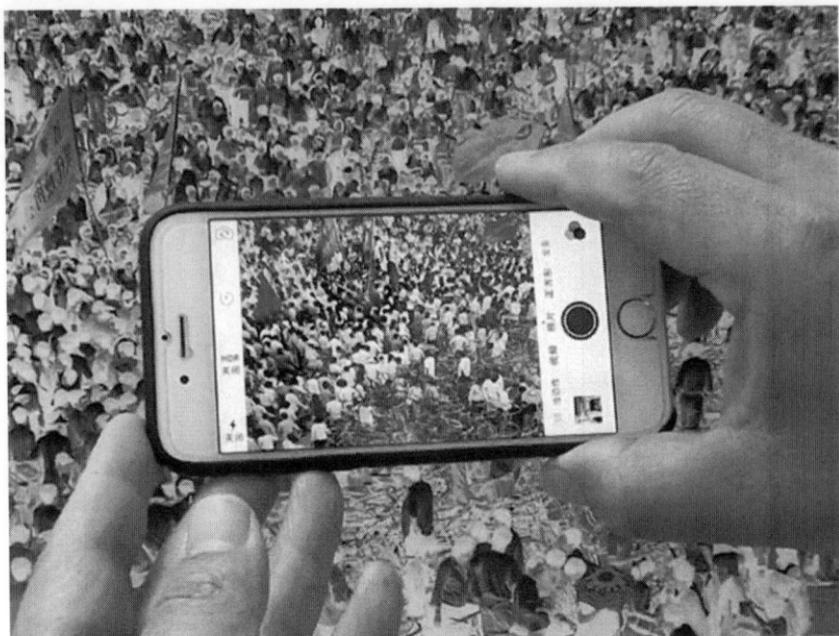

FIGURE P.3 Xu Yong, *Negatives*, 2014. Through the looking glass: the camera lens of a smartphone becomes a slim portal to the past in all its colors.

machine, teleporting the spectator back to a long-hidden past. The protestors and the square do not simply come alive—though of course, that does happen, as their hollow eye sockets radiate light and hope, their pale lips become smiles, the green flags turn to the red of political action, and the energy of so much massed humanity is restored to the frame. They also come to constitute a shared secret, an initiation into forbidden history that viewers must activate for themselves, entering into a pact with the artwork and agreeing to its demands for a measure of spectatorial effort and labor. This quota of engagement is necessary, *Negatives* suggests, if we are to wrestle with those things that are simultaneously very known and very secret. It is not enough merely to look and ponder at these negatives that visualize the disavowed of history as ghosts. These works about public secrecy in China stipulate more: they enjoin a specific kind of parallax viewing community made up of all the people with their phones who invert the colors and stare straight at the unsayable.

I begin here with Xu Yong and *Negatives* because his photobook encapsulates succinctly the themes that dominate this study. The first of these is the overlooked power of public secrecy about China's troubled past as a containing force in its sociopolitical present. At first sight, Xu Yong's negatives seem

like long-forgotten objects. More than this, in fact, they seem to exemplify the idea that histories that are censored will fade from mind, just as the photo-chemical images faded to yellow. Yet rather than suffering oblivion, the reels of film in Xu Yong's archive were forced into hiding, whereas the memory of what happened in 1989 stayed so fresh that the book's epigraph barely needs to gloss it ("These photographic negatives were taken 26 years ago, in 1989"). In this sense, Xu Yong's photobook serves as a paradigm for the claim, made throughout this study, that the forces of censorship and amnesia cannot adequately explain why parts of China's modern history are missing from public discourse, and that it is also the collective decision not to talk—not to develop the negatives—that keeps the past in a state of restless quiescence. In the chapters that follow, I home in on three core episodes from China's long twentieth century—the Nanjing Massacre of 1937; the Cultural Revolution, which lasted from 1966 to 1976; and the 1989 Tiananmen Square protests—to argue that understanding their afterlives in terms of public secrecy opens up new ways of thinking about the past as an ongoing process of making and unmaking that textures life in China today. All these momentous events are well remembered by those who experienced them. But all have, at different points in the past, been rendered either publicly unsayable or open to only limited kinds of enunciation.

Yet even as they have struggled for open speech, these episodes have all left astonishing traces on the photographic record: stills that grip and wound the viewer. These images have been hidden, classified, or suppressed at different points in their circulation histories; but in recent years they have emerged from deep cover, either via underground circuits or through state-sponsored channels. And as they have broken the surface, makers of culture have seized on these photographs, repurposing them in paint, ink, celluloid, codex, mural, fabric, sculpted matter, the digital image, even human skin—whatever medial substrate comes most readily to hand. I call these objects photo-forms. This book theorizes this aesthetic category for the first time and shows how these works function within suppressive environments as modes for visualizing what is hard to say aloud. Photo-forms, I show here, are key sites in which public secrecy and our relation to it happen. As Xu Yong's *Negatives* also makes clear, this is because of the way in which such works—via their encrypted nature—compel from their spectators an active and interrogational kind of viewing. The key point here is that grappling with public secrecy is not about suddenly "seeing" that which once was hidden, about opening a long-locked drawer and finding something explosively clandestine inside. Rather, to paraphrase John Berger, it is about different "ways of looking": strategies of defamiliarization that encourage viewers to gaze anew at the social world precisely

within its settled groove and thus allow the elephant in the room, the nudity of the emperor, to crystallize into an apparition worthy of notice, thought, even action. Photo-forms give their spectators a code to crack, and this labor of decipherment binds the artwork and its audiences together, creating fleeting worlds in which the shape of things that are hard to say aloud can be seen or sensed. Relatedly, Xu Yong's *Negatives* also points to the insistent presence of ghosts across aesthetic practices that try to grapple with the unsayable-but-unforgotten. The way that *Negatives* uses wraiths to explore ghosted histories, and the people who are disappeared by them, belongs to a consistent practice of spectrality in works that riff on well-known photographs of troubled pasts.

Finally, Xu Yong's work points up the overarching claim made in this book: that it is indeed possible to study the clandestine in China. Questions of secrecy and surveillance, of accountability and the opaque, have an escalating salience in our contemporary world. Yet scholars who work on China have mostly shied away from these themes because of the manifest difficulties of pursuing them in a hard-core cryptocracy. Sealed archives, closed trials, "disappeared" dissidents, and the notorious sock puppets and astroturfers who patrol the Chinese web conspire to make the topic seem unapproachable. In what follows, I show that artworks can be as revelatory about secrecy as any declassified document or leaked file, and never more so than when that which is hidden is also very widely known.

Introduction. Staking out Secrecy

My trouble is that I struggle to forget—or to forget entirely—and those things that I cannot wipe from mind are what have produced *A Call to Arms*.
—LU XUN 鲁迅, "Preface" to *Nahan* (A Call to Arms), 1922

Public Secrecy and Its Discontents

The afterlives of China's twentieth-century past are strangely misaligned. While the memory of some events is cherished, vaunted, or held up as an unrepeatable example, other episodes languish in zombied half-life, uncommemorated in public culture despite their incalculable impact. This book interrogates that anomaly. It is hardly an undocumented one: not just in China but across the globe, cultural historians of the twentieth century in particular have probed the protocols of disavowal—the neglect of the dark side of imperial history in Britain, the denial in some quarters of Japanese society of the nation's wartime atrocities, the pall of silence that fell over core aspects of the Partition of India and the Spanish Civil War, the reluctance of many Germans during the Third Reich to dwell on the death camps in their midst—exploring how nations that decide to disown their violent or troubled pasts attempt to calcify that strategic renunciation into hard social fact. Scholars who research China, a prime "disowning" nation, have argued repeatedly that this process is led by the state. Such histories are censored to the point that they either fade from mind or live on only in the tamed or remolded ways that the government permits. Omitted from school textbooks, deleted from social media, banned in books or films, the red-hot core of such events suffers a commemo-

rative attrition that results—or so it is argued—in slow amnesia, in a kind of vanishing. Censorship and amnesia couple up to conjure the disappearance of "bad" pasts.

In this book, I argue that such a top-down view is missing a dimension, and that the disavowal of history in China has many stakeholders, whether willing or otherwise, affiliated with the state or not. I proceed here from the premise that extreme events are seldom forgotten by those who lived them, however diligently the government and its agencies apply themselves to the task, and however keenly individual subjects might crave release from their memories. What happens, then, to that red-hot core? If it does not disappear into oblivion, how is the radiation of the past contained or even cooled? This book argues that public secrecy—what Michael Taussig calls that which is "generally known, but cannot be articulated" (1999, 5), whose not-saying is a convention most conspire to maintain—is an overlooked structuring force in Chinese sociopolitical life today. Moving away from the standard narrative of censorship and amnesia, which accords more power to the state than to the people in the management of troubled pasts, I argue here that the hushing of history is a densely collective endeavor in China. The silences of the present are conspiratorial.

Public secrecy of the kind practiced in China vis-à-vis the troubled past is akin, in certain ways, to the forms of passive or aggressive non-acknowledgment found in other historical contexts. Self-evidently, knowing what not to know is a stricture as pervasive in liberal-democratic states as it is in authoritarian ones. Indeed, it is among the grossest of public secrets that several liberal-democratic orders—those in the U.S. and the U.K., for example—rest nervily on infrastructures built on slave labor or race-based imperialist conquest, dependent on those historic abuses for their current political rationale and rhetoric. What's more, every time the revelations of a whistle-blower barely ruffle the surfaces of power, every time an exposé discloses little more than what was fully intuited already, every time a major information leak seems to bed in, rather than bring down, malfeasants in power, the public secret whispers its ascendancy. And it does so everywhere, even as different societies answer the call to silence differently. In this sense, the attention I pay to China in this study is intended, in part, to suggest that its responses to the felt exigences of the public secret might have a broader valence, particularly at a time when new regimes of the clandestine are on the march.

That said, the tense interplays between a party-state with real muzzling powers and a citizenry conflicted over the troubled past give public secrecy in China a specifically textured complexity. In an evident sense, public secrecy is

self-defensive, because those who break the silence in China might face grave sanction. It is similarly protective, in that elders may choose not to share stories with the young because that initiation into knowledge can bring related risks. It is preeminently social, since members of a given cohort who share a troubled past—Red Guard factions, for example—come together in their adherence to non-saying. It can be embarrassed, because sometimes not only the emperor is naked, and so calling out awkward truths can be self-shaming, particularly in a contemporary moment in which the passion of revolution has long faded. It is often pragmatic; it sees the benefits of letting sleeping dogs lie. It may even, on occasion, be palliative, constituting a form of repair that has fallen out of fashion in the confessionally exhibitionist culture of contemporary Euro-America. In short, and in direct contrast to the rigidity of censorship and the numbness of amnesia, public secrecy in contemporary China is a highly agential process whose actors choose to obey the law of *omertà* for shifting, mindful reasons.

I should make it clear early on that this study of aesthetic forms does not try to prove the unprovable—namely, that the public secret is qualitatively more potent than amnesia or censorship as a strategy for subduing the restive past, for example, or that it is quantitatively more rife in cryptocratic settings than in others. Common sense might decree that the latter point most likely holds because secrets breed secrets. But to an extent, it would require a different kind of study, one rooted in comparative sociology and politics, to flesh out any such claims. Yet in a deeper sense, the public secret—as something deemed unsayable and therefore left unsaid—may ultimately lie beyond the purchase of empirical fact. This is Ian Kershaw's point about the Nazi genocide when he writes that "documentary evidence can hardly provide an adequate answer to the question: 'how much did the Germans know?'" (1983, 364). Or as Robert Eaglestone puts it: "Evidence here is effervescent, hard to pin down, much more a matter of judgement than a document. . . . This is also precisely the sort of issue about which people are unlikely to be honest if asked" (2017, 11). As a quantity that lies "beyond the limits of the discipline of history" and instead "within the discursive space of personal and communal subjectivity" (9–15), the public secret resists positivistic analysis and leaves little concrete trace. For this reason, aesthetic works are better tooled to capture its fluid but decisive workings, and I present the case studies here not as data-driven offerings on the structuring power of "knowing what not to know," but rather as conceptual ones.

A further clarification: this book implies no equivalence between the events whose legacies it tries to rethink. In a self-evident sense, a profound

incommensurability separates the Nanjing Massacre, the Cultural Revolution, and the Tiananmen protests from one another, and it is an incommensurability in every register, from loss of life to popular involvement to historical impact to aesthetic afterlife. Just as tellingly, a significant disjuncture exists in the ways that these events have hardened into public secrets. To argue that they can—even should—be approached together is not to flatten this incommensurability; in fact, the chapters that follow disaggregate different forms of public secrecy precisely in order to honor the incommensurable. In studying these events together, my claim is rather that public secrecy is a neglected force whose operations require a mode of academic address, and the mode I use here is the multiple case study. Case studies are, by their very nature, partial rather than impartial, and they rely on the logic of selectivism, even sampling. Thus other historical events that also lie in some ways within the domain of the publicly unsayable—such as the Anti-Rightist Campaign, the Great Famine, the Sichuan earthquake, the experiences of non-Han peoples—might also have served as exemplars if space had allowed. Brought together, though, the case studies I explore here permit a purchase on public secrecy as a force that has decisively contoured the shape of the past in the present.

Yet public secrecy is a stubbornly penumbral form; its operations are tricky to track. Secrecy is hardwired to resist study, which is partly why "secrecy studies" has only recently begun to gain traction as a field within the Western academy. If that field has fought for a foothold in democratic settings, how are we to approach the workings of the clandestine in China? This is a society in which cryptocracy reigns, where secrecy of any kind does not even exist as a local object of academic enquiry. Unsurprisingly, then, no substantive discourse on public secrecy has developed among historians, anthropologists, sociologists, and political scientists who work on China, however proficient individual citizens may be in "knowing what not to know."[1] I argue here, though, that such disciplines may not be our most propitious route into the subject anyway. This is because public secrecy, as a felt but elusive force, leaves its most visible traces not in historical archives, fieldwork data, or government legislation, but in aesthetic forms—and in one category of representational objects, in particular. These are works that riff on well-known historic photographs.

As mentioned in the preface, I call these objects "photo-forms." Their presence, this book shows, is profuse in places where public secrecy reigns. Some photo-forms, both in China and elsewhere, are celebrated or even canonical in their individual instances; after all, arresting photographs were born to be remediated. But the status of these works as a discrete genre or genus, bearing what Wittgenstein calls a set of "family resemblances" (*Familienähnlich-*

keit) (2009, 67–77), has yet to be discussed, and the talismanic role they play in cryptocratic societies has been overlooked altogether. This book names and conceptualizes the photo-form for the first time, and it specifically identifies these works as key sites within which public secrecy, so ungraspable a force as it steadies the social world, emerges as material form in suppressive environments. Photo-forms are adept at shadowboxing with those things that people find difficult to say aloud, principally because they are visual objects that "speak" the language of secrecy. The very making of a photo-form mimics the act of hiding, as a well-known photograph is cloaked in different material guise. And as part of this process of cloaking, the visual field of the photo-form bristles with clues and allusions that the viewer has to decipher—a process that, in its turn, mirrors the experience of being initiated into a secret. The circulation of these works is often samizdat, or below the radar; as a result, viewing photo-forms creates an in-group or clandestine collective. But at the same time—and crucially—the fame of the original image means that a photo-form always remains instantly recognizable, even as its shifted shape allows it, for example, to dodge the online militia who patrol the Chinese web. Just like the public secret itself, in other words, photo-forms are both occluded and blindingly obvious, encrypted and clear as day. In places where public secrecy reigns, photo-forms and the communing they enjoin can form a fleeting parallax world: an alternative space in which public secrecy can be named and even owned, and in ways that bind spectators both to the artwork and to each other.

As such, photo-forms become akin to what in European folklore used to be called a "familiar," a regular spirit companion or alter ego of the maker of social magic that is the public secret itself. Indeed, another reason why photo-forms can stage a reckoning with public secrecy is because these works are insistently spectral. In part, this is the shadow of ghostliness that is cast over all photographic objects: the historical photograph as a chronicle of death foretold, in Barthes's famous formulation. The haunting character of the photo-form also comes from its status as an interstitial object. These works hover between media, and they often dwell in liminal, halfway spaces: in banned films, in the hidden cracks of the internet, in social media posts that are deleted but still pop up in online searches, in exhibitions that get closed down quickly and leave only vestigial traces. But for the most part, photo-forms look like phantoms because their makers actively spectralize them. Ghostliness is the dominant visual language of the photo-form—whether poignant, satirical, fugitive, vengeful, or uncanny—and it recurs because these image-works are haunted by the gaps that public secrecy seeks to paper over, gaps that ghosts,

as figures of absence made visible, can register. These revenants do not refer predominantly to the dead and to our mourning of them, although this urge is always latent. Rather, as Avery Gordon puts it, "the ghost is primarily a symptom of what is missing. . . . What it represents is usually a loss, sometimes of life, sometimes of a path not taken" (1997, 63–64). It is in this sense that photo-forms, as noted earlier, shadowbox with public secrecy. This notion of a gentler kind of combat is crucial because it recognizes that public secrecy is not an axiomatic social evil that always requires, or will necessarily succumb to, hard antagonism as its main response. If the spectral force of these works can offer what Walter Benjamin called "a revelation that does justice" to the secret (1977, 31), this is because it acknowledges, through the persistence of its returns, the enduring magnitude of what cannot be said aloud. But at the same time, the ghost's fitfulness—the tactful nature of those returns—is also a recognition that keeping *schtum* is sometimes a social need, a strategy for survival for those who might otherwise capsize in the backwash of history.

In this introductory chapter, I sketch out these core arguments in close focus. I begin by noting the elusiveness of secrecy as an object of study whatever its provenance, and most especially in hard-core cryptocratic environments, where the deterrents to research are daunting. Yet public secrecy is a highly social affair, and precisely as a shared quantity it is hard to quarantine, spilling out in unexpected ways; furthermore, it expands in natural tandem with the overall secretiveness of a given social order. Of all the secrecies, it should be the hardest to hide. Given this, I ask why "knowing what not to know" has yet to be properly acknowledged as a force in postsocialist China. I argue in answer that public secrecy is missing across cultural, academic, and media accounts of how China has processed its troubled pasts because two linked and highly plausible proxy forms have conveniently covered up its labors. These proxy forms are the discourses of censorship and amnesia. Together they have coalesced into the now entirely normative argument that China's troubled past is mute or barely talkative because it has been policed into oblivion, and that we should look to the etiology of memory fail, brainwashing, even coma to explain why contemporary historical consciousness is so cratered with gaps. But the question then becomes: If public secrecy is itself so hidden, where do we go looking for it? I show next that representation is often the place where public secrecy breaks cover, as makers of culture exploit the powers of encryption harbored by representation—and the photo-form in particular—to encode the unsayable in their work. I go on to parse the photo-form as an aesthetic category with a distinctive ontology and scope out the parallax world formed by these image-works, their makers, and their audi-

ences. These are fleeting spaces in which public secrecy is named and outed via the visual language of the ghost who serves as an undying reminder of justice and its demands.

The Missing Discourse That Is Public Secrecy in China

Secrecy is perennially evasive as a form, repelling those who enquire after it. Its persistent elusiveness as an object of study is partly why the sole journal expressly dedicated to such an enterprise, *Secrecy and Society*, brought out its first issue only in 2016 (as an open access publication, appropriately enough). Writing in that issue, Clare Birchall begins by noting the core epistemological slipperiness of the secret: How can we study it when that very process of investigation renders it no longer clandestine (2016a, 1)? The act of uttering the secret aloud sheds its aura, turning it instead to hard-and-fast information, a point that Derrida flips around when he observes that the origins of the secret also lie, paradoxically, in speech (1989, 16–17). Secrets both are born and move steadily toward their death through the act of enunciation, a perversity that Susan Maret acknowledges in a different way by calling secrecy a "wicked problem" in theory (2016, 1–28), borrowing from Rittel and Webber's (1973) coinage. This "wickedness," always there, has become more wayward over the past two decades as the intersection of social media in a confessional key with wraparound digital and spatial surveillance has created lifeworlds in which secrecy is at once nowhere and the substance of pretty much everything. This sort of untrackability extends to tracing secrecy as an evolving conceptual construct: while many theorists engage with it, they often do so either intermittently or as a cog or constituent part within larger frameworks, as in Max Weber's studies of bureaucracy, Elias Canetti's conceptualization of crowds, Deleuze and Guattari's anti-capitalist philosophy, and of course Derrida's many insistent but irregular returns to the theme. Although Georg Simmel, "the sage of secrecy studies" (Maret 2011, xx), published his landmark essay, "The Sociology of Secrecy and of Secret Societies," well over a century ago, it may not be accident that a concentrated disciplinary energy has begun to build around the subject only since the millennium.

This emergent, newly named field has an extensive, though critically scattered, repertoire of conceptual resources on which to call, still more so if we include adjacent topics of surveillance, whistle-blowing, propaganda, and so on. These resources are fullest in the social sciences, where studies of secrecy in governmental, corporate, state security, scientific, or technological environments since World War II have helped pin the theme down as a moving

target for inquiry. These studies, almost invariably and often without specific acknowledgment of the fact, take the so-called Western democracies as their theater of action, with certain a priori assumptions about such matters as free speech, public accountability, and access to information. They pass over their non-democratic others, for whom Sissela Bok's aphoristic point about "the sheer extent of all we do not know about the many aspects of secrecy" becomes a hard deterrent to research (1989, 282). The rigors of the Maoist era were such that the only studies to delve in depth into secrecy as a norm or force in revolutionary China are those by Frederic Wakeman (2003) and Michael Schoenhals (2013) on espionage, and by Michael Dutton (2005) on public security and policing. And few could dispute that secrecy studies in contemporary China is just as tough a sell. From where exactly, in one of the globe's most secretive states, is the study of the clandestine supposed to launch itself?

This creates a theoretical quandary or impasse, another wickedness. In a sense both real and rhetorical, secrecy is not fully researchable as a topic for scholars who live and work in China itself, however sensed and immanent a force it may be.[2] This is the grim logic that the tighter the cryptocracy, the less accessible secrecy itself becomes as an object of inquiry—or the more we need to study secrecy, the less we can. The inverse of this logic, as suggested a moment ago, is that the more transparent a society is, the more it luxuriates in theoretical articulations of what it means to live with secrecy. Cryptocracies, in other words, are implacably self-sustaining in their secretiveness. By using "cryptocratic" as a descriptor for contemporary China, though, I seek to expand on the standard definition of the term—namely, a society in which *éminences grises* behind the scenes, rather than publicly elected representatives, exercise power—to suggest a more comprehensive governmental mode. Taking the term back to its etymological root, "rule by secrets," I use "cryptocracy" here to refer not simply to nations that govern via secrecy in the shadows. After all, even the most professedly transparent of states possess a "secret core of government where information is considered and decisions taken far from the public gaze" (Harrison 2004, 1). And needless to say, the Chinese state ranks high on these normative measures of the clandestine—as many Western media accounts have shown, zeroing in on China's hidden overseas aid empire, its secret bitcoin mines, its covert nuclear program, its use of cross-border extraordinary rendition, even its espionage tactics against global lingerie giant Victoria's Secret. The predations of state secrecy against the government's own subjects have also emerged as an inevitable parallel theme: the exact number of clandestine executions China carries out, the vast sums that some high officials have secreted in offshore bank accounts, the undercover "clean-ups" the

state carries out against some of its most vulnerable citizens. Yet in dubbing contemporary China cryptocratic, my aim is to highlight how this tight sequestering of information also coexists with the status of secrecy as a mode of governmentality that is practiced, rather more paradoxically, out in the open.

Media and even academic commentary on China that chiefly views the state as the custodian and arbiter of *arcana imperii*—those "mysteries of rule" that must always remain occluded from public scrutiny—misses the extent to which the Chinese government seeks to advertise its clandestine powers: not in their details, of course, but via the deeper message that secrecy rules, that it is a governmental *modus operandi* crafted as a visible strategy even while its practical workings remain necessarily obscure. As I discuss in greater detail in chapter 3, this mode of spectacular secrecy is, of course, by no means restricted to China. When Debord noted some time back that "almost no one sees secrecy in its inaccessible purity. . . . Everyone accepts that there are inevitably little areas of secrecy reserved for specialists; as regards things in general, many believe they are *in on the secret*" (1998, 60–61; emphasis in the original), his point was that secrecy has leached away from sacralized status, and it has done so precisely by becoming bigger and more apparent. Debord continues with the observation that "the spectacle has brought the secret to victory" (79), and the fruits of that triumph are ubiquitously on display in liberal-democratic states, from the consumer ploys of "secret cinema" (in which the deliberately hidden details of an upcoming show become a marketing technique), to the in-house security services now commonplace within major corporations, to the surveillance satellites that we know full well are always watching us.

Against this widespread backdrop—we all live in cryptocracies now—secrecy in China stands out because both the chokehold on information and the deployment of secrecy as a spectacular power play operate at full tilt. They exist in a kind of magnetic balance and produce a prevalence of secrecy that is not just generalized, to use Debord's term, but palpably ambient in quotidian life, helped along by a comprehensive surveillance regime consisting of wraparound CCTV, an incipient "social credit" system which encourages self-monitoring,[3] and the spreading deployment of biometrics for social profiling purposes. This climate has led to an abundance of so-called hidden rules (*qian guize* 潜规则) and at the same time has created the conditions in which "knowing what not to know"—public secrecy—has become something close to a normative felt need. As a mode of concealment, public secrecy is not shuttered in closed archives but dwells in the interstices of the everyday and the everywhere, akin to what Birchall calls "shareveillance" (2016b, 1), a form of control in which we are all enforcers. And as such, it is as brittle as its co-conspirators

are ubiquitous and unpredictable, always susceptible to the little boy of legend who finally scoffed at the naked emperor. The status of public secrecy as a molecular thing, stretched out thinly across the social world, is both its power and its vulnerability. At the very least, it should make this covert quantity a discernible object for attention.

This apparent accessibility of public secrecy makes its absence from the discourses about the afterlives of China's past all the stranger. When I began writing this book, I imagined that its separate chapters would each take in various modes of secrecy; that as a whole the study would follow the naming pattern prevalent in the contemporary humanities and feel the need to pluralize its object of study ("secrecies in China"); and that the legacy of Tank Man and the crushed Tiananmen protests of 1989 would serve as the sole standout of the publicly unsayable as a specific phenomenon. Certainly, each of the following chapters begins with a different premise about secrecy and pursues its distinct outworkings. But what transpires, sooner or later, is that public secrecy repeatedly surfaces as a core force directing the journeys that these events—the Nanjing Massacre, the Cultural Revolution, the Tiananmen protests—have made to the present. All have been shaped by precisely that kind of willed opacity that shields people from what is not in their gift or power to acknowledge openly. Or, as Taussig puts it, "if secrecy is fascinating, still more so is the public secret into which all secrets secrete" (1999, 223). These unforgotten, unsayable things are also pluralized themselves; thus their publics may be greater or lesser, and the kind of knowledge they disown may be particular to a cohort or more generalizable to a generation. Yet public secrecy is as present throughout as it is missing from the interpretive apparatus of China's modern history: a public secret in and unto itself. The only study to date that begins to grapple with the unsayable as a social force in China is Stephanie Donald's *Public Secrets, Public Spaces: Cinema and Civility in China* (2000). But rather than China's vexed pasts, her focus is on women and children, and the public space that Chinese cinema affords for their visible expressions.

At a now-notorious Pentagon briefing in 2002, Donald Rumsfeld set out some stakes for knowledge, power, and the role of secrecy as their broker: "Reports that say that something hasn't happened are always interesting to me, because as we know, there are known knowns; there are things we know we know. We also know there are known unknowns; that is to say we know there are some things we do not know. But there are also unknown unknowns—the ones we don't know we don't know. And if one looks throughout the history of our country and other free countries, it is the latter category that tend to be the difficult ones."[4] But as Slavoj Žižek (2004) later pointed out, there is also

a fourth category: "the 'unknown knowns'—the disavowed beliefs, supposi-tions and obscene practices we pretend not to know about, even though they form the background of our public values." In fact, we might revise Rumsfeld's tongue twister to suggest that, when looking through the histories of "unfree" countries, it is this final category that tends to be the truly "difficult one." Pub-lic secrecy about the shared past may well be the toughest form of knowledge to grapple with in China, despite its ubiquity and the fact that the concept has been crucial to the growth of secrecy studies in societies where its articula-tions (or inarticulations, one should say) are rather less palpable and determin-ing. Sparked in many ways by Michael Taussig's rich study *Defacement: Public Secrecy and the Labor of the Negative* (1999),[5] public secrecy has become a core paradigm for the clandestine in the age of WikiLeaks, as Abu Ghraib, race relations, the prison system, and other rankly present crises remain, de-spite regular exposés, strangely unsayable as facts and more untouchable still as problems.[6]

Significantly, though, the origins of Taussig's book lie in Colombia during the 1980s, a situation of paramilitarism and so-called low-intensity democ-racy, in which seeing and speaking no evil was a response to fear more than to awkwardness. In this sense, the noisy silence over forms of injustice in con-temporary Western democracies may better fit the paradigm of denial set out by Stanley Cohen in his study of compassion fatigue, bystander passivity, and other kinds of political and private blinkeredness. Here, the decision not to know mostly relates to the lives of others, as the terms "compassion fatigue" and "bystander passivity" show well enough (Cohen 2000). Such silences can also be understood in terms of what Peter Galison terms "anti-epistemology," a mode of enquiry that asks not how knowledge is produced but rather how it "can be covered and obscured" (2004, 237). Also relevant is the new disci-pline of ignorance studies, which explores "the mobilization of ambiguity . . . [and] the realization that knowing the least amount possible is often the most indispensable tool for managing risks and exonerating oneself from blame in the aftermath of catastrophic events" (McGoey 2012, 3). The strategic options availed by ignorance, by deliberately seeking to be ill-informed, are a step be-yond considered silence, because a lack of knowledge can be openly voiced, even declaratively owned, and we can surely expect the resource of ignorance to be harvested more intensively as surveillance grows. But these varieties of non-knowledge as a paradigm falter in the face of mass collective experience. What the suppression of certain histories in China forces us to consider is how a surfeit of shared knowledge, inadmissible and steeped in pain, has been socially managed.

In such a context, public secrecy almost inevitably becomes a hard norm, and one that is not merely socially avoidant but also personally defensive at a population level. Yet, true to its name, this norm has hidden itself from discursive scrutiny even as its reach as a processual mode for troubled histories in China has become extensive. Ultimately, it is in this sense that public secrecy is a "wicked" problem since challenges of this kind "defy efforts to delineate their boundaries and to identify their causes, and thus to expose their problematic nature" (Rittel and Webber 1973, 167). To be more precise, public secrecy has escaped notice because other explanations for why historical consciousness in China is so full of potholes have proved both more politically gratifying and less politically awkward. These proxy forms are censorship and amnesia. As a paired argument, they have functioned as stand-ins for public secrecy in cultural, academic, and media discourse even though their epistemological limitations are often quite well understood. Both strip out the lateral sociality of public secrecy—the sense of horizontal cohorts who withhold lived experience en bloc and as a joint labor—in favor of top-to-bottom relations that locate agency in the state and treat the people as coercible herds. As such, they gratify the grandiosity of the Chinese Communist Party (CCP), which strives after precisely that absoluteness of power over its subjects. At the same time, they also suit the pieties of liberal-leaning foreign media, whose indignation at that regime is often so tunnel-visioned that the more discomfiting point that silence might be shared work slips from their view.

All Power to the State and Its Censors

The first reason for the neglect of public secrecy is the focus on censorship among many who write about contemporary Chinese culture: its enforcement, its evasion, and the distortions it inflicts on social behavior and creative acts. This is not to deny the role that organs of censorship play in keeping troubled histories muzzled. China's censorship apparatus is both vast and tentacular, "unprecedented in recorded world history" in its capacity to regulate different kinds of speech acts and varied platforms of articulation (King, Pan, and Roberts 2013, 1): from literature to instant messaging, print media to video games, school textbooks to memorial steles. This apparatus consists of regulatory bodies such as the National Radio and Television Administration, which issues directives, acts as a gatekeeper of new content, stipulates revisions, restricts circulation, enforces the removal of material deemed unacceptable, and exercises opaque discretionary powers over all stages of the culture-making process. Just as crucially, this redoubtable apparatus has also bred habits of

self-censorship among makers of culture throughout the twenty-five-year period I focus on in this book. Strategic ambiguities, gnomic pronouncements, and invisible red lines keep writers, filmmakers, and artists on the *qui vive*, so fearful of breaching the code that many barely broach its outer edges.

Censorship also preoccupies itself in almost ceaseless ways with micromanaging the online world in China: blocking websites and VPNs, voiding certain keyword searches, stipulating real-name registration for online forums, disrupting messaging services, and making platform stakeholders responsible for the content on their sites. In its mission to ensure that the Chinese web stays both economically turbocharged and politically obedient, the state is served by a vast corps of internet cops who labor round-the-clock to identify and delete undesirable content. Censorship is just as formidable in education, ensuring that episodes such as the Anti-Rightist Campaign of 1957–59, the Great Famine of 1958–61, the Tiananmen Square crackdown, and sensitive aspects of the Cultural Revolution experience are either omitted from school textbooks or downplayed in a vague sentence or two. It extends decisively into scholarship, controlling archival access and using digital tools to amend the archive itself by deleting critical articles from databases (Bland 2017). University classrooms are also subject to both surveillance and sousveillance, especially during the Xi Jinping 习近平 era, when many historians have felt compelled to swerve around the glitches in the China's modern past in favor of bland studies on Marxist-Leninism. Censorship also shapes the physical and discursive limits of commemoration in contemporary China, as the state's refusal to lay wreaths, erect statues, honor sites, build museums, establish national holidays, and encourage intergenerational dialogue about taboo pasts produces a dehistoricized landscape.

As a supple strategy for political control, censorship in China does not simply denote banning cultural texts, products, or activities; as suggested above, it also involves modifying and managing provocative content. Here, though, I deploy the term principally in its most rigid and prohibitive form, as an instrument for keeping certain kinds of material out of the public domain. And it is in this guise that state censorship might reasonably be taken as a core architect of the many taboos that shroud the past in contemporary China. According to this view, stories are not told, remembrances are not shared, histories are not researched, and commemoration is not performed because the government muzzles any such speech acts the moment that they fall from the lips of the people—and the people respond by stayed close-mouthed because they have little other choice. Yet this focus on censorship treats enunciation as a preeminently public act. It passes over the point that private, unsurveilled

spaces can—in theory, at least—serve as arenas in which friends and families breach state injunctions on not-saying. In China, however, widespread ignorance among later-born citizens about the nation's *verboten* pasts suggests that such opportunities are mostly forsworn as elders censor themselves—or so the standard argument goes. Yet to make this claim is to assume that the people always wish to speak, that words would brim forth if only they were permitted to flow freely. This view discounts the possibility—the likelihood—that many survivors, witnesses, and perpetrators of violent histories are gripped by no such urge to speech, and indeed they may actively prefer, for reasons of pain, fear, complicity, guilt, or shame, to abjure discussion of their pasts. Self-censorship is an inadequate descriptor for silences such as these, for reticence that may be willing. Indeed, we might even suggest that rather than chafing under the yoke of state censorship, cohorts exist within Chinese society who quietly welcome, and for many different reasons, the injunctions placed by the party-state on "speaking evil"—or speaking at all—about the nation's wounded past.

But the argument about (self-)censorship dominates nonetheless, and it is often framed in accusatory terms. Prevalent here is the suspicion that saying nothing is a strategy that reaps rewards as part of a tacit pact between rulers and ruled. This point about the perks of self-censorship emerges in an essay by Ai Weiwei 艾未未 published in 2017 in the *New York Times*, entitled "How Censorship Works." In it, the artist argues that the state and its subjects in contemporary China contract a Faustian pact in which creature comforts are exchanged for keeping *schtum*:

> Whenever the state controls or blocks information, it not only reasserts its absolute power; it also elicits from the people whom it rules a voluntary submission to the system and an acknowledgment of its dominion. This, in turn supports the axiom of the debased: Accept dependency in return for practical benefits. . . . The most elegant way to adjust to censorship is to engage in self-censorship. It is the perfect method for allying with power and setting the stage for the mutual exchange of benefit. . . . That's what we have here in China: The self-silenced majority, sycophants of a powerful regime, resentful of people like me who speak out, are doubly bitter because they know that their debasement comes by their own hand.

This critique is, in some ways, an exegesis of Jiang Zemin's 江泽民 famous motto for the post-Tiananmen era, "Keep your mouth shut and get rich" (*mensheng fadacai* 闷声发大财), and Ai Weiwei's notion of the "self-silenced majority" skewers

certain social behaviors in the contemporary PRC with undeniable acuity. Yet a critical difference exists between self-censorship and public secrecy, even if they may overlap at points in the Venn diagram of non-saying, and that difference swims into focus when we consider the legacies of China's troubled pasts. Keeping quiet is not always the clear-cut moral choice that Ai Weiwei claims it to be here; nor do those who maintain these consensual silences always do so as a strategy for acquiring "benefits." Critiques of self-censorship, which focus on "currying reward and avoiding punishments" (C.-C. Lee 1998, 57), fail to acknowledge that those who do not speak are sometimes protecting private secrets rather than wearing the muzzle of cynical obedience.

As a flawed but eye-catching paradigm for why silence happens, censorship draws attention away from this wide prevalence of secret-keeping about the past in China. Thus it functions not just as secrecy's tool but as its proxy, a force that can be railed against for its throttling powers and sclerotic effects, while the larger force—secrecy in public culture, secrecy as public culture—avoids scrutiny. In present-day commentary on China and its cultural scenes, lamenting censorship has assumed the status of a default liberal critical position to the extent that studies of the topic absurdly outnumber those that explore secrecy as a mode of sociopolitical containment. In this sense, we might argue that censorship serves its master exceptionally well, not simply because it blocks specific kinds of creative content but because, together with amnesia, it has supplanted public secrecy itself as the chief object of intellectual inquiry. Rather than the elephant in the room, a presence whose huge size causes discomfort because it is ignored, public secrecy has thinned out into the ambient air. It is so obvious—of course China is a cryptocracy!—that its movements in culture have barely been tracked.

Oublier *Amnesia*

This notion of public secrecy as a mindful process is flatly refuted by the second part of the two-step story about why certain histories have such scant traction in China's present. This is the discourse of amnesia: the notion that if troubled pasts strain for speech in contemporary China, it is because state censorship has succeeded in wiping them from the popular mind. Just as it has become commonplace to describe China's twentieth century in the language of cataclysm, so too is it now standard to view the flawed processing of that past in terms of memory fail. In a regime that fears its own guilty history and has tools of deletion at its disposal, forgetfulness becomes state policy and has crystallized as a cultural, academic, and media trope. Literary and cinematic

works such as Wang Shuo's 王朔 *Playing for Thrills* (*Wanr de jiushi xintiao* 玩儿的就是心跳, 1989), Ma Jian's 马建 *Beijing Coma* (*Beijing zhiwuren* 北京植物人, 2008), Chan Koonchung's 陈冠中 *The Fat Years* (*Shengshi: Zhongguo 2013* 盛世: 中国 2013, 2009), Wang Xiaoshuai's 王小帅 *Red Amnesia* (*Chuangruzhe* 闯入者, 2014), and Fang Fang's 方方 *Bare Burial* (*Ruan mai* 软埋, 2016) feature characters whose memories have been wiped, warped, and medicated into void, or who even engage in what Yomi Braester describes as a flippant kind of forgetting (2016).[7] As writer Yan Lianke 阎连科 (2013) puts it, "Have today's 20- and 30-year-olds become the amnesiac generation? Who has made them forget? . . . Are we members of the older generation who still remember the past responsible for the younger generation's amnesia? The amnesia I'm talking about is the act of deleting memories rather than merely a natural process of forgetting. Forgetting can result from the passage of time. The act of deleting memories, however, is about actively winnowing out people's memories of the present and the past. In China, memory deletion is turning the younger generation into selective-memory automatons."

At some point in a dystopian future, what Yan Lianke calls "state-administered amnesia"—a key plot element in *The Fat Years*, in which the authorities dose the population with MDMA—might be actualized in the water supply of repressive regimes. In the short term, it is more likely that those who carry *verboten* memories will pass away, thus obviating the need for chemical intervention. Until that point, though, amnesia needs also to be understood in its role as a figure of rhetoric, whose invocation can perform acts of finessing. To query this twist in the mnemonic turn is not to discount the value of studies that document or instigate actual processes of remembrance: these are far too numerous to list and have steered a transformative shift in Chinese historical studies over the past twenty years. Memory as methodology starts to falter when remembrance-related terms are deployed counterindicatively as "amnesia," "selective recall," "coma," and "brainwashing," words that suggest forgetfulness not merely as failing cognitive function but as a medicalized etiology. Nor is it my intention here to dispute that the failure to commemorate the past in public can impair memory, forcing it inside and underground, and denying those who remember the chance to activate their recall through telling and retelling. All the events I discuss here are diminished by missing memories: the details of people, places, words, smells, sounds that have been permanently lost as the state makes commemoration taboo. But at the core of these events lies the unforgettable, and for those who have been scorched by its fear, violence, and shame, true oblivion is surely a chimera, a pipe dream, even. Mass forgetfulness is a misnomer because rather than being a nation of amnesiacs,

China is divided between those who cannot fully forget but stay mostly silent, and those who have never, or barely, learned about the events that are seared across the cortices of their elders and so have nothing to unremember.

In this sense, the Chinese amnesia discourse is always overdetermined by irony. Hints of this are visible in Yan Lianke's subject-nonspecific syntax ("the act of deleting memories"), a symptom mirrored by the recurring use of the passive voice in academic accounts ("about once each decade, the true face of history is thoroughly erased from the memory of Chinese society" [Fang Lizhi 1990]). Another instance is the use of scare quotes around words such as "forgetting," which carries a similar sort of hedging effect. The rhetorical character of the amnesia discourse also surfaces in the often sardonic tone in which it is called to account, such as the title of Louisa Lim's study of the Tiananmen protests—*The People's Republic of Amnesia* (2014)—and Geremie Barmé's (1987, 2017) two essays on the subject, which lampoon "China's memory hole industry." In other words, the amnesia paradigm is caviled at in such discussions even as it is asserted, and this use of irony points to the limitations of memory fail as a methodology. Rather than amnesia *per se*, it is the shadowy pressure of the nonspecific subject, the enforcement inherent to the passive voice, the sense of the arguably inaccurate implied by scare quotes, and the mordant critique that reveal more about why certain events struggle for sound in the present. Some might call these strategies the "art of forgetting," harking back to Nietzsche's notion of "active forgetfulness," which helps ordinary life proceed and functions as "a preserver of psychic order, repose, and etiquette" (1989, 58). Or as Elizabeth Jelin puts it in relation to traumatic pasts, "oblivion is not an expression of absence or emptiness . . . rather, it is the presence of that absence, the representation of something . . . that has been erased, silenced or denied" (2003, 8). My aim here is not to refute the concreteness of what cannot be said, but rather to query whether the lexicon of forgetfulness always captures it rightly. The caviling strategies listed above are symptoms of a broad awareness that something else is at work, and so it might be argued that simply renaming "amnesia" as "public secrecy" might be sufficient remedy in and of itself. Yet it is equally symptomatic for the secret to seek out proxies for its doings, and this use of dummy fronts suggests that its practices need closer attention on their own terms.

Furthermore, if the discourse of forgetfulness is in large part euphemistic, then we should ask why it is deployed so routinely. Euphemisms themselves are of course a form of public secrecy, a means of covering up obvious but awkward truths—an irony too rich to overlook. Rather like the term "ethnic cleansing," which has come to denote the filthy practices of forced emigration,

deportation, and genocide, or the military sex slaves who are still unconscionably called "comfort women," "amnesia" in the Chinese context functions as accepted code for a relationship with the past that is in many ways the very opposite of forgetful. And just like "ethnic cleansing" and "comfort women," "amnesia" is a term that suits the forces of oppression, as the power to make its people forget the past is precisely what the Chinese state wants to own and flex. Reminiscent of Cold War paranoia about the Yellow Peril—mind control and brainwashing of a passive populace—the top-down execution implied by the memory wipe makes "amnesia" a term that we should deploy only under advisement. The repeated use of terms such as "ethnic cleansing," "comfort women," and "amnesia" has a long-term softening or distracting effect, even when these euphemisms are deployed, with scare quotes, by those most opposed to the realities they mask. Indeed, the expression "veil of semantics" has currency precisely because language is often where secrets go to hide. To call Chinese society "amnesiac" is—in effect, if not intention—to elide once again the agential nature of the silence that shrouds the past: its status as a social fact that is made and maintained by the many. Keeping secrets, as Simmel pointed out, is a highly social business (1906, 464).

In short, it is not my intention to add to the already extensive documentation about state-managed memory in China, nor to join the many voices who impugn the CCP for its grip on informational access to the past, though those voices constitute an inevitable background chorus. Nor does this book significantly revisit traumatic memory in China, a topic that others have ably explored already.[8] Ultimately, the discourse on memory and its distortions in China is what the philosopher Max Picard called one of the "loud places of history" (1952, 84), a space of noisy disputation in which, perhaps most vocally, dissident exilic intellectuals shout back to the Chinese government about its betrayal of the past. In writing about history's "silent side" (84), Picard's aim was both to recover silence as a social good and to show that it can be a Durkheimian "social fact" in the aftermath of brutal history, a way of "acting, thinking, and feeling . . . invested with a coercive power" (Durkheim 1982, 52). The chapters that follow are neither ethnographic, anthropological, nor sociological, but instead push toward a cultural turn in secrecy studies, an emergent discipline in which the social sciences still mostly rule.[9] Sensing out public secrecy in culture is crucial because it is in representational forms that these silences, via the antagonistic responses that makers of culture address to them, can take discernible shape. As such, the works I look at here are never "just" aesthetic. They also constitute forms of knowledge—speech acts—that feed back as ripples and show that the past lives on despite the silence that shrouds it.

Secrecy, I argue here, is best engaged with on its own terms, especially in cryptocratic societies, where antagonism must remain in the shadows. Representation offers exactly the disguise and encryption necessary for this kind of endeavor because it mimics in its deepest structure, and in the provocations it offers to those who read and view, what Simmel called the "charm of the secret" (1906, 465).[10] This is evident as a blatant meta-strategy in the genre of the *roman à clef*; in the labyrinth walk of Chartres Cathedral; in Leonardo's visual puns and in Holbein's rebus of mortality in *The Ambassadors*; in the work of all the artists, from van Eyck to Velasquez to Picasso, who have slipped hidden self-portraits into their paintings; and in the venerable Chinese literary tradition of "using the past to satirize the present" (*jiegu fengjin* 借古讽今) via elaborate encrypted allusion. These works advertise representation as the craft of encoding, and reception as the labor of its decipherment—so much so that *The Ambassadors* is a painting that is so spectacularly known, in an arresting paradox, precisely for the secrets it hides with such *mysterium*. It is via the devices of concealment that the painting vouchsafes, down the generations, the thrills of revelation that have secured its fame and exposure.

Works of this kind are less an outlying category than extravagant exemplars of a fundamental relationship between creative objects and their audiences. Or, as Frank Kermode puts it of the secretive potential of even the most candid narrative, "If we are willing to do so, we shall find over the plot the shadow of a secret that has defied . . . readers who want the work to be throughout like beer in a glittering glass" (1980, 94). It is this fundamental, already existing relationship between secrecy and representation that makes aesthetic forms so natural a site or seedbed for any effort that seeks to do justice to the unsayable. The stakes for the aesthetic realm, and the revelatory burden it needs to bear, grow of course in tandem with the grip of covert powers. But if we take public secrecy—even more than "disappearances," closed tribunals, and blatant "black ops"—as the surest marker of such a society, then the relationship it comes to bear with representation becomes more pointed still, as *The Ambassadors* also makes clear. In a pictorial space jostling with secrets—the globe, the mosaic floor, the lute with its broken string, the half-hidden crucifix, the polyhedral sundial, the hymn book in Luther's translation—it is the anamorphic skull floating in the foreground that has always grabbed the limelight. The space it occupies is the "locus of the secret" in an archetypal sense. As Daniel Collins notes, anamorphosis as a perspectival device has a history rooted in secrecy and the illicit: "The effect has been widely used to surreptitiously

depict subjects one might otherwise be reluctant to represent: the erotic, the scatological, the occult, the religious, the politically controversial and the philosophically abstruse" (1992, 77). It operates like the keyhole, glimpsable only as the viewer passes through a particular observational point, and only if that viewer is prepared to peer hard.

Indeed, such images require what Collins calls an "eccentric" spectator, one who is not simply "willing to sacrifice a centric vantage point for the possibility of catching a glimpse of the uncanny from a position off-axis" (1992, 73), but who is ready to engage in the labor of image-making, because "there are few models of vision that explicitly place the percipient in the role of creating her own experience" (78). Figurally, then, the elongated skull belongs to an order of the clandestine different from that of its companion objects, which all adhere to their God-given perspectival shapes and places. These other objects also cleave to the broader notion that some kind of disclosure—the crucifix unveiled, the broken string decoded as religious disharmony—will solve the secret puzzle. The skull defies this logic of resolution. Certainly, the spectator's efforts are rewarded when the skewed slash in black-and-white resolves into a skull, seemingly illustrating Shakespeare's point in *Richard II* that "... perspectives, which rightly gazed upon / Show nothing but confusion— eyed awry / Distinguish form . . ." (2011, 184). But where, really, does this leave the secret? In a way, it remains as intractable as ever, because the death's head merely encrypts the picture further: Is it a memento mori, a virtuosic display, an authorial signature, a "trap for the gaze," as Lacan (1998, 89) argued in his equally cryptic seminar on Holbein's masterwork? More to the point, this desire to uncover the secret may lure the viewer into missing what is arguably the real "reveal." This is because the sideways apparition of the secret skull forestalls a focus on how that glitched, paranormal shape actually functions within the immediate visual field of the painting, viewed head-on and without the always anticipated mitigation of the left angle. In an image overinscribed with the language of the code and the crypt, the skull viewed head-on shows that secrecy is most distorting when it is most central, most present, most public. If anamorphosis makes the familiar strange, then Holbein's perspectival play reveals not the secret-as-content so much as secrecy as a structural force within the very plane of normal human vision. It shows secrecy as something public.

As surveillance and secrecy have ramped up in recent years, artists have tried to grapple with the political order of the covert. The signature example of this is drone art: the work of photographers and artists such as Mahwish Chishty, who sets the sharp outlines of Reaper unmanned aerial vehicles against Pakistani "truck art" to show how these secret vessels are shaping the

milieu of the country's border regions; James Bridle, who created a drone iden-tification kit in order to strip these aircraft of their grim mystery; Katheryn Brimblecombe-Fox, whose "dronescapes" juxtapose missiles with the vascular structure of the Australian aborigine tree-of-life symbol to explore the anthro-pomorphization of unmanned weaponry; and Trevor Paglen, who hired a he-licopter to take eerie dronelike shots of the National Security Agency in rural Virginia. These works, which go head-to-head with forms of state secrecy, are all locked into the logic of exposure, mostly conducted from an implicitly overhead position that substitutes the surveilling eye of the drone with that of the artist and throws that which wants to stay invisible into sharp, seeable relief. As Paglen (2014) puts it, "My intention is to expand the visual vocabu-lary we use to 'see' the U.S. intelligence community."

But public secrecy, as a force that positively thrives on exposure, exists in a different kind of relation with the artwork. It requires a different kind of gaze: not the ability to see what was hidden but to look afresh on that which was always already there. This is why Holbein's painting offers a model for how representational forms might both get, and get at, public secrecy. *The Ambas-sadors* shows how the artwork can both find a language for the intractability of what is known but unsayable—the skull-blot—and also encode this language in ways that acknowledge that dealing with public secrets—exposing the familiar as strange—requires work, as shown by the labor of the spectator. And via this labor, representational forms can also engender a dialogic mode of reckoning with the shared things that cannot be said. They have the capacity to create what Nicholas Bourriaud has called a "social interstice," a "space in social rela-tions which . . . suggests possibilities for exchanges other than those that pre-vail within the system . . . an inter-human intercourse which is different to the 'zones of communication' that are forced upon us" (2006, 161). Works that use encryption to take on public secrecy, to enjoin new ways of looking, induct the viewer into a different kind of relationship with the artwork, one in which she becomes "a witness, an associate, a client, a guest, a coproducer and a protago-nist" (168). As they do so, such works forge coalitions of shadowboxers, made up of artists and audiences who are willing to experiment together with being more candid about those things that are broadly known but seldom said aloud.

Trash and Treasure

The question then becomes, What are those works, in China, that might en-able public secrecy to enter the "zones of communication"? Where might we find them? In his work on spymasters and secret agents during the Maoist

period, Michael Schoenhals begins by arguing that "we must find room in our analyses of Maoism as a way of life for the informers, collaborators, and secret police" who made the "system work" (2013, 11). But he wastes no time in spelling out the manifold difficulties: the "blanket ban" the CCP issued in 1981 on the publication of scholarship "detrimental to the normal conduct of our present and future intelligence and protection work"; the archival materials that remain off-limits well into the twenty-first century; and the wry caveat of CIA analyst Olivia Halebian, who reminded would-be chroniclers of espionage in 1965 that "we should assume that all memoirs, biographies, and historical studies of the . . . intelligence services are prepared with the aid of disinformation experts" (quoted in Schoenhals 2013, 11).[11] For Schoenhals, what ultimately made his study of Maoist spies possible were "chance discoveries in flea markets and the back rooms of antiquarian bookshops in urban China of archival material that has *not* been subject to positive information management" (12). Schoenhals calls these "garbage materials," the flotsam and jetsam that made a historiography of the secret service possible (12). "Garbology," as a recognized mode of PRC historiography, is now a lively field (Brown and Johnson 2015), and its flea market finds are hugely instructive on matters of secrecy.

Although the term "flea market" exists in Chinese as a direct translation from English (which itself derives from the French *marché aux puces*), it is the Australian term for these bazaars—trash and treasure markets—that gets closest to their value for grassroots historians of Maoist China. These scholars have turned up discarded dossiers, personnel files, declassified policy documents, abandoned police reports, diaries, and private letters that often washed up there as work units have been disbanded and their reams of paperwork suddenly made homeless. Unlike the "eye of the drone," which scans the horizon for known targets, the garbological approach to pursuing the covert takes a worm's-eye view: it hunkers down in the dirt, scavenging for the as-yet-unknown. In part, this ground-level focus is necessary because secret-keepers open up what Istvan Rev calls "hiatuses, holes in the texture of history," forcing their investigators into fingertip searches for "the traces of nonobjects" (1987, 349): the shadows of things that never happened, of people who never were. In this sense, researching secrecy means acknowledging that we do not always know what we are looking for. Yet these dossiers that escaped the shredder are secrets tossed not merely into the trash but out into the open. By dint of their abandonment, such materials become a species of priceless junk, both worthless and invaluable. More than this, they materialize the public secret: they are objects once radioactive with clandestine meaning that are now allowed to lie in plain sight. As such, they demonstrate not merely that secrets have half-lives

whose duration can be difficult to quantify (officials have begun to crack down on the trade, thereby driving the papers back into secret storage once again), but also that public secrecy lies in unexpected places, in overlooked or over-familiar things.

It is no accident, therefore, that this book also began in a flea market and is similarly prompted by what unexpected finds, hiding in plain sight, can tell us about public secrecy. Its origins lie in Panjiayuan 潘家园, a sprawling hive of stalls, shops, and arcades covering nearly fifty thousand square meters in Beijing's Chaoyang 朝阳 district just south of the East Third Ring Road. Panjia-yuan is China's largest flea market, where sellers peddle antiques, heirlooms, knick-knacks, curios, kitsch, and the kind of Maoist memorabilia, both faux and genuine, that has become highly collectible. But what leapt out during one particular visit as I walked through the cramped alleyways of the market's central semicovered section was the way that the stalls of Panjiayuan seemed to offer up a randomized slideshow of modern Chinese history in assorted objects. Artifactual moments from China's long twentieth century, from the late Qing period to the premiership of Deng Xiaoping 邓小平, flashed by staccato style, rather like the jerky motions of Muybridge's famous animated horse. Indeed, if something about the scene was akin to the galloping race horse, it was because so many of the objects on sale that day riffed on the past photographically. Photographs were—and still are—everywhere on Panjiayuan's main drag. Originals, reproductions, and creative reconfigurations hit the eye every few seconds, jumbled and achronological.

Vendors hawk photobooks of Beijing's vanishing courtyards. Tea sets emblazoned with the faces of the party leadership circa 1966, playing cards with images dating back to the 1911 Revolution, postcards reproducing hand-painted daguerreotypes from the late Qing period, seductive pin-ups from Old Shanghai, alarm clocks embossed with photographs of Red Guards, sepia architectural views of the capital's landmarks, and vintage photographs of ethnic minorities in the 1950s or Peking opera stars on the stage (figures I.1 and I.2). The sharp-eyed visitor might spot grimmer images of militia on maneuvers during the Sino-Japanese War or scenes of torture and hazing from the Cultural Revolution. And, if requested, certain sellers in the book section will pull out plastic-covered albums full of faded family portraits, their names lost forever, even if rough dates can be hazarded from the Mao badges pinned to the subjects' lapels. Other uses of photography in Panjiayuan are more hybrid. Specialist stalls sell pointillist-style stone carvings modeled on photographic portraits of former Chinese leaders, while others produce crude pastiches of the work of China's globally fêted pop avant-garde artists, themselves inspired

FIGURE I.1 Shuffling past and present: playing cards at Panjiayuan.

FIGURE I.2 Red Guard alarm clocks stacked in a display of totalitarian nostalgia.

by old photographs. The presence of these photographic artifacts alongside stalls that hawk Maoist-era "garbage materials" is full of a symbolism that is only partly accidental. These objects—the kitsch, the fakes, the shabby second-hand goods—constitute another form of "trash and treasure" because they, too, have a bearing on China's missing histories. These photo-things cluster together densely at Panjiayuan, in part because flea markets have always been a home from home for secrets. But the objects at Panjiayuan are also a micro-cosm, or snapshot, of something bigger.

Photo Fever, Photo-Forms

During the late 1990s, something close to a sepia boom swept Chinese society as archival photographs began to enjoy an extraordinary afterlife in offline and online spaces. This rise of the historic photograph is commonly attributed to the launch of a periodical entitled *Old Photographs* (*Lao zhaopian* 老照片) by the Shandong Pictorial Press in 1996. As I discuss in chapter 2, the magazine stormed China's publishing market: by December 1997, 1.2 million copies of its first few issues had been sold, triggering a kind of photo-mania.[12] Scholars have mostly argued that this photographic turn was about misty-eyed, money-spinning nostalgia.[13] But photographs exhumed from archives and private collections also gave the traumas of the twentieth-century past a new visibility. Connections have not been drawn between the two, but it is no coincidence that the launch of *Old Photographs* dovetailed with the broad release of a state-sponsored photographic album that displayed previously classified im-ages of the decapitated men and violated women of the Nanjing Massacre.[14] Not so long ago, historians in China lamented that the nation's museums gave photographs short shrift (Lai 2001, 44), but such a complaint would be im-possible now. Photographs now loom large within exhibitionary space; they thickly populate online spaces about the past; and their presence is routine in scholarly, mainstream, and pedagogical treatments of Chinese history.[15] And although Frank Dikötter claimed as recently as 2008 that "we still know more about the history of photography in Bamako, Mali, than about the history of photography in China" (76), the photographic image in China has emerged in the years since as a freestanding historical subject in its own right.[16] Under-lying these shifts is the assumption that photographs can unlock episodes that have long been recalcitrant in their secrecy (Bao Kun 鲍昆 2010, 365–67).[17]

Indeed, this rise of the photographic image speaks to a long-suppressed will to *visual* knowledge about the blind spots of China's modern past, those epi-sodes that official historiography has placed off-limits.[18] David Der-Wei Wang

calls this version of the past "a discourse of make-believe," and his terminology is instructive (2004, 3). Discourse, in its primary definition, refers to acts of speech and script, and these antecedents of the word bear on the documentation of modern China's troubled pasts. Part of the reason why suppressing parts of Maoist history has been possible is because image-making during that epoch was mostly reserved for the demands of the utopian present, whether in the form of propaganda posters, Mao badges, or the photographs of ideal families that adorned publications such as *The China Pictorial* (*Renmin huabao* 人民画报).[19] As Jonathan Spence put it in 1988, "surprisingly large portions of the Chinese story are still not available in any visual form" (7), and partly dictating that unavailability was the photographic void within which troubled histories were subsumed.[20] Political and personal turmoil such as the Great Famine, the Anti-Rightist Campaign, and to a lesser extent the Cultural Revolution passed into memory with little visual assistance, even as the iconography of the rulers entered millions of homes via Mao's black-and-white *prie-dieux*.[21] As Arthur Kleinman and Joan Kleinman point out, "The absent image is also a form of political appropriation; public silence is perhaps more terrifying than being overwhelmed by public images of atrocity" (1997, 17). In this context of fearful dearth, those photographs that do exist, and that have latterly come to prominence, matter all the more. This is precisely why extant images of *verboten* pasts have spawned aesthetic works of such range and volume both in contemporary China itself and in those places outside the mainland where Chinese cultural makers live and work.

These works—photo-forms—remediate images whose retinal familiarity is such that viewers often do little more than merely "see" them. The process of repurposing, however, induces acts of "looking" as the familiar becomes strange, and these images begin to speak. How, then, to define the photo-form, and what it means and does, in a social context where public secrecy is a sensed force? The photo-form as I define it here does not refer all-encompassingly to any aesthetic entity that remakes a photograph in other medial matter. Such works evidently belong to a far broader genus, which might be usefully termed works-that-work-with-photographs. Rather, the photo-form narrows this expansive category to something much more specific: image-works that meld well-known historical photographs with different material substrates. This process of melding is diverse. A photo-form may be a family portrait reimagined in oils on canvas; a tattoo of Tank Man inked on an artist's skin; a statue that reproduces the two-planed outlines of a well-known image in three-dimensional bronze; a cartoon that edits down the visual data of a historical photograph and re-renders it in starker graphic form; a film or

animation that either intercuts live footage with instantly recognizable stills or restages photographs as "moving pictures"; an autobiographical essay that juxtaposes text with photographic portraits; a piece of performance art in which the actors reenact the scene of a historic photograph or wear masks modeled on an image; a mural in a museum comprising a medley of historical photographs; an augmented reality phone app that overlays a photograph over physical space; or an original historic photograph that the artist doctors, tweaks, or recomposites in some way. A book cover that reproduces and restyles a well-known image from the past is a photo-form, as is a T-shirt, key ring, or coffee cup which does the same.

As a term, "photo-form" is as arbitrary as most acts of naming, but these works do need a label—both for this book and more generally because they constitute a group of artifacts that possess a distinctive and not yet fully described ontology, at once circumscribed and quite loose-limbed. It is restrictive insofar as such objects are spawned by an image or category of images that possess a high recognition quotient, and such images are, by their very nature, limited in number. Yet it is simultaneously open-ended in the sense that photographs such as these—precisely because of their reflex and instantaneous knownness—can be repurposed almost to the point of faithlessness, and in prolix form, while always retaining their basic recognizability. Repurposing, then, is a portmanteau term for the multiple routes via which a well-known photograph can transition into a mixed-matter photo-form. This is itself another way of saying that the photo-form is a continuum object, a spectrum-situated artifact of varying aesthetic tone and photographic saturation that moves in fuzzy ways from painting and cinema, through the indexical arts of documentary and reportage, along to blog posts and T-shirts. This state of continuum is covered by repurposing as a definition, but with the proviso that this is a catchall for processes that can be more variegated on the ground.[22] Throughout this book, I alternate "repurposing" with close lexical companions such as "re-version," "remake," and "reconstitute" in recognition of the inexactitude that still bedevils the critical vocabulary of image/narrative transfer, from debates over what adaptation studies can and should include to the differences between remix and remediation in digital culture. But repurposing remains my key term here because of the dual semantic freight it bears. To call an object "repurposed" captures the historicity of its source image—its earlier life and times—at the same time that it specifically registers the fact of its adaptation for a different or even contrarian kind of use. Photoforms are typically once-secret things that, in their new incarnation, try to reckon with that same secrecy. As they do so, they often disguise themselves

so that they both resemble their source image and yet are also tactically or rhetorically other to it.

It is this repurposed character that distinguishes photo-forms from works-that-work-with-photographs, whose manifestations date back almost to the advent of the daguerreotype. Indeed, the photographic image seems innately predisposed toward restless movement of this kind, forever seeking a stage, substrate, backdrop, or material companion for itself. Baudrillard might have claimed that "whatever the noise or violence surrounding it, the photo gives its object over to immobility and silence . . . it re-creates the equivalent of the desert, a phenomenal isolation" (1998, 86); but the photographic image itself is a vastly different animal. Photographs have always gravitated toward objects than can shelter, house, or display them, from lockets and albums to coffee cups and credit cards. Yet even when the image rests stock still in the palm of a hand, it is always gravitating instinctually toward forms beyond itself, if only to the words it summons from those who view it. When it does take wing, it is often impelled to do so by a desire to engage in more transformative relationships with other aesthetic forms, as the very names of genres such as photorealist painting, photosculptures, and photonarratives make clear. Such journeys have constituted a major aesthetic migration in recent years, as painters, writers, and filmmakers have subjected the photographic image to intense artistic reworking: Gregory Crewdson's narrative photographs, Lynn Cazabon's shadow photographic archives, Oliver Herring's photosculptures, Duane Michals's photosequences, and W. G. Sebald's photonarrative. The genus of works-that-work-with-photographs, even if it does not call itself that, has surged in tandem as a field of study.[23]

Like these works, photo-forms evince an indefatigable colonizing impulse for the photographic image: transgenre, transmedial, transcultural, transtaste. But their status as repurposings of well-known historic images endows them with additional powers and properties. If, as Hollis Frampton puts it, "where we once thought in language we now find that we think, more often than we know, in photographs" (2009, 100), this is in part because of the photo-form and its propagation of hyperfamiliar images, without even the most vestigial visual trace of light on photochemical paper. This latter point is crucial to the photo-form and its distinctive morphology. For some time now, photographic representation of all kinds has been inching, sometimes speeding, away from the notion that the "photographic" will necessarily take indexicality—once its *sine qua non*—as a determining criterion. This point is suggested by Mieke Bal, who notes that the presence of photography in Proust can be seen "in the cutting-out of details, in the conflictual dialectic between the near and the far,

and in certain 'zoom' effects" (1997, 201); and is implicit in Michael North's (2005) more encompassing argument that "camera vision" has shaped the way that many important authors see and write. Gerhard Richter (1995) puts it most pungently to an interviewer who questions whether his photorealist practice is at base a mimetic one. He replies: "I'm not trying to imitate a photograph; I'm trying to make one. And if I disregard the assumption that a photograph is a piece of paper exposed to light, then, I am practicing photography by other means: I'm not producing paintings that remind you of a photograph but producing photographs . . . those of my paintings that have no photographic source . . . are also photographs" (73).

Ultimately, it is photography's jettisoning of indexicality as baggage that has enabled it to journey so easily into other medial spaces. Potentially true of all photographic representation, this point is exemplified with extreme force by the photo-form, since the high recognition quotient of the source image allows its aesthetic offspring to proliferate in protean ways while always remaining, like an Ariadne's thread, traceable back to source. Put differently, the photo-form retains what Barthes called the *ça a été* of the photographic image by other means. In this sense, the photo-form recalls Rosalind Krauss's point that "categories like sculpture and painting have been kneaded and stretched and twisted in an extraordinary demonstration of elasticity, a display of the way a cultural term can be extended to include just about anything" (1979, 30). If, as Krauss suggests, "mirrors placed at strange angles in ordinary rooms [and] temporary lines cut into the floor of the desert" (30) can be called sculpture, then that migration of the sculptural from marble, clay, or alabaster to other sites and substances is a process stepped up radically in the photo-form, which ranges far into the vernacular, amateur, and prosumer realms—zones that scholars of photographic representation have not really touched. These objects assert the capacity of the well-known photographic image—once repurposed—to become a node within convergence culture, a sign of heightened agency that arrests attention in an era when most photos do not even make it into hard copy.

To speak of singular images in this way is to stray close to the territory of the iconic photograph, a zone that I have so far skirted. This hesitancy comes in part from the fact that the epithet "iconic" has been deployed to the point of semiotic overkill, often when the term is not merited,[24] and from the varying fame of the images whose aesthetic offspring I explore here. A photograph such as Tank Man is rightly dubbed iconic and has a reach that has been global from the outset, even as it remains taboo in China; the Nanjing Massacre archive is well-nigh iconic within Chinese visual culture, but it took decades to

achieve this status, and its signature images command less traction elsewhere; and the Cultural Revolution images I discuss belong more to the category of the "significantly salient" image, to borrow Hariman and Lucaites's (2007, 7) phrase. In *No Caption Needed*, their study of the tiny group of standout photographs that make up the "American family album," Hariman and Lucaites offer a trenchant analysis of how such icons circulate in U.S. public culture. These photographs exert an ideologically centripetal force: they help to model liberal-democratic citizenship in postwar American society by cultivating "the habit of being benignly attentive toward strangers" (17). Hariman and Lucaites are up-front about the limits of their study: "We examine only U.S. domestic media, as that is what we know," and "it remains to be seen whether and how iconic photos operate in other national and transnational media environments" (7). Although they discuss repurposings of these images, dubbing them "appropriations," their focus remains the source photographs themselves as constitutive elements of public culture.[25]

By contrast, all the photographs I discuss here have pasts, not in public culture but in secrecy, however exposed to view their offspring may later become. They are twilight, penumbral images despite the impact they possess. As such, it is their "appropriations"—photo-forms—that carry out the core labor of political making. Unlike the Times Square Kiss and others (images with scant secret history), the movements these works perform are for the most part centrifugal in character, emerging in interstitial spaces—small vents in the veil of generalized secrecy—where they look and act like specters, rather than figures who encourage "the habit of being benignly attentive toward strangers." This is why the "expanded field" of the photographic is so crucial a conceptual frame for the photo-form within a culture that sequesters certain histories from spectatorship and debate. It is the medial elasticity identified by Krauss that allows the photo-form to shadowbox with the unsayable in China via its accessibility to untrained, non-professional makers of culture (chapter 2); its ability to assume inventively hybrid form, often coupling intuitively with new and emergent media (chapter 3); and its capacity to remain recognizable to the in-group even while it shape-shifts to conceal itself from outsiders (chapter 4). If secrecy is everywhere and yet nowhere, so too are its photo-form antagonists, as they mimic this ubiquity in muted, sub-radar apparitions that often cluster together in collectives of works that share the same source image. Inevitably, this is also why the photo-form is the tool of choice for the Chinese state when, as I discuss in chapter 1, it chooses to publicize its own secrets.

Ultimately, it is also this elasticity that gives the photo-form its edge over other cultural forms that seek to grapple with public secrecy. Over the

past quarter of a century, a limited range of literary, cinematic, and artistic works have attempted to speak the unspeakable in China, and it would be absurd to suggest that the photo-form is the only aesthetic artifact that can give eloquent voice to public secrets. Any work that trades in allegory or allusion is, evidently, well tooled for this task, since such forms—just like Holbein's *The Ambassadors*—rely on the parallel labors of encryption and decipherment: they work with and through secrets. The photo-form does, however, arrogate quite specific powers to itself. To an extent, these stem from its pictorial status: in situations of unsayability, the duty of articulating the forbidden often falls most heavily on makers of visual culture because their ability to show rather than tell gives them a deftness not vouchsafed to other cultural actors. The senses substitute for one another; the ocular stands in for the sound of forbidden syllables. But beyond this truism, the photo-form has a heightened potency because it can cut to the quick far more incisively than the intricate, often invisible devices of allegory. A film such as Stanley Kwan's *Lan Yu* 蓝宇 (2001) is well understood to be a metaphoric treatment of the Tiananmen Square Massacre, but as Michael Berry notes, state suppression was so felt a force for its filmmakers that "the massacre is left unaddressed to such a degree that viewers unfamiliar with June Fourth would be left wondering what had actually happened" (2008, 331–32). A republished photograph would, of course, eliminate such uncertainty; but it would also have to travel through a surveilled world without disguise and without the incitements to pensiveness that a remediated image offers. By contrast, a cartoon remake of Tank Man wears the camouflage necessary to slip past the censors, but its resemblance to the source image means that it never needs to surrender its instant recognizability—its shock value, on occasion. That resemblance also brings with it a faint echo of indexicality that allows the photo-form to leverage some of the truth claims still vaunted by the photographic image. Yet at the same time, the process of repurposing grafts layers of fresh meaning onto the image's photochemical base, compelling viewers to look closer. It is in this sense that the full force of the photo-form as an artifact both concealed and open, as mentioned earlier, comes into its own. Other kinds of text or image may seek and sometimes gain a reckoning with the unsayable, but photo-forms have clustered so densely around China's forbidden pasts because their dual nature, their capacity to hide while staying seen, enables them to meet the public secret on its own terms.

If photo-forms are prolix, so too are their practitioners. They work inside and outside China, for and against the state, and with varied viewers

in mind. In this book, I discuss or refer to works by the artists Zhang Xiaogang 张晓刚, Ai Weiwei, Xu Weixin 徐唯辛, Li Zijian 李自健, Zhang Huan 张洹, Chen Shaoxiong 陈绍雄, Sheng Qi 盛奇, Lily and Honglei, Feng Mengbo 冯梦波, and Song Dong 宋冬; the sculptor Sun Jiabo 孙家钵; the writer Liu Xinwu 刘心武; the photographers Hai Bo 海波, Song Yongping 宋永平, Li Wei 李暐, Zhang Dali 张大力, Shao Yinong 邵译农, and Mu Chen 慕辰; the filmmakers Hu Jie 胡杰, and Lu Chuan 陆川; and the cartoonists Crazy Crab, Badiucao 巴丢草, Jiu'an 鸠鹌, and Rebel Pepper. I also explore the work of graphic artists, reportage writers, journal editors, web archivists, political performance artists, videogame designers, and popular historians. Relatedly, I take the photo-form as a resonantly vernacular form and investigate how "amateur" essayists writing creatively for the first time (sometimes even for a scribe), schoolchildren working on homework assignments, and netizens on social media platforms have created photo-forms that repurpose historic photographs in improvisational, sometimes ephemeral ways. Finally, I look at "authorless" works—book covers, websites, printed T-shirts, and museum exhibits—whose creators are unattributed but whose remakings of these images often command the broadest spectatorship.

Photo-forms are, of course, found in many places and spaces. They constitute what Marlene Dumas (Coelewij 2014) calls the "image as burden," freighted with the load that all difficult histories steadily accrue—from Gerhard Richter's fifteen-picture cycle on the Baader-Meinhof photographs, *October 18, 1977*, to the avant-garde Holocaust installations by Nancy Spero, to Dumas's own photo-portraits of Osama bin Laden, to Don DeLillo and the various performance artists, documentarists, and grotesque GIF-makers who have worked with Richard Drew's photograph of a man falling from one of the Twin Towers in the aftermath of the 9/11 attacks. Lego memes of the raising of flags at Iwojima are photo-forms, too, as are the bronze statues of Roosevelt and Churchill by Lawrence Holofcener, entitled *Allies* (1995), which sit on a bench on the corner of Old and New Bond Streets in London, their staging powerfully suggestive of the photographs taken at the Yalta Conference of 1945 (figure I.3). To suggest that such works exist in greater profusion, and bear a greater load, in places where public secrecy reigns is doubtless an empirically unprovable claim, however intuitively plausible it may be. Yet the photo-forms that grapple with China's missing histories are so legion that they point clearly to the intimate relationship this category of objects sustains with the unsayable. These works exist as viral aesthetic responses to a climate of public secrecy about the past that steeps the Chinese present yet has itself not been outright named as such.

FIGURE I.3 Lawrence Holofcener, *Allies*, 1995. Stalin is forced to cede his seat at the Yalta Conference, creating an empty berth for map-toting tourists.

Spirited Images

To make this argument is to countermand a more obvious one: that of memory. At first, it seems perverse to suggest that photo-forms could betoken anything more powerfully than they do the transgenerational *aide-mémoire*. After all, works that repurpose well-known historical photographs generate an intricately textured sense of time for the simple reason that their source images whisper of so many different pasts. Any such photograph is at once a trace of that "real" moment in history caught in the viewfinder; a historical actor in its own right, which over the years is reproduced, circulated, consumed, or hidden; a piece of photographic history, taken with a particular camera, using particular film stock, and following particular genre conventions; and an artifact that can sometimes wear its age and experience so visibly that it comes to possess an archaeological history unto itself.[26] To these layered, crosscut temporalities is added the time of repurposing, or rather the viewer's recognition of that moment when the photochemical image was elided with a different kind of material support. Writing of phototextuality, Liliane Louvel argues

that the transition of the image onto the literary page constitutes a particular kind of "phenomenological event," one that she dubs the "pictorial third": "... a visual movement produced in the viewer-reader's mind by the passage between the two media ... In between word and image, in the mind's eye or on its interior screen, the 'pictorial third' is more present when the image figures in the text and when it is a photograph, thought to be closer to extratextual reality" (2008, 45). This time of remediation, amplified by photography's proximity to "extratextual reality," arguably turns up the volume of the past still higher.

From this, it is no great step to identify the photo-form as a deft tool for the grafting of memory. Such works surge with sentience of the past, as these registers reverberate against one another to produce a sonorous sense of asymmetrical time. If, as Jacques Rancière (2011, 107–32) argues, photographic images can be "pensive" via the indeterminacy between aesthetic and social meaning they conjure, the photo-form summons a rich chronological indeterminacy, evoking pasts both experiential and inexperiential for the spectator. Invoking history *in* the image, history *of* the image, and history *as* the image, photo-forms insinuate themselves into memory, especially among the later-born, who are separated from the photograph's primal scene. We might suggest, then, that the photo-form belongs within the aesthetic repertoire of prosthetic memory, postmemory, belated remembrance, and vicarious witnessing, concepts that have been elaborated by scholars such as Alison Landsberg, Marianne Hirsch, James Young, and Froma Zeitlin in their work on the Holocaust.[27]

Yet as they are made material, in the very action of remediation, photo-forms often unsettle or traduce the transgenerational memory project. *Allies*, Holofcener's aforementioned sculptural monument to the postwar settlement, shows this process writ large. Roosevelt and Churchill sit at opposite ends of the bench, from where they converse amiably with each other over a space large enough to accommodate a tourist in search of a photo opportunity with the mediators of peace. The work's meanings are fluid: the space between is filled and then vacated by different people over time, turning the bench, worn and faded with all their sittings, into an active memorial. That space, though, is not neutral in its emptiness. It also marks an instance of excision, of Photoshopping by sculptural means: Stalin, present at the Yalta Conference and its photographs, is missing from the bench, ghosted by the London monument to peace. Stalin's absence goes unmentioned in discussions of the monument, which becomes, without him, a memorial to transatlantic amity rather than to the negotiations that decided the shape of postwar, then Cold War,

FIGURE 1.4 Yalta Monument, 2015. Stalin stages his supersized return on Crimean soil.

Europe. Yet anyone who has seen the Yalta photographs cannot help but sense Stalin's wraith hovering over the bench—indeed, that apparition is actively encouraged into presence by the voided seat between Churchill and Roosevelt. Stalin's failure to make it into bronze, presumably a political response to the long-term controversy of Yalta and its soured legacy, thus has something of the open secret about it: both evident and ignored in equal measure. In 2015, Russia unveiled its own repurposing of the "Big Three" photographs to mark the seventieth anniversary of Yalta, a ten-ton bronze sculpture by court artist Zurab Tsereteli, which not only reinserts Stalin but depicts the dictator as ten centimeters taller than his counterparts (he was a full twenty-three centimeters shorter than Roosevelt, by most accounts), as if in material compensation for his rubbing out elsewhere (figure 1.4).[28]

The Yalta statues—all of them—are commemorative objects, of course. But they also show how photo-forms, via the step change they make from one medium to another, open up spaces in which public secrecy—the marker of memory's limits as a paradigm—can be registered, at least for those who know the Yalta photographs and so see the elephant squatting soundlessly in the middle of the bench. For these spectators, the statues are indeed *prima facie* artifacts of memorial, but ones that also commemorate the "how" of memory's

failure to make it into the present, via the visual idiom that they imagine for the conspiratorial silences of the public secret. I referred to this visual idiom just now as the elephant in the room. This usage, though, is arguably malapropos, because what the Yalta statues suggest is not a surfeit of visibility, quixotically ignored, but rather a purchase on the seeable that flickers in and out and thus is better understood in the language of the ghost. Yet spectrality is mostly missing from Western discourses on public secrecy, which prefer to figure this taboo in terms of visual excess: the naked emperor; the elephant in the room; the three monkeys who see, hear, and speak no evil. According to this imagistic logic, that which cannot be uttered aloud compensates for its unsayability by becoming seeable in the extreme, as if to throw into relief the quasi-comic absurdity of silence. But is this really how the public secret works, most particularly in environments where breaking into voice can carry hard political penalties? If, as is the case in such places, the most fundamental labor of the public secret is to make woefully egregious things—trauma and violence—"disappear," then the specter, as something often banished but difficult to exorcise, is its far more apposite anointed symbol.

This, then, is the final core claim I make here: that in nations that deploy the protocols of disavowal, the ghost is an abiding trope for that which is "generally known, but cannot be articulated." To invoke spectrality in this way is a move that must be cautious, since the use of the revenant as a conceptual metaphor has swelled to almost catch-all dimensions in recent years as researchers have grappled with historical erasure across the matrices of race, class, and gender. The ghost may not quite have become "a meta-concept that comes to possess virtually everything" (Blanco and Peeren 2013, 14), but it has certainly been stretched close to the limits of reasonable utility. If, as Martin Jay notes, "the past makes cultural demands on us we have difficulty fulfilling" (1998, 163–64), we might press his point further to suggest that scholars now see apparitions around every corner because the specter is so ready a way of acknowledging these demands without getting around to satisfying them. It is the business of wraiths, after all, to elude our grasp. Yet spectrality remains critically underexplored as a conceptual metaphor outside Euro-America, despite the fact that its contours often emerge with renewed force and clarity in the "non-West." A core site for the investigation of such underexamined "spectropolitics" is China, a society that is shadowed by "mutually imbricated sets of spectral apparitions," as the ghosts of communism lurk in the "vestigial socialist institutions" of the capitalist present (Rojas 2016, 3, 12). What's more, these "spectral apparitions" are tightly bound to public secrecy: indeed, what secret is more spectacularly "out there" than the fact that the CCP, ruled by the

progeny of the Long Marchers, now presides over the world's most rampant capitalist economy?

Indeed, this recurrence of the ghost as core conceptual metaphor for public secrecy in China is so fitting that its relative absence in other contexts starts to seem strange. Like the ghost, the public secret is a thing that hovers between the visible and the occluded, the known and the unsayable. Just as we understand that ghosts are figments of our fancy but sense their force anyway, so do we know that public secrets exist all too brazenly but feel compelled to speak no evil. Both are entities that hide in plain sight, whose power impinges forcefully on political life even though it is nominally dismissed. What's more, both have a steadfast character: the public secret has nothing much to fear from revelation, nor does the specter need to quail before the exorcist, for the simple reason that both are necessary for society's functioning. Just as shared secrets form "the basis of our social institutions, the workplace, the market, the family, and the state" (Taussig 1999, 3), so do vestiges from the past that cannot be buried return again and again to remind those institutions of the duty they owe, and yet often betray, to the demands of justice. In this sense, the public secret and the specter are hostile *doppelgängers*, similar in their operations yet antithetical to one another, moving in gestures of feint and counterfeint in their parallel spaces. It is for this reason that cultural practices that seek to aggravate the public secret can productively take on the lineaments of the spectral to do so.

Yet how can we trace these lineaments when public secrecy remains so discursively elusive in China? Ghosted from open discourse, public secrecy has become displaced into the realm of the visual, where its apparitions give recharged meaning to the adage "a picture is worth a thousand words." And within the realm of the visual, the constant pull of cultural makers toward the historic photograph—an image-making practice that has itself always been tinged by haunting—helps invest their works about the unsayable with spectral force. In short, there is nothing accidental about the prevalence of the photo-form as a representational mode for modern China's disappeared histories. Photo-forms are natural-born responses to histories that have been ghosted by silence, thanks to the evocative shorthand that takes us from the black-and-white photochemical image straight back to the phantom. Photography, after all, is always already spectral, from stealing souls to spirit photography to Barthes's chronicle of a death foretold and Sontag's characteristically unforgiving point that "to take a photograph is to participate in another person's . . . mortality" (1979, 15). This relationship is encoded into the very language of photography in China, as Carlos Rojas notes: the term *"zhaoxiang"* 照相 (to

take a photograph) is "a synthesis of two more specific terms that have largely fallen out of use: *xiaozhao* 小照, or portraits of living subjects, and *yingxiang* 影像, or portraits of the deceased" (2009, 208).[29] Rather like its much-debunked but still loyal attachment to the referent, a photograph of the dead or disappeared retains the gift of haunting, even in these jaded days. As Marianne Hirsch puts it, "the referent haunts the picture like a ghost; it is a revenant, a return of the lost and dead other" (1997, 5).

The status of the photo-form as a *repurposed* photograph, an object that transitions from one medium to another, spectralizes these works further. In part, this is because photo-forms—as image-works that are not photography *per se* even though they are spawned from it—summon up the ghost as a double who dwells in the interstices: between spaces, between mediums.[30] As works that bear a strong but often twisted resemblance to their source image, photo-forms serve as aesthetic emblems for this in-betweenness and its spectral possibilities. They also evoke the link between intermediality and the spirit medium, because the repurposed image is always possessed by its original, whose "soul" it channels: the remake as dead ringer. Most significant, though, is the potential for warping the source image into something yet more uncanny that the process of aesthetic repurposing opens up—possibilities so rich that it is hard to find a photo-form about ghosted histories that does not exploit the visual idioms of haunting. As a conceptual metaphor for what is unsayable about the past, ghostliness coheres around a set of image vocabularies, a spectral lexicon that articulates itself through color, substrate, artistic techniques, and genre choices.

Thus photo-forms tend to adopt a grayscale palette, partly as a nod to their origins in black-and-white photography but also to display wraiths who subsist without corporeal form. When color asserts itself, it does so via sanguinary reds, as in Sheng Qi's canvasses of Tank Man at Tiananmen, which are awash with blood, or the popular histories of the Nanjing Massacre whose pages are steeped in red ink. Photo-forms also speak their ghostliness by means of their medial substrate (Zhang Huan remakes historic photographs in ash); through the aesthetic techniques they use (Chen Shaoxiong favors chiaroscuro ink animation, Xu Weixin deploys photorealist blur); and via the genres, platforms, and sites in which they are lodged (photo-altars, online cemeteries, burial sites). Missing body parts haunt these occult works (Song Yongping repaints his parents' wedding portrait in charcoal and cuts out their heads, Lily and Honglei "dismember" Tank Man, Li Wei "decapitates" himself using a specially designed mirror, Sheng Qi slices off his finger and makes his palm, haunted by that mutilation, the subject of the image). Photo-forms also bare the scars

of the past, whether via the eerie blotches that sear faces in Zhang Xiaogang's *Bloodline* series (*Xueyuan: dajiating xilie* 血缘: 大家庭系列) or in the battered family portraits that inspire the photo-essays I explore in chapter 3. The works I discuss here are preoccupied in equal measure by the *doppelgänger*, who leaps out unbidden when she or he should not (see the work of Zhang Dali), and by the "disappeared," who are forcibly deleted (see Hai Bo's photographic series with its trademark missing subjects).

Yet beyond these figural links, it is also the question of justice that makes spectrality the default visual language of works that try to grapple with China's silenced histories. In part, this is a response to the demands of mourning and it occurs most acutely in the works discussed in chapters 2 and 3, which speak to the unjust loss of loved ones. But the justice of the ghost is also— more so—about the lives of the living. Writing about the Cultural Revolution, Susanne Weigelin-Schwiedrzik refers to "the means that made life after the event possible with people from different factions sitting side by side in one office" (2006, 1089). She argues that people managed this daily fraughtness by forming fragmented memory groups, discussing the past only with fellow carriers who shared the same databank of recall. But rather than a mechanism for memory, what is this if not a form of necessary and palliative public secrecy? In this sense, the project of theorizing the unsayable in contemporary China has to address this force not only as dysfunction and suppression but also as a functional mode of repair, if not actual redress. Ghostly figures recur in photo-forms because their in-betweenness gets the measure of this labile character of public secrecy. Like the ghost, secrets sometimes hide in the open because they have to, even though the burden of never saying can cost their keepers dearly.

Haunting is key to public secrecy, and to the artworks that register it, because ghosts, however angry they are, need sometimes to be denied: we can either choose not to see them or simply profess disbelief. As reminders of pasts that cannot be owned, their unobtrusive shape befits the limitations within which they operate. Photo-forms deploy spectrality as a language because they shadowbox circumspectly with public secrecy rather than attempt exposure or confrontation. This is the justice that is owed to survivors and the weight of the unforgettable-unsayable under which they struggle. In keeping with this, the specter also serves as a figure of the future: as Avery Gordon writes, "from a certain vantage point the ghost also simultaneously represents a future possibility, a hope . . . it has designs on us such that we must reckon with it graciously, attempting to offer it a hospitable memory *out of a concern for justice*" (1997, 64; emphasis in the original). Here, "spectrality" refers to an alternative

history that is denied to the present but might yet find realization in a world to come. This sense of the road not traveled is never better illustrated than in the Tank Man image, whose iconography is not just about the Manichean standoff on Chang'an Road, but the political choice that opens up as a fork in the highway and that always carries the possibility of reversal.

Finally, it is because of this always imminent reversal that spectrality in these works is also about repetition. As David Der-Wei Wang has noted, a core motif of the classical Chinese ghost tale is the spirit who appears, and reappears, at times of chaos in the empire to mingle with the world of men, dwelling in "the hiatus between the dead and the living . . . the unthinkable and the admissible" (2004, 262–63). Makers of culture in China circuit back again and again to the historical photographs I discuss here because those images both mark the moment of chaos and register the injustice of the inadmissibility that now surrounds it. As artist Sheng Qi put it to me, "Tank Man has been blocked, he has been disappeared . . . so I paint him again and again" (personal communication, 2017). Indeed, a culture—a cult—of reiteration exists around the photo-form and occurs both within the work of individual artists and across informal groupings, as shown in chapters 3 and 4. These repetitions ask to be interpreted in terms of a coalition of solidarity; but they must also be understood as spectral returns. As projects of justice, photo-forms use ghostly figures to register loss, anger, remonstrance, and hope. But photo-forms also function as revenants themselves, remaking the same images because they speak of the things so many know and that are too momentous to be permanently hushed.

Reading Public Secrecy

To flesh out these ideas in depth, this book is divided into five chapters, each of which explores public secrecy in its different but overlapping variants. Chapter 1, "Don't Look Now," focuses on the Nanjing Massacre and its infamous photographic record of beheaded men and violated women to show that the operations of public secrecy in reform-era China reach deep into the traumatic past. As signifiers of national cataclysm, these images of atrocity have a certain ubiquity in China today, where they constitute the heart and soul of patriotic discourse. Indeed, their prominence is such that it is easy to forget that these stills of rape and murder were sequestered state artifacts for decades. Yet in the mid-1990s, and in response to the turmoil that followed the crackdown at Tiananmen, photographs of these atrocities were released and briskly circulated, first via commemorative albums and then in popular

histories, exhibitionary culture, websites, films, paintings, reportage, graphic art, and videogames. The chapter explores how these photo-forms have spread the once-was-secret far and wide, mostly by repurposing the same core cache of ultra-violent images. Over time, these photo-forms have codified Massacre memorial into a fixed visual language, an ocular shorthand, a set of logos even, designed to embed a synaptic set of patriotic responses. Whatever their stated purpose, I show that these photo-forms have inaugurated new modes of public secrecy. Retooling grotesque perpetrator images as nationalistic propaganda (often displayed to children), these photo-forms confine the Massacre—whose trauma will always confound stark visual reckoning—to a continuing place of interdiction and the unsayable.

Arguably predominant among China's so-called amnesiac histories is the Cultural Revolution. Chapter 2, "Keeping It in the Family," takes this period as its focus and explores the genre of the family portrait, a form of image-making instantly recognizable for people who lived through those times. Taken at moments of emotional significance—before parting, at reunions—these precious images were often hidden away during the Cultural Revolution. But in the mid-1980s, a pioneering set of essays by the writer Liu Xinwu, in which he married family portraits to words, broke their cover. This new genre of photo-text went on to inspire the hugely popular pictorial *Old Photographs*, in whose pages amateur writers, with no training, connections, or reputation, used family portraits to share secrets about their Cultural Revolution experience, effectively under the radar. These photo-texts are poignantly spectral, deploying a visual language that plies the hinge between physical scarring and ghostliness. Their hauntedness touched many of China's leading artists, who were drawn repeatedly to the same portraits from the mid-1990s onward. Their works seek a visual idiom for the most taboo core of Cultural Revolution experience: the public secret that the ongoing absence of a full societal reckoning about those events serves multiple constituencies in Chinese society—not just the state, but also those citizens and their family members who acted back then in ways that they now prefer to disavow.

Public secrecy about the Cultural Revolution takes different form in chapter 3, "Cracking the Ice." There I trace the journeys of a singular photograph: the portrait of Bian Zhongyun 卞仲云, the vice-principal of the Girls Middle School attached to Beijing Normal University, who was beaten to death on August 5, 1966, by her Red Guard pupils. For decades, Bian's portrait was hidden behind a false-fronted bookcase in her widower's apartment. But since the millennium, that once-secret portrait has been repurposed repeatedly, and to the point of real fame, across varied aesthetic media. I argue that the makers

of these photo-forms have tried to apply lateral pressure on the larger public secret about the identity of Bian's killers and their likely connections with China's top leadership. Their purpose is not to "out" the guilty; rather, these photo-forms aspire to revelation and induct their spectators into an encounter with the dead that is numinous in its spectrality. By chance or otherwise, the work of this collective coincided with increasingly public reflection by Red Guards from Bian's school about the events of 1966. These reached a climax in 2014, when several former pupils bowed in apology before a bronze bust modeled on Bian's photograph. Their contrition met a mixed response, but it also forced a crack in the ice of public secrecy that surrounds the most sensitive aspects of the Red Guard legacy today.

Chapter 4, "Ducking the Firewall," turns to the 1989 Tiananmen Square crackdown and explores the aesthetic afterlives of the Tank Man photograph, über-emblem of citizen dissent. Tank Man is a famously *verboten* image in China, so strictly "disappeared" from public view that many claim he has been forgotten by the citizens of the "People's Republic of Amnesia." In this chapter I argue, to the contrary, that Tank Man exemplifies the public secret as a form of surreptitious intergenerational split. The image sunders Chinese people of a certain age, who have a retinal imprint of that encounter between man and tank, from younger people who have scant awareness of the photograph and the crushed protests it emblematizes. Tank Man constitutes a form of consensual silence whose tensions are heightened by the fact that the in-group and the out-group are constituted horizontally across society, across families. Since the millennium, however, Tank Man has been repurposed with increasing inventiveness by digital artists working inside and outside China. These works are harried by the censors, with the result that their audiences are small and short-lived. Man and tank must shape-shift to avoid detection, which they do in ways both comic and spectral. But precisely because of their fugitive character—which produces audiences who are alert, amused, and on the *qui vive*—these photo-forms ensure that Tank Man remains the grit in the clam of public secrecy about 1989.

The book's conclusion, "Out of the Darkroom," opens with a discussion of what may be China's most telling treatment of the relationship between public secrecy and the photographic image: Zhang Dali's *A Second History* (*Di er lishi* 第二历史, 2012). In this archival tour de force, Zhang presents a sequence of paired images to show how the Chinese state systematically doctored the most iconic photographs of the Communist revolution in its party-run photo labs: removing political enemies, rejuvenating the faces of ancient leaders, retouching discordant details. Displaying the manipulated images in panels alongside

their originals, which he unearthed through ardent detective work, Zhang shows how tight the relationship has been between photography and the clandestine in modern China. In this coda to the book, I use his work to reflect on why the photographic image has served as the persistent base for engagements with the openly unsayable. In part, this is because of the medium's origins in the darkroom, which is both a "chamber of secrets" and the place where those secrets are lifted from the acid into clarity. But Zhang's discoveries about how extraordinarily public images enacted extraordinarily blatant cover-ups also show that public secrecy is so pervasive because it serves deep public needs. At the same time, the series also exemplifies the powers photo-forms possess to generate coalitions of makers and spectators, contingent spaces in which the unsayable can find its voice.

×
× 1
×

DON'T LOOK NOW

Our concern with history . . . is a concern with pre-formed images already imprinted on our brains, images at which we keep staring while the truth lies elsewhere, away from it all, somewhere as yet undiscovered.
—W. G. SEBALD, *Austerlitz*, 2001

Ex-secrecy

For many people in China, 1995 marked the moment when commemoration of the Nanjing Massacre became irreversibly visual. That year saw the publication of a landmark album entitled *Photographic Evidence of the Nanjing Massacre* (*Nanjing datusha tuzheng* 南京大屠杀图证, 1995), brought out under the auspices of the Central Historical Archives, Number Two China Historical Archives, and Jilin People's Press. This album was "the first systematic effort to publicize the Chinese-held photographic archives on the Massacre" (Gao Xingzu 高兴祖 1997, 22), and it brought to light 820 photographs, most of them never made public before, many of them unswervingly explicit (Hu Jurong 胡菊蓉 1995, 120; Wu Guangyi 吴广义 1995, 31). The first print run of *Photographic Evidence of the Nanjing Massacre* sold out almost immediately (Gao Xingzu 1997, 22). That same year, a mobile exhibition about the Massacre, featuring 280 photographs, toured eleven cities in Jiangsu Province. Nearly half

a million people visited the exhibition, and lines of expectant visitors formed thickly outside the exhibition sites (Yoshida 2009, 159). A year later, across the East China Sea, graphic photographs of Massacre victims were included in the new Nagasaki Bomb Museum until a huge protest from Japan's revisionist camp of Massacre deniers forced their removal. In 1997, to mark the sixtieth anniversary of the Massacre, another epic album of photographs was brought out, *A Collection of Photographs of the Massacre Committed in Nanjing by the Japanese Military* (*Qinhua Rijun Nanjing datusha tuji* 侵华日军南京大屠杀图集), this time the joint work of Number Two China Historical Archives, Nanjing Municipal Archives, and the Nanjing Massacre Memorial Hall. A full quarter of the images it contained "had either never been published before, or were fresh to the eyes of ordinary readers" (He Ping 何平1997, 210). Similar albums have continued to appear, on a metronomic basis, up to the present, and they constitute a core mode of momentum in driving remembrance of the Massacre.[1]

These examples show that the photographs had the power to act on public susceptibilities like electrodes applied to soft pressure points: the images pitched their spectators, whether pilgrims or protestors (or people who sought to prevent spectatorship), into a place of renewed engagement with the Massacre. This was not merely an effect of their horror. The photographs also drew this reaction because their entry into mass consciousness marked the end point of a long period of visual darkness about the atrocities, particularly in China. Although photographs had featured in the commemorative discourse before, notably in the Nanjing Massacre Memorial Hall, which opened in 1985, the advent of the albums brought a prolific visuality to Massacre memory that was game-changing. It took the image archive into the published light of day, from where it became peripatetic and far more easily reproduced. Nowadays, it is as difficult to imagine the Nanjing Massacre without the archive as it is to "unsee" its awful catalogue of images. Once the genie was out of the bottle, it steadily recast Massacre memorial in its image, as the pictures migrated to a huge range of sites and spaces in the guise of protean photo-forms. Daqing Yang notes that popular fascination with the Nanjing Massacre "seems to have transcended a particular historical event and taken on a life of its own" (2001, 50), and for this, in part at least, we have the genie to thank. Most strikingly, the archival images have evolved under the aegis of their photo-forms into an emphatic visual shorthand not just for the Massacre itself, nor even, as Robert Chi notes, for "the whole of the anti-Japanese war in the official historical imagination" (2001, 65), but also, and ultimately, for the Chinese patriotic posture in macro terms. To "remember" the atrocities through viewing these

images and their photo-forms is to be interpellated into nationalistic person-hood, or so the logic goes.

Yet it was not always so. In fact, the photographic archive of the Massacre that is so visually prominent now lay out of general reach for the best part of half a century. The Chinese scholars whose observations on the albums I quoted a moment ago understandably focus on the pioneering role of these volumes in the evolving historiography of the Massacre, which had been mostly script-based until that point. But we might just as revealingly turn the telescope around to home in on the status of these photographs in the inter-vening years, long decades during which they were sealed in "strictly moni-tored" archives alongside "unknown quantities" of other classified documents about the Massacre (Yoshida 2009, 110). In plain terms, these images of rape and murder were sequestered artifacts of the state, whose display was limited and controlled. In fact, it could be argued that the images possessed a height-ened clandestine status because their dissemination to mass audiences came later than text-based records about the Massacre, which were orchestrated into the public domain a good decade earlier as part of the first stage of what Chi has called the "Nanjing Massacre revival" (2001, 51).[2] The broad release of the photographs marked the state stepping up that revival, and resorting to much greater visual openness via the release of more sensitive visual evidence in order to achieve its patriotic aims.

The story of how the Nanjing Massacre "all but disappeared" (D. Yang 2001, 55) from public view in China only to storm back to prominence in the 1980s and 1990s is a well-known one whose telling has been dominated by the tropes of remembering and forgetting.[3] After the Communist victory in 1949, the narrative of the long Second Sino-Japanese War was edited into an account that told only of the rightfulness of the CCP's mandate, and of the Manichean struggle against Japan's Imperial Army in which the moral strength of Mao and his fighters won out. The victims of Nanjing, however, received no succor from "Communist superheroes" in 1937 and no redress in the early postwar period either (Chen 2009, 30). The Massacre thus became the unsayable part of China's past suffering and weakness, the most gaping lacuna of CCP historiog-raphy,[4] missing from school textbooks,[5] unmarked in the memorial landscape.[6] Pragmatically, too, the fledgling regime was focused more on marshaling its re-sources for survival than on past affliction: the struggles of the here-and-now were so fierce that "to turn attention to the disasters of a bygone day would seem a luxury" (Link 2002, xiii). As the years passed, the praxis of regime consolida-tion, with its regular campaigns and the febrile mood they produced, drummed home this focus on the present. "Forgetting" the Sino-Japanese War, and the

Nanjing Massacre in particular, also served geopolitical imperatives. Beijing was too intent on winning Tokyo over to the PRC's diplomatic fold to risk raking over the embers of conflicts past, and few topics were more inflammatory than the atrocities of 1937 (Mitter 2003, 118). The status of Nanjing as the Kuomintang (KMT) capital prompted further forgetfulness, since mourning the Nationalist dead scarcely served the propaganda war that the CCP was waging both at home and across the Taiwan Strait and that designated the KMT as chief national foe. The dead of Nanjing were, in this sense, the "wrong" victims; to commemorate them would have contravened Communist goals.[7] Squeezed on two geopolitical fronts, the Massacre became a "no-go area," sealed up in archives and mostly cordoned off from historical inquiry (Sun Zhaiwei 孙宅巍 2008, 34).

But in the mid-1980s, consciousness of the Sino-Japanese War began to surge back, first coaxed by the state and its agents, and later animated by the less biddable forces of public passion (Gries 2005; He 2007b, 51–59). The advancing reform process had cracked open social fissures that the old rhetoric of class struggle could no longer seal over. A new glue was required, and it took the form of nationalism (Christensen 1996; Zhao 1998, 288–91). This nationalism required its bogeyman, and Japan could be fitted up for that role now that the PRC had its seat at the UN and no longer had to court favors so assiduously (even though the mutual need for economic cooperation has always put brakes on how far state-to-state criticism could go). A crucial trigger for this process was the textbook controversy that blighted Sino-Japanese relations from the early 1980s onward, as groups inside Japan tried to bleach imperialist aggression from school curricula, provoking outraged protest in East Asian nations. "Remembering" the Sino-Japanese War also dovetailed with another pressing policy drive: reunification with Taiwan. The war was a crucible of memory in which comradeship with "Taiwanese compatriots" could be forged, as writing the Nationalists back into China's victory narrative reminded rivals across the Strait that they were also brothers-in-arms who had fought the same foe. Last, rising China needed a moral banner for its bid to supersede Japan as the region's next "great nation." The newly remembered war, and Japan's barbarous conduct during it, evoked across East Asia a sense of "us" and "them" that helped to concretize China's claims in suasive terms.

All this produced a major historiographical turn. Archives opened, historians seized their moment, and the War of Resistance staged its dramatic return to Chinese consciousness. And in many ways, the Nanjing Massacre led the way, as dominant in the limelight now as once it had lain hidden in the shadows, the "prime icon of Japanese brutality" (He 2007a, 7), the very centerpiece of

the state's flagship campaign for "patriotic education." Prepped by the opening of the Nanjing Massacre Memorial Hall two years earlier, the period around 1987—the fiftieth anniversary of the atrocities—saw a commemorative blitz: radio and TV broadcasts, memoirs, eyewitness accounts, new works of fiction and reportage,[8] and the release of a major feature film entitled *Bloody Evidence in the Massacred City* (*Tucheng xuezheng* 屠城血证, dir. Luo Guanqun 罗冠群, 1987). Jungmin Seo argues that "the post-Maoist Chinese nation emerged through the symbolic power of the Nanjing Massacre" (2008, 372), a remarkable pivot for an event so long deemed inadmissible. Memory charged back with even fuller force during the 1990s, as the fallout from the bloodshed at Tiananmen Square in 1989 made rebooting "patriotic education" a panicked necessity. Barely two weeks after the crackdown, state media were already promoting "correct" ways to love the nation, and the effort to securitize China internally led the party-state to "displace memories of the June 4 massacre with those of the Nanjing massacre" (Callahan 2007, n.p.), thus further enshrining the atrocities as the foul nadir in China's past that made the pedagogy of patriotism necessary. The 1990s were also a boom time for revisionists in Japan, and their activities inevitably lent yet more ballast to the Nanjing Massacre revival.[9] The welter of books, illustrated articles, exhibitionary attention, and media coverage was such that Takashi Yoshida has argued that "a new commemorative tradition (for the atrocities) began in 1996 and has continued to the present" (2009, 160). It is no coincidence here that the mid-1990s also saw the advent of the photograph albums as a memorial mode.

Fleshing out Callahan's point, we might argue that the party-state substituted the forbidden image of Tank Man braving annihilation by People's Liberation Army tanks with the now infamous photograph of a man beneath a tree awaiting execution by Japanese swordsmen—a straight swap that signaled how crucial photographs would be to commemorating the atrocities from then on. Or to couch this in the language of the clandestine, the creation of one secret (Tank Man) was helped along by the broad exposure and syndication of another. During the 1980s, the images of the Massacre had still been treated gingerly, as befits a secret emerging from deep cover—a point made melodramatically in Luo Guanqun's 1987 film, whose plot turns on the recovery of a small cache of photographs taken by the Japanese military to record their deeds. In the penultimate sequence of the film, these vital images, wrapped in dark cloth, are finally shown to the camera. The photograph of the man beneath the tree is the first to be revealed, its display so momentous that cinema audiences were permitted only a momentary glimpse. By contrast, the second mnemonic epoch for the Massacre showed no such scruples, as the same photographs

FIGURE 1.1 The man awaiting the sword beneath a barren tree, an image that has journeyed from closed archive to overexposure.

that appear for mere seconds in Luo's film—the man under the tree preeminent among them—came to monopolize the commemorative stage. Figure 1.1, a screenshot of a search for the image on Baidu, clearly visualizes its path from top secret to almost banal accessibility. Small wonder that it is this image more than any other that the revisionists in Japan have tried most energetically to discredit (Higashinakano, Kobayashi, and Fukunaga 2005, 86–87).

As with June 4 and the Cultural Revolution, the lexicon of remembrance and amnesia dominates discussions of the Massacre and its historiography, from the subtitle of Iris Chang's (1997) famous study—"The Forgotten Holocaust"—to the motto "never forget," which is branded on the walls of the Nanjing Massacre Memorial Hall, to the rising chorus of skeptical voices in the Sinophone blogosphere that ask how an event of such magnitude failed to register on Maoist China's memory scale for so many years.[10] Or as one blogger asks bluntly, "Why did Mao Zedong cover up the Nanjing Massacre?" (Jiang

Fenglin 姜凤林 2012). Ultimately, these online voices are pushing at the point that both amnesia and its opposite notion of an abrupt return to mindfulness are imperfect constructs for grappling with the afterlives of the Nanjing Massacre in reform-era China. Chi calls this idea of "memory return" contrived, noting that "either [the Nanjing Massacre] was artificially forgotten via an unnatural repression during the socialist period and then naturally remembered afterward, or it was naturally forgotten during the socialist period and artificially revived as an object of memory after the Cultural Revolution" (2001, 50). A Hong Kong blogger self-named "Herzog" has digitally mapped this artificiality, scanning the *People's Daily* (*Renmin ribao* 人民日报) for the search term "Nanjing Massacre" and publishing his results online in 2012. Herzog found not a single mention of the atrocities between May 1960 and June 1982; but between the period June 1982 and February 2012, this zero had leapt up to 825 (Herzog 2012).[11] Even if this "artificiality" is not named as such so directly elsewhere, scholarship on the Massacre is fully predicated on the state's interventions into what can be "remembered" and when. But concomitant and crucial to these suppressive interventions is the secrecy required to make them work. This secrecy has won much less attention, presumably because the point is deemed too obvious: How, after all, can facts be suppressed without secrecy? What more is there to say beyond this self-evident truth?

In this chapter, I argue that the secrecy that shrouded the Nanjing Massacre until the 1980s is an essential interpretive mechanism for understanding its memorial in the years since. In contrast to the other case studies explored in this book, the Massacre is what might be termed an "ex-secret": an episode whose epistemological status in the public sphere has experienced a radical *volte-face*. More than an ex-secret, a term that merely suggests declassification, the ending of clandestine identity via rubber stamp, the Massacre is in fact now the heart and soul of "the hegemonic discourse of Chinese nationalism" (Callahan 2007, n.p.). And as an event whose documentary record was once classified and yet is now ubiquitous within the performance of patriotism, the atrocities of 1937 constitute what may be a case study without peer or precedent of state secrecy and its capriciously shifting operations. This chapter explores how photo-forms of the Massacre have disseminated the once-was-secret far and wide, creating a dense image ecosystem wherein commemoration of the Massacre now mostly happens. In addition to the albums, it spans academic and popular histories, museum culture, websites, cinema, painting, reportage, graphic art, videogaming, and social media, the latter most particularly on the Nanjing Massacre Memorial Day, inaugurated in 2014.[12] All these photo-forms have remediated the catalogue of beheaded men and raped women; most re-

turn insistently to the same core cache of ultra-violent images. These photo-forms, I argue, exist in a dialectical relationship with the secret that the Nanjing Massacre was during the Maoist period. Over time, they have created a codi-fied visual language for the atrocities, an ocular shorthand, a set of photo-logos, even. These logos work to embed a certain synaptic set of responses among those living in the here-and-now who have no direct experiential understand-ing of the Massacre. In one sense, this visual regime both metaphorizes and makes real the final demise of the secrecy that once veiled the atrocities of 1937. But in another it has set up new structures of sociopolitical concealment that keep the most taboo aspects of the Massacre contained with the zone of silence.

Proof Positivist

At this point, though, a brief caveat is needed. To write about the Nanjing Massacre is to tread delicate ground. The events of 1937 were appalling, and to this day their factual horror alone is enough to arouse justified fury in China. As these sentiments have been repeatedly stoked, both by constituencies at home to stir nationalist passions and by the denial of Japanese revisionists, the legacy of the Massacre has become a tinderbox, capable of inciting civil disturbance. Yet at the same time, and alongside this very real volatility, the discourse on the atrocities retains a certain static character. For this, the re-calcitrance of the deniers bears a good deal of blame because it has propelled the study of the Massacre in the direction of empirical proof, often articu-lated numerically—particularly the death toll—but in a zero-sum game with-out foreseeable end. In other words, this is a discourse that runs furiously, but it does so on fixed rails and within the broad domain of evidence, either presented or contested. In one sense, this impasse is enraging for China, but the well-rehearsed postures of the standoff also maintain a received and even reassuringly stable epistemology of the Massacre.[13] To ask different kinds of questions about the atrocities, as commentators began to do at the turn of the century, destabilizes this dominant mode of knowing. It does so not to query evidence or numbers or the grim fact of the Massacre, but to expand understanding of this core event in necessary new directions. For scholars of "new Massacre history," it is the problem of proof—first as a burden, now as a fetish—that stymies deeper conceptualization of the Nanjing atrocities, and these researchers are using new approaches to prize the subject from the grip of empiricism.[14]

The photographic record lies at the heart of this dialectic between proof and denial, and for that reason it is an obvious place within which to try

to unsettle it. Since the mid-1990s, China's commemorative discourse on the Massacre has leaned heavily on the photographic image for what Tom Gunning (2004) calls its "truth claims," the blunt, wordless riposte these stills of atrocity thrust at the deniers. Wu Guangyi favors the still more robust term *tiezheng* 铁证, "iron-clad proof" (1995, 31), and these black-and-white images—blurred, smudged, and erratically composed—have every rushed hallmark of authenticity. This equivalence between photography and *tiezheng* is a terminological commonplace of Chinese scholarship on the Massacre, and the phrase accompanies the photographic record with a liturgical force and regularity.[15] Almost as routine are the efforts by Japan's revisionists to discredit the photographs via tendentious publications that seek to cast doubt on the provenance of specific images, but merely underscore the core role the archive plays in confining the Massacre within the domain of proof. Indeed, *tiezheng* as a term here is so telling because it also articulates the solidity of the photographs as evidentiary artifacts. They are, or seem to be, objects that provide anchorage in a knowledge system that runs on fact. But if we are to understand why the Massacre "has taken on a life of its own," enmeshing itself within the popular psyche, far exceeding its historicity, and becoming something akin to a hyper-event, some recognition is due to the free-floating narrativity that these images now possess as they move, as photo-forms, across the commemorative landscape. To rethink the Nanjing Massacre requires, in this sense, a rethinking of its photographic record. Rather than artifacts that are "true" or otherwise (and thus keep the discourse moored in empiricism), these photographs need also to be understood in their afterlives as photo-forms, as active makers of memorial.

Above all, photo-forms exist in a dialectical relationship with the secret that the atrocities used to be. These image-works are the major means through which the once-was-clandestine has become almost excessively public; as such, they are also the route via which secrecy as an epistemological mode for understanding the legacy of the Massacre can finally break cover. Neglected though it has been, secrecy is an essential methodology for making sense of the afterlives of the Massacre because, like the photo-forms, it disrupts the stubborn lockstep between proof and denial. Secrecy can do so because it is a practice in which both China and Japan have been persistently invested: it crosses the dividing lines and helps to explain the emergence of this lockstep as a structuring force in Massacre historiography. China's secrecy is my main subject here, but cover-up and its counterstrategies have also shaped Japan's handling of the Massacre-as-history for decades, from media blackouts to whitewashed textbooks to the fiercely contested confessions of former

soldiers. Both countries also passed through extended periods during which the Massacre laid almost entirely hidden from view, only for it to loom out of the shadows with a sudden electrifying force. It is scholarly convention to attribute these vagaries of recall to politics, and for them, of course, politics is partly responsible. But homing in on secrecy also opens space for the notion that these atrocities hid themselves for years because they bore the unshowable stigmata of shame: Japan's shame at having committed such an outrage and China's shame at having suffered it. That sense of shame was scorching for both sides. For years, it made the Massacre untouchable, a kind of radioactive zone better left abandoned, subject to a joint recoiling. That shame, in other words, was a shared secret, harbored by victim nation and perpetrator nation alike, whose belatedness in reaching public knowledge was always about more than Realpolitik alone. And if, as the years have passed, it has become safer to approach the site, this does not mean that the shame of the Massacre has been fully owned and processed into acceptance. Quite the contrary, in fact, and secrecy helps to shed light on why certain aspects of its legacy remain so intractable.

What, for example, is ongoing Japanese denial if not an inverse formulation of the public secret, in which an event too terrible to own is not disavowed in silence but loudly shouted down in ways that only garner the atrocities more attention? Denial, in this sense, is the aggressive refusal of the shame that so often accompanies a secret, a point that Mishima Yukio 三島由紀夫 pushes to the extreme in a little-known short story about the Massacre, entitled "Peonies" (Botan 牡丹, 1955). In this text, the narrator and his friend visit a garden of floridly blooming peonies: "Each of the peonies had its own character . . . and each one, surrounded by its patch of soil, had a solitary air" (Mishima 1968, 170–71). The narrator's companion informs him that the owner of the garden is Colonel Kawamata, "the ringleader of the Nanjing Massacre" (*Nankin gyakusatsu no shubôsha* 南京虐殺の首謀者), who went into hiding to avoid the war trials and reemerged later to buy the garden and plant it with 580 peonies—one for each of the Chinese women he murdered, "pleasurably and conscientiously, with his own hands" (172). The friend concludes: "He wanted to commemorate, in a secret way, his own wickedness" (173), which he exhibits to the public—the garden is full of tourists taking photographs—in grotesquely encrypted form. Mishima's story is superficially about one man's depravity, but it is also a larger comment on the suppression of the atrocities in postwar Japanese society, written at a time when the Massacre "lay largely outside common awareness in Japan" (Yoshida 2009, 59). Above all, though, "Peonies" foretells, in horror-satire mode, the later actions of the revisionist

camp, whose refusal of shame is so often linked to the recrudescence of Japan's militarist desires in part because behind their denials presumably lies a certain pride in the nation's violent past. Denial, like the peony-women in Colonel Kawamata's garden, publicizes in encoded form the secret that, for some at least, there is no shame at all.

Membership of the Club

In very different ways, China has also struggled with the shame inflicted by 1937, as the push-and-pull struggles for publicness that the Massacre went through during the Maoist period make clear. In the early 1960s, a small team of teachers and students in the history department at Nanjing University began an intensive research project on the Massacre. Under the leadership of history professor Gao Xingzu, they gathered data, interviewed survivors, and compiled statistics; in 1962 they collated their findings in a draft manuscript entitled *The Massacre Carried Out in Nanjing by Japanese Militarism* (*Riben diguozhuyi zai Nanjing de datusha* 日本帝国主义在南京的大屠杀). Their assiduous work was the "first comprehensive study" of the Nanjing Massacre in post-1949 China (Yang 2001, 55); it also turned out to be the last until the 1980s. Zhang Lianhong 张连红 notes that shortly after the manuscript was completed, "work on the project was suspended (*zhongduan* 中断)" because of the "prevailing leftist thought at that time" (2007, 96). Mark Eykholt (2000, 25) writes more bluntly that the manuscript was "classified," a state of secrecy that continued until the post-Mao thaw of the late 1970s. At that time, a new plan took shape to publish the eight-chapter manuscript, including photographs, with the Jiangsu People's Press, "but just as the final proofs were ready, it was decided for various reasons that that book could not be formally published. Instead, it was printed as a so-called 'white paper' [*baipishu* 白皮书, literally "a book with a white cover"], without a book registration number [the Chinese equivalent of an ISBN] or a publishing house, and was designated for 'internal circulation' [*neibu* 内部] only" (Sun 2008, 34). Eykholt defines the latter term in this context as meaning "for government officials and others with inner-circle connections," though he notes that over time "it became available to most Chinese interested in the Massacre," and a Chinese scholar who had smuggled a copy of the document to the U.S. even posted a partial translation on the internet in 1995 (2000, 63). Data from the manuscript were also released to the Nanjing City Government, which showed it to select groups of "interested Japanese visitors" (Xu and Spillman 2010, 119).

In an obvious sense, this story of the 1962 manuscript demonstrates succinctly that practices of secrecy, rather more than forgetfulness, determined the afterlife of the Nanjing Massacre in China until the mid-1980s. That manuscript, the work of local historians and archivists, shows (entirely as we would expect) that recall of the events among survivors remained fresh and hungry for documentation a quarter of a century after the atrocities. The vagaries of memory did not afflict this carrier group. More pertinent, though, is the idea of secrecy as a highly social habitus that emerges from this story: the small team who worked on the manuscript, the classified status that restricted it to elite hands, the broader circles among whom the later white paper moved, the way it slowly spread among "most Chinese interested in the Massacre," its eventual appearance in translation on the internet, its display to those Japanese visitors invested enough to travel to Nanjing and make enquiries. Rather than being clandestine in the strict sense of the word—under lock and key, encrypted, subject to high-level security clearance—the manuscript exemplified instead the ceaselessly segregating character of secrecy. As it moved through ever-expanded circles of belonging, first among a core group of insiders and later within a wider group of secondary info-sharers, the journeys of this text showed that membership of the "club" mattered almost as much as the details of the secret itself, and that its final public outing was prepped by multiple prior disclosures.

Even as access to the document widened there remained both a sense of divisiveness—Who got access first? Who was second-tier?—and its corresponding other, the frisson of power that emanates from becoming privy to an object marked with *neibu*, the apparent imprimatur of the "state secret."[16] Indeed, China's complex apparatus of internal publication before the mid-1980s almost begs to be read through the prism of secrecy rather than via the much more common mechanism of censorship.[17] But the operations of the *neibu* system also reveal just how quaint and quixotic it is to view secrecy in terms of the crypt or locked drawer alone. In practice, the *neibu* stamp actually "allowed for the speedy circulation of new information" (Vittinghoff 2005, 85) an ultimately sense-making paradox whose significance is captured by the fact that the *National Bibliography of Internally Distributed Works 1946–1986* (*Quanguo neibu faxing tushu zongmu* 全国内部发行图书总目 *1946–1986*), a volume that spread information about these gray-zone tracts, was itself a *neibu* publication. Particularly noteworthy in this context is the journey that *The Massacre Carried Out in Nanjing by Japanese Militarism* made through various formats as it inched its way toward the public domain. The version dating from 1962 was mimeographed (*youyinben* 油印本) and only graduated

to "white paper" status, intended for limited circulation, in 1979. Ultimately, it would take the auspices of a different material substrate—photochemical paper—for the secret of the Massacre to achieve a fully viral kind of exposure, a point to which I return shortly.

In the meantime, what the story of *The Massacre Carried Out in Nanjing by Japanese Militarism* testifies to most plainly is the clubbable character of secrecy. As Simmel observed over a century ago, secrecy marks boundaries, and those boundaries have the "force of an expression of value," they create qualitative distinction (1906, 486). This notion of secrecy as a form of exclusionary sociality based on insider knowledge takes as its *locus classicus* the biblical story of the shibboleth. This Hebrew term, as recounted in chapter 12 of Judges, was used by the Gileadites as a password to identify the invading Ephraimites, whom they had routed in battle. As the surviving Ephraimites attempted to cross the River Jordan and return to their own lands, the Gileadites blocked the fords and forced all comers to utter the word "shibboleth" in order to secure safe passage across the water. The Ephraimites could not pronounce the "sh" sound, and those who uttered it as "sibboleth" were duly put to the sword—forty-two thousand altogether. As such, the story of the shibboleth captures what is predominantly segregating, and only nominally clandestine, about secrecy as a deployment of power. The Ephraimites, forced one by one to utter a password—a secret phrase that must be used to gain admission to a place—which they knew full well but could not enunciate the "in" way, paid the highest price for not belonging to the club. The whispered watchword was merely a show of secrecy, as its true purpose was to single out and exterminate political enemies. Or as Derrida puts it, the shibboleth is a "secret formula such as can be uttered only in a certain way in a certain language . . . a secret within one's so-called . . . mother tongue" (1995, 88): a secret that is not hidden so much as phonetically unattainable for those outside the in-group. It is not clandestine so much as a strategy of apartheid: both "the mark of an alliance" and "an index of exclusion" (Derrida 1986, 346).

Making Logos

Following on from this, Derrida writes elsewhere that the shibboleth can be seen as an operation of marking, because it names

> every insignificant, arbitrary mark, for example the phonemic difference between *shi* and *si*, as that difference becomes discriminative, decisive and divisive. The difference has no meaning in and of itself, but it

becomes what one must know how to recognize and above all to mark if one is to get on, to get over the border of a place . . . to see oneself granted asylum . . . So as to no longer be an outlaw there . . . It does not suffice to know the difference, one must be capable of it, one must be able to do it . . . and doing here means *marking*. It is this differential mark which it is not enough to know like a theorem which is the secret. A secret without secrecy. The right of alliance involves no hidden secret, no meaning concealed in a crypt. (2005, 26)

This idea that secrecy as exclusionary sociality is a kind of "arbitrary mark" opens up an understanding of what might be its opposite form. If secrecy works by "marking" out social groups in divisive ways, it is not enough to argue that ending such a state of affairs—as the state sought to do with the orchestration of the Massacre revival—simply means the opening of archives, the public disclosure of relevant facts, the mass dumping of information. As stated already, the revival was intended to serve as a sociopolitical adhesive, most particularly after the 1989 protests. It was the ex-secret that was suddenly required to unify where for many years it had divided. As such, it had to transform itself from an "arbitrary mark" into an entity that did not merely reveal its face to those who had previously been beyond the pale of knowledge, but could also help to turn the broad mass of society into a more patriotically cohesive unit.[18]

The opposite of an arbitrary mark—a sign socially "discriminative," linguistically "divisive," at times politically fatal—is, of course, the logo. Designed and then redesigned in a process that tends to streamline to the bone (as the various configurations of McDonalds's Golden Arches show), the logo is a sign to which arbitrariness is anathema. This is because the logo requires mass reflex recognition. As Kohli and Suri put it, "Nike's swoosh has become so prominent that the company's ads often do not even mention the name" (2002, 59)—a far cry from the phonetic snares of the shibboleth. Indeed, the ideal logo forswears language: not just "no password required" but preferably no words at all. Because the logo must travel across borders and languages, its natural domain is the visual one, so much so that a logo that does have to "mention the name" may need redesigning. Words, if they do appear, should take the form of slogans, snappily memorable enough to boost the process of synaptic recognition. Culturally and linguistically fungible—as opposed to fluffable, like the shibboleth—the logo harnesses its pictorial character to speed up the processes of information storage and retrieval, both of which boost its recognition quotient. Yet recognition *per se* is not enough, because

the logo, unlike the arbitrary mark, always has a mission in mind. At base, that mission is inclusive (as we would expect from the logo's drive for recognition), rather than operating *per exclusionem* like the shibboleth, and as Kohli and Suri note again, "logos with high meaning are 'highly codable' symbols that evoke consensually held interpretation within a culture" (2002, 60). They are about unity and groupthink. Veteran logo designer Otl Aicher might have it still better, though, when he observes that while "good art inspires, good design motivates" (quoted in Simmons 2011, 19).

The stepped-up phase of the Massacre revival, which began in the mid-1990s with the release of the albums, marked a conspicuous shift from a historiography of the atrocities based in language to one that mobilized images and thus made memory "photographic." Yet more than just mobilization, the albums inaugurated a long process of what I will call—with some necessary caveats—a multi-sited program of logo design around the photographic archive of the atrocities. This process has been conducted under the auspices of prolix photo-forms, which have molded the atrocity images into a codified visual language with its own dominant signs and syntax. These photo-forms, as a media ecology, have disseminated their visual language into public consciousness via transmedial nodal points—albums, museums, websites, histories, films, artworks, reportage—often accompanied by the slogan "Never forget national humiliation" (*wuwang guochi* 勿忘国耻), as seen in figures 1.2 and 1.3. Ultimately, though, this is a sign system that seeks less to communicate than to rouse and rally, and so it is not enough to speak merely in terms of visual language, even if its speech acts are highly codified. To take a rhetorical step further and call this visual language a logo, or set of logos, is by no means to suggest that these photo-forms share precise space with "the Swoosh, the Shell, and the Arches," as Naomi Klein dubs the triumvirate of über-brands in her polemic *No Logo* (2000). Rather, my aim is to invoke the capacity of the logo to bear down on its publics ("bully" is Klein's term) in ways that compel a certain kind of unified compliance. This state of compliance is sought in the complex space between broad presence, instant recognition, and affective legitimacy that the logo claims as its own. A version of this process can be seen in the photo-forms that dominate Massacre memorial, and it takes place in gradated stages.

The first labor performed by these photo-forms is the distillation of the archive of the atrocities into a core canon, a task initially performed by the photographic albums discussed earlier. These volumes contain hundreds of images, vastly too many for a commemorative campaign that needed the photographs to assume stark emblematic value—logos, as Doreen Massey

FIGURES 1.2–1.3 "Never forget national humiliation": online slogans that circulated on social media in the run-up to the Nanjing Massacre Memorial Day in 2016. Both images repurpose Li Zijian's well-known oil painting of the atrocities.

has demonstrated, rely heavily on the "strategy of synecdoche" (2007, 41). From the outset, the presentational format of the albums shows the pull of strong rhetorical forces, which militate toward selective, synecdochal display. In the 1997 album edited by Zhu Chengshan 朱成山, for example, a general law of co-relation operates between the horror of the image and the size of its magnification: the most graphic photographs often occupy a two-page spread, whereas "lesser" images are shrunk to the size of passport photos. The canon is thus nudged into preliminary formation as the most dreadful photographs demand their spatial due. I identify these images, which form the core of the "canon," as those that feature decapitation, violated women, bayoneting, live burial, killing fields strewn with corpses, and the two Japanese soldiers who took part in the infamous "killing contest."[19] In some of these categories, a single photograph has gained huge traction (such as the image of a man kneeling beneath a barren tree, mentioned earlier; the still that shows the anguished face of a woman in the aftermath of rape; or the picture of the two competitors in the killing contest), whereas in others, especially the killing fields and photographs of bayoneting, a small number of cognate images has acquired "viral" status.

These first steps toward canon formation were soon consolidated elsewhere. The photographs that loom largest in the albums are also those that are reproduced most frequently in the legion print media products about the Massacre that have appeared in China over the past two decades: journal articles, magazine features, school textbooks, and historical accounts of the atrocities. An eighth-grade history textbook from 2010, entitled *Chinese History* (*Zhongguo lishi* 中国历史), exemplifies this process. It contains a double spread that shows photographs of decapitation, bayoneting, live burial, and the killing contest, captioned with a phrase that professes the canonizing drive: "These are only a small selection of the many photographs of the massacre carried out by the Japanese army in Nanjing" (76). Here, also, we find a preliminary instantiation of another strategy of logo-building: the photographic medley, in which the power of the canon accrues in part from its identity as a bonded assemblage of images, intended to be viewed together—a point also developed in historical accounts, both academic and popular. The photographs that accompany these latter texts are usually sized small, so it falls to their textual positioning to bespeak their canonical status. It is common practice for histories of the Massacre to open with a slim visual epigraph or frontispiece consisting of half a dozen photographs drawn from the aforementioned canonical categories, whose front-loaded presence signals to readers that these images not only preface but also *précis* the account that follows.[20] Epigraphs, after all, are

quotations from acknowledged sources; they are set a privileged place above conventional citations because of the epitomizing meaning they project forward onto all that follows.

Motivational Design, Synaptic Rage

Forming canons, though, is not the same as designing logos, and shaping the core cache of images into branded formats has also required the marshaling of specific elements of design: line, color, shape, space, balance, texture, scale, and other strategies of creative remodeling. Book and website design have been crucial spaces for this task. The covers of both scholarly and popular books about the Nanjing Massacre are commonly emblazoned with one or more master images in embellished, multimedia, or medley layouts. A preeminent example here is the epic series *Historical Documents on the Nanjing Massacre* (*Nanjing datusha shiliaoji* 南京大屠杀史料集, 2005–). Each of its fifty-five covers carries an identical collage of photographs—a composite image of General Matsui Iwane's 松井石根 troops marching through the city gates of Nanjing on the upper half, which then dissolves into a shot of corpses strewn on the banks of the Yangtze River on the lower half—individually highlighted in a broad palette of colors. Inevitably, the use of archival photographs as cover art mandates a degree of "souping up," as filters, frames, textures, and so on are layered over the images to enhance their photogenic powers. And as the flipside of this coin, the archival photographs also become subject to a powerful momentum of "editing down," as they are visually reduced via a suite of operations—streamlining, contouring, cropping, and stylizing—that make the images "readier" for the retina to identify.

A display I saw in a Nanjing bookstore in 2013 lined up almost every volume of this epic series, the books arrayed like a vast fan across a table in the middle of the store, rather like in figure 1.4. On one level, the display registered the hard scholarly graft and grand disgorging of archival matter that has made the project of *Historical Documents* possible (28 million characters and counting). But on another level, it is difficult to imagine a more emblematic staging of the process from state secret to branded logo that the history of the Massacre has undergone, as huge tranches of once-clandestine information (the series collates diaries, letters, photographs, surveys, statistics, news reports, survivor testimonies, diplomatic papers, transcripts of the Tokyo trial, and burial data) are made public under the cover imprimatur of an identical photographic medley again and again. Indeed, this cover art performs, via the very repeti-

FIGURE 1.4 A remediated rainbow: covers of *Historical Documents of the Nanjing Massacre* wash the same pair of photographs in multiple hues.

tiousness of its design, a direct acknowledgment of the role that a small canon of photo-logos has played in relaying the Nanjing Massacre into public consciousness. Over time and across multiple book jackets,[21] these design strategies have helped the photographic record morph from images that denote the Nanjing Massacre into photo-forms that subsist in a more fluidly connotative relationship with those atrocities. After all, the measure of a logo's success is in part the visual distance it can travel from the object it represents. Thus the Nike Swoosh transitioned from a winged logo that bore the company's name; to one without text that used a red and white palette; to the black symbol of speed, motion, and agility so ubiquitous in the retail world today.

This point is well illustrated by the cover of *A Photographic Catalogue of the Nanjing Massacre* (*Nanjing datusha tulu* 南京大屠杀图录), brought out by the Nanjing Massacre Memorial Hall in 2015. The book's pared-down design is dominated by its title, which takes the form of a central white panel printed with bold black characters. Its backdrop is a monochrome image comprising stark and random shapes, which to the untutored eye resolve into no identifiable pattern. In fact, this background image is a deliberately overgrainy reproduction of one of several well-known photographs of mass execution sites in and around Nanjing, in which corpses were strewn in brutally anonymous heaps, and it is unlikely that readers in China would fail to identify the cover's

photographic provenance. In one sense, this cover design, however stylized, is familiar simply because the photograph itself already possesses a high recognition quotient. It features, for example, in many of the print and online venues I reference in this chapter. But it also "clicks" with readers because the practice of vamping up these images of mass execution as cover art had already been established by the multivolume series *Historical Documents on the Nanjing Massacre*, which featured remediations of a very similar photograph on every one of its fifty-five book jackets.

Other texts, such as *The Longest Fourteen Days: Testimonies and Records from Survivors of the Nanjing Massacre* (*Zui manchang de shisi tian: Nanjing datusha xingcunzhe koushu, shilu yu jishi* 最漫长的十四天:南京大屠杀幸存者口述实录与纪实, 2015), logoize the canonical images inside their covers. This volume, the tips of its pages stained red as if dipped in blood, blends witness statements with canonical photographs, themselves also washed in the same crimson color: the rawness of the oral accounts bleeds physically into the images, transmuting them from illustrative to rhetorical objects. Captioned as "file photographs" (*ziliao zhaopian* 资料照片), the images emphatically cast off this status, not just on account of their bloody color (which sometimes appears in swirls), but through a pattern of reiteration in which a single image, reproduced in sharp focus at the bottom of the page, is photographed repeatedly, always using the previous copy as source, until only the bare outlines of shape and form remain (figure 1.5). On one level, this image-making gestures to the reiterative violence of the Japanese troops, a point also made in the albums, which display on a single page or double spread a medley of decapitations, sometimes using different photographs to "stage" the process sequentially as the sword falls.[22] But the mounting abstraction of the image, its build up of photographic grain, also mimics the journey from photograph to logo, from a testimonial image that needs its details to one that functions as a rhetorical wallpaper—a background logo—for the text, and whose repetitions are symbolic.

Commemorative websites about the Nanjing Massacre also perform this logic of the logo. A standout is the cyber-memorial *Never Forget: The Historical Facts of the Nanjing Massacre* (*Yong bu wangque: Nanjing datusha shishi* 永不忘却: 南京大屠杀史实), which displays scores of images and offers viewers a virtual experience of leafing through one of the atrocity albums.[23] The design throughout is again melodramatic: candles glimmer on the homepage, set beside a rolling slideshow of black-and-white photographs of the Japanese atrocities, vivified by the superimposition of artificial intensity flicker to suggest an archive newsreel effect (figure 1.6). Another section of the website is

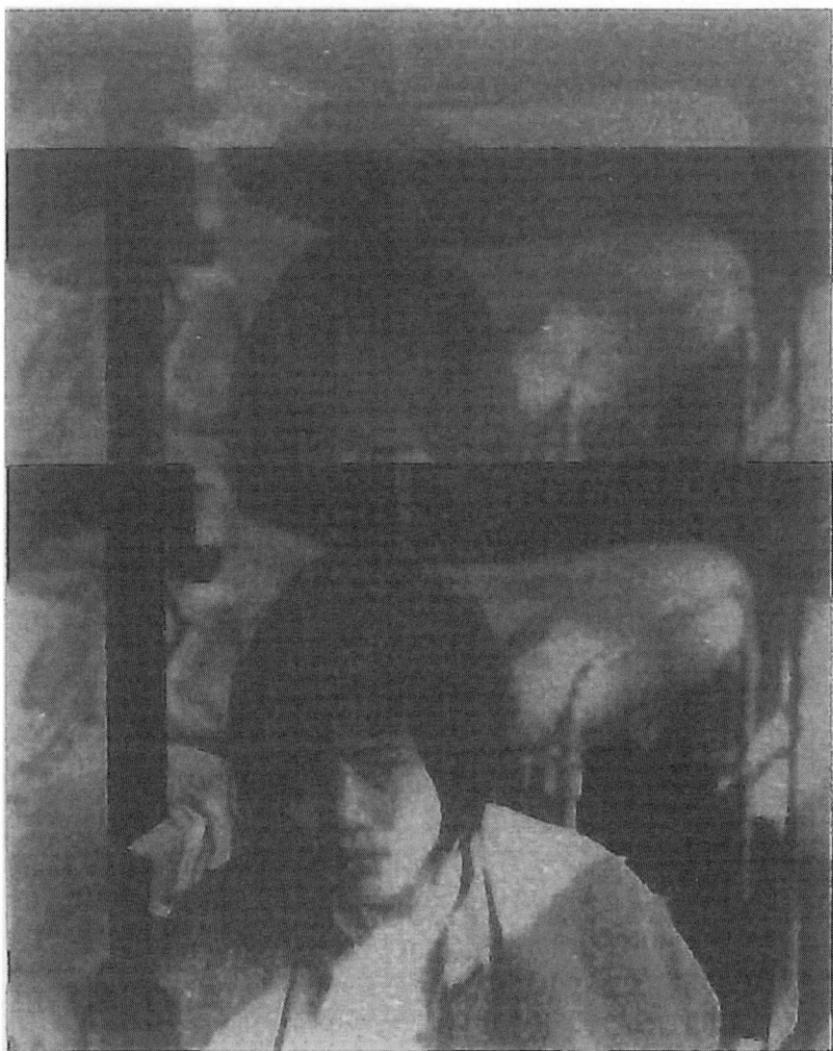

在金陵大学医院接受治疗的18岁中国少女。她因被
日军轮奸，而染上性病。（资料照片）

FIGURE 1.5 Image of a comfort woman from *The Longest Fourteen Days*. The pages
of the book are rough-cut and dappled with red ink.

FIGURE 1.6 Artificial flicker on *Never Forget*, a website that commemorates the Nanjing Massacre via stagey flourishes.

visually anchored by the image of a man awaiting the sword beneath a barren tree. The photograph is deployed as a blurred sepia background against which the more sharply defined, black-and-white individual shots are overlaid, forming a kind of ground zero against which the catalogue of atrocity unscrolls. This background/foreground relation both analogizes and acts out the capacity of the high-recognition photograph to slip into the place of the event itself as primary reference point for commemorative discourse. This force emanates not just from the notoriety of the image, already long accrued, but from its strategic deployment within the space of authority—the zone of the logo—in a given visual field. Just as the photographic epigraphs wield this power by dint of their prefacing position, *Never Forget* intuitively follows the principles of commercial web design in which logos are frequently used as background images.

This process of logo design also recurs off the page and within the dimensions of museological space. From their first unveilings, the Nanjing Massacre Memorial Hall and the Museum of the War of Chinese People's Resistance Against Japanese Aggression in Beijing gave the photographic record space and prominence. Over time, however, the use repertoire of the archival images has diversified through new curatorial coinages. In some cases, photographs are "exhibited" in the normative sense of the word: laid out behind glass as articles of proof alongside the diaries and water flasks of Japanese soldiers. More

typically, though, the museums favor the image-as-logo, and photo-forms thus predominate over photographic originals. In both museums, hugely magnified photographs are used as a constant frieze-style backdrop for the artifacts encased below. This amplification fuzzes their details, producing a granular effect that turns the familiar images into monochromatic murals, the photographic equivalent of surround sound—or background images on a website— whose power to connote, rather than denote, is signaled by that transition away from the foreground. Mirroring the color-washing of book design, these frescos are sometimes processed with different filters, juxtaposed for contrast. Other exhibits push the photographs further beyond their use-value as proof, often recasting the planar image as a three-dimensional object, such as the sculpture in figure 1.7, which stands outside the entrance to the annex to the Memorial Hall. It repurposes in metal a photograph of a comfort woman so familiar that the shift from iron clad proof to cast-iron sculpture needs, and receives, no glossing.[24] Another variant is a hybrid exhibit that occupies the central space of a hall in the Beijing museum. A ruined wall of rubble is embedded at child-height with a digital screen that is programmed to display, on repeat, the core cache of photographs: bayonetings, decapitated heads, a field of skulls, the killing contest (figure 1.8). This museological curio—What might we call it?—both acts out the labor of repetition that the logo requires in meta-mechanistic style, and shows again how the photographs have exceeded the demands of proof even as the mantra of *tiezheng* is reiterated in exhibitionary space all around them.

Across each iteration, these photo-forms turn the core images into a "visual identity program" intended to elicit reflex response and that operates by analogy. Like the Campbell's Soup can, which once upon a time denoted a grocery item but later came to emblematize the aesthetic of the ready-made, these photographic logos are at once irrevocably coterminous with what they show and also distant enough from it for other meanings to fill the space that analogy opens up. The prescribed meaning here is patriotic personhood, whose duty is to be animated by fury and ressentiment. Its trigger point is humiliation, understood as a turning pivot in time: the beheaded men and raped women must incite anger about the past, but also fervor for a future in which such catastrophic shame can never be inflicted again. There is, of course, nothing new to the notion that the Massacre has special status in China's discourse of "national humiliation" (*guochi* 国耻).[25] But the photographic regime that dominates Massacre memorial and wants to stoke nationalist passion does not—cannot—run on the photographs *per se*. If it could, the images would be deployed in more neutral and circumspect dispositions, as visual evidence

FIGURE 1.7 Statue of comfort women at the Nanjing Massacre Memorial Hall Annex. As a familiar image is reborn in three dimensions, the agony of the victims resists the eternal stasis of the photograph.

FIGURE 1.8 A rolling slideshow of atrocity: an exhibit at the Museum of the War of Chinese People's Resistance Against Japanese Aggression.

感受如何？

| 99 | 29 | 12 | 53 | 5312 | 25 | 9 | 61 |
| 精彩 | 感动 | 搞笑 | 开心 | 愤怒 | 无聊 | 灌水 | 惊讶 |

FIGURE 1.9 Graphic from *Military Affairs Eye*: Japanese war crimes calibrated in emoticons.

alone. Reading their use as an enterprise of logo design, replicable across different formats and platforms, foregrounds the extent to which these photo-forms are intended to act upon their audiences, rather than simply offer themselves up as mild riffs on artifactual history. This process of acting upon seeks to call a reflexive, unreflecting viewer into being. The premise of the logo, after all, is that it can "enable product placement without the need for words," provoking a conditioned response and short-circuiting critical thought (Middleton 2014, 316). I see the logo, therefore I feel patriotic. A visual mapping of the affective aims of logo-making can be seen in an article published in 2014 on the website Military Affairs Eye (*Junqing guanchashi* 军情观察室). Entitled "Photographs of Women in the Nanjing Massacre, Images of the Violence Inflicted by the Japanese on the Women of Nanjing" (*Nanjing datusha funü zhaopian, Rijun dui Nanjing funü baoxing tu* 南京大屠杀妇女照片, 日军对南京妇女暴行图), the piece posts a dozen much-circulated photographs of sexual violence. At the end is an emoticon graphic that asks readers "How do you feel?" (*ganshou ruhe* 感受如何?) and invites them to select from a range of affects ("wonderful," "moved," "happy," "amused," "enraged," "bored," "surprised," "tasteless") (figure 1.9). "Enraged" tops the poll with 5,312 clicks, its nearest competitor ("wonderful") gaining 99.

Whose Logo?

This brings things around to the status of the logo as a hallowed sign and to the fact that these photo-logos mostly carry an official imprimatur. The two main museums that commemorate the Massacre are, of course, government-run; indeed, the initial idea of a Memorial Hall in Nanjing "was clearly the result of

interest in the topic at the highest levels of [the] state" (Denton 2014, 143). The school textbooks that contain graphic images do so with official endorsement; the albums are drawn from state archives, produced in conjunction with the main museums, and compiled by their curators; and numerous accounts of the Massacre are written by historians who are based in public universities, have close ties to the museums, or both. More complex is the state's relationship with websites that commemorate these atrocities. Vastly popular according to their own visitor counters, the Nanjing Massacre portals do not overtly profess their links to the state. Yet Florian Schneider has deconstructed them as components of "an info-web: an archive of vetted, authoritative narratives about the event" that contradict their populist air either by closing down interactive functionality or by manipulating it on the server side (2016a, 2669). Thus the commemoration site Sina.com provides links to pages upon pages of comments, but Schneider shows that these consist of a limited number of posts, copied and pasted thousands of times. The comments themselves stick to a set script of fury, which is further sanctioned by "likes," thus "giving the impression that patriotic outrage is the appropriate response to the already highly pathos-infused content" (2669).

Ultimately, the secret workings of these websites are an indirect reminder that the Chinese state must always operate with one hand tied behind its back, however energetically the other fans the flames of anti-Japanese sentiment, as amity—with its economic benefits—marginally tips the scales over rage. Here again the relationship between photo-forms and secrecy is illuminating. Reflecting on the long-suppressed history of the Massacre, James Reilly has argued that the core agents in converting the atrocities from classified data into patriotic cipher are, in fact, a group he dubs the "history activists," who "teach in mid-sized, province-level normal universities, [though] some have positions in elite universities, city-level universities, or serve as curators of recently established history museums" (2004, 277). These activists are broadly "aligned with the moral rhetoric of the central government" on Japanese atrocities but are discontented with the state's relative pragmatism in its handling of popular response to this violence (285). In reaction, the activists have made a coordinated push toward outreach, and their programs include "field studies with local students, holding public events on key anniversaries, presentations at middle and high schools, creating publicity materials (websites, bulletin boards at universities), writing school textbooks, publishing in popular media sources, and promotion of the researchers' work on television" (280). Or to put this another way, the history activists are combatants against the last vestiges of state secrecy surrounding the Massacre, and

their mission is to draw the event into the most uncompromising kinds of publicness.

It is thus no coincidence that many of the photo-forms described here have been produced by the activists, with Zhu Chengshan as core provocateur. Zhu is former curator of the Nanjing Massacre Memorial Hall, and under his stewardship the museum went from provincial backwater to national landmark. When Zhu took over in 1993, it held 100 exhibits and received 100,000 visitors annually; it now houses 3,300 display objects, and on April 4, 2015, it topped that former yearly tally in a single day when 112,000 visits were recorded. Zhu is candid about his mission: "In 1994 . . . I saw in Hiroshima and Nagasaki that the scale of Japan's commemoration of those lost in the atomic bombings far exceeded what I had imagined . . . It really jolted me, since our victims have never uttered a sound, while Japan—who was the original perpetrator—has gradually taken on the mantle of victim nation. After I returned, I immediately suggested to the relevant provincial and municipal departments that they too should hold solemn ceremonies to remind people that they must not forget history" (Wu Zhenghua 伍正华, Sang Linfeng 桑林峰, and Tian Yawei 田亚威 2015, 17). Zhu does not mention the photographs in this interview, but they lie at the core of his endeavors, from the overwhelming presence of photo-forms in the Memorial Hall to the many photographic publications that have appeared under his editorship and the museum's aegis. Unconstrained by diplomacy, the activists have pressed hard on the photographic archive, generating many of its most graphic, logolike offshoots. But their use of photo-forms also shows that the logo is not just the opposite of secrecy here, but its antagonist. Photographs of raped women and decapitated men, retooled as graphic motivators, militate against the more controlled patriotism favored by the state, as online responses to the images from so-called angry youth (fenqing 愤青) make clear enough.[26] These logos push for a radicalized exposure of what once was hidden, an inversion in which the contents of the crypt are not just outed but aggressively repurposed in order to defy attempts at a more managed kind of disclosure.

Animated Albums

Indeed, to survey Massacre memorial over the past twenty-five years is to gain a sense not merely of the rise of photo-logos but also of their mobile, infiltrating powers. These powers, so visible in the "authorless" spaces of book covers and museum exhibits, also extend into the representational realm. Reilly notes how the history activists have stepped "outside the narrow realm of academia" to engage in outreach and institution-building (2004, 288). Yet their deployment

of the photographic record in a range of creative formats is just as energetic, especially in hybrid texts that sit at the interface between the educative and imaginative modes, such as historical reportage and palm-sized linked picture books (*lianhuanhua* 连环画). A useful case study, written by history activist Sun Zhaiwei, is the reportage work *Nanjing Elegy 1937: An Account of the Massacre of the City by the Japanese Military* (*1937 Nanjing beige: Rijun tucheng lu* 南京悲歌: 日军屠城录, 1995). Sun bills his text as "on-the-spot historical writing" (xiv), distinguishing itself deliberately from straight-up-and-down history, though to call it a photo album remade in different medial matter would be more accurate. The book, like many others about the Massacre, features a small epigraph of canonical photographs, which mold the tone and architecture of the text that follows.

The book is divided into 124 chapters, each approximately four pages long, strung together as loosely linked vignettes. This brevity, methodically regularized, gives the episodes the feel of successive snapshots, reinforced by the fact that each chapter, while connecting up with the whole, is also discrete unto itself in the manner of a photo in an album. Although several of these photo-chapters recall the Nanjing archive in a generalized *déjà vu*, the process of image-text remediation is most direct in Sun's prose renderings of images that appear in the book's epigraph, such as the chapters entitled "Matsui Iwane Enters the City," "Secret Order: Execute All Prisoners of War," "Using Living People for Bayonet Practice," "They Disposed of a Hundred Thousand Corpses," "An Unfortunate Mother and Daughter," and "A Woman's Wretched Fate." These turn specific images in the preface into short textual versions of the photo-logos familiar to readers from other venues. These chapter titles also imitate the terse style of the captions in the epigraph and thus reinforce the album-like look of the text, as does their lack of contextualizing material (dates and names are almost always missing). Above all, *Nanjing Elegy* promotes the photographic record as an animated, animating force. The book favors a lively style, sped along by free indirect speech, plentiful dialogue, present-tense narration, and suspense tactics that imply that the outcome of history still hangs in the balance. But it is the ekphrastic summoning up of the photographs just glimpsed that, more than any other narrative feature, gives the text its immediacy and "on the spot" feel.

The photographic record serves a similar function in the picture book *Azuma Shirô Atones for His Sins* (*Dong Shilang xiezui* 东史郎谢罪), scripted by Zhu Chengshan and illustrated by a team of artists (2002a).[27] This volume, which recounts the crimes and later contrition of one of Japan's best-known veterans, begins with simple black-and-white sketches of Azuma's early life,

but when the timeline reaches 1931, photographs of the Mukden Incident appear, sized to match the sketches in collage form. Graphic drawings of the canonical photographs from 1937 onward leap from the page at neatly paced intervals: the bayoneting of trussed-up victims; Japanese soldiers surveying the bloodshed; bodies of the dead piled up; scenes of riverside carnage; beheadings by samurai sword; female nudity and sexual violence. Some of the pictures look like mimeographed copies of the original images, but as more pages turn, the two media begin to merge, with reproductions of photographs superimposed on sketches that are themselves copies of stills from the archive. Azuma's diary entries, meanwhile, are condensed into snappy "captions" that run along the bottom of each page. As before, the text refashions its host medium—the graphic novel, this time—into a quasi-album, attesting again to the plasticity of the photographic image, which readily enters and recasts other forms of medial space.

But the picture book also "logoizes" the archive. On page after page, it performs pictorial sleights of hand with the original photographs, trimming them of detail and contouring their visual data in ways similar to the branding strategies of book design. Taking this process a stage further, the artists turn repeatedly to standbys of the graphic tradition in order to propel the images out of stasis. Some drawings use dramatically angled viewpoints—overhead, from below, oblique, tilted, even shifting—to transform the head-on, fixed-viewpoint perspective of the photographs into a more kinetic image. Others substitute a single vanishing point with several perspective possibilities to keep the eye engaged. These angled viewpoints are mirrored by strong diagonals, which pull the gaze deeper into the image. Violent action in the foreground is thrown into relief by pared-down backgrounds; figures are cropped or cross-hatched to generate verve; sweeping lines show rapid movement; jagged outlines and bold capitals mark explosions of force; trajectories of blood and bullets are tracked in midair; exaggerated facial grimaces signal terror or bloodlust. While sticking close to the photographic canon of atrocity, *Azuma Shirô Atones for His Sins* (and other graphic novels like it) mobilize the photologos, lending them an agility that is utterly at odds with the fixities of "ironclad proof."[28]

Camera Works

As if in direct reply to this point, Sun Zhaiwei writes in his preface to *Nanjing Elegy* that "recondite academic research is no substitute for the popular dissemination of patriotism" (1995, xiv), a statement seldom truer than when

applied to the photographic record, which has been hitched relentlessly to the patriotic machine. The forays into creative formats that history activists have made, and their self-professed identity as "Massacre specialists" or "Keepers of the Flame," have come under fire, mostly because their passion has sometimes led them to play fast and loose with conventional historiography.[29] Yet other, stronger grounds exist for critique. As the makers of photo-logos, the activists have been instrumental in creating a stage for Massacre memorial that is patterned starkly with the acts and postures of affliction. Indeed, the "animated albums" show not simply that the atrocious image can pervade other kinds of medial space, but that the logic of the logo ensures it will. Designed to generate synaptic rage, the more telling impact of the photo-logos may actually lie in the way that they close down or short-circuit more varied kinds of imaginative response. Once seen, their force is such that it arrogates the visuality of the Massacre to itself; it is difficult to see and think beyond the mutilation of bodies and the ultra-violence of those who perpetrate. The photo-logos may or may not generate reflex rage, but it is surely unarguable that they have produced an optic for the Nanjing Massacre that is overwhelmingly lens-based.

The effects of this camera vision are plain to see in fictional, cinematic, and painterly representations of the Massacre. These, it should be noted immediately, remain rare in China, though their number has been slowly increasing. Michael Berry observes that "fewer than a dozen novels reflecting the Nanjing atrocity have been published" (2008, 112), several of which are written by non-Chinese and published outside China; filmic treatments run to about two-thirds of that small total. Berry draws the inevitable, but no less instructive, analogy with the Holocaust, which lives in richly varied ways across culture. Aesthetic representations of the Massacre tend, by contrast, to dwell within the shadow of the photographic archive, whose iconographic pull takes two main forms. The first is the use of photographers, film, cameras, and photography shops as plot devices, a pattern that recurs across a range of different texts. In films such as Luo Guanqun's *Bloody Evidence* and Zheng Fangnan's 郑方南 *Qixiasi Temple, 1937* (*Qixiasi* 栖霞寺 *1937*, 2005); in Xu Zhigeng's 徐志耕 reportage work *The Nanjing Massacre* (*Nanjing datusha*, 2014); and in *EyeWitness* (*Jianzhengzhe* 见证者, 2002), a video game created by the Multimedia Innovation Center of the Hong Kong Polytechnic University (for which Zhu Chengshan served as a consultant), characters are evidence gatherers, documentary makers, photojournalists, and darkroom technicians. In the name of proof and patriotism, they track down lost films, develop incriminating evidence, smuggle images abroad, and get behind the lens themselves.[30]

The other form is reproductions of specific photographs within other kinds of visual space: the archive in the image, as it were. Luo Guanqun's *Bloody Evidence* intercuts its cinematic text with canonical photographs, as does Mou Dunfei's 牟敦芾 notorious banned film *Black Sun: The Nanjing Massacre* (*Hei taiyang: Nanjing datusha* 黑太阳: 南京大屠杀, 1994). In Mou's case, this urge runs amok. The original DVD case is emblazoned, once again, with the photograph of the man beneath the tree, and its "extra features" section contains a gallery of another thirty-two canonical photographs. The film itself converts this gallery into moving celluloid montage: Mou's signature flourish is to shoot a scene of rape or murder that culminates in the precise restaging of a specific photograph before cutting self-reflexively to the photograph itself for comparison (Berry 2008, 126). That same image of the man beneath the tree also appears in the promotional material for Lu Chuan's *City of Life and Death* (*Nanjing! Nanjing!* 南京! 南京!, 2009). Painter Li Zijian's series in oils on the atrocities, entitled *Nanjing Massacre: Slaughter, Rebirth, Buddha* (*Nanjing datusha: tu-sheng-fo* 南京大屠杀: 屠· 生· 佛), takes this process further.

Li has painted the Nanjing Massacre three times since 1991, on canvases that have become steadily distended in size and scale: the most recent version measures 4.25 meters by 3.15 meters. The upper background of the canvas is brush-stroked in black and white in a first nod to the painting's origins in the photographic record, a citation that gets bolder with the chromatic figures in the foreground. These are painted avatars for several of the most canonical images in the archive, welded together to form a medley in vibrant oils: the killing fields in Nanjing, the pair of Japanese soldiers surveying the scene, the bared female torsos and decapitated heads.[31] The overall effect is *déjà vu* on repeat, a reprise of the photographically familiar that unfurls again and again as the eye travels the canvas. This motif of repetition is also writ large in Li Zijian's re-versionings of his own work across the series and by its regular exhibition across China, which makes these reiterations itinerant, reinforcing the theme of repeat through space and time.[32] Li Zijian hardly belongs on the roster of China's top contemporary artists, yet his series on the Nanjing Massacre is arguably one of the most viewed canvases in Chinese history. The 1991 painting hangs in the Nanjing Massacre Memorial Hall, a museum that was visited by 8 million people in 2014 alone. Another is on permanent display at the National Museum of China, which recorded 7.5 million visits in 2013; and as it traveled the series has taken in uncounted spectators in the tens of thousands. This abundant spectatorship matters not just because the series is touted (often by history activists) as a crucible for patriotic passions.[33] More to the point, and like so many of the works discussed already, *Nanjing Massacre* is also marked

FIGURES 1.10–1.13 Handwritten homework assignments on the Nanjing Massacre by primary school pupils. The routine incorporation of ultra-violent photographs strikes an unsettling note.

by an extreme candor, as schematized victimhood and iterative violence are made the objects of official public display.

This candor begins to make sense only when we see it as the curious off-spring of the state secrecy in which the Massacre once lay. In particular, the mission to end secrecy has led not just to the new publicness of the atrocities but to the abandonment of the propriety of concealment. Thus while the Memorial Hall once shrouded the most violent photographs in black cloth during school visits, it is now routine to observe young children viewing images of rape and murder, and on the rare occasions when photographic exhibits have been removed because of their "improper" character—as happened in 2009—this was done at the behest of Japanese political activists, not local Chinese agitation (Hiranuma 2009, 2–3). Indeed, although the question of whether primary school children should be taught the Massacre is periodically aired in official media and a cautious, humanitarian approach is counseled,[34] other evidence points toward a less inhibited pedagogical practice.[35] Offshoots of this kind of candor are visible in figure 1.10, which shows a handwritten assignment (*shouchaobao* 手抄报) produced by a primary school student, posted on the teaching website *Thinking Carefully about Education* (*Sansi jiaoyuwang* 三思教育网) as part of a feature on teaching the Massacre. The brightly colored childish script sits alongside two photographs of live burial, jarring in its contrast. Further examples of these primary school photo-forms, melding other canonical photographs of atrocity with primary school art, can be found on the image-sharing site Qushouji.com (figures 1.11–1.13); figure 1.13 includes a screenshot of Li Zijian's painting, thus layering up the sense of photographic remediation.[36]

No Caption Needed

Ironically, this loss of propriety shows the extent to which the photographic archive of the Massacre remains confined within the shackles of secrecy, though not the kind that requires encryption. This is evident in the way that the dark provenance of these images is finessed in their venues of display. As Susan Crane has noted, the glib use of photographs as historical props—"sans captions, sans credits, sans textual references to figure" (2008, 324)—is commonplace everywhere, mostly because concrete information about the originals is often hard to come by. But the missing backstory can also be a strategy of silencing or concealment. Crane cites the example of a scholar who met a "skeptical, irritated response" when she asked an archivist about the source of a Holocaust image, as if what such photographs show is so eloquently

self-explanatory, and so always already familiar, that to request details of person and place is pedantic, or worse (325). The Massacre photographs appear with either tersely descriptive (as opposed to factually informative) captions or, more commonly, with no captioning at all, a custom that has regrettably left the field of provenance wide open for the Japanese revisionists. In China, meanwhile, the photographs sit uneasily between foul fame and a peculiar obscurity: they are known to millions, but their victims live on in an indefinite anonymity that ultimately fosters disidentification. Long kept out of view, they now hide in plain sight, so excessively visible in their mutilated body parts that the eye and mind struggle to register their personhood. To an extent, this is because there is no way of knowing the "who." But in the absence of names, it is surely all the more salutary to be reminded that most of these photographs are grotesque trophies of war, and that their place within the iconography of commemoration is, for that reason, highly fraught.

To put this more bluntly: What does it mean to incite patriotic response from perpetrator images that do not simply show war crimes but are also war crimes themselves, photochemical residues of what Ernst Jünger once called a "peculiar way of seeing" (2008, 39)? As Susan Sontag put it, "to display the dead is, after all, what the enemy does" (2004, 57), and in one sense, the photo-logos can be charged with interpellating their mostly Chinese viewers into precisely that subject position. But as Bernd Hüppauf has argued, radicalizing Sontag, perpetrator photographs go further, exemplifying the camera apparatus at its full technogenetical potential, capable of annihilating the rapport between spectator and victim in ways that are physiological as much as psychological. As he observes:

> A Freudian reading of these photos as the realization of sadism and voyeurism . . . [reduces] them to documents of individual pathologies and offers little insight into problems of a photo-history . . . Lifting the camera, looking for an appropriate angle, setting the shutter speed, determining the distance etc. kept eyes and minds occupied with the technical aspects of documenting . . . Their ways of seeing . . . transformed the eye into a neutral instrument for registering movements . . . It is the atmosphere of shouting, hectic activity, distorted body movements, corporeal signs of ultimate degradation, gestures of force and hysteria together with the all-pervasive emptiness of [this] gaze from nowhere that is the common denominator of this photography. (1997, 28–34)

What Hüppauf calls the "problems of a photo-history" refer to the process whereby both the eye behind the viewfinder and the eye that looks on the

photograph "harden in analogy to the camera lens" (33). The peril of viewing such images, then, is not that the spectator becomes one with the "I" of the perpetrator but rather with the glassy "eye" of the camera, which "captures the flying bullet as well as the human being at the moment when he is torn to pieces by an explosion" (Jünger 2008, 39).

Yet the problem with the Nanjing Massacre and its photographic after-lives is not merely that repurposing perpetrator images has become common practice, despite these ethical dilemmas. Still more at issue is the fact that the origin of these images in a violent viewfinder is a matter of simple common sense, if not common knowledge. The circulation of unattributed war pornography retooled as patriotic propaganda logos might be called, in this sense, an instance of the open secret, in which a truth not just obvious and awkward, but humanistically compromising, is hustled through silence into something like acceptability. To date, a robust discourse on the uses of the atrocity photographs has yet to emerge in China, and what scant debate there is lies low in private conversation or the interstices of social media sites.[37] Whether these questions are left unasked or posed without enough vigor to break the surface of public debate, they struggle for speech because to query—and to look away—is behaviorally "unpatriotic" within a commemorative discourse that has made the images coterminous with nationalism.[38] Like the dreadful but unspoken origins of some of these photographs, the dearth of discussion on their fitness for open display is a form of silence structured by the unsayable, which becomes normative over time. If the logo is the very opposite of the secret as a socially segregating force, one that seeks to unify through mass recognition, then these new silences that the photo-logos impose underline still further the close but antithetical relationship between the two. Sculpting the shape of memorial so that a few atrocious images flash before the eye again and again in places where the Nanjing Massacre is remembered, the logic of the photo-logo is coercive: it drives contrary or disunified views into mute-ness, creating a situation where, as Daqing Yang puts it, the Chinese seem "to be speaking in unison" (2001, 51).[39] Just as the Massacre during its classified years was an event that divided people into those who knew and those who didn't, so does its commemoration now seek to produce a vision of the atrocities that unifies precisely because it is singular and delimited.

An inverse permutation of this occurred during the 2006 controversy over the Visualizing Cultures web project at the Massachusetts Institute of Technology, when Chinese students at the university reacted with fury to the inclusion in the site's pedagogical materials of a woodblock print that showed a Japanese soldier decapitating a Chinese prisoner. Ironically enough, the students objected

in large part to what they perceived as a lack of captioning, and they demanded that the image be put in its "proper historical context" with "accessible explanations" (Chinese Students and Scholars Association 2006). William Callahan notes some anomalies in play here: "Although they might unproblematically consume the 'war porn' of the Nanjing Massacre albums at home in China, when abroad some felt that it was their duty to assert control over images of ethnic Chinese people" (2015, 137). This duty of control, one might add, stems more specifically from the status of images of Sino-Japanese atrocity as logos within the local patriotic regimen, since the logo, as the brand's epitomizing sign, is subject to the protectionism of "copyright": my logo, not yours. More than this, crying foul at so-called scrappy captioning outside China testifies still further to my earlier point that the absence of "proper historical context" for the images inside China is not an oversight but rather a considered strategy of silencing, as appropriate contextualization of the kind demanded of MIT would render the images unfit for the uses to which they are put domestically. We might even speculate, in this sense, that the students' fury might be a mechanism of displacement, which vents itself via proxy in places where the secret does not rule.

The Unlookable

This notion of displacement brings matters closer to the nub. What lies still deeper within this structure of the unsayable is the relationship between the rigid semiotic regime of the photo-logos and the Massacre as a trauma that, for all its unflinching visuality, remains in some senses hidden and untreated. It is worth recalling here that the viewing of atrocity photographs—pre-logo, pre-remediation even—has been taken for some time now as a troubled form of spectatorship by many (though not all) who work in trauma studies. In part, this is a reaction to what Barbie Zelizer calls "photography's triumph" (1998, 140), to the fact that mass media circuits, in tandem with their own expansion, are now awash with this image-making, from conflicts old and new. The coincidence of this bloated circulation with what many scholars see as a waning of political will has sharpened the fear that such images change little and may even obviate action. At worst, they are themselves the instruments through which torture is inflicted, as in the humiliating photographs of internees taken by military guards at Abu Ghraib. Yet even when they "merely" appall, the horror such photography provokes is mostly hopeless and defeated. People look, then look away, even as the glut of these images in ambient media extends the limits of the legitimate ever outward in what Zelizer refers to as "atrocity's normalization" (212). To an extent, this is an effect of photography's reductionism,

which crystallizes history into the singular still, blocking other lines of sight and feeling; or as Kracauer complained, "it is not the person who appears in his or her photograph, but the sum of what can be deducted from him or her" (1993, 431). Photographs are, of course, called "stills" for a reason, and when their subject is atrocity, this can be a dangerous kind of arrest. Trapping atrocity in aspic, as photographs do, delimits even as it pretends to explicate, as the stasis of the still combines with the verisimilitude of what it "shows" to produce a deceptively full and final understanding. Writing on the Holocaust, Ulrich Baer calls this the "mass-produced sublime," and his riposte to it is to reject all direct images of the Nazi genocide (2005, 77).

Photographic representation of trauma—the very notion of the photo-form— is also disquieting for some, and for related reasons. Roger Luckhurst summarizes these as "the familiar rhetoric that trauma can only be represented by foregrounding impossibility and aporia" (2008, 163). At issue here is experiential knowledge and the limits of its communicability, or as Vera Schwarcz puts it, "trauma . . . is defined by its assault upon the conventional structures of knowing. The more extreme the anguish, the fewer the resources for translating it into conveyable discourse" (2002, 200). It is for this reason that scholars of trauma have routinely argued that forms of representation shine the most lambent kind of light on trauma when they approach it from odd angles, through a cracked glass, in its shadowy corners, off-screen entirely. The photo-form, with the presumptions of indexicality that still cling to it—however theoretically untenable they have been shown to be—always risks being the anti-apotheosis of this aesthetic of the indirect. This aesthetic reaches a high-water mark in the work of Alfredo Jaar, particularly a photo-essay cowritten with David Levi Strauss entitled "The Lament of Images" (2012). The work consists of six plain black spaces, eight centimeters by just over twelve centimeters, arranged verso to recto in three pairs. Beneath each "photograph" is a body of text describing what the blank black spaces do not show. One reads: "Autopsy image of an Afghan prisoner who died in the custody of military contractors, showing rope burns on his body and a cross cut into his scalp" (280). The photo-essay clearly repudiates the photochemical cast that has tinged contemporary consciousness of traumatic experience. It is an attempt to reclaim that experience from the vortex of the lens: an anti-photo-form, by any other name.

Jaar and Strauss's work also lies as far from the logo within the field of the visual as an image could presumably reach. It returns atrocity not just to the darkroom and the moment before the photograph is lifted from the acid, but to the realm of the secret. As such, it makes an unsettling comparator for the commemorative discourse of the Nanjing Massacre. After all, the photographic

record of the atrocities as it is deployed in China today does not merely flout the norms and forms of respectful traumatic representation as these have been laid down in (mostly) Anglophone scholarship, but it actually undertakes the reverse journey from that traveled by Jaar and Strauss in their lament: from the secret to the logo, from taboo to totem. In one sense, it is impossible not to lament, once again, these opposite trajectories. But in speaking allusively to the link between secrecy, trauma, and the photographic image, Jaar and Strauss also shed another kind of sideways light on the photo-logos of atrocity. Just as this "visual identity program" cannot be untangled from the toils of the secrecy that the Massacre once was, so too are the photo-logos indissociable from the still more intractable problem of trauma-as-secrecy.

In their work on post-traumatic stress disorder (PTSD) among survivors of Japanese wartime atrocities, Zhang Lianhong 张连红 (2003, 2006, 2007) and Zhang Sheng 张胜 (2009) have shown that these trauma victims received no psychotherapeutic care whatsoever, despite in some cases displaying on national television the scars left on their bodies by Japanese bayonets.[40] Indeed, PTSD as a field of enquiry in China is at least as belated as the Nanjing Massacre revival itself. To display the scars of physical wounds on TV while suffering decades of psychotherapeutic neglect becomes, in this sense, a lived analog for the regime of the photo-form, which showcases mutilation on repeat as part of a specific strategy of avoidance. As Perry Link has put it, "in 1937 something so grossly ugly and humiliating as the Nanking Massacre seemed to Chinese sensibility so profoundly wrong . . . that . . . in a sense it deserved only to be ignored" (Link 2002, xiv). Now, of course, the Massacre's days of being ignored are long gone, but its ugliness and humiliation, thanks to the photo-logos which show these things so starkly, are in some senses still as unowned as ever. In part, this is because they corporalize the victims so schematically that they are dehumanized, so that the ugliness and humiliation are "othered" with them. But it is also because the photo-logos lock the uncontainably traumatic import of the Massacre within a new space of confinement, one that is all too accessible wherever the atrocities are remembered but whose operations, in their relentless repetition, mimic the experience of traumatic return and thus render the event itself more inaccessible, more secret, than ever.

No Ghosts Here

Small wonder that one of the few creative works that really envisions the Nanjing Massacre differently—Ye Zhaoyan's 叶兆言 novel *1937: A Love Story* (*Yijiusanqi nian de aiqing* 一九三七年的爱情, 1996)—stops just before the

atrocities begin. Indeed, the text's status as a prequel is an oblique commentary on the force field of the photo-logos and on the distance from it that may have to open up before new imaginative work can occur. But what about the limit event itself and the possibilities for its representation in a commemorative landscape overshadowed by the photo-logos? More particularly, what of the spectrality that so often surfaces in aesthetic works that seek a reckoning with trauma? Given the ever-presence of the specter as a metaphor within trauma studies over many years now—Luckhurst calls the traumatic ghost "almost a cliché" (2008, 93)—its absence from the discussion so far might seem counterintuitive. Because "haunting, unlike trauma, is distinctive for producing a something-to-be-done" (Gordon 1997, xvi), one might argue that the Massacre, as a locked-in event, *needs* its spectral figures and the in-betweenness they make incarnate. It needs, in the Derridean sense, to start living with its ghosts. Yet rather than being truly absent, spectrality is Banquo's ghost in China's copious but narrow discourse on the Massacre, awkward in its (dis)appearances. This is because even when—especially when—spectrality is invoked within Massacre memorial, the deep structure of the logo can make its operations too overt for the difficult work of haunting. This is evident in the Nanjing Massacre Memorial Hall: part museum, part mausoleum, its graveled gardens contain a mass grave pit filled with bones, which turn the photographic murals mentioned earlier into spirits rising from the ground. The exhibits are powerful, but they are spectral more in letter than in spirit.

Ultimately, future representations of the Massacre may need to meditate not only on the untreated trauma that lies hidden beneath the logos/scars of atrocity, but also on that visual regime itself and the role it has played in turning classified objects into a patriotic sign system that remains riven by the distortions of the unsayable. Such a meditation would, I think, need both to acknowledge and then to look beyond the photographic record, because to bypass it entirely, as Ye Zhaoyan does, is to leave too much in the darkroom within which such a portion of this legacy has developed. It would also need to move beyond the whispering walls and open tombs of the Nanjing Massacre Memorial Hall and seek a mode of address for the ghosts who have been exorcised from the commemorative discourse: not the spirits of the dead, but the spectral figures who might shadowbox with the Massacre as a history in and of the photographic image. Lu Chuan's *City of Life and Death* suggests a move in this direction. Both lauded and maligned on political grounds, the film is also about the photographic record, though few have read it as such, despite many obvious signs. Lu prepared carefully for the film, which was four years in the making, borrowing what he needed from Fan Jianchuan 樊建川, founder of

the Jianchuan Museum cluster, in order to create "realness" on set. Fan loaned service uniforms, military swords, telescopes, even dinner sets (Li Fang 李舫 2009). When interviewed about his preparations for filming, Lu stated that "even the actors playing war prisoners were chosen according to pictures of the victims" (Tang 2009).

This quest for "truthful images" has led to comparisons with Spielberg, especially in his combat choreography, whose immediacy—something quite new for Chinese audiences at the time—recalls Spielberg's renderings of the D-Day landings in *Saving Private Ryan*.[41] The amputees cast as injured servicemen, the drops of blood that fall on the lens of the handheld cameras and lie there unwiped, the decision to allow normal production values to tumble off a cliff— all these pitched viewers of Spielberg's film into the thick of combat, with no way out for a full twenty-six minutes. "I did everything I could to my camera to get June 6, [19]44 to look like Bob Capa's photographs," said Spielberg in interviews (Kuper 2013). And Lu Chuan does everything he can to his camera to make December 1937 look like—what, exactly? Robert Capa's photographs at Omaha beachhead, Spielberg's remediation of those images, the black-and-white look of *Schindler's List*, the Nanjing Massacre photographic archive, or something in-between? Whatever the answer, this composite layering gives the cinematic image in *City of Life and Death* a multiply exposed feel. Indeed, the *hintergrund* presence of Capa's photographs even recalls spirit photography, as war dead from an as-yet-unfought battle hover like revenants from the future over Lu Chuan's 1937. "Realness" here is photographically derived, a point that becomes overwhelming as the film repurposes one canonical image after another in its crystalline monochrome. In interviews, Lu Chuan has stated that the film was shot in black and white to dull the color of the bloodshed (Smith 2011). But the choice of stock also means that the leitmotifs of the photo-logos stand out as such all the more vividly.

Dying Twice

The most vivid is the man awaiting decapitation beneath the tree, who is finally made flesh as the heroic resistance fighter Lu Jianxiong 陆剑雄 in *City of Life and Death*, put to the sword by the sadistic Japanese commander Ida Osamu 伊田修. Yet Lu, it would seem, dies twice. Online searches for him, and for the film in general, turn up several screenshots of the scene, which show him kneeling on the ground, Ida's sword poised. But in the film as it was eventually released, Lu dies by gunfire along with several hundred others at a mass execution site, an anomaly that Lu Chuan has attributed to the de-

mands of government censors, who found the beheading scene too politically provocative and insisted on its deletion (Wong 2009). Yet unlike Lu Jianxiong and his double demise, the screenshots live on in cyberspace, more memorable as they rise like apparitions from the cutting room floor than the more "acceptable" death scene that made the final edit, functioning on the symbolic plane as a kind of found-footage version of the never-traced lantern slide of Japanese soldiers beheading a Chinese spy that made Lu Xun give up medicine for literature a hundred years before.[42] Indeed, it is this never-screened scene of decapitation that was printed on the back of a hoodie sold in 2016 by Nordstrom Rack, which discontinued the item after a Facebook uproar started by Chinese users living in the U.S. (figure 1.14). Lu Jianxiong himself was cropped out of the image and thus made still more spectral (Linder 2018).

The haunting powers of the decapitation scene asserted themselves via another sartorial furor that flared up online in the summer of 2016. Weibo trends for the term "Nanjing Massacre" across that year reveal a sudden spike in July, not for the anniversary of the Marco Polo Incident on July 7, as we might expect, but on the more historically innocuous date of July 17. On this day, a Japanese YouTube star and professional "competitive eater" named Kinoshita Yûka 木下ゆうか livestreamed a performance of herself eating huge quantities of rice while wearing a T-shirt bearing the blurry black-and-white image of a decapitation scene, in which swordsman and victim were surrounded by a crowd of impassive spectators (figure 1.15). In China, where Kinoshita has a significant profile despite YouTube's blocked status, online protest exploded: the T-shirt was taken as a provocative slur on Massacre memory, and Kinoshita became a target of web rage.[43] Closer inspection revealed, however, that the T-shirt actually showed artwork by the American underground cartoonist John Holstrom: the atrocities at Nanjing were nowhere. As such, the incident showed that the equivalence of decapitation/motionless bystanders/the Japanese humiliation of China is now so hardwired thanks to the labor of photologos that this pictorial template has become ripe for misrecognition. It incites the seeing of ghosts where none exist, even as the kind of spectral figures that might do justice to the dead remain difficult to find.

It is in this context that the online apparitions of Lu Jianxiong take on a telling shape. On the surface, the wiping of his execution scene revisits some familiar terrain: the state censoring of the man as a global cinematic image when his other iterations are omnipresent in local Massacre memorial, and the rage from Chinese abroad about the violation of "copyright." But something else is also at work here. As the image of the man works the hinge between censored object and propaganda, between secrecy and exposure, it also performs that

FIGURE 1.14
Nordstrom hoodie
showing the deleted
scene from *City of Life
and Death*. All eyes in
the image are "blind-
folded" in red, courtesy
of Photoshop, in phony
acknowledgment that
war trauma exceeds the
realm of the visual.

FIGURE 1.15 Kinoshita Yûka's controversial broadcast. What W. G. Sebald calls the "pre-formed images already imprinted on our brains" trump what the eye actually sees, causing an online storm.

harder work of haunting I mentioned a moment ago. Not a revenant of the event itself but rather of its legacy as a media ecology rooted in the photographic record, this scene of decapitation that played in no cinema—the logo that was returned to secrecy but then broke cover again in online spaces—is the ghost finally escaping from the machine. Even if Lu Chuan did not intend this outcome, the deleted scene, by registering its simultaneous status as both logo and secret, creates a space within which the dialectical forces that have structured the passing of this event into history can be acknowledged. It can do this because of the excess of spectrality that the scene produces: Lu Jianxiong, the man who dies twice, is a ghost twice over, too, and as his image is retrieved by web searches or cropped from sweatshirts, its spectral character becomes the means through which the visual legacy of the Nanjing Massacre can at last emerge as a subject of representation in its own right. This is not the same as a reckoning with the event itself. But any such aesthetic encounter, if it is even possible, will remain in perpetual deferral so long as the visual regime, the Massacre in and as the photographic image, is merely the object of spectatorship rather than analysis.

×

× 2

×

KEEPING IT IN THE FAMILY

Now is the time to use words to interpret old photographs: those momentary figures frozen in the frame often contain messages and inner meanings that are hard to measure. And it seems that when we begin to speak there is no end to it.
—WANG JIAMING 王家明, *Old Photographs*, 1996

Privacy Issues

What is more redolent of memory than a family photograph album? Or rather, what *was* more redolent, since the practice of archiving and displaying such images has now mostly moved online and in the process shrugged off many of its mnemonic duties. But not so long ago, the dusty tangibility of the album betokened memory in an almost metonymic sense: what the Coca Cola bottle was to high capitalism, the family album was to the remembrance of things past. If, as Barthes observed, "the nature of the photograph is not to represent but to memorialize" (1978, 194), then the photograph album was the most important of the *ars memoriae* in domestic space, the touchstone, kept on the bookcase or tucked away in the drawer, that made remembrance flow. Indeed, if there were any resonance evoked by the family album as potent as that of memory, it must surely be the notion of privacy. Once upon a time, the family album enjoyed the narrowest circle of address, as what it contained was both too banal and at the same time too intimate to spread abroad. Within a long-established print media world, the family album harked back to the days of manuscript culture, when precious items circulated among friendly hands that knew their value, rather than needing privacy settings as they are dispatched into the ether. Ultimately, it is only to be expected that just as the family album

as a material art and practice is disappearing under digitality, so, too, are the memory functions it performed and the privacy it enshrined. These, though, are recent changes. In 1980s China, perhaps more than in many other places, family photographs were still tied in definitional ways to memory and privacy.

This is what makes a little-discussed but remarkably influential book by the veteran Chinese writer Liu Xinwu, entitled *My Private Photograph Album* (*Siren zhaoxiangbu* 私人照相簿), and first published in 1988, so counterintuitive a text. From its very opening pages, it moves directly against the grain of both memory and privacy. The book anthologizes ten essays that Liu wrote for a special column in the leading literary journal *Harvest* (*Shouhuo* 收获) during 1986–87,[1] in which photographs of both his own wider family and the families of others are set to words,[2] creating a genre of informal photo-text that was entirely new to China at that time (Zi 1998, 33).[3] These photo-essays are ruminative in style as they string together the stories of past people and places. Yet "memory," either specifically as a term or more abstractly as an impulse or effect, is mostly missing both from the book proper and from the two prefaces that Liu wrote for its different editions. Its place as presiding keyword is taken by another word: "information" (*xiaoxi* 消息). On one level, of course, these stories are inarguably the stuff of memory—how could they be otherwise, since they delve so subjectively into the past? So why does Liu Xinwu restyle them as sources of information? In some cases, the reason is simply that the old photographs are, indeed, straightforwardly informative, delivering up facts about the "fashions, utensils, toys, marriage and funerary customs, or housing" (Liu Xinwu 2012, 20) of China's Republican era, for example. But more commonly—compulsively, in fact—Liu's photo-essays are drawn toward the Maoist period, and the Cultural Revolution in particular. Here, "information" acquires a different slant. It comes to denote instead the lost and invisible stories of the people in the frame: all, in other words, that the photograph does *not* show and that the surrounding text takes it upon itself to disclose.

This brings things round to the other way in which Liu's book confounds obvious expectation. It may expressly call itself a "private album," but it does so only to signal the fact that its real mission is, in fact, publicity and an end to the long state of privacy—secrecy, even—in which the images had previously existed. As Nicole Huang has noted, there was an art to keeping family photography hidden during the Cultural Revolution: these treasured things were often concealed in "worn manila envelopes that bore the red printed characters of work units" or were tucked away in pay packets to avoid detection (2010, 685). So it is telling that many of the 167 photographs in *My Private Photograph Album* do not even belong to Liu and his family, and that some of these im-

ages were also reproduced without permission. Liu admits that readers have grilled him about privacy as a point of ethics. One writes to him asking, "If you value the right to individual privacy, how could you have brought out *My Private Photograph Album*?" His answer is that "respecting the right to privacy is the absolute premise" of the book (Liu Xinwu 2012, 3). The photographs of his family he revealed "by choice" (even though Liu's own face never features), and those of others were "obtained with the trust, understanding, and willingness of their owners" wherever possible. Where not, he has "taken the utmost care to avoid secondary repercussions" (3). This equivocal response does little to dispel an incipient sense, which only grows as the photo-essays progress, that Liu is committed to what is effectively a counterprivacy agenda. By this, I mean not that the volume intends a reckless violation of personal privacy, even if it crosses the line on occasion. Rather, its purpose is to assert the value of small-scale, vernacular disclosure within a social environment that might be called the "cryptosphere," a term that denotes the experience of living with secrecy as well as under it, as suggested by the more familiar term "cryptocracy." Despite Liu's apologia, it is the renunciation of privacy, not its maintenance, that becomes the ethical move here, because to surrender up one's own stories is to cut through the suffocating air of the clandestine.[4]

In his first preface to the book, Liu Xinwu describes China as a nation "full of denunciations written in tears and blood, but sorely lacking in confessions" (2012, 3). This knotted relationship between denunciation and confession is unspun in the following lines, as Liu closes in on what he really means: "On the one hand, in our social life we neither understand nor are skilled at respecting individual privacy; and on the other hand, in our art and literature we neither understand nor are skilled at revealing the most secret things in the depths of our hearts. These two aspects often work in conjunction to construct a particular human environment. *My Private Photograph Album* emerged from the severe dejection caused by this human environment" (3). Keeping secrets is a state of mind—a practice of the everyday—in China, Liu suggests, without specifying any particular cover-up or covert behavior. It is as generalized as the surveilling drive—the lack of respect for individual privacy—that is its alter ego. What Liu describes here is not the stringent state censorship of the June 4 protests (chapter 4), nor the elite closing of ranks, the circling of the caravans around a secret broadly suspected, that we see in the case of schoolteacher Bian Zhongyun and her killers (chapter 3). Instead, the condition sketched out above has a saturating ambient character, which is why Liu Xinwu chooses the term "human environment" to name it, and why this "human environment," through its ubiquity, can cause such "severe dejection." Elsewhere he

uses the term *kuailei* 块垒, which straddles both indignation and depression, to describe its long-term effects.

Liu uses the expression "human environment" in vague, atemporal ways in the passage quoted above, but so many of the stories he tells loop back to the Maoist era, and the Cultural Revolution in particular, that the role of this period in shaping the cryptosphere is never in doubt. Of the periods I discuss in this book, high Maoism is the era into which the field of secrecy studies has made the greatest inroads (even if that new disciplinary approach is not named as such). Surveillance, public exposure, self-confession, house-searching, samizdat circulation, gossip, slander, and informal espionage—what Derrida calls "all the semantics of the secret" (Derrida and Ferraris 2001, 75)—were so routine, yet often so spectacular, that this academic notice is only to be expected. Interestingly, though, scholarship has focused either on the aggressive attrition of the private realm (especially the intrusions of the Red Guards into family life) or on specific types of behavior (secretly reading "forbidden books" or gathering confidential data about citizens in state dossiers).[5] The cryptosphere itself, as an integrated social space within which these different practices meshed as mutually constitutive elements, or what Liu Xinwu describes as the "human environment" and its affliction, still awaits an extended treatment.

Liu's book does not task itself with that historical labor, however. Rather, his photo-essays circle back to the Cultural Revolution because their real "absolute premise" is that the cryptosphere which took shape during that time still lingered on into the mid-1980s—when Liu was writing—and beyond. Rather like postsocialism itself, which Michel Hockx usefully defines as a condition in which "socialist institutions such as state planning, collective work units, guaranteed job allocation, housing distribution, free health care, and fixed pricing have all disappeared but residual socialist mentalities, sensibilities, and hierarchies continue to impact on people's behavior" (2015, 2), the mind-set and mores of the Maoist cryptosphere did not cleanly evaporate with the dawn of the reform era and China's new "information age."[6] And this enduring afterlife of the cryptosphere is never more evident than in the partial taboo that surrounded the Cultural Revolution itself during the mid-1980s as Liu wrote his photo-essays, and which the state labored, with limited success, to maintain throughout the post-Tiananmen period too. The official silence which greeted the fiftieth anniversary of the start of the Cultural Revolution on May 16, 2016, shows that this striving for secrecy still lives on in zombie form today, even as the advent of the internet has effectively killed off many of its powers.

Liu Xinwu certainly applauds the new "information age" that was unfolding around him in the late 1980s. "Nowadays, things are much better in all respects," he writes, "and a crucial element of 'opening up' is the opening up of information . . . which brings me to old photographs" (2012, 21). For most of Liu's contemporaries at the time, China's new information age was spelled out in techno-utopian fantasies and made incarnate via new media: systems theory, cybernetics, teletext, advertising, science fiction, and the like. Liu's sudden reference to "old photographs" here seems contrary, as time-out-of-joint as Rip van Winkle. What place could these faded images possibly have in China's "information explosion" of the 1980s? The answer lies in their status as emblems of the continuity of the Maoist cryptosphere, as a story Liu tells about his mother reveals in the first photo-essay of the series. He describes the "routine" house searches that his family endured during the Cultural Revolution, when family photographs were "ransacked and removed"; only a few survived, though others were returned after the restitution policy of the 1980s. He continues: "Nowadays, the photographs that remain are locked away in an old iron box underneath my mother's bed. Every day my mother sits on that bed, deep in thought, and every night she sleeps on it as she wanders in her dreams; the old photographs in that box often dictate her thoughts and her reveries. . . . In that iron box there is a secret drawer. Inside it is a yellowed envelope, brittle with age, which holds a set of photographs have long held mystical meaning for me . . . These are the photographs of my uncle" (22). Once the props for public shaming and punishment, the "bourgeois" photographs of a long-dead brother remain concealed inside the fragile envelope, inside the secret drawer, inside the locked box decades after the Red Guard rampages. From that hiding place, they haunt his mother.

Liu Xinwu digs out these images and publishes them, first in a major journal and later in a book with a well-known publishing house. He does so because he wields old photographs—these emblems of the cryptosphere—as small bombs whose detonation could help crack the hard surface of the public secrecy that still shrouded key aspects of the Cultural Revolution during the 1980s. In the first part of this chapter, I explore the shape of this secrecy during the 1980s, a time when China's future direction was still uncertain, when memories of unwanted exposure were often raw, and when breaking silence would have felt like courting risk.[7] I show how Liu repurposes family photographs not simply to inaugurate a novel kind of photo-text in China but also to pioneer, and model to others, this new method of vernacular revelation. In its radical take on how private information could be

publicly networked, this mode, analog in every facet of its operation, closely anticipated the photo- and secret-sharing social media platforms of today. Liu (2012, 4) felt slighted by the scant notice that critics paid to *My Private Photograph Album* and its legacy, even though he knew that he had made his mark with readers.[8] But eventually his revelatory method took off, precisely because it sought to be so participatory, so intuitively responsive to nascent digital desires. The new genre he coined directly inspired the journal *Old Photographs*, which became the publishing sensation of the late 1990s and sparked a passionate "old photos" craze that continues in abated form to this day.[9] *Old Photographs* was studiously eclectic throughout its print run, featuring everything from snapshots of China's vanishing built environment to bygone fashion and furniture. But mostly through its "Private Album" (*siren xiangbu* 私人相簿) column, which featured photo-essays sent in by readers, it also carved out space for the public and networked display of that category of artifact that Liu Xinwu had prized from deep cover: Cultural Revolution–era family photographs.

These photo-essays lean heavily on spectrality to gain a purchase on hidden experiences of political extremity and the toll they exact. Yet these works also parlay the ghost into other interactions with secrecy, combining hauntedness with the motif of the scar. Scarring as a trope emerged almost as soon as the Cultural Revolution was over, in the well-known forms of "scar literature" (*shanghen wenxue* 伤痕文学) and "scar art" (*shanghen yishu* 伤痕艺术), which used the language of mutilation as a blunt tool for laying claim to victimhood and laying blame elsewhere. The photo-texts I examine here carve out a different iconography for the scar, one that draws out its dialectic rapport with both secrecy and the ghost. Spectral scarring also dominates the repurposings of Cultural Revolution family portraits that emerged in Chinese art and conceptual photography from the mid-1990s onward, and that have yet to be explored through the prism of secrecy: the work of Feng Mengbo, Song Yongping, Zhang Xiaogang, Hai Bo, and Zhang Huan.[10] I show in the final part of this chapter that repurposings of family photography—some of them "named," others emphatically anonymous—try to find a visual idiom for the vexed questions of guilt and complicity that lie at the most sensitive core of Cultural Revolution experience. In particular, these works wrestle with what may be contemporary China's darkest public secret: the scarcely sayable fact that the lack of truth and reconciliation about those years is a silence that has suited many. The iconography of kith and kin I explore here cuts right to the quick of why this public secrecy can be so intimate but distorting a force.

Molecular Secrecy

Public secrecy is a slippery target even when that which hides from speech has shape and form, because the escalator of conventional counter-clandestine strategies—leaks, whistleblowing, full-blown exposé—have little chance when secrecy as a mode of control operates in public. What responses, then, were possible in the 1980s for a secrecy that was everywhere and, for some at least, oppressive, cloaking those experiences of ordinary people that in some way gave the lie to the terse official verdict on the Cultural Revolution? This verdict, the "Resolution on Certain Questions in the History of Our Party since the Founding of the People's Republic of China," was issued on June 27, 1981, and published a few days later in the *People's Daily*. It pronounced that the Gang of Four and, to a limited extent, Mao Zedong were responsible for the "ten years of disaster" that had engulfed the nation (CCP 1981). By this rationale, the Chinese people had been traduced and were the passive victims of this treachery, rather than the sometimes willing actors of political violence. The terseness of this judgment, the result of input from Deng Xiaoping himself (Goodman 1994, 96), was a strategy against the raw micro-complexity of the period and the clear and present danger of renewed factionalism. Scripted in a macro key, this version made no mention of how the Cultural Revolution had been lived in private domains, at the local level, by common people, nor of how responsibility for the social conflict of the period might, in fact, be more diffuse and distributed. Yet by strategically exonerating the Chinese people for acts of violence and disorder that many had either committed or witnessed or failed to stop, the Resolution also, and paradoxically, worked to ensure that everyone still felt themselves to lie within the zone of guilt, a sense that militated powerfully against open discussion (Weigelin-Schwiedrzik 2006, 1080). It deployed a broad sense of complicity about what had happened during the Cultural Revolution to encourage cooperation in the state project to hush that past up.

"Complicity" is, of course, is a disagreeable term since it assumes that counteraction is a choice available and consciously rejected. Or as Edmund Burke's motto has it: "The only thing necessary for the triumph of evil is for good men to do nothing" (attributed in Bartlett 1980, ix). More commonly, and in a pattern that recurs across the case studies I examine in this book, this management of history is called the state suppression and manipulation that produce amnesia.[11] These descriptors have some solid rationale, and my aim in adding public secrecy to the roster of terms is not to discount or supersede them, but rather to grow that standard frame of reference via a fuller scoping out of the

tacit consensus on which prescriptive state narratives depend. It is, of course, well understood that some personal memories of the Cultural Revolution are "embarrassing and shame-inducing," as Diana Lary puts it, in part because of the fervor of that time: "Very few Red Guards, as parents trying to discipline their own children, have wanted to tell [them] what they did in the Cultural Revolution" (2015, 247). Yet to recognize the individual desire to hide is not the same as tracing mass structures of concealment: how they work and the crucial ways in which they differ from forgetfulness-as-pathology. After all, "forgetting" the Cultural Revolution has been a highly selective process: some aspects were memorialized quickly and openly; others took longer to acquire commemorative traction but have now become iconic, such as the fetish for Mao memorabilia that crested in the 1990s; and others again have yet to break through properly at all.

Individual storytelling about the period, for example, was surprisingly plentiful right from the start of the post–Cultural Revolution epoch. These include the already mentioned "scar literature" of the late 1970s, pioneered by Liu Xinwu's own short story "The Class Teacher" (*Banzhuren* 班主任, 1977);[12] "scar art," especially the work of Luo Zhongli 罗中立, Gao Xiaohua 高小华, and Cheng Conglin 程丛林; TV series about "educated youth" (*zhiqing* 知青) sent to the countryside during the Rustification campaign, such as *Times Wasted* (*Cuotuo suiyue* 蹉跎岁月, 1982); and a huge range of filmic productions, with *Bitter Laughter* (*Kunao ren de xiao* 苦恼人的笑, dir. Yang Yanjin 杨延晋, 1979), *Night Rain at Bashan* (*Bashan yeyu* 巴山夜雨, dir. Wu Yonggang 吴永刚 and Wu Yigong 吴贻弓, 1980), and *The Herdsman* (*Muma ren* 牧马人, dir. Xie Jin 谢晋, 1982) serving as a few notable examples.[13] These works showed that micro tales about the Cultural Revolution could be readily told during the immediate aftermath of the events, so long as this narration kept within the approximate space permitted by the party line and apportioned blame "correctly"—preferably with a melodramatic flourish. These were fictive personal narratives, in other words, within the prescribed political key, which served as a vent for acceptable forms of postrevolutionary *tristesse*.

The CCP's blanket doctrine of blame, and the more dissonant microhistories it tried to conceal, extended its coverage after the "total negation" of the Cultural Revolution in 1984, which went still further in disavowing both the period itself and public discussion of it. This negation was followed during the 1980s by other state directives that admonished publishing houses that had "put out so-called Cultural Revolution 'anecdotes,' 'secrets,' and 'behind-the-scenes accounts,'" and decreed that "one should not plan to publish titles specifically researching the 'Great Cultural Revolution' or specifically telling the history

of the 'Great Cultural Revolution'" (Schoenhals 1996, 310–11). What Arthur Kleinman calls the "public transcript" on the "decade of chaos" was propagated in school textbooks at the same time as it put certain brakes on academic research (1995, 142). Although memory management by the state never succeeded in quashing debate—indeed, the period has always been "the subject of wide-ranging discussions" (Gentz 2014, 2), despite the restraints—from the mid-1980s those who wished to touch on more delicate aspects of the Cultural Revolution increasingly turned to literature and the involved idiom of ambiguity. Coded representations came thick and fast in the 1980s: misty poetry, root-seeking fiction, and avant-garde fiction all approach the Cultural Revolution warily, via circuitous routes (the latter movement treats the violence of China's recent past as the unmentionable elephant in the "room" of virtually every text).

These, though, were elite literary responses aimed at elite reading publics, and ambiguity, as their representational mode, is not especially well suited to the needs of vernacular revelation. More to the point, they took hard textuality as their medium of expression. As Sebastian Veg notes, fiction and poetry functioned as "a substitute for public discussion of the history of the Mao Era" from the late 1970s onward (2014, 8), precisely because these genres not only profess their inventedness but are polysemic, even recalcitrant to fixed meanings. As such, they were safer spaces within which to circle taboo things. But such texts did not, could not, offer a forum for sharing stories, breaking the silence, among ordinary people. Little wonder that Liu Xinwu in *My Private Photograph Album* craves the commonplace, "the living thing, flesh and blood," the stories of "the most undistinguished, the most trivial people," those historical subjects "whose names are unknown, whose bones are scattered who knows where, and the whereabouts of whose descendants are a mystery" (2012, 15–16). As he puts it, "I always feel a certain dissatisfaction with the combed-through, sieved, sterilized, bleached, condensed, and purified sense of history passed down to me by others. I want to investigate primary materials myself" (16). Old photographs, he writes, are "most capable of satisfying this desire" (16).

Fast forward to China in the new millennium, when the internet began to transform the rules of engagement, and Liu Xinwu's vernacular vision was fast becoming a reality. Over the past twenty years or so, thanks to the "participatory and informational" character of the Chinese internet (its digital archives, virtual museums, and dedicated chatrooms), conduits have opened up through which ordinary people can share stories, and these now buzz noisily beneath the carapace of the official narrative (Yang 2007, 292). This buzz—whether it

expresses neo-Maoist nostalgia for the period and its hopes and dreams, or exchanges experiences of violence, guilt, or loss—has become so persistent that it no longer makes sense to speak of the Cultural Revolution *in toto* in terms of public secrecy, even as specific incidents (the death of Bian Zhongyun, for one) remain locked down and discourse still flows far from freely. Yet China before the web, the post-Mao China of the 1980s in which Liu Xinwu wrote his photo-essays, was incomparably less hospitable to sharing, to the trading of confidences among ordinary people that has helped to hollow out the official narrative into the shell that, tough as it may still be, the verdict on the Cultural Revolution now resembles. This withholding of information, though, was not just a matter of choice, as sharing secrets outside intimate circles—specifically for those who did not write fiction, make films and TV series, or produce art—required what I referred to earlier as methods of revelation. To gain traction, these had to be proto-technological, by which I mean capable of scaling up and reaching strangers.

To put this another way, the Cultural Revolution in the 1980s might be called not just a public secret, but a *vernacular* one, because what was hushed up were those experiences of countless ordinary people that contradicted the state narrative—most particularly if such experiences lay in the fraught, often overlapping domain of victim/perpetrator relations. This notion of the vernacular secret does not simply refer to the micro details of what was deemed untellable. It denotes in equal measure the social injunction to silence both sensed and obeyed by people who lacked access to significant sources of information, to tools for self-expression, and to participatory activities through which memories could be legitimately shared. Yet like all public secrets, this mode of reckoning was collaborative: it needed the ongoing participation of the people who had lived through the Cultural Revolution and who tacitly agreed not to share certain experiences in the open. But unlike other clandestine forms, this vernacular secrecy was not really about being "in the know" and belonging to an in-group that exercised power through knowledge. It was not merely "knowing what not to know," but rather a constructive ambiguity over what exactly was off-limits. That uncertainty incited silence in a secrecy not of enlightenment, but rather of shadow.

Christopher Kutz has recently described the condition of "meta-secrecy," a state that prevails "when the fact that there is a secret is itself secret" (2016, 112). By contrast, the clandestine character of the Cultural Revolution in China in the 1980s was more about this amorphous sense of knowing that parts of the past were to be kept secret—but not who was hiding exactly what or why, because the prohibitions on public discourse meant that they could only scope

out that *verboten* ground through the patchy purview of personal memory. Su-sanne Weigelin-Schwiedrzik has argued that "the fragmentation of Chinese society that surfaced during [the Cultural Revolution] is reproduced by the fragmentation of communicative memory today" (2006, 1084), that communi-ties of memory were divided against each other in the aftermath of that time. Weigelin-Schwiedrzik suggests that this fragmentation allowed "for memories to be exchanged without attracting public attention" (1089), and the post-Mao period has certainly seen this group-based, below-the-radar memorial and mourning (Li 2016b, 333–41; Mazur 1999, 1019–35), particularly from the 1990s onward. But this kind of secret-sharing required clear knowledge of who is "in" and "out," and the relief that comes from breaking cover may not have been worth the risk. After all, such memories were in some cases dangerous, since to stir them might also reignite the violent explosiveness of the peak Cultural Revolution period.

Moreover, as Mazur makes clear, mobilizing micro-memory groups in 1980s China was more typically a feature of "elite political culture" (1999, 1021), or at least was dependent on the discreet support of local officials (Li 2016b, 335–37). For those outside this kind of nexus of connections who still had a story to share, trading confidences was far more logistically problematic. In a wider sense, too, the constructive ambiguity mentioned above can also be understood as a further means of controlling citizens because it made so broad a range of private experience potentially taboo, even—and this is a pertinent subpoint—when there was nothing much to hide. One is reminded of Liu Xinwu's mother, who hid the cherished photographs of her long-dead brother for years after concealment was necessary, mostly because hiding private things and thoughts had become a habit. But we might also include here the many mil-lions of people, often in rural areas, who were not as vastly affected by the upheavals but might still have wished to speak their pasts. This is Simmel's argument when he observed "the logically fallacious, but typical, error, that everything secret is something essential and significant" (1906, 465). In short, any project of revelation about the Cultural Revolution in 1980s China had to find a way of contending with what was a vast quilt made up of tiny patch-worked silences, which veiled sensitive parts of that history and which the state and its agents wielded as a form of power.

Yet this kind of inchoate prevailing secrecy also exemplifies Deleuze and Guattari's point that "the more the secret is made into a structuring, organ-izing form, the thinner and more ubiquitous it becomes, the more its con-tent becomes molecular" (2004, 289). Here, the idea of molecularity refers to the incalculable number of hushed-up experiences whose coalescence

turns secrecy into a mode of power. And by the same token, this molecularity is also what turns the owners of those hidden experiences, willingly or otherwise, into members of a network yoked together by their very lack of information about each other. Or more accurately, they belong to a series of networks-in-incubation, awaiting the nodes that will draw them into linkage. Weigelin-Schwiedrzik is instructive here, noting that "fragmentation" has created a situation wherein "groups who share common experiences . . . are rarely able to overcome their own limitations and [thus] need support in accessing the public" (2006, 1084). She continues: "For memories to be communicated publicly, survivor groups need the attention of intellectuals who take over the task of articulating memories on behalf of those who do not have access to the public sphere" (1088). It is in this context that Liu Xinwu's photo-essays, and their participatory method of vernacular revelation, begin to acquire a certain activist meaning.

Photo-Sharing, ca. 1986

Recent work in secrecy studies has been understandably riveted by the internet and what its "ever-increasing technologically mediated capacities for connectedness" (Siegworth and Tiessen 2012, 49) mean for the clandestine, whether this is the supersurveillance exposed by WikiLeaks or the confidences that Facebook winkles so effortlessly from its users. Photography is the online practice that, more than any other, straddles both forced and voluntary exposure, all of it dependent on the emergence of photo-sharing as a de facto form of web-based language from the mid-2000s onward. Photographs, swapped within safe and unsafe circles online, whisper secrets as readily as flesh-and-blood informants. But like most seemingly born-digital practices, photo-sharing has its own media archaeology, and one of its gnarly techno-cultural roots can be traced back to the photo-texts that had such a flowering in China during the 1980s and 1990s. Liu Xinwu's *My Private Photograph Album* pioneered a participatory method that was later picked up and vastly expanded by the pictorial *Old Photographs*. It is a method predicated on the voluntary disclosure and circulation of private photographs within unsecured networks, where they play a role that is far more informative and communicative than it is conventionally mnemonic. If not quite social media sites *avant la lettre*, these print media photo-publications promoted a use-value for the shared family image that we now see operating at full algorithmic tilt on platforms such as Instagram.

Liu Xinwu was justly proud of his innovations in *My Private Photograph Album*. Back in 1986, he notes in his second preface, the fusion of word and

image—in which photographs were not merely illustrative handmaidens for the text but actually incited it—was rare if not without precedent in China (2012, 8). Yet their means of dissemination was just as radical. Social media scholars assume that the sharing of family photos beyond intimate and physically immediate networks is a practice contingent on the digital; before this point, the fixed materiality of the medium supposedly set the limits for its distribution. This is the argument Prieur et al. (2008) make when they describe the shift from a "Kodak culture," wherein "a small group of persons (friends and family) share oral stories around images with others," to a new regime of the family image, dubbed "Snaprs culture, " in which photos tell stories with images "in a large-scaled conversation" shared with strangers. *My Private Photograph Album* first, and *Old Photographs* thereafter, belong within what Xiao Liu calls an "*ur*-history" of the digital in China because their method prefigured this Snaprs culture in virtually all respects other than their algorithmic base (2016, 45). Like photo-sharing sites, their intention was not to archive images so much as to impart information through them. Indeed, just as Flickr is "not a logical place to nurture interpretations of the past because the site is primed by the *present*"—which is why it became a "forum for eyewitness (and documentary) photography" (van Dijck 2011, 409–10)—so too are China's photo-publications from the 1980s and 1990s driven more by information need and desire than by memory-making. These photo-texts fostered an incipient version of a "culture of connectivity" (401) in which networks between viewers are not just enabled but actively created.

In the first photo-essay of *My Private Photograph Album*, Liu launches his mission to solicit photographs from readers:

> Although the number of old photographs in China has been painfully reduced as a result of the cataclysm of the Cultural Revolution, a considerable number have certainly been conserved through sheer good luck. I believe that many people still have their own albums or boxes, which still preserve and treasure countless "originals" from 20, 30, 40, 50 years ago, or even further into the past. Of course, many people will not want to make these photographs public. . . . But there are bound to be a good many others who would be happy, or who could be persuaded, to present some of the "originals" in their private albums to society, and join the current "information explosion." (2012, 21)

Then, more directly, in the photo-essay's final lines: "In countless private albums, old photographs silently tell of countless people and events . . . and bury secrets that are hard to divine. . . . Would you like to provide photographs

from your private album for this column? Together let's create a new informa-tion system . . . !" (2012, 30). And at several other moments throughout the book, he enjoins readers to reveal their "secrets" and reminds them that he wants "to use other people's photographs as much as possible" (2012, 174). Yet this was a tough call. Unlike *Old Photographs*, which was launched ten years later, at a time when some of the taboos around the Cultural Revolution had begun to lift and a brisk memory market was building, Liu Xinwu's photo-texts were a chancy enterprise in the 1980s. That he was able to publish his series at all, and in such innovative format, was in large part because the chief editor of *Harvest* at the time was Ba Jin 巴金 himself, whose exalted status "en-sured that *Harvest* could publish formally audacious texts and be spared the criticism that several other journals incurred between 1986 and 1990" (Iovene 2014, 99).[14]

In a broader sense, Liu Xinwu was asking his readers, his would-be collabo-rators, to take risks that might have seemed senselessly retrogressive. Maoism had set its canon hard against privacy, from collectivizing land, to creating com-munal kitchens, to monitoring women's menstrual cycles (McDougall 2004, 4). The mid-1980s, when Liu was writing, were years in which people in China were learning how to "do" privacy all over again; privacy—personal, property-based, political—was one of *the* core questions of the decade (S. Wang 1995, 156–66). More than this, it could be argued that the public secrecy about who did what to whom during the Cultural Revolution was one of the means via which the delicate boundaries between the inner and outer domains of experience were sketched anew. Private, secretive citizens, after all, were also citizens on whom the new ideologies of economic individualism could gain a stickier purchase. And in a different sense, the de facto state edict of 1981 to keep guilty secrets about the Cultural Revolution might well have felt like sweet relief after so many years of compulsory publicness about everything. So why spill the beans unnec-essarily? The core point here is that Liu Xinwu's photo-essays draw an implicit yet unmistakable demarcation between privacy per se and the public secret about what happened to so many Chinese families, and what they did to themselves, during the Cultural Revolution.[15] Privacy is a glorious thing, Liu intimates, but it cannot come at the expense of honesty; maintaining strategic silence is not the same as having a true private life. This is why Liu can say to his critics, without the slightest irony, that "respecting the right to privacy is the absolute premise" of a book that lifts the lid on other people's secrets (2012, 3).

Small wonder, though, that Liu's efforts to crowdsource family photographs often failed or faltered. He tells of readers who suffered "revealer's remorse" and who castigated him for the way in which he had used their private im-

ages in print. He twice mentions the story of a former Red Guard who delivered up an astonishing cache of photographs that showed the man and his associates "posting big character posters, smashing the 'four olds,' destroying old-fashioned shop signs, struggling against 'black gangs,' and proclaiming the 'highest directive' on the streets" (2012, 4). He writes: "Of the ten essays that I'd already published, which had greater historical value than the piece which I then put together from the material he offered me, which had a greater sense of the solemnity and sorrow of individual destiny?" (4). But just as he has his photo-essay packaged up to send to *Harvest*, the man returns, "wringing his hands, breathing hard," and implores Liu to withdraw the essay and return the photographs. His fear is that of *shizhong* 示众, a loaded term that means "being exposed in public" (4). Terror of being turned into a spectacle because of his Cultural Revolution past forces the photographs back into hiding; but just as interesting is how much they wanted to be revealed. This tension between the desire to share a secret and trepidation at doing so echoes Simmel's point that "secrecy sets barriers between men, but at the same time offers the seductive temptation to break through the barriers through gossip or confession. This temptation accompanies [its] psychical life . . . like an overtone" (1906, 466). But it is also specifically constitutive of the Cultural Revolution as a set of aftereffects; secrets were hoarded in part because people were still unsure whether it was safe to share. Liu wagered that the photo-essay might possess the necessary seductions to tip the balance.

Secret Networks, Networked Secrets

This anecdote also makes it clear that photo-texts from 1980s China were not just "beta" versions of image-sharing sites such as Instagram. Their role as repositories for confidences, together with their persuasive melding of image and text, suggest that they also foretold the emergence of platforms such as PostSecret and Whisper, PostSecret begun as a small weblog in 2005, nowadays posts and hosts millions of secrets, from the funny to the traumatic, sent in anonymously on postcards (rather than via email with traceable IP address) that combine the words of revelation with a picture. Whisper, its offspring in app form, does much the same but through image macros sent on smartphones, with some interactive functions built in. Yet rather than simply noting a one-way prehistory—the idea that piano rolls presaged digital downloads and so on—these relationships are better understood in *interhistorical* terms because they work retroactively as much as preemptively in what they reveal. This is not simply the point, now well taken, that the digital was desired long before it ap-

peared, but rather the recognition that new media can shed keen backward light on how their analog forebears functioned within their own historical time. In particular, looking back at China's photo-texts from the vantage point of the web platforms they unwittingly predicted throws into relief the role of these print publications as proto-technological tools for sharing among strangers. Here, it is the notion of the network, and the photo-texts that it distributes, that stand out.

PostSecret, and Whisper still more so, are not secret networks so much as sites that network secrets: they disseminate willfully disclosed confidences as publicly available information while retaining the anonymity of the confessor. This is why they are as useful as Instagram as latter-day models for making sense of China's photo-texts from the 1980s and 1990s, which offered up family photographs as secrets for sharing—or rather, networking—with strangers. Both *My Private Photograph Album* and *Old Photographs* were serial publications, and serialized works arguably constitute the print media forms closest to the social media platforms of today, with their posted entries; their sequential, ongoing character; their "updating" function; and the closer rapport they fostered with readers (who could and did write in to the host publication with "comments"). Such networked traits are now understood as core hallmarks of the contemporary social media regime, and China's photo-texts, as such, become linear prototypes for the highly distributed models that increasingly structure human interaction today. This notion of structuring once more flashes back to Deleuze and Guattari: the secret as "a structuring, organizing form," whose content "becomes molecular" (2004, 289). This is no accident. If the Cultural Revolution as public secrecy was (and, to a limited extent, is still) a form of collaborative network stitched together with the silence of countless private individuals who hid their experiences of that time, then these photo-texts—which deployed the network strategies now fine-tuned and fully viral on social media today—built what was effectively an incipient counter-network of revelation. Liu Xinwu initiated this network, but its wings were clipped by the small scale of his photo-essays, by the tremulous hesitation he encountered among his would-be reader-collaborators, and by his own desire to script the text of other people's photographs. It took the launch of *Old Photographs*, which took the photo-text directly to the people, for the project to achieve real lift-off.

Protective Camouflage

It is in this sense that *Old Photographs* should be seen as an extraordinary experiment in folk history, a signal event in China's late twentieth-century print media culture. Launched in 1996 by a little-known provincial publisher, the

pictorial was small and cheap and poorly produced. But its first three issues, as Wu Hung notes, became "instant blockbusters in the mass book market" (2008, 119).[16] He continues, quoting an interview with the journal's chief editor, Feng Keli 冯克力: "For the fourth issue, therefore, the publisher decided to produce an astounding initial print run of two hundred and forty thousand . . . these four issues, published within a single year . . . eventually sold more than 1.2 million copies altogether, making the serial one of the most popular publications in post–Cultural Revolution China" (119). The series tapped such a nerve, and tapped it so instantaneously, that other presses rushed out copycat volumes, and a passionate "old photo" craze (*lao zhaopian re* 老照片热) was soon in full swing.[17] Hanchao Lu suggests that it was the prefix "old" that sold this array of spin-offs: he cites "Old Cartoons (*lao manhua*), Old Coupons (*lao piaozheng*), Old Houses (*lao fangzi*), Old Customs (*lao fengsu*), Old News (*lao xinwen*), Old Callings (*lao hangye*), Old Cities (*lao chengshi*)" (2002, 184). But it was arguably the informal image-text format and its vernacular potential that really shifted copies and kickstarted the craze. Lu's list indicates the miscellaneous character of that craze and its many forays into collectible culture. Yet within the pages of *Old Photographs* itself—the nucleus of the craze—family photo-texts, and those from the Cultural Revolution especially, maintained a core and steady presence.

This nerve that *Old Photographs* so deftly tapped should, under any circumstances, have made it a major topic for analysis both inside and outside China. In particular, the way in which the periodical was partially crowdsourced before the term was even invented, and gave such space to the unpolished writing of ordinary readers at a time when literary publishing in China was subject to strict gatekeeping, make its experimental character and achievement all the more striking.[18] Above all, though, the enduring presence of the family photo-texts make this periodical a quasi-political entity whose role within the landscape of post-Mao discourse on the Cultural Revolution deserves close study as such.[19] Yet neither *Old Photographs* nor the craze it sparked have fully crystallized as an object of research outside China.[20] Within Chinese-language scholarship, the focus has been on the text-image interplay the periodical fostered and on its pivotal place within a *fin de siècle* nostalgia boom.[21] Yet as Li Zeng has argued in an unpublished PhD dissertation, "the perspective of nostalgia simplifies *Lao zhaopian*" and fails to give proper due to the abiding presence of "heart-wrenching writings" about the period (2008, 192) throughout the periodical's pages.[22] *Old Photographs* is a "people's history" that created an open space in which personal stories could be shared. More than this, in fact, it was "the first publication that allowed photos of political trauma to be seen in public" (197).[23]

Old Photographs was able to do this in part because the state narrative on the Cultural Revolution was coming under different kinds of pressure during the 1990s. This decade saw the revenge of history as a populist backlash against the "public transcript," abetted by an emerging market for memory products, led to a spate of memoirs, exhibitions, photo-works, and first-person commemorative enterprises, especially from the former Red Guard and "educated youth" generation (Davies 2005; G. Yang 2005), though professional writers such as Wang Shuo and Wang Xiaobo 王小波, and a select group of filmmakers, also challenged it. Some of these memory works detraumatized the Cultural Revolution, wresting it back from the state narrative of disaster by recuperating the period as a time of ideals, freedom, creativity, eroticism, even boredom. Meanwhile, a mercantilist Mao fever was raging in which badges, Little Red Books, and portrait busts of the Great Helmsman served as fodder for China's new entrepreneurs. This is by no means to say that the Cultural Revolution was now a free-for-all in public discourse. Li Zeng (2008, 85) points out that of the 1,209 films made between 1990 and 2000, only six addressed the Cultural Revolution, and two of those—*To Live* (*Huozhe* 活着, dir. Zhang Yimou 张艺谋, 1994) and *The Blue Kite* (*Lan fengzheng* 蓝风筝, dir. Tian Zhuangzhuang 田壮壮, 1994)—were banned in China. Not coincidentally, both films placed familial experience at their heart, unlike the outpouring of "educated youth" experience, which in a substantial sense is defined by the break with family.[24] This split during the 1990s—the flowering of "educated youth" memorabilia versus the censoring of two major and much-lauded films about the family—suggests a delicacy, a secrecy, around the latter topic, in part because familial space was the zone within which the "public transcript," with its abstract claims that the past was done with and all scores settled, made least sense.

More than this, the experience of "educated youth" was, for all its variety, remarkably cohort-based and thus to a degree containable;[25] this helps explain why it became the more or less acceptable face of Cultural Revolution memoir-writing in the 1990s and beyond. In a profound, unspoken sense, the family photo-texts of *Old Photographs* militate against both this generational divide and the notion of fragmented memory communities. Few common denominators, after all, trump the experience of belonging to a family, even if all its bonds are shattered. In this sense, the network of family photo-texts published in *Old Photographs* were a below-the-radar attempt to expand public discussion of the Cultural Revolution beyond the dominant formats that had, by the end of the millennium, cornered the market for the "expressible" within China's still-censored environment.[26] These photo-texts went much further than the formats sketched above: they declared that the Cultural Revolution, for all

its social conflict and resultant fragmentation, was ultimately a shared experience, with clear implications for broad complicity, responsibility, and blame.

Li Zeng notes that the diversity of *Old Photographs* in both time period and topic meant it did not receive "special surveillance from the government" (2008, 198), though the fact that the publishers received an oral warning about a photo-essay that praised Jiang Qing 江青 indicates that someone was watching (269). Given this, a better way of putting things might be to suggest that the Cultural Revolution family photo-texts were hiding in plain sight, or at least borrowed the lucrative, state-approved nostalgia all around them as protective camouflage. While not quite assuming the guise of the secret in order to go head-to-head with the secret, they comported themselves discreetly (which may explain why these photo-texts have largely escaped academic notice too). Wang Jiaming, general editor of the Shandong Pictorial Press, carefully set out the nostalgic stall in the journal's inaugural issue: "The twentieth century is coming to an end. A distinctive feature of the *fin de siècle* is a universal nostalgic mentality" (1996, 126). But once it got going, the series was quick to "shrug off its unadulterated emotional sentimentality" (He Qun 合群 2003, 68). A survey of the periodical from 1996 to its one-hundredth issue in 2014 reveals that 354 photo-texts that dealt either fully or partially with the Cultural Revolution appeared in *Old Photographs*, constituting just under 17.5 percent of the entire content, and averaging at just over 3.5 photo-essays per issue. Of these photo-essays, more than forty featured family portraits, defined here as photographs showing either an entire family or smaller groupings of grandparents, siblings, couples, and mother/father with child.

These family photo-texts are brief—no more than seven or eight pages, often less—and they follow a terse biographical format, molded around one or more family portraits, in which the authors mostly recount the experiences of their parents during the Maoist period, with the Cultural Revolution usually forming a sharp nadir in the narrative sequence.[27] The format proffers a wealth of data about these fathers and mothers: many hailed—as we might expect from the literary ambitions of their children—from the educated classes of cadres, soldiers, teachers, and lower-ranking bureaucrats, but others were peasants, seamstresses, wheelbarrow pullers, bicycle repairmen, factory workers, and cooks. In this sense, the photo-texts tender an unusually diverse cross section of Cultural Revolution experience, the telling of which has less frequently featured the voices of peasants and the urban proletariat. Some of these latter narratives recall the period as a time of deprivation but also of togetherness, grit, and authenticity, and they testify to the fact that the confessional impulses that *Old Photographs* so richly gratified were not always rooted in

trauma.[28] Others, though, tell stories that probe the sorest political sensitivities of familial experience during a time of revolution. As they do so, these photo-texts frequently identify persecutors far more intimate than the Gang of Four—neighbors, colleagues in work units, community members—and thus they refer directly to the ferocious, locale-based social conflicts that the state was so keen to keep out of discussion. And all these photo-texts, whatever their affective tenor, helped to open up a networked space in which the secrets of familial experience, so ghosted from the Cultural Revolution memoryscape, could be traded amid the kindness of strangers.

Wu Hung is surely right that *Old Photographs* did not seek overtly to take up Ba Jin's (1987, 819–23) famous call for the establishment of a Cultural Revolution museum and that its editors rejected "an explicit political or ideological agenda" (Wu 2008, 124). Yet the numbers just mentioned, accumulated during an epoch in which public discussion of the Cultural Revolution remained restricted, tell their own story nonetheless. These family photo-texts, published issue after issue, season after season, built a molecular network of revelation that operated by sharing images as secrets, secrets as images. As such, they formed an evocative counterpoint to that other, more extensive network of personal secrets in China: the government dossiers on individual citizens that bulged with confidences, thoughts, and feelings, often extracted under duress. It is only fitting, in this sense, that the network of revelation operated partly under cover.[29] It was never obtrusive enough in volume to call much attention to itself, an impression increased by the serialized nature of the publication, which to the casual reader made each revelation seem more isolated than it really was. Almost every issue featured family photo-texts from other "safer" eras, which helped the "heart-wrenching" images to melt into the larger crowd of black-and-white faces. Furthermore, some photo-texts deployed the form of a longer piece, featuring several portraits through time, in order to mix nostalgia with an abrupt turn toward darker themes and images, thereby creating another kind of smokescreen.[30]

Above all, though, these photo-texts could get away with sharing sensitive stories about Cultural Revolution experience because they were so self-evidently inconsequential. Their writers were unknown, unpracticed amateurs, nonentities who would never join the Chinese Writers' Association nor publish books or short stories. They were ordinary people with one story "in them": the story of a photograph, or a tiny cache of photographs, that held extraordinary meaning for them. Early on, they probably submitted their photo-texts in a spirit of spontaneity, rather than with any aim of network-building, but as time passed and regular readers saw these memoirs appear one after another, the

desire to join in would have quickened for those who possessed a photo with a tale. As it did, these reader-writers began to defy the wisdom that only those survivor groups able to attract an established intellectual as mouthpiece could "enter the contest of interpretations" about the Cultural Revolution (Weigelin-Schwiedrzik 2006, 1088). This was the logic behind *My Private Photograph Album* and behind Feng Jicai's 冯骥才 well-known *A Decade in the Lives of a Hundred People* (*Yibai ren de shinian* 一百人的十年), first published in 2004, in which Feng compiled and edited raw oral testimonials about the period that had been submitted to him by thousands of ordinary people after he sent out a call in the *Tianjin Evening News*.[31] Even "educated youth" memoirs were not immune to this logic of textual authority: those "who had no reputation, little training in writing, or no way to have their memoirs published, supplied their life stories to authors with . . . literary training" (Li Li 2016, 16). And unlike the contributors to Feng Jicai's collection, and in contrast to some of the published "educated youth" recollections, the authors of these family photo-texts shunned anonymity. They did this mainly because they knew they were political nonentities. But to name or not to name, as I discuss shortly, remains a decision with symbolic value in the cryptosphere, in the social spaces of vernacular secrecy.

Talking Photos

In a crucial sense, the network came to pass because so many of these family photographs desperately wanted their tale to be told. Back in the mid-1980s, Liu Xinwu had already understood that the photo-text genre that he was developing in China could act on the pressure points of secrecy. Discussing the condition of *kuailei* mentioned earlier, the dejection and anger caused by living with secrecy, he writes, "when I wrote in this way [combining photos with text] I wasn't specifically aiming for innovation. I just felt that if I didn't select this hybrid format, I would not be able to express and dispel the gloom in my heart" (Liu 2012, 8). The special capacity of photo-forms, in a generic sense, to engage with different forms of secrecy is a base theme of this book. It stems, as I argue in the conclusion, from photography's status as an object which bridges darkness and light, transparency and concealment, candid camera and the subterfuges of Photoshop. Virtually all of the photo-forms I discuss elsewhere, though, are the works of artists and filmmakers who remediate images not with text but via paint, ink, bronze, digital video, animation, photochemical paper, and so on. What's more, these artists and filmmakers mostly identify as professional practitioners, and even if they operate outside state systems,

they have access to the resources that "dissidents" can gather to themselves within the global system of recognition. This point about the exercise of cultural capital also holds for established author Liu Xinwu, who solicited photographs from his readers but wanted to do the writing himself. This is precisely where the family photo-essays in *Old Photographs* show the power of image-plus-text as a means of getting at secrecy—and for those without cachet, those outside the grid.

The photo-text as a representational mode outside China has been the subject of sustained scholarship, particularly since the mid-1980s as texts such as Paul Auster's *The Invention of Solitude*, Richard Powers's *Three Farmers on Their Way to a Dance*, and W. G. Sebald's *Austerlitz* have radicalized the image-word relation anew. True to its etymology, photography has always sought to connect with the world of words, but the view that the photographic image was a direct "emanation of the referent" (Barthes 2000, 80)—in short, indexicality as the medium's calling card—led to the suppression of its labile narrative powers and kept images in the subordinate position of "mere illustrations" to the text (Hüppauf 1997, 15). More recently, though, "a global rediscovery of the narrativity of the fixed image" has occurred (Baetens 2001, 87), whether via the photo-fictions cited above or the strong storytelling momentum of Gregory Crewdson's staged photographic tableaux. Baetens is right to note that photonarrative is "a domain suffering cruelly from a lack of academic and social distinction" (88), even as scholars such as Liliane Louvel (2011) have begun to parse these works much more precisely. Yet one might also note the recurring focus on photonarrative and narrative photography as elite practices; certainly, the most cited and celebrated examples of each can be described as such. China's photo-texts, expressly by and for the people, both offer a vernacular lineage for the "talking photograph" and show how the invitation to wrap narrative around images can become an irresistible provocation, one that calls out particularly to secrets.

Victor Burgin claims that "even a photograph which has no actual writing on or around it is traversed by language when it is 'read' by a viewer" (1982, 144). But what about images that seem to beg for text? Nicole Huang suggests that Cultural Revolution family photography does just that: "A *quanjiafu* [whole family] photo must be read as a picture with a story to tell" (2010, 685). Even more than a story, though, it is typically a secret that pleads for revelation. The family portraits in *Old Photographs* are rife with hidden messages; in them is a "striking gap between what we can see and what we know" that is bridged only once we read the surrounding text (Baer 2005, 2). These images are encrypted, and only their narratives can decode them. In key ways, this

is an effect of the strict syntactic conventions that governed the visual language of family photography during the Maoist era, a language articulated, as Jiehong Jiang notes, in response to felt ideological need: "There were some common rules for the family photograph in Mao's era . . . the father is always positioned on the right, mother on the left and child in the middle. The photographer would offer them some criteria for positioning their body, gesturing and even expressions, offering an idealistic model of society . . . family photographs [were sometimes] rendered by hand after the studio shot to match the 'standard' aesthetics . . . with or without the subjects' agreement" (2007, 21). These earnest, stiffly angled, black-and-white close-ups shot in high key against a neutral gray background were expressly designed to give nothing away. Their codified formality, repeatedly enacted in photographic studios across the country, was itself a form of declarative secrecy.[32] Wang Min'an 汪民安 notes that "having a photograph taken was a significant life event in China during the 1960s and 70s," and "people underwent huge psychological pressure as they faced the camera" (2013, 7).[33] This locks these images into an oddly intimate relationship with the "public transcript" of the Cultural Revolution. Like that telescoped version of events, these portraits have something "macro" about them. Their conventions produced a smooth, population-level uniformity that belied the range of experience Chinese families underwent during those years.[34] This link is reinforced by the scarce access to camera technology during the Cultural Revolution, which meant that these rigidly posed studio shots usually constituted the only visual record from that time: one image, one story.[35]

The Mao-era rules for portraiture seem ripe for satire now; indeed, they were roundly mocked in 1979 during a famous crosstalk skit entitled "How to Take a Photograph" (*Ruci zhaoxiang* 如此照相), by Jiang Kun 姜昆 and Li Wenhua 李文华. But at the time they were stringent, like the expectation, mentioned in several of the family photo-texts in *Old Photographs*, that everyone in the portrait would wear a Mao badge.[36] In a sense, formal family photography is always a masked ball of sorts, under whose staged surface secrets and lies often take cover. This is Marianne Hirsch's point when she argues that these images "locate themselves precisely in the space of contradiction between the myth of the ideal family and the lived reality of family life" (1997, 8). Yet in the Cultural Revolution photo-texts, secrecy was much more than merely pretending that every family fit the "idealistic model of society." Both the unity of the assembled figures and the fixity of their facial expressions often hid more devastating truths: that the father missing from the picture has committed suicide, died of stress-related alcoholism, or been forcibly isolated

for months in a political "study class"; that a parent present in the image will soon be imprisoned; that a smiling uncle in the frame will, after days of persecution by "revolutionaries," jump to his death, his mother a witness; that a sibling is about to be sent indefinitely to the countryside; that the everyday intimacy captured in the viewfinder will only last the duration of a short visit home, thus making the photograph, in that sense, an uncanny testament to all the things that the family was but is no longer.[37] Ultimately, the secret of such photographs is that the togetherness they showed was being spectralized outside the frame. The image was the only place where it clung to life, and this is the secret that such photographs want and need to "speak."

Spectral Scars

This point is borne out by the repetitive thematic nodal points that string the network of family photo-texts in *Old Photographs* together: in particular, "missing persons" and "then and now." Both these motifs are spectral, and both are secretive. One example is a photo-text entitled "Taking Photographs" (Zhaoxiang 照相, 2003), by a reader-writer named Shao Changbo 邵长波 (figure 2.1). This piece narrativizes a *quanjiafu* 全家福 (photograph of the entire family), which occupies a full page adjacent to the text. The photograph alone presages a strong sense of the uncanny. It shows mother, daughter (the author of the photo-essay) and son against an amorphous backdrop (the portrait was taken in a local photography studio), but the eerie positioning of their bodies already gestures against familial unity. The mother's dark clothes and abnormally short stature—the result, the text discloses, of doing hard labor that had left her as "hunchbacked as a prawn" (124)—cause her head to float inches below the figures of her children, almost as if it were superimposed, spirit photography–style, in a double exposure. This intimation of the spectral is repeated by the wordless horror on the daughter's face: she stares open-mouthed and aghast at the camera, as if she had seen the ghost of someone all too familiar. The father, meanwhile, is the "missing person" in the shot, and turning to the text, the reader finds out why. A teacher in a tiny mountainous village in Shandong, he was hounded for being a bad element during the Cultural Revolution and died shortly after of sickness and shame.

The father's fate made his remaining family outsiders in the closed-off community—so much so that when a mobile photographic unit arrives in the village, Shao Changbo is too nervous to request her own picture and sneaks into someone else's photo opportunity unnoticed. But when the photographs are developed, she is nowhere to be seen, wiped from the negative in a prefiguration

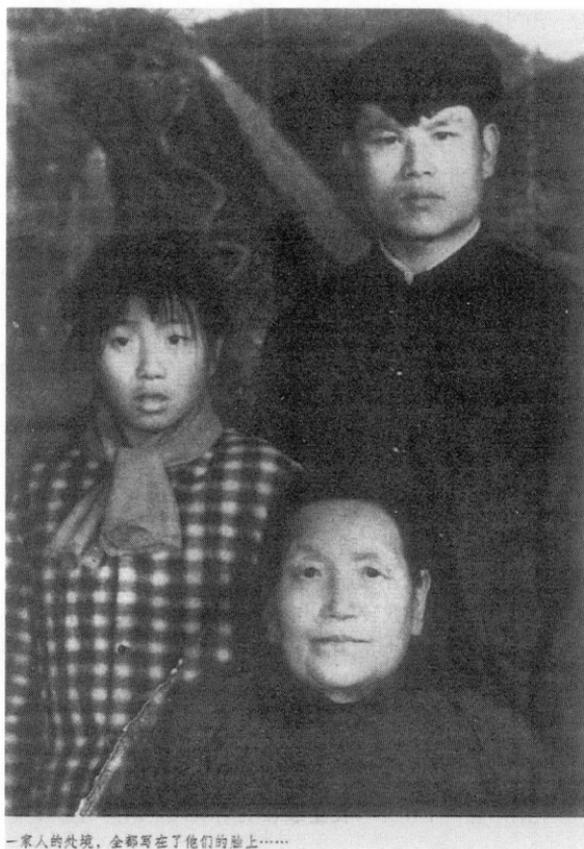

一家人的处境，全都写在了他们的脸上……

FIGURE 2.1 Templates for the familial turn in contemporary Chinese art: portraits such as these combine the homely with the *unheimlich*. From Shao Changbo, "Taking Photographs," *Old Photographs* 27 (2003).

of her own mortality that becomes even starker when she reveals that both her mother and her brother died prematurely in middle age. Six months after the mobile unit leaves, her mother scrapes together the money for their first and last *quanjiafu*, and the three journey through the mountains on foot to a private photography studio in the county town. Shao concludes, "no-one in the village ever saw that photo, and no-one ever knew that we had gone in secret to have our picture taken. Late every night before I go to sleep, I often take out that photograph and gaze at it . . . It's old now, and its surface is creased" (Shao Changbo 2003, 127). Specters and secrecy, then, come together in this brief photo-essay. Entirely commonplace nowadays, photography back then was mystical and privileged, Shao notes, which is why her outcast family had to travel in secret to the studio. The secrecy of this photo-taking practice connects with the quasi-occult appearance of the image and its ghostly presences: the missing father, the "superimposed" mother, and the daughter who glimpses

something fearful outside the frame. Studying the picture again after reading of their fate, the reader might conclude that it encrypts a further secret: that the daughter, the only person in the image whose face registers that fear, is staring into the future, at the deaths of the mother and brother who stand right next to her. The secret of the photograph is the specters it foretells, or as Barthes put it, "I observe with horror an anterior future of which death is the stake" (2000, 96).

Politics as extreme attrition is a repeated focus of this photo-essay and of many other family photo-texts in the pictorial. The author's father dies prematurely in the aftermath of persecution, her mother's body is bent double by the physical labor that she has to do as a result of the family's disgrace, her brother dies even younger because their circumstances left him without medical care. This attrition is expressed as facial scarring, both in the caption to the image, which reads, "The family's plight was etched all over their faces" (Shao Changbo 2003, 125), and in Shao's observation that her mother, forty-six at the time, looked like "an old woman in her seventies" (127). Unsurprisingly, scarring becomes a still more dominant expressive mode in family photo-texts that work with different portraits through time. The piece that directly follows Shao's essay, entitled "Debts of Loving Care That Cannot Be Repaid" (Nanbao san chunhui 难报三春晖, 2003) (figures 2.2 and 2.3), features two family portraits juxtaposed recto and verso. The first shows the family of the author, Zhang Yuhong 张玉洪, in a portrait posed shortly before his own birth; handwritten at the top of the image is the caption, "Family Photograph. May 18, 1966." Zhang reminds the reader, if any prompt were necessary, that the image was taken just two days after the "May 16th Notification" that launched the Cultural Revolution: "Neither my parents nor my siblings," he writes, "had the slightest inkling of the storm that loomed" (Zhang Yuhong 2003, 128). This date, scratched across the surface of the image, is transmuted into the ravages that score his mother's face when the reader turns the page and sees the second picture. Taken in 1974, it shows his mother with her surrounding children reduced in number and her physical persona shrunken: "The clothes she wears, the expression on her face show the trauma and pain wrought by the 'ten years of chaos.' But what really makes me gasp is how dreadfully she had aged in those eight short years" (128).

Scarring recurs in a photo-text by Xia Liqun 夏立群, entitled "My Father's Old Camera" (Fuqin de lao xiangji 父亲的老相机, 2000). The rare access to a Zeiss Ikon camera Xia's family enjoyed means that the essay is structured around a series of photographs, which allows for iterations of "then and now." The most striking pair captures the contrast between "before and after" the

·私人相簿·

难报三春晖

张玉洪

这张36年前的全家合影（图①），是那个年代我家惟一保存下来的全家福，而且是缺少我的特殊的全家福。

1961年，那时还没有三哥，父亲工作的单位给职工照全家相，照片照坏了，没能冲洗出来。当时说好以后补照，结果一拖就是5年。1966年5月，父亲领着姐姐和哥哥们去县城补照。那时祖父去世才一年多，从穿上看，父母亲还戴着"孝"。那年姐姐15岁，大哥13岁，二哥9岁，三哥才3岁。去县城的路上，母亲和姐姐替换着背，背着幼小的三哥。那年月，农村孩子能进县城照相，是件非常荣耀和幸福的事情！全家人都以为这就是我家的全家福了，没想到照相后的第二年，我又来到了世上。记得小时候母亲经常指着这张照片说：全家福不全，得重照！然而在以后的漫长岁月中，却再也没有了重照的机会。

这张全家摄于1966年5月18日。那年5月召开的中央政治局扩大会议通过的所谓的"五·一六通知"，是文化大革命开始全面启动的标志。然而，像千千万万普通农家一样，父母亲和姐姐、哥哥们丝毫没有意识到暴风雨即将来临。图②摄于8年之后的1974年，母亲、三哥和我在自家的院子里拍下了这张照片。与图①相比，母亲的穿着打扮、面部表情，足以说明"十年浩劫"带来的创伤和苦难。更让人感叹的是，短短8年间，母亲明显地苍老了！当时二哥已经接着父亲参加了工作，准备替换拍一张真正的全家福。可姐姐已经出嫁，大哥也参军去了远方，母亲身边只剩下了三哥和我。二哥从县城借回一架老式海鸥相机，为母亲、三哥和我拍下了这张照片。那年我7岁，正调皮。仔细

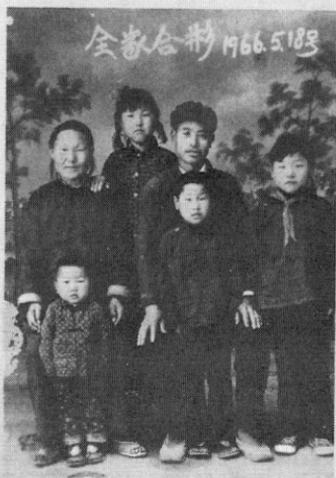

图① 1966年，缺少我的全家福。

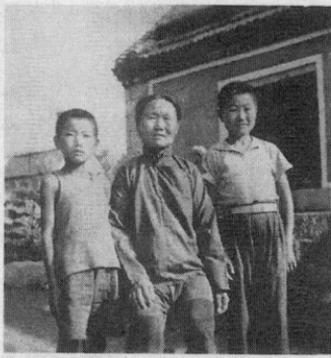

图② 1974年，母亲、三哥和我。

端详照片，您能看到我额头上肿起的大疙瘩，那是我被蜂窝留下的"纪念"。

父母1947年结婚，父亲比母亲大10岁。因家境贫困，1958年父亲买了一辆独轮木车，去县运输队给人家运货。1959年父亲又到棉花加工厂打棉花包。就凭这些又苦又累的力气活，身高力大的父亲居然成了一个在当时的农村人眼里人人羡慕的工人阶级。

听母亲说，三年困难时期，父亲在县药材公司食堂当伙夫，虽然老家宝山离县城不过十多里路，但父亲一个月半月回不了一趟家。母亲带着姐姐和哥哥们在家里挨饿，眼瞅着三四岁的二哥饿得又哭又叫，母亲只得抱上二哥，领着姐姐和大哥进城去找父亲。父亲在食堂当伙夫，近水楼台，按说家人不至于像其他农家那样饿得那么厉害。可秉性耿直的父亲一点也不会学"乖"，母亲和姐姐、哥哥们照常挨饿。姐姐实在看不过去，将家中仅有的二斤地瓜干拿到我家。母亲将地瓜干放到院墙上晾，馋坏了的大哥实在忍不住，便偷偷吃了几斤，被母亲发现后换了好一顿打，从小胆小的大哥吓得惊了一场病。母亲将地瓜面做成面，每顿饭往榆树叶菜窝窝里掺上一点；给二哥的掺得多一些，给姐姐和大哥的掺得少一些，母亲自己吃的几乎一点也不掺。尽管母爱如海，童年的二哥还是因营养不良，显得瘦弱、单瘦。

日子慢慢好了，大哥、二哥都上了学，而姐姐一天学也没有上，13岁那年就进了林业队，过早地替母亲支撑起这个缺少男劳力的家。

岁月悠悠，如今父亲已离我们远去，母亲也已白发苍苍，步履蹒跚。不惑之年的姐姐因脑溢血成了半植物人。七旬有三的母亲一提起姐姐，就禁不住老泪纵横："你姐姐这苹子命太苦了！"

大哥、二哥、三哥和我都已人到中年，我们的孩子也渐渐长大。直到此时，我们才体会到父亲当年生育教养我们五成人是多么的艰难与不易……辛劳一生的父亲已离我们而去，我们只能在母亲的有生之年为她老人家尽孝心，可我们还能有多少机会呢？

FIGURES 2.2–2.3 Politics incises itself on the photographic image as family members age or disappear. From Zhang Yuhong, "Debts of Loving Care That Cannot Be Repaid," *Old Photographs* 27 (2003).

launching of the Cultural Revolution. The first photograph of Xia and her three siblings from 1963 features four identically upturned faces, smiling expectantly, whereas the image on the opposite page, from 1971, shows the siblings with their parents, staring at the camera with matching strained and somber expressions (figures 2.4 and 2.5). During the intervening years, Xia reveals in the text, the father had been labeled a capitalist roader and the children sent as "educated youths" to different parts of the countryside. The portrait marked "our only full family photograph [*heying* 合影] from the Cultural Revolution period . . . after that temporary reunion, we had to go our separate ways again, which is why our faces are so overcast" (Xia 2000, 125). As Gao Shen 高燊 puts it in an essay about a portrait taken in the aftermath of his father's suicide: ". . . our expressions are both complex and uniform: grieving, helpless, submissive, the smiles forced. This was the facial expression shared by all those families who endured suffering during that time" (1999, 94–95). Scarring here means the grooves that suffering carves on faces: the mutilation, on the very human visage, that "scar literature" and "scar art" had depicted. But it is also the expressionistic restraint, the pressure of keeping stories secret from the camera, whose surveillant viewfinder metaphorizes social interaction more broadly.[38] Above all, though, it is the controlled rictus the face forms at seeing, but being unable to acknowledge, the family ghosts and former selves that hover at the borders of the frame. It is in this sense that the forced smile or strained expression is both a secret and a scar, and it is in this sense that secrecy itself is scarring.

Thus the scar functions—much like humor in the photo-forms of Tank Man discussed in chapter 4—as a connective node between secrecy and ghost-liness in these photo-works, which bear only superficial resemblances to the "scar" texts of the late 1970s and early 1980s. As a vestige of wounding, the scar is an anomalous, even extraneous presence on body or mind. Its tissue is warped or mortified, even as it lives alongside unblemished cells. This is why Derrida calls it phantasmic, and why it represents what he calls "*the dead time within the presence of the living present*" (2016, 74; emphasis in original). This interstitial character draws the scar into a structural resemblance to the ghost, which is a sinister familiar within the house of the living, always present but at the same time set apart, banished to the outer edges of the dwelling—attics, corridors—like the scar that stands proud from the skin. Precisely because scars protrude, so, too, are they caught within a dialectic of concealment and revelation, and thus become emblematic of the dynamics of a secrecy that is often shared. Allen Feldman draws out this point when he notes not only that "the transgressed body or body politic archives itself in the scar," but that "the scar is a shibboleth that installs a possibility of community among those so

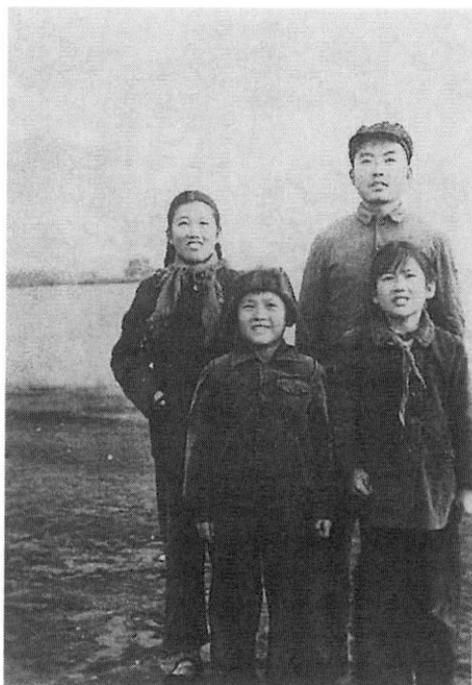

1986年我搬家，不知怎么丢失了。父亲问过多次，我不敢说，只是搪塞应付。后来，我偷偷地告诉了母亲。直到去世，父亲便再也不曾提起过相机的事。

相机跟随父亲40多年，记录了我们家的岁岁月月、风风雨雨，留下了许多珍贵的照片和美好的回忆。我深感对不起父亲，每每想起，自责、内疚之情无以言表。

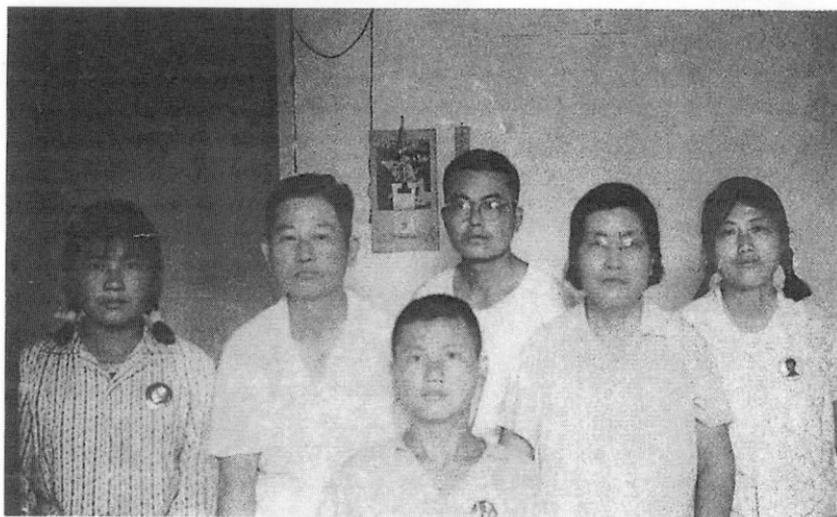

FIGURES 2.4–2.5 The figures squint happily into the sun in the first image, but all faces are overcast in the second as history takes its toll. From Xia Liqun, "My Father's Old Camera," *Old Photographs* 13 (2000).

marked and divided" (2015, 323–24). Photo-forms are apt aesthetic spaces in which to host these dynamics. Just as photography is always a *memento mori* that foretells our own passing, so, too, is the scar not just a trace of past injury but a pre-memory of the wounds that will ultimately lead to death.

It is not surprising, then, that scarring in these essays is about the deep cuts scored on faces and photographic surfaces alike. Both are governed by secrecy and drawn together by it. This is, of course, partly why the photographs themselves sometimes became contraband, hidden deep to avoid Red Guard house searches—and this secret status marks them physically, too, prematurely aging them just as it steals the youth of their pictorial subjects. As Shao Changbo puts it, her family photograph "is old now, and its surface is creased [*shangmian hai you yidao zhehen* 上面还有一道折痕]" (2003, 127). The term for "creased"— *zhehen* 折痕—contains the character for scar (*hen* 痕); secrecy, the repeated act of folding and hiding, has physically scarred the photograph, as the scars that are hidden force their way into the texture of the image itself. The same is also true of Xia Liqun's photographs. The treasured family photograph from 1971 is much more scratched and mottled than the others in the collection, so much so that the figure of her youngest brother is faded to the point of making him spectral. And the phrase for "overcast" that Xia uses to describe their faces—*yinyunmibu* 阴云密布—includes the character *mi* 密, meaning clandestine, offering a lexical signal to the reader/viewer about the secret tension their strained expressions encode.

These family portraits offer clear evidence of traumatic experience, if at one remove. Yet they are not quite what Baer (2005) calls "traumatic photographs," nor do they lend themselves fully to trauma theory, even if their repeated focus on scar tissue might seem to mandate such an interpretation. These images, in the end, were "instrument(s) holding the family in place, sustaining its togetherness against all odds" (Huang 2010, 684). Essay after essay attests to the obdurate difficulty of making these portraits happen: the pennies saved, the formal clothes borrowed, the miles trudged to the nearest photography studio. As such, they are artifacts of triumph as much as trauma, and thus traumatic discourse can only go so far in explaining objects whose very purpose was to deny the atrocious power of the political through the performance, however scarred and spectral, of family life and love. Their Chinese terms—"*quanjiafu*" (literally, the happiness of having the family altogether) and "*hejiahuan* 合家欢" (which means very much the same)— might seem intolerably bitter in their irony, but this is to forget the role that formal portraiture played as secret protest against the forces that militated for the family's disunity or destruction. To quote Huang again, "in a politi-

cally oppressive era, the family's very journey to the local photo studio was a quiet gesture of defiance" (683). Family photography, once dismissed and then later recuperated as the prime art of the idealized mundane, becomes here a practice of the logistical extraordinary. Above all, though, it is the transformation of these once-hidden images into a network of photo-texts, which not only speak but share their secrets widely, that lifts them from the domain of the traumatic. Like Liu Xinwu's mother, the other reader/writers mentioned here were haunted by their family portraits. But they draw those images out of hiding nonetheless, sending them on an odyssey into public-ness that is all the more remarkable for their decades spent in hiding. If the Cultural Revolution was in part an assault on the family and its bonds—a pe-riod when becoming a member of the "socialist big family" meant sidelining or even forswearing kith and kin—then this network of family photo-texts was not merely a reaction against that drive but a patchwork quilt that gave succor and repair.

Naming Not Shaming

Just as *Old Photographs* was reaching its heyday, and in no sense coincidentally, Chinese art also found itself caught squarely in the gaze of family photographs from the Cultural Revolution. From the mid-1990s onward, this genre of por-traiture became as dominant a master trope in conceptual art and photogra-phy as urban demolition would become during the decade that followed, even though it has generated vastly less interest to date.[39] As with the photo-texts already discussed, secrecy and its counterpractices go a long way toward ex-plaining the rise of this signature theme among avant-garde artists. Just as their work "developed side by side" (Wu Hung 2008, 133) with the mass-produced photo-texts, so was it susceptible to the same motivations. Certainly, a degree of cross-pollination existed between these multimedial repurposings of the *quanjiafu* genre, which riffed on original photographic portraits. Wu Hung notes that the "before and after" photo-texts in *Old Photographs* may have inspired Hai Bo's "double portraiture" (132), and a still more obvious rapport can be found between Liu Xinwu's *My Private Photograph Album* and the digi-tal installation bearing the exact same name that artist Feng Mengbo created ten years later, which contains a section dedicated to his parents' photographs from the Cultural Revolution era, couched alongside much more neutral im-ages in a pattern of camouflage similar to that found in *Old Photographs*.

Above all, though, it is Feng Mengbo's making public of once-private family photographs that aligns his work most closely with Liu Xinwu's project of

vernacular revelation. Like Liu, Feng raids the family archive to rob secrecy of its stigma, and it is no accident that the work is often described as China's first foray into digital art, given digitality's associations with the free and frank movement of images. Photographer Song Yongping takes this idea of using family photographs to plunder domestic privacy to a different level in his series *My Parents* (*Wo de fumu* 我的父母, 1998–2001) (figure 2.6). The first photograph in the six-image series shows his parents as a young couple posing stiffly for their wedding portrait in a Maoist-era photographic studio, but the photographs that follow are the work of Song himself. They show his parents in precipitously declining health, overtly featuring the medical paraphernalia they needed to stay alive, and culminating in an image of their funerary portraits and their junked postmortem apartment. In interviews, Song has said that the series was intended to document the final collapse of their bodies, a "record of mortality" (Chen Tao 陈涛 2011, 30). As the shadow of death lays itself ever more heavily on the photographs as the series progresses, the figures become not just living ghosts but decrepit celebrants within a *danse macabre*, a point that Song Yongping makes mordantly in image 3, which shows his parents attired in ill-fitting Western-style wedding outfits.

Yet anger can also be seen in this barbarous rehashing of the Maoist-era wedding portrait. The original photograph, Song notes in the text he wrote to accompany the series, hung on the wall of the family home throughout his childhood, a "favorite of his parents." This anger surges again in a so far overlooked painting from 2003, which remediates the much-loved wedding portrait original in grayscale oils, but with the faces of his parents blacked out, as if scissored neatly from the canvas (figure 2.7). The painting acts out an anecdote related by W. J. T. Mitchell, in which he describes the classroom lesson used by a colleague to "de-banalize" the photographic image: "When [students] scoff at the idea of a magical relation between a picture and what it represents, ask them to take a photograph of their mother and cut out the eyes" (2013, 9). Mitchell's argument here is about the latent sorcery of the photographic image, a point to which Song Yongping's painting amply testifies. But in his partner text, Song also politicizes the series, once again through the idiom of secrecy and its unveiling:

> In 1976, just a few days after retiring from military service, my father suffered a cerebral hemorrhage that was believed to result from overwork and the stress of his work post... Father was only 42 years old when he became disabled... My parents belong to a generation without thoughts of individualism or in more conventional terms, the generation

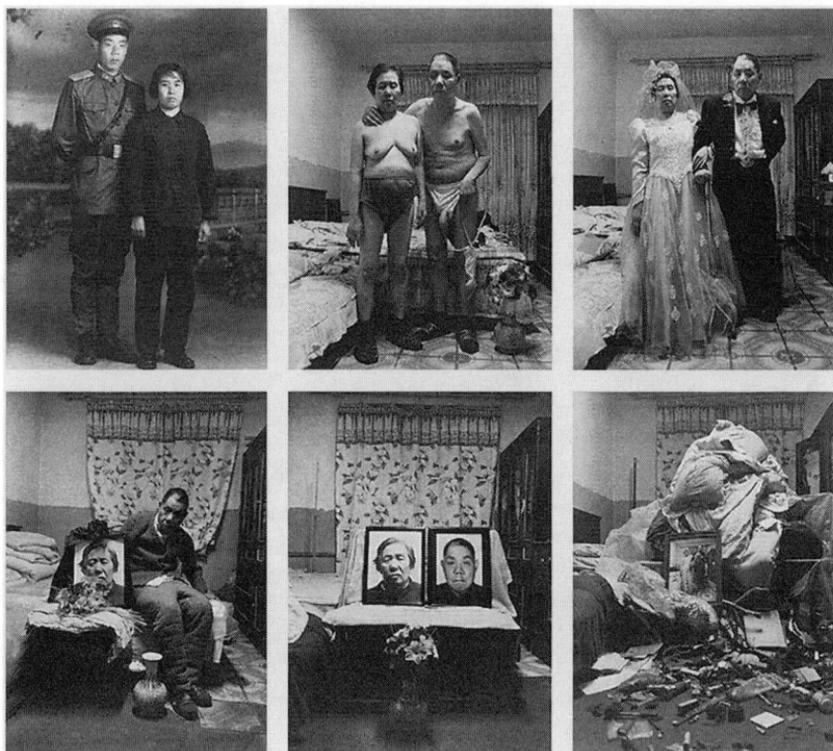

FIGURE 2.6 Song Yongping, *My Parents*, 1998–2001. Stirring pathos but also skirting indignity, the series uses nudity to reveal the skeletons in China's closet.

with collective spirit . . . I am not a good son, since I was unable to help change the life situation of my parents. My solution was to unveil to others the horrible living situation that could be regarded as my family skeleton . . . I wanted people to know that the modern prosperous economy [of today] is the result of the personal investment of my parents' generation, who sacrificed so much with so little personal reward . . . how many others' parents are living like mine; ignored and abandoned? (Song 2016)

Churned through the vortex of the Cultural Revolution, Song's father winds up on the other side, in 1976, as a disabled man in early middle age, whose suffering is hidden away in the narrow and squalid room that forms the backdrop to the series. Song's parents were "public servants utterly loyal to their work," who "could not secure support from the state as they aged and were left to their frailty, haggardness, and despair" (Ting 2014, 101). Their secret is,

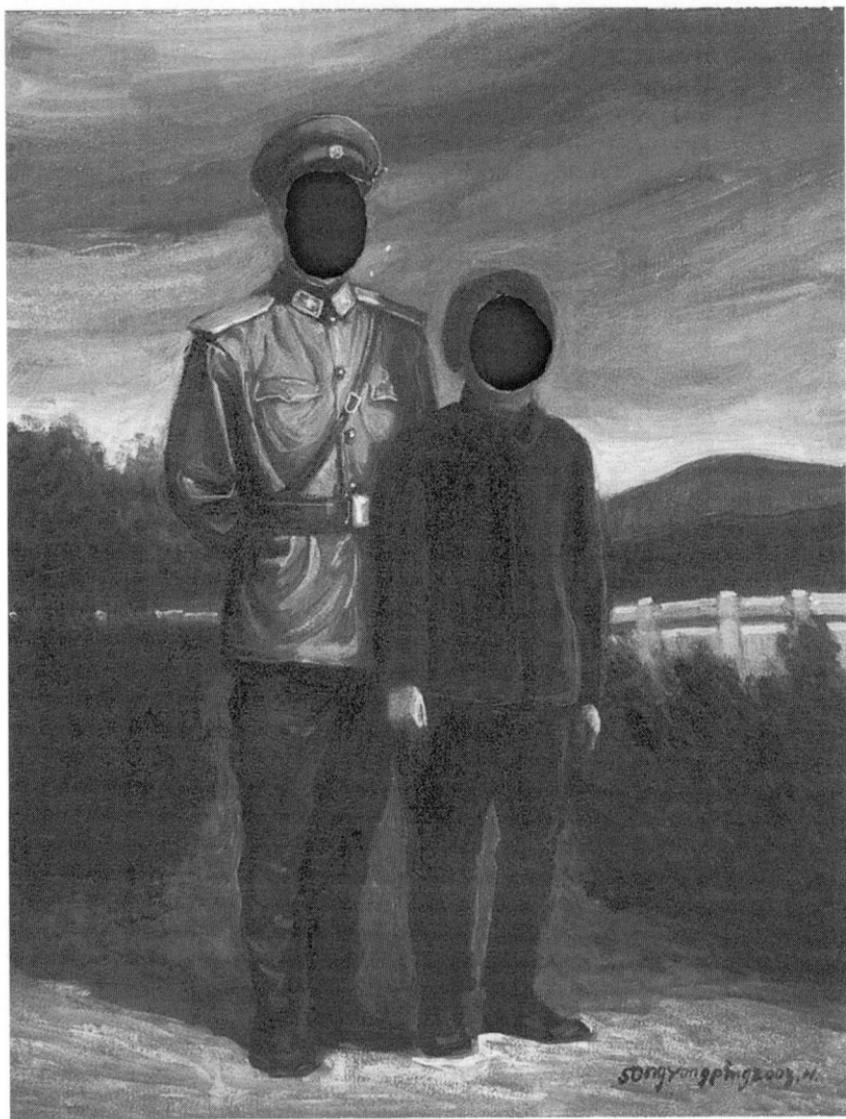

FIGURE 2.7 Song Yongping, *Untitled*, 2003. The couple's missing faces, as stark as bullet holes, parody the uniformity of family portraiture during the Maoist era.

paradoxically, their very blamelessness: the inability of those who led a model communist life—and whose catastrophic loss of health is linked directly to the turmoil of the Cultural Revolution—to receive the most basic social care and recognition. This failure, furthermore, turns them into a secret: "skeletons," to use Song's word, that rattle in the national closet, figured in the photographs as the parents' cramped apartment. To unveil both the secret of their blamelessness and the grubby secret into which that blamelessness has turned them, Song physically disrobes his mother and father, stripping them down to their skeletal state to show their scarred, forlorn bodies. Their flawed corporeality is so exposed in photograph 2 that the series has a near-indecent character to it. This is partly the taboo against displaying maimed or aging flesh, but the point is more that Song's series, which is an act of love and veneration, has to proceed via the cruelty of exhibitionism if it is to cut through the secrecy in which Song's parents and their plight exist.

Song Yongping (2016) concludes his accompanying text by declaring his parents emblems for a generation of people—the older Cultural Revolution generation—who have been cast off in China's reform era: "I opt to use my artworks to express my concern for all of them and respect for their genuine and ordinary lives as anonymous members of our society. My works are a kind of memorial to all of these unknown lives." This statement of intent, a nearly verbatim echo of Liu Xinwu's words in *My Private Photograph Album*, sites itself within the domain of the vernacular. But as with Liu and the contributors to *Old Photographs*, this remains very much a space of openly declared identities. Indeed, part of what gives the family photo-texts in *Old Photographs* and Song's *My Parents* their revelatory power is this decision to surrender anonymity. If the disclosure of a personal secret is to have more than merely cathartic value, we need to know the identity of its keeper; for revelation to have teeth, it needs a wager—it should court some kind of risk. In this sense, then, it is again no accident that family nomenclature emerged as a distinctive aesthetic trope elsewhere in Chinese art circles at precisely this time. One example is *Family Tree* (*Jiazu tupu* 家族图谱, 2000) by Shao Yinong and Mu Chen, a thirty-eight-meter-long continuous silk scroll in which are assembled black-and-white photographic portraits of over one hundred members of the artists' extended families. For the portraits, Shao and Mu clothed their relatives in Mao suits from the waist up and instructed them to adopt the same pose and the same rigid expression (figure 2.8). As they put it, "we hide personal experiences inside the Chinese tunic suit . . . On their faces you can read another book of history. In fixed postures and costumes with no personality, they create a gross intensity." As with the photo-texts in *Old Photographs*, the embodied language

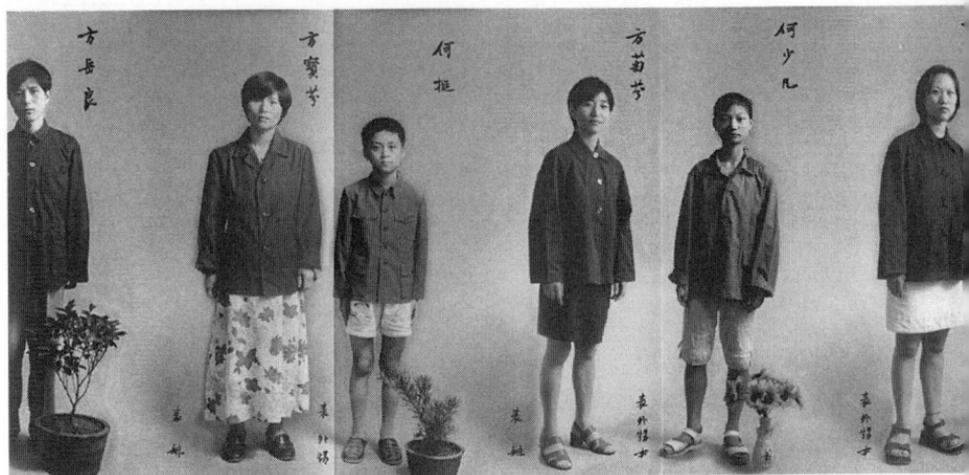

FIGURE 2.8 Shao Yinong and Mu Chen, *Family Tree*, 2000. The melding of socialist and postsocialist attire captures China's crisscrossed temporalities.

of hiding—posture, sartorial choices, forced smiles—repeated across countless domestic units becomes what Shao and Mu call a "gross intensity," a scar by any other name.

Unowned, Disowned

A work also dating from 2000 and bearing almost the exact same name is Zhang Huan's *Family Tree* (*Jiapu* 家谱). In this series of nine chromogenic prints, shot from dawn to dusk on a single day, three calligraphers scripted Zhang Huan's name and lineage directly onto the artist's own face (figure 2.9). In the first few photographs, the writing resembles tattoos or ink brandings, but as the day wears on and the characters swarm, both Zhang's visage and his familial roots merge into a viscous black. It is possible to argue that the legacy of the Cultural Revolution, and the so-called bloodline theory (*cheng-fenlun* 成分论) in particular,[40] means that "the act of publicly wearing one's connections must be read as an act of defiance" (Tai 2010). But the merging of face and name into illegibility, or rather into a death mask that defaces and disidentifies the artist, mitigates that message of rebellion. In the final image, Zhang is both scarred and anonymous, in a move that pivots 180 degrees away from the notion of naming as defiance. Thus although Zhang's series might seem of a piece iconographically with those discussed so far, in fact it forms a bridge between family photo-forms that practice vernacular revelation and

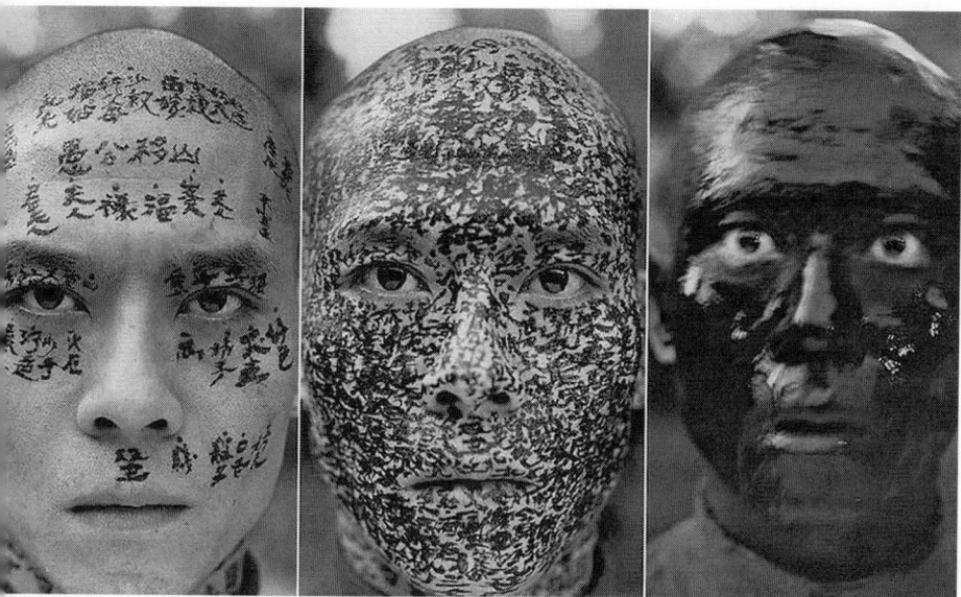

FIGURE 2.9 Zhang Huan, *Family Tree*, 2000. Here, lineage is rendered as a spreading tattoo that ultimately voids identity. Zhang Huan's blacked-out visage also prefigures the faceless parents in Song Yongping's *Untitled*.

another category of deceptively similar image-works. These are remediations of Cultural Revolution family photography that explore anonymity-as-secret and its own patterns of scarification.

Family photographs are beloved things. The acts of touching, treasuring, folding, hiding, and finally revealing these singular portraits are premised on the assumption of their inestimable value. Already in Liu Xinwu's preface to *My Private Photograph Album*, though, it is all too evident that one person's precious object can become another's *objet trouvé*. Liu writes of how he once uncovered an old leather case in a dusty school storeroom and opened it to discover "spoils" seized by Red Guards during house raids: "family photographs: old, large in size, and yellowing, featuring at least four different generations," which had been snatched from several households and carelessly "stuffed into a suitcase" (2012, 18). Liu is intoxicated by his find—it was "a thrilling sensation," "a singular experience"—but the truth is that visitors to flea markets all over China can pick up similar caches of family photos, some marked with names and dates, but most of them utterly deracinated from their emotional source. I have purchased a few such images myself over the years, and juxtaposing them with my copies of *Old Photographs*, whose family portraits are

so cherished that their well-thumbed tactility sometimes survives mass re-production on cheap paper, produces an uncanny feeling. On one level, these lost and nameless family photographs are foraged, like affective rebar, from the detritus left by house clearances or urban demolition precisely because, to quote Marshall Berman, they come from "ruins but are not ruined" (1989, 49), and because their eerie anonymity makes them piquantly sellable items within China's memory market.

But this does not deal with the fact of disavowal—dumping, even—that led these images to the salvage market in the first place. To grasp why family photographs from the Cultural Revolution are as easily abandoned to scav-engers as they are disguised in faded envelopes and locked away in boxes, we might usefully look to public secrecy—or rather to the fact that some secrets are more disclosable than others. I suggested earlier the notion of a molecular or quilt-like secrecy: the countless personal experiences of the Cultural Revo-lution that were supposedly untellable because they contradicted the narrative that identified the Gang of Four, and to a lesser extent Mao Zedong, as distant and abstracted bearers of blame. Many family photo-forms in *Old Photographs* pick at the seams of this secrecy, principally by naming agents of persecu-tion far closer to home. One or two photo-texts in the periodical—though not those that feature family portraiture—even go so far as to narrativize perpe-trator experience directly.[41] The overwhelming focus, however, is on revealing victimhood, and if the idea of complicity is faintly mooted, it refers only to the hiding of that personal pain over many years. Yet what of the fact that to this day China lacks a systematic calling to account about the political violence of the Cultural Revolution, let alone any processual moves toward truth and reconciliation? This failure to reach a societal reckoning, one might argue, is the biggest secret of all, cloaking society in its entirety, and for good reason.

It is within this context that I conclude this chapter by looking briefly at two final family photo-forms: Hai Bo's photographic sequence *They* (*Tamen* 他们, 2000) and Zhang Xiaogang's *Bloodline: The Big Family* series, the best-known aesthetic repurposing of family photography from the Cultural Revolu-tion. There are notable points to make about the haunted character of these works and their elevation of the scar to almost iconographic status. Critics have covered this ground, as has Zhang Xiaogang himself, who makes the spectral point explicitly when he states, "I have to make a clear distinction between the Zhang Xiaogang of reality and the demonic one. When I paint, I am a ghost . . . If my ghostly spirit has not assailed me, I do not paint" (Zhang Xiaogang and Ouyang Jianghe 欧阳江河, 2009). Of greater interest to me here, though, is the signature anonymity of these works and the relationship between this deliber-

FIGURE 2.10 Hao Bo, *Three Sisters* (*San jiemei* 三姐妹, 2000). The photographer stages an encounter with the past that proves the latter is a foreign country.

ate namelessness and the "biggest secret" of the Cultural Revolution. Hai Bo's *They*, an extended series created at the turn of the millennium, restages Cultural Revolution photographs by reassembling their pictorial subjects decades later. These subjects are then posed precisely as in the original image, and the two photographs are exhibited in diptych form. The "before and after" thus created has a ghostliness that grabs the viewer most aggressively when the "after" photograph, as in figure 2.10, leaves gaping spaces for missing persons, or when the scars morph from the rough texture of the original image to the deep planes that fissure people's faces. The key to *They*, though, lies in its title, which arrogates an emphatically generic quality to the series, despite the fact that its composition was evidently based on painstaking efforts to locate specific individuals and persuade them into the photograph.[42]

Turning a *sui generis* private artifact into a generic imagistic type in this way is a gesture that seems to motion viewers of a certain age and experience into the frame: the Cultural Revolution happened to all of "us," in other words. This argument surely has a still stronger valence with Zhang Xiaogang's *Bloodline* paintings, a series that, in its balance between flat repetitiousness and a facial expressivity that almost stalks the viewer out of the gallery, also seems to include all the Cultural Revolution generations in the haunted circle of its address. It insistently plies the paradox between the family photograph as a secret artifact and one that came to connote collectivity via the standardization imposed in photo studios. The same is true of the "scars" in these paintings, the colored blotches that sear the porcelain-smooth texture of the face/canvas and that are as randomly assigned as birthmarks. In this sense, they link up with the series title and its language of lineage, which recalls Feldman's point

about the scar as "a shibboleth that installs a possibility of community among those so marked and divided" at the same time as it refuses to name names. Thus it might seem reasonable to ask: Where does Zhang's source material come from? By most accounts, he was inspired by his own family photos, but the faces that seem neither to change nor to stay the same across this long series belong to no identifiable clan despite their stated "bloodline." As such, they are as rootless as the photographic equivalents of found footage that tourists can pick up for a few yuan 元 in flea markets, and their generic character distances more than it beckons in. They "ghost," through their anonymity, the family photo-texts of *Old Photographs* and their efforts at networked revelation. Surely it is no accident that the *Bloodline* series began in the mid-1990s, the very same period in which the periodical launched.

Living in a "big family"—Zhang's code word for socialist society—"the first lesson we have to learn is how to protect ourselves and keep our experiences locked up in an inner chamber away from the prying eyes of others" (quoted in Chang 2012, 95). Here Zhang signals, in ways that have been ignored in favor of the familiar mantra about amnesia, that his series is also and crucially about secrecy.[43] But what does it hide? To answer this question, we might look sideways at the "named" photo-forms of *Old Photographs* and Song Yongping, which were exactly contemporaneous with the "nameless" works of Zhang and Hai Bo. At a time when family photographs were being crafted via practices of remediation into vessels for revealing long-buried secrets, the anonymity of these peer works—even as they repurpose exactly the same category of image—functions as a kind of re-veiling, a visual avowal of the fact that public secrecy remained the macro mode of knowledge about the Cultural Revolution during the late 1990s and beyond. Unclaimed family photographs are not just lugubrious artifacts (thanks to the backstories they can never tell), but articles with a whiff of shame about them: not unowned so much as disowned. As such, they show that the amorphous secrecy discussed earlier should now be recast to designate the bigger and dirtier secret that the continued absence of a full societal reckoning about the Cultural Revolution is an arrangement that has served multiple constituencies: not just the CCP, but also those citizens who acted then in ways that they would now prefer to hide and disavow.[44] In this sense, the responsibility for those years remains as anonymous, but as potentially everywhere—and at home—as the ordinary families whose faces stare out from the photo-forms. And the dirtiest secret of all, which tinges all of this iconography by faint association, is the barely spoken of— the unspeakable—legacy of intra-family violence and betrayal during the Cultural Revolution: the children, grandchildren, and spouses who informed on

their own kin, denounced them publicly, or cut ties with them on ideological grounds.[45]

Meanwhile, the serial character of Zhang Xiaogang's *Bloodline*—numbed face after numbed face—hints at how secrecy functions as a means of social management, of pacification almost. Simmel noted that "everyone who has been active in public life knows that a small collection of people may be brought to agreement much more easily if their transactions are secret" (1906, 492). But large groups, too, can be herded into alignment under the aegis of secrecy, especially when its exposure carries a threat. Photo-forms emerge throughout most of this book as aesthetic objects that attenuate the grip of secrecy in some way, if they do not apply pressure to it directly. But if family photographs are indeed "emblems of the cryptosphere," it is only to be expected that their remediations might be used both to reveal secrets within a pioneering proto-digital network but also to show the extent to which public secrecy still reigned at the turn of the century and beyond. This equivocal nature of the photo-form as artifact took center stage in the previous chapter, which explored how remediations of the Nanjing Massacre archive have served not the artist-activists who have dominated this chapter, but rather the Chinese state. Photo-forms are equivocal because public secrecy is so protean and ungraspable, prone—unlike amnesia—to unexpected mobilizations. As artifacts that are immanently responsive to the public secret, the image-works discussed in this chapter both make portraits speak within the pages of *Old Photographs* and then return those selfsame pictures to silence: they show, like Liu Xinwu's friend who wanted and then did not want to show his photographs, that vernacular revelation existed in constant tension with vernacular secrecy as China grappled with the shadow of the Cultural Revolution in the 1980s and 1990s.

The wide take-up of the internet, as discussed earlier, changed these rules of engagement as the century turned. Since the mid-2000s, information about the Cultural Revolution, much of it personal, has spread online in sufficient volume to shake secrecy, even though web censorship still imposes restrictions. But as a form of state power play, public secrecy lives on and is perhaps all the more flamboyant for the challenges it has faced. This point is keenly illustrated by the fate of the privately run "Cultural Revolution Museum" in Shantou, the only brick-and-mortar site to use that name ever to be built on Chinese soil. In April 2016, a few weeks before the fiftieth anniversary of the launch of the Cultural Revolution, work teams arrived at the museum: "They smoothed concrete over the names of victims, wrapped 'Socialist Core Values' banners around the main exhibition hall, placed red-and-yellow propaganda

posters over stone memorials to the terror, and raised scaffolding around statues of critics of Mao" (Tatlow 2016). Described as a "literal cover-up," the swathing of the museum in banners and concrete demonstrates public secrecy at peak performance, as these actions were at base spectacular, even if they did not gain much coverage in mainland media. More than this, they show that memory, dominant though it has been as a prism through which to view China's modern history, is insufficient on its own as a tool for grappling with how that past has made it into the present. After all, the state and its agencies could just have easily have demolished the museum, a prime *lieu de mémoire*, or unceremoniously closed its doors. The elaborate acts of cloaking, paving over, and disguising they opted for instead show that public secrecy remains—now as then—a core epistemological mode through which to grasp the fugitive afterlives of the Cultural Revolution.

×
× 3
×

From an anecdotal standpoint, the perception of the secret is the opposite of the secret, but from the standpoint of the concept, it is a part of it. What counts is that the perception of the secret must necessarily be secret itself: the spy, the voyeur, the blackmailer, the author of anonymous letters are no less secretive than what they are in a position to disclose . . . the secret has a way of spreading that is in turn shrouded in secrecy. The secret as secretion. The secret must sneak, insert, or introduce itself into the arena of public forms; it must pressure them and prod known subjects into action.
—DELEUZE AND GUATTARI, *A Thousand Plateaus*, 2004

There was no place to put her ashes, since she had been condemned as the member of a "black gang" . . . When the bookcase was closed, it was no different from an ordinary bookcase. When there were no outsiders, we kept it open. For years the altar was hidden by books.
—WANG JINGYAO 王晶垚, quoted in *Wo sui si qu* 我虽死去 (*Though I Am Gone*), Hu Jie 胡杰, dir., 2006

Taking It Viral

The photograph in figure 3.1 shows Bian Zhongyun, former vice-principal of the Girls Middle School attached to Beijing Normal University, who was beaten to death by Red Guard pupils on August 5, 1966, in one of the earliest killings of the Cultural Revolution. Her death, "the first recorded Red Guard murder in Beijing" (Walder 2012, 128), is seen as a watershed event in the Cultural Revolution, both the symbol of and the spark for a summer of extreme political violence in the capital, in which many hundreds died in chaotic conditions.[1] For years, Bian's photograph was almost impenetrably inaccessible.

FIGURE 3.1
Photograph of Bian
Zhongyun. Once a
private keepsake,
her portrait now vi-
brates with political
meaning.

It formed part of her shrine, placed above an urn containing her ashes that was concealed behind a false-fronted bookcase in her widower's apartment. That photographic reliquary served as what Deleuze and Guattari call the "container, envelope or box" in which clandestine content dwells (2004, 316), the blind passage, false chamber, or sliding panel that skirts the edges of the living room, the secret in densely metonymic form. What, after all, is more covert than an altar, bearing the physical remains of a wife and mother who cannot be openly mourned, hidden in a recessed cavity in the family living room? But since 2006 a steady process of "the secret as secretion" has unfolded, driven mostly by the internet. A search for Bian Zhongyun on Baidu or Google Images turns up Bian's smiling photograph again and again, along with several much more private images—mortuary photographs, in fact—taken by Bian's husband, Wang Jingyao, with a Seagull camera in the hours after her death. From hidden family altar to something close to virtual public shrine, Bian's photograph, with its hidden history, seems to demonstrate how readily secrets

can be brought into open air in the digital epoch. From WikiLeaks to Facebook, from forced exposure to willful divulgence, we all know that the internet hates a secret, even as it plays ready host to countless clandestine practices: avatars, the dark web, the trolls who violate anonymously.

The relationship between the internet and secrecy is a point to which I return throughout this book, but for now it is the power of digital networks to spread rather than to sequester information that comes to the fore. Photographic repurposing is the web's close ally in this process of dissemination, as figure 3.2 demonstrates clearly. It shows an image capture of the results of a Baidu search for Bian Zhongyun's name in July 2016. Items of particular interest are ringed in white. The first, figure 3.2A, is a digitized version of Bian's original photograph. That image first gained significant exposure via a website entitled *Chinese Holocaust Memorial* (*Zhongguo wenge shounanzhe jinianyuan* 中国文革受难者纪念园),[2] an online cemetery that Chicago-based researcher Wang Youqin 王友琴 set up in 2000,[3] motivated in part by her own memories of being a pupil at Bian's school in 1966. The mission of the website is to enshrine "forgotten" victims of the Cultural Revolution period: to record the names, show the faces, and relate the final stories of those who died in the violence of those years. Bian Zhongyun's entry in Wang's online register features her photographic portrait, provided by her husband, which is garlanded by white chrysanthemums (a symbol of death in China), and is followed by a long account of her life and murder. The website was blocked in China a year after its launch, but it gave Bian Zhongyun's photograph enough traction to move into other spaces. In fact, *Chinese Holocaust Memorial* features a link to a now quite celebrated documentary, *Though I Am Gone* (*Wo sui si qu* 我虽死去, 2006), which was directed by underground filmmaker Hu Jie with the express aim of forcing a head-on reckoning with Bian's death. Hu's intense film is structured around a series of to-camera interviews with Bian's husband Wang Jingyao, interspliced with lingering shots of the above-mentioned portrait and several other photographs of her in life and death, which recast those analog images in the medium of digital video. Figure 3.2B shows one of the mortuary photographs he took, which feature in the film.

Hu's film was far too forthright for the authorities, and *Though I Am Gone*, like *Chinese Holocaust Memorial* before it, is now banned in China. But its digital video format, and the web-based mobility that format affords, allowed the documentary to disseminate Bian's story, and her once-secret photograph, still farther afield. In particular, the image reached Beijing-based artist Xu Weixin, who went on to paint a vast diptych of the married couple, half of it based on the photograph, for his epic series of photorealist portraiture, *Chinese*

FIGURE 3.2 Screenshot of results from a Baidu search for "Bian Zhongyun" (卞仲耘), taken July 15, 2016. The transmedia travels of her portrait speak to the restiveness of the silenced past.

Historical Figures (Lishi Zhongguo zhongshengxiang 历史中国众生相). Figure 3.2C shows Wang Jingyao standing in front of Xu's canvases. Evidence that Bian's photograph made its way to Xu Weixin on the wings of the digital can be found in the artist's blog, a rich resource he has used for some time now to build the meaning and impact of his paintings paratextually: one section is devoted to displaying his series *Chinese Historical Figures*. Each photo-painting is accompanied by the life story of its pictorial subject; in the case of Wang Jingyao's portrait, this narrative makes direct reference to Hu Jie's film *Though I Am Gone* and acknowledges *Chinese Holocaust Memorial* as a key source for its biographical material (Xu n.d.).[4]

Figure 3.2D, meanwhile, shows the original photograph on which another of Xu's photo-paintings is based: his portrait of Song Binbin 宋彬彬, a Red Guard leader at the Girls Middle School attached to Beijing Normal University in the summer of 1966, and the daughter of Song Renqiong 宋任穷, general in the People's Liberation Army and one of the Eight Elders of the Chinese Communist Party. Song's face and name became synonymous with the Red Guard terror of the summer of 1966 when a photograph of her pinning a red

Song Binbin: Teacher, I'm sorry. I didn't protect you... Don't you see who this is? I was barefoot when it happened!
Bian Zhongyun: There were three feet kicking me. (Jiu'an)

FIGURE 3.3 Jiu'an, cartoon of Song Binbin, 2014. Song Binbin attempts to exculpate herself mid-apology by quibbling about footwear.

band on Mao Zedong's arm, taken thirteen days after Bian's death, became national news (figure 3.2E).[5] During their encounter, footage of which appears in *Though I Am Gone*, Mao reportedly told Song to change her given name from Binbin, which means "gentle and refined," to Yaowu 要武, meaning "be violent"—an exchange that was broadly taken as a quasi-formal endorsement of Red Guard violence. Things then turn "meta" in figure 3.2F, which shows the "photograph" accompanying Bian's entry on Chinese-language Wikipedia. Yet the picture shown is not, in fact, Bian's photograph at all, but rather Xu Weixin's hyperrealist painting of that photograph, made curiously "official" despite the fact that Xu's paintings themselves have sometimes been subjected to censorship. Next is figure 3.2G, which shows a bronze bust of Bian Zhongyun carved by sculptor Sun Jiabo and erected in her old school in 2011. In 2014, that statue made headlines in China as it served as a site of controversial penitence for some of the former Red Guards—Song Binbin among them—who "could not stop the violence" on the day Bian died.[6] As Sun Jiabo has indicated, the statue is modeled closely on Bian's photograph, from the expression on her face to the style of her shirt collar (Feng Jinglan 冯敬兰, 2011). Finally, that photo-sculpture, in its due turn, spawned a mordant digital cartoon by political artist Jiu'an, which spoofed an apology that some saw as self-serving (figure 3.3).

The interlacing web of repurposed images and objects traced above shows that the digital realm has helped to propagate these photo-forms, spawning

one from another in a process of aesthetic pollination, one that transforms Bian's photograph from a clandestine object behind a false-fronted bookcase into one that moves provocatively across wide spaces. As the cross-referencing and name-checking between these various digital platforms demonstrate, the commemorative website propagates the digital video documentary, and together they help to yield the artist's blog, the Wikipedia image, the bronze bust, and the online cartoon. The Baidu screenshot in figure 3.2, then, inadvertently maps a network of dissemination via photo-form. The screenshot itself is as static as it is zigzag and random (search engines, after all, change their algorithms frequently). But nevertheless, it plots an intensely communicative matrix, and one that refutes the rising argument that the internet is atomizing. Its operations have endowed Bian Zhongyun's portrait—and the extraordinarily sensitive story about violent mayhem among the offspring of the top Communist Party leadership during the Cultural Revolution, which that photograph now represents—with what Jenkins, Ford, and Green (2013) describe as "stickiness" and "spreadability," or what Deleuze and Guattari (2004) would call the power to "secrete." What does this steady under-the-radar dissemination mean in the context of ongoing public secrecy about the role played by party princelings in the days of bloodshed that launched the Cultural Revolution? Does it bring about an end to secrecy, its opposite state, or something else altogether?

In this chapter, I argue that this network of photo-forms repeatedly repurposes that once-hidden image of Bian Zhongyun in order to put steady sideways pressure on the larger secret of who killed her. The objective of those who built this network is not exposure, mostly because the latter has lost its mettle as a combatant against secrecy in recent years, and surely stands little chance in an advanced cryptocracy such as China. Rather, this network, which is better described as cautiously insurgent, operates by repurposing Bian's photograph in ways that incline toward the subtler tactics of revelation. In returning to this term, with its Benjaminian connotations of justice and accountability, I explore in particular the power of photo-forms to induct their viewers into an encounter with the numinous. As discussed in the introduction, ghostliness is an abiding trait of aesthetic objects that re-version historical photographs. But this chapter shows how the network of photo-forms that remediate Bian Zhongyun's photograph draws spectators into an understanding of the relationship between secrecy and the more mystical nature of our rapport with the dead. Coincidentally or otherwise, the years when this network of photo-forms became active saw mounting moves by Red Guards from Bian's former school to engage in public reflection about the events of summer 1966,

culminating in Song Binbin's apology in 2014, delivered with bowed head before Bian's photo-sculpture. The apology proved divisive and contentious. But I conclude this chapter by suggesting that it constituted a nascent challenge to the public secrecy that surrounds aspects of the Cultural Revolution today, not merely as a specific set of "unknown knowns"—the "whodunit" that seems all too obvious—but as the epistemological mode via which the violence of that period has hardened into history.

Secrets, Minor and Public

The story of Bian Zhongyun and her photograph offers an object lesson in secrecy as a Hydra-like form, with many possible antagonists. Early in *Though I Am Gone*, Bian's husband, Wang Jingyao, describes the practice of "ransacking households," or *chaojia* 抄家, which was a common Red Guard tactic in the early days of the Cultural Revolution. "What was *chaojia*?," the filmmaker asks. Wang replies: "It was when rebel factions ganged together and set upon the house of a target. They would rummage through chests and cupboards, or worse still even rip up the floorboards and pull down the rafters . . . they'd smash up the things that could be smashed up and burn the stuff that could be burned." Above all, *chaojia* was about the rough and violent exposure of secrets and the denial of any right to them; it was the rootling out of private things (letters, books, photographs) that could be used to incriminate the person who was being struggled against. *Chaojia* was desecration, in other words, and as Deleuze and Guattari (2004, 316) note, this kind of sacrilege is only one of secrecy's many antonyms. The partner form of *chaojia*, which Bian Zhongyun and her family also directly experienced, was to be turned into the subject of "big character posters" (*dazibao* 大字报), hand-scrawled messages that defamed political enemies with extreme prejudice and served as a widespread tool for intimidation during the Cultural Revolution. Wang Jingyao describes, later in the documentary, how Red Guards broke into their home and plastered the walls with reams of profane personal abuse. Having endured both *dazibao* and the fear of desecration—the reason why he placed Bian Zhongyun's photograph and ashes behind the bookcase in the first place—Wang Jingyao, in his demand for justice, has little interest in mere exposure, in simply tearing away the bookcase to show what lies behind. His excruciating experiences of political shaming make incarnate the need for more supple modes of reckoning with secret histories. The network of photo-forms sketched above, in its links and nodes that knot together over time, exemplifies this idea of a coaxing or gradated approach to drawing long-hidden things out of occlusion.

Yet Wang Jingyao is not the only secret-keeper, and the false-fronted bookcase is only one aspect of Bian Zhongyun's death and its long concealment. There is also the larger secret about who murdered her—the veil drawn over the exact identity of the pupils, in a school that educated the so-called red aristocracy, who battered her to death using planks of wood studded with nails. In *Though I Am Gone*, Wang Jingyao describes his wife's place of work as an "imperial school" (*huangjia nüxiao* 皇家女校), which contained many pupils of even higher sociopolitical "rank" than Song Binbin. The daughters of Deng Xiaoping and Liu Shaoqi 刘少奇 were also pupils there on the eve of the Cultural Revolution—indeed, both have been accused online of having had a direct hand in the killing[7]—and Wang Jingyao tells the camera matter-of-factly that the school was full of the "daughters or nieces or granddaughters of members of the Standing Committee of the Chinese Communist Party," the sister of disgraced party chief Bo Xilai 薄熙来 among their number. Wang Youqin's (2000) account states that half the school's intake in 1965 were the offspring of top cadres and, moreover, that Bian Zhongyun had been the teacher of Mao Zedong's daughter Li Na 李讷 and was personally acquainted with Mao's wife, Jiang Qing. The school's extraordinarily entitled status may explain why Wang Jingyao felt the need to hold tightly to every jot of evidence relating to Bian's murder. He kept the abusive *dazibao* on the walls of his home for years so that anyone who visited could witness them; he safeguarded all "first hand written materials" relating to Bian's case, including the signatures of the people who visited her in the hospital on the night of her death; and he carefully stored the photographs he took and the clothes she wore on the day she died. The status of the school may also explain why a letter he received from a teacher who witnessed the beatings was penned anonymously. Even after Hu Jie tracked the author down nearly forty years later, she declined to reveal her identity, saying that "the time was not yet right." In fact, there has never been a timely moment for exposure, as Wang Jingyao discovered when he tried to file a lawsuit against one of the alleged ringleaders and received a letter stating that the "prescribed time had passed." On the back of the letter, he added his own enraged handwritten judgement: "Officials shield each other, and never need to find a pretext."

Wang's efforts were stonewalled in part because so many of those bearing firsthand memory of August 5, 1966, closed ranks against him. In their study of Bian Zhongyun's death and its long aftermath, Susanne Weigelin-Schwiedrzik and Cui Jinke argue that Song Binbin and her classmates form a so-called carrier group of Red Guard memory: "Carrier groups are formed from among 'insiders' sharing similar, and in this case traumatic, experiences as victims or

perpetrators. They exchange memories among themselves and refrain from communicating with 'outsiders' while developing their own narrative of the past. . . . Because this form of coming to terms with the past is not public, outside observers gain the impression that the Cultural Revolution is forgotten . . . [they define] the rules of inclusion and exclusion" (2016, 738). Weigelin-Schwiedrzik and Cui go on to argue that Song Binbin and her in-group "see themselves as non-participants in the beating" but at the same time lack the courage "to reveal the names of those who did take part" (740), presumably because the perpetrators belong to a still more elite group, to whom Song and the others owe a looser group-based debt of fearful loyalty. Thus they stay silent on the identities of the killers, even though this muteness keeps them under suspicion at the same time as it signals to Wang Jingyao and the "interested public" that there is "something to this case everybody knows but nobody dares to address" (743). That something relates to "an aspect of the Cultural Revolution which has so far never been publicly addressed in the PRC: the participation of the sons and daughters of the leadership of the CCP back in 1966" (739–40). Throughout their closely argued study of Bian's death, Weigelin-Schwiedrzik and Cui return repeatedly to "memory" as their core conceptual tool. Yet the situation they describe is closer to one of intricately nested secrecy, in which memories matter only insofar as they serve as clandestine tokens of belonging, Masonic handshakes that mark those in know from others who are excluded from the "club." The act of concealing, more than that of remembering, is what creates community here.

Beyond this, of course, lies the greater "unknown known": the generalized yet unutterable sense that certain members of the CCP progeny who enjoy inherited positions of extraordinary wealth, power, and privilege today may well have blood on their hands. According to Song Yongyi 宋永毅 (2004), this is the "open secret" that during the reform era many former Red Guards who had been active in 1966 rose to power "by virtue of their connections with the Party establishment." As he puts it, "under China's ongoing economic reforms, many of them have also prospered under red-bureaucratic capitalism through involvement in corruption, abuse of power and de facto looting of state-owned property. Since the 1980s, such individuals have acquired notoriety in popular parlance as the 'princelings' (*taizidang*)" (22).[8] Building on this, we can see the story of Bian Zhongyun as a tale of two secrets. On the one hand is the secret of the false-fronted bookcase, with its photograph and altar; the Seagull camera and the long-hidden mortuary images it took; and the suitcase, unopened for forty years, in which Wang Jingyao hid the soiled and furled-up clothes Bian wore on the day of her death. This, by all measures, is a personal or minor

secret. It is Wang Jingyao's response to violent bereavement and the testimony of his drive to keep his wife's murder "true to history." For decades, this minor secret coexisted alongside, yet sequestered from, the public secret about the identity of Bian's killers, a secret whose reach and purview stretch all the way into China's ruling echelon and into the domain of public life. Bian's death, in the context of this larger public secret, may even function as a codeword, an encrypted sign, for the problematic power-holding of the princelings more generally.

In this sense alone, the story of Bian's murder exemplifies the entanglements that drive the economy of secrecy in a cryptocratic society, where cover-ups generate counter-cover-ups and where clandestine actions proliferate. More intriguing, though, is the relationship that unfolds between these two secrets from the turn of the millennium onward, a relationship the network of photo-forms I describe here purposefully mediates. This network, built by artist-activists, takes justice for Bian as its aim. Yet it refrains from trying to name and shame Bian's killers; by revealing the minor secret, this network of photo-forms act on the public secret in other ways. After all, exposure as a strategy against Bian's killers had patently failed long before the network came into being: all the text-based evidence that Wang gathered came to naught, and the case was closed. What the network charts, by contrast, is a different kind of insurgent operation: the aesthetic disclosure of one secret as a means of putting lateral pressure on another, and in ways that end up challenging public secrecy itself as the macro mode of knowledge through which taboo aspects of the Cultural Revolution's legacy are processed today.

Time's up for Exposure

This moving away from exposure as a means of reckoning chimes intuitively with a larger disenchantment with the once strong belief that publicity is the decisive act that can conquer clandestine forces. Much recent thinking on secrecy argues that it is time to jettison that faith. The fate of leakers such as Edward Snowden shows that lifting the lid is more often a case of Pandora's box, where evils spread unchecked, than a disclosure that then cleanly leads to closure. At the very least, the fact that exposés so often fail to change the malfeasance they unmask ends up giving ballast to the status quo, a diagnosis Baudrillard made long ago when he argued that the scandalous exposure of Watergate really only reaffirmed the ruling order (1983, 27). This point became clearer still with Abu Ghraib, whose lasting significance may lie, as Alasdair Roberts observes, "in the extent to which we overestimated the catalytic effect

of exposure" (2006, 238). In spite of this—because of it, perhaps—the drive for full-frontal publicity continues, so that we now routinely "over-expose secrets to the half-light of attention" as the depreciated currency of exposure simply leads people to tender its coin ever more doggedly (Siegworth and Tiessen 2012, 53). But how can exposure ever hope to work when secrecy is now so brazenly out in the open? In an era of what Debord calls "generalized" or "spectacular" secrecy (1998, 12), in which the capacities of states to conceal their doings are openly showcased via rendition programs, illegal detainments, and closed tribunals—the clandestine as power play, in other words—the belief that whistle-blowing could call time on secrecy seems quaint. In China's cryptocracy of today, where secrecy is so blatantly tied to power-holding that it sometimes exceeds the semantic properties of the term "spectacle," the notion that exposure could be its antidote veers toward farce.

How, then, to deal with secrecy in both liberal and illiberal states? The general loss of faith in the powers of publicity to effect social justice has led some scholars of secrecy in Western democracies to advocate rehabilitating the term from the moral badlands. Secrecy, this argument goes, should be released from its associations with the corrupt and the cabalistic, partly because no governmentality can function without it, and partly because to damn secrecy out of hand is to assume that transparency is always the friend of the good, when in fact opacity may sometimes be a more effective safeguard against a "datafied, securitized, and surveillant state" (Birchall 2016a, 154). Better instead to watch and learn how secrecy works. Or as Jack Bratich puts it, "in an age where secrecy is virtually everywhere as a strategy of domination, can we begin to experiment with an insurgent secrecy, a minor secrecy . . . ? Why not accord it some affirmative powers? . . . Secrecy as a strategy is already the subject of experimentation in the activist milieu. So what better way to explore active secrecy than by tracing a line through secret activism?" (2007, 48). Bratich cites in particular the example of black bloc, in which activists and anarchists mask themselves with dark scarves, balaclavas, or helmets in order to disappear into a secret collective that touts the anonymity of camouflage. Black bloc wrests secrecy from elites and the state, and practices it brashly in public spaces.

The fact that the only occurrences of open-air black bloc to date on Chinese soil have taken place in Hong Kong (Lo 2015), where state power still waxes weaker, gives some indication of the limited traction that occult strategies such as these can hope to gain in a hard-core cryptocracy such as China. Here, secrecy itself—by which I mean the right to practice it in public, as something performative—is as jealously guarded as any sealed archive or encrypted file.

This is, of course, Derrida's point when he argues that "if a right to the secret is not maintained, we are in a totalitarian space" (Derrida and Ferraris 2001, 59). Approximations of black bloc have also occurred on the Chinese web in response to state crackdowns on political dissidents, but the closing in by the security apparatus on these attempts to reclaim spectacular secrecy reveals their limits, as a couple of examples show. After the house arrest of leading activist Chen Guangcheng 陈光诚 in 2010, cartoonist Crazy Crab set up an on-line protest, inviting concerned netizens to post pictures of themselves wearing sunglasses to a website entitled "Dark Glasses" (Chen is blind and wears a distinctive pair of dark spectacles). As An Xiao Mina notes, "These selfies . . . served a dual purpose. First, they seemed innocuous enough to censors, who weren't clued in to the sunglasses reference. Secondly, they showed scale for the in-group in a powerful way" (2014, 365). A scan of the website reveals something more than this, though. Many of the netizens discarded the sunglasses in favor of thick black cloths that swathed the face; they pixelated, blurred, or overexposed their images; they photographed themselves in semi-darkness. They were practicing digital black bloc, in other words, and the movement even migrated briefly offline, as flash mobs sporting sunglasses loitered outside the hospital where Chen was held under guard. This tactic shares some space with netizen responses to the closed trial of human rights lawyer Pu Zhiqiang 浦志强 in 2015. As the courthouse was patrolled by plainclothes policemen who wore yellow smiley face badges—ostentatious secrecy, once more—netizens who wanted to show support changed their profile pictures *en masse* to photographs of Pu himself: not black bloc, but what we might term "photo-bloc," a social media variant on public masking as an insurgent mode of secrecy.

Both these attempts to practice secret activism, though, were dependent on an online anonymity that bloomed briefly and is now under assault. As Florian Schneider notes, Weibo now "requires users to upload their full personal information, including a digital copy of their passport. Other services in digital China require a Chinese mobile number to verify credentials. Since spring of 2016, new restrictions in China apparently prohibit the sale of anonymous prepaid SIM cards in the PRC" (2016b). Just as pertinently, the network of photoforms I discuss here had launched itself well before the window for practicing secrecy via social media had swung open, however fleetingly. Now that it has slammed shut, secrecy-as-strategy will have to rethink, and regroup, in China. Bratich and others may well be right to recuperate the productive capacities of the covert via "secret activism" in liberal democracies. But in places where the latitude to practice secrecy is barely granted, such strategies may be premature, if not impossible over the long-term. In contexts such as these, even

as outright exposure has scant efficacy, other means of coaxing secrets into the light may still have a certain political utility and impact: for example, when such secrets, and the mode of their revealing, act on other, bigger secrets. What's more, some of the ploys of a "minor activist insurgency" might well form part of such a pressurizing project. If so, this begs some questions: If not exposure, what should we call this process of drawing secrets out of hiding? And how, exactly, does the network of photo-forms discussed here practice some of the strategies of a "minor activist insurgency" and thus nudge the larger conspiracy of silence some way toward enunciation?

Circuits of Revelation

Going back once more to Walter Benjamin, it seems most apt to call this process "revelation," for several linked reasons. Revelation, as a counter-term for "secrecy," carries a richer semantic freight than many of its other antonyms. It conjoins the notion of uncovering what was hitherto hidden with startlement or shock ("the big reveal"), with a sense of fear and wonder ("it was a revelation"), and with a whisper of the numinous (imparted to the word in some linguistic contexts by its biblical associations), a final gloss to which I return later. Furthermore, if exposure or desecration are essentially inimical to the secret and "shame" it into wider knowledge, revelation is, as Benjamin noted, often the ally of justice. As such, its operations need to do more than merely rip back the veil. Revelation does things to the secret, not simply turning a laser light on it, but sculpting unexpected angles of illumination: it performs a more processual and responsive kind of labor. The network of photo-forms that remediate Bian Zhongyun's photograph attempts this work of revelatory justice. In so doing, it exemplifies Lauren Berlant's (2008) point that "the event of the secret, its meaning and force is, paradoxically, how it's shared." The specificities of that "how" are where the work of revelation happens, and they relate both to the mechanics of sharing and to the affects it generates.

When Deleuze and Guattari write that "the secret must sneak, insert, or introduce itself into the arena of public forms; it must pressure them and prod known subjects into action," their crux and keyword is that word "sneak" (2004, 317). It moots the idea that secrets often reveal themselves best when they do so in deliberately surreptitious fashion. In most digital contexts, this sort of spreading abroad is difficult to orchestrate; far more common, in fact, is the secret that shows its slip rather too openly online. Trite information is shared all too promiscuously on the net, epitomized by the very public demise

of the celebrity superinjunction in U.K. law over the past ten years.[9] What's more, it is often the process of remediation that speeds up that devaluation: as Seigworth and Tiessen put it, "doing justice to the secret today regularly feels less like a moment of revelation and more like the viral movements in a remediation ('hey, omg, did you see this?' See: copied link, attached file, or post to Facebook wall)" (2012, 51). We might even say that secrets now find themselves actively competing to be outed in virtual space—almost, as it were, against their better judgment. Certainly, even confessions that burn brightly in the first glare of attention can fade to gray in a matter of days. Most secrets, in fact, suffer a reverse teleology online, rapidly shedding value rather than accruing it steadily, as has the suppressed tale of Bian Zhongyun since the turn of the century.

These rules are, of course, subject to change in a propagandist society. Any student of such a state learns very quickly that prohibiting a book, for example, often mostly serves to fan the flames of readerly desire. Several Chinese writers have leveraged this truism successfully, turning sometimes pedestrian offerings—the standout is Wei Hui's 卫慧 *Shanghai Baby* (*Shanghai baobei* 上海宝贝, 1999)—into media events via the fuel of censorship and the money-spinning label "banned in China." Attempts to block contraband culture online can have still more telling effects. Alison Klayman, director of the documentary *Ai Weiwei: Never Sorry*, alludes to this point when she remarks that "without the cat-and-mouse [game] that the Chinese authorities instigate, Ai wouldn't have nearly the profile he does" (quoted in Silverman 2012). Ai Weiwei's "cat-and-mouse" game occurs mostly in cyberspace, of course, and the artist is now incomparably more famous than Wei Hui ever was, in significant part because the digital is his sphere of operation. His heightened celebrity has come to pass not merely because his work is attractively subversive and can reach, via its digital pathways, broader audiences than a printed book. The dynamics of the virtual hunt also play powerfully into his charisma. Online space, with its nooks and crannies, its morphability, its avatars and reincarnations, is a zone of hide-and-seek, of seek and destroy and pop back up again. As Klayman puts it, Ai Weiwei "knows the difference between a museum piece and a tweet," and he also understands that "the artist is the message" (quoted in Silverman 2012). Or to put it another way, Ai Weiwei, as the nimble hare who is hounded by the internet cops, has intuited that—on the internet, more than ever—it's all about the chase. Yet even more than this, perhaps, Ai's artist-activist practice recognizes that a censored object is ultimately a secret object too: it creates an in-group and an out-group, and those group dynamics can help carve counterpublics. And this, in inverse fashion, is also why Ai has such a penchant for the

naked selfie. Such shots declare that, despite the harrying, the artist is doing nothing that he should really have to hide.

Ai Weiwei's path to celebrity sheds sharp sideways light on the case of Bian Zhongyun. Photo-works about her display a steadily mounting, but repeatedly challenged, kind of visibility: from Wang Youqin's virtual cemetery (launched from the U.S. and almost immediately blocked in China) to Hu Jie's documentary (excluded from the YunFest independent film festival in 2007, unavailable on video-sharing sites, and only viewable at private screenings or via virtual private network) to Xu Weixin's paintings (deemed "unpublishable" in catalogue form yet formally exhibited, with certain prohibitions, on several occasions in China)[10] to the statue at Beijing Normal University (which sparked a brief but significant media furor until it was muzzled by a memo, later leaked, from the State Council Information Office).[11] On one level, this journey from secrecy into knownness has an appealingly utopian teleology, and it seems to support Liu Xiaobo's 刘晓波 famous claim that the internet is "God's great gift to China" (quoted in Xie Zhihai 2013), which will raze the roadblocks to truth and, one day, reconciliation. On this same level of reckoning, it is also impossible to deny that the network-as-instrument has drawn Bian's photograph out of hiding and turned it into a multi-vectored multimedia site for the telling of her story. Yet it is more accurate to describe this path out of seclusion as a crooked or at best circuitous one that has had to double back consistently in order to make small headway because of regular surveillant suppression. One thinks again of Ai Weiwei and how he shoots his activist films *in situ*, edits them at top speed, and then quickly posts them online, where they are downloaded onto laptops during the short interval before the internet police home in and delete. But from this come both his magnetism as an artist-activist and the potential of his practice to craft in-group consciousness in a secretive environment.

The remediators of Bian Zhongyun's photograph both pick up this logic and sharpen it further. Her photograph and its story have not simply been forced to sneak their way into knownness; they have also, and more importantly, turned that repeated surreptitious action into a positive value. The fact that each iteration of the photo-network—from the online mausoleum to the digital documentary to the paintings and their associated website to the sculpture in the news bulletin—has been subject to some kind of censorship creates not simply the kind of in-group, linked by secret objects, that Ai Weiwei has forged between himself and his audiences. It also generates a de facto collective of artist-activists who operate in part below the radar. If not quite a samizdat circuit, the image-network and its artist-activists emerge as a loose approximation of a secret society.

This is a "minor activist insurgency," to borrow from Bratich, unified by the network as a shared practice of struggle, even a shared ideal of solidarity. This point is obvious when we recall the dense interpersonal and intertextual relationships between the members of the network, who have, through the collectivity of their work, transported Bian's photograph stage by stage from behind the false-fronted bookcase to the front page of the *Beijing News* (n.a. 2014a). In a sense, then, the remediators of Bian's photograph are reminiscent not just of Deleuze and Guattari's (1986) notion of "minor literature" (the network uses secrecy against the masters of the discourse; it is immediate in its politics; it draws purpose from collectivity). It also recalls their point that "the spy, the voyeur, the blackmailer, the author of anonymous letters are no less secretive than what they are in a position to disclose" (2004, 316). Yet these artist-activists are more than merely what Bratich calls "shadowy revealers" (2006, 494). Their networked character, woven together through the aesthetic remediations they make, turns these artist-activists into a bloc. This is not black bloc, but again something closer to photo-bloc: a cohesive grouping that, like the mothers of the disappeared in Argentina, holds aloft the image of the person whose death has been concealed as a tactic of insurgency.[12]

Revenants, Again

In her study of ghostliness and the *desaparecidos* in Argentina, Avery Gordon notes how state torturers often used the photographs of loved ones, with all their haunting power, to distress and menace those who had been abducted. The photographs became an instrument of clandestine war, in other words. Gordon continues:

> Into such a contest is exactly where the Mothers of the Plaza de Mayo entered, photographs pinned to their hearts . . . The women wore "flat shoes so we could make a run for it if they came after us" and left their handbags at home. They carried posters with enlarged photographs of their children on them or wore the photographs attached to their clothing with pins. Their own children at first, but [later they] . . . moved well beyond the unique photography of my child that I long for to handing out photocopies of faces, eyes, and mouths . . . For the Mothers, the photographs were a spirit guide to the *desaparecidos* and to disappearance as an organized system of repression. The photographs . . . constituted a repertoire of counterimages, part of a movement to punctuate the silence. (1997, 108–9)

On one level, the Mothers reclaimed the use and meaning of family photographs, switching their role from tools of the cryptocracy to artifacts of revelation, with strong elements of secret activism (they were ready to run, and they left their handbags, with their ID cards, at home). As I discuss in the conclusion, photography has always had a special relationship with secrecy. Photography, saturated—oversaturated—as it is with what Gordon calls "declarative verisimilitude" (1997, 102), is an irresistible line of recourse for artist-activists in states that practice secrecy as a mode of domination. One need not believe in photography's "truth claims" (does anyone now?) to understand that photography still has the capacity to speak truth to power, as the Argentinian mothers show so effectively. But beyond such declarations, photography belongs tightly within the repertoire of the artist-activist who wants a reckoning with secrecy, because the photographic image can play covert too. It willfully obscures, crops, or airbrushes as much as it reveals and so can lend itself with just the same ease to the cause of clandestine activism.

Gordon's discussion of the Mothers of the Disappeared and the role photographic portraits played in their protests against spectacular state secrecy is also, of course, shaped by the figure of the specter, as indeed is her entire study. Spectral forms and feelings also animate the various remediations of Bian Zhongyun's photographic portrait which have emerged since the turn of the century. Her image and its aesthetic remediations harness the power to haunt—despite the fact that calling any photographic portrait "spectral" these days might seem to chafe nostalgically against the grain. Once upon a time, of course, photography was the prince of haunting media. The radio box that emitted disembodied voices from the ether, the telegraph wires that communicated specific messages just like a séance with the departed, more latterly even the TV tube that physically glowed in the corner of the room with the force of the spirits captured on its screen—all were spectral back then. But none so much as the black-and-white photographic portrait that trapped the traces of the dead in photochemical aspic, always as they were—*ça a été* in Roland Barthes's (2000, 76) poignant coinage—spectral symbols of the demise that awaits us all.

To call any of these media ghostly now, though, is to butt up against their utter banality, and again, never more so than with the photographic portrait. This is a category of image that digitality seems to have reduced to something not far from chatter, even if the evolution of photography into a conversational form also counts as yet another marker of its onward march as a medium. Thus photo-sharing sites are not just albums or shoeboxes for the virtual age, but a kind of talking space in which images are uploaded as "experiences" (van

Dijck 2011). They proffer colloquial sorties or snippets of dialogue that often elicit a photographic response in kind. Cell phone images make the point more assertively, functioning as quick-fire repartee in which photographs speak for and through their subjects (Rubinstein and Sluis 2008, 17–18). This status of the photographic portrait as image-cum-speech makes the medium so wrap-around, so everywhere, that the idea that a simple photographic portrait might cast a sudden eerie shadow seems as Victorian as the antiquated practice of spirit photography itself. The selfie, by this rationale, stands as apotheosis of the unhaunted, ghostbusted portrait, which is why, in a gesture of desperate self-parody, "every found-footage paranormal figure succumbs at one time or another to the urge of capturing a selfie when left alone with a surveillance camera" (Olivier 2015, 264).

It is no coincidence here that not so long ago the digital world seemed quite unearthly too. In "early" scholarship on the internet—by which I mean research dating through to the end of the 1990s—this theme was briefly paramount. Back then, scholars called the internet a space of the supernatural, of "ambiguity and the abject" (Waldby 2000, 152), of "postorganic life forms" (Tomas 1991, 33), the crucible for a "postnatural" existence (Cubitt 1996, 236), a haunting zone that paralleled "proper identity" in the offline real. This theme reached a peak with the Visible Human Project (VHP) launched by the U.S. Natural Library of Medicine and brought to its first fruition in 1994. Two human cadavers underwent computed tomography and magnetic resonance imaging, and were frozen in gelatin. Thin slivers of flesh were then shaved off and the resulting cyrosection photographed, digitized, and rendered, in full anatomical form, as visual data on a computer screen. One need look no further for an incarnation of the virtual zombie, and the media frisson surrounding the project was heightened by the fact that one of the corpses used in the project belonged to a murderer executed by lethal injection. What really calls for attention here, though, is that the VHP made no further Frankensteins until 2015; despite the success of the project, the ghostly cloning remained for years a one-off. If this is mere coincidence, it is a telling one. Those twenty-five-odd years between then and now have seen the internet shed its uncanny aura, becoming instead practically wearable in its 24/7 ubiquity, even as its actual capacity for abjection has exploded. Nowadays, the web habitat, just like the photographs that are its flora and fauna, has become so much the world we walk in that we choose not to dwell on the eeriness of the membrane-like screen that teleports its users into other realms or on the unsyncopated telepresence of Skype.

Habituation un-haunts, seems to be the message. But do we really want our media exorcised of the spectral character that was once so core to their fasci-

nation? And does overfamiliarity with media offer immunization against their suppressed spectrality anyway? Bian Zhongyun's net-powered photo-forms coalesce into a case study that suggests not. This was already obvious with Wang Youqin's *Chinese Holocaust Memorial*, the first digital artifact in the network and an early Chinese-language variant of the online memorial, with its new machine-based rituals of mourning.[13] Typically interactive, with guest-books and dialogue boxes, these commemorative sites permit users to engage in the Derridean goal of parlaying with specters (albeit in literalist ways), enabling them to retain a posthumous connection with the dead that can help with grief, even if the conversation is unidirectional. Most online memorials are expressly personalized and consecrated to a single life, even if they belong to a larger commercial website. Mourners click through to a specific page, with little interest in or awareness of the parallel pages—the distant lives—that sit adjacent to it in the database. They take, in this sense, the individualization of the grave (which was itself a modern phenomenon in the West, as Philippe Ariès noted [1981, 520–22]) to the next level of atomization.

Chinese Holocaust Memorial, by contrast, is an online burial ground in which the gravestones and epitaphs of countless deceased make up a totalistic virtual landscape. More than this, in fact, the site approximates a war cemetery in the sharedness of its arbitrary victimhood. Wang Youqin builds this sense of community by grouping the dead of the Cultural Revolution alphabetically, flattening out "the differences between a nonentity (such as a worker who drowned herself after [her] home was stormed by the Red Guards) and a celebrity (such as Liu Shaoqi who used to be the second most powerful man in Beijing)" (Dan Hansong n.d., 4). The effect of this is to render the virtual memorial, a space that usually echoes with individual voices, into a kind of spectral chorus. The fact that the victims it memorializes are wraiths twice over—first by simple dint of their passing and second because the state has effectively "disappeared" their traces, rendering them angry ghosts—amplifies this resonance. As Yu Ying-shih 余英时 puts it in his preface to the book version of Wang Youqin's website, "she has single-handedly rescued 659 dead souls from hopeless oblivion, as if bringing ghosts back to the world of the living" (Wang Youqin 2004, 21). Usually described as an "oral history" and a "memory document" (Schoenhals 2008, 164–65), a "mosaic" of historical sources with "performative" intentions (Dan Hansong n.d., 4), or a banned database or "archival project," *Chinese Holocaust Memorial* should also be understood in its guise as a digitized spirit medium. Indeed, its status as archive is crucial to this understanding. If, as Derrida argued, "the structure of the archive is . . . spectral *a priori*" (1996, 84), then this hauntedness grows when the archive doubles up

as cyber-mausoleum, one to which angry ghosts are consigned. These spec-
ters, rather like the zombies of the VHP in reverse, are bound to the database
in ways that reanimate them with materiality. They moot the possibility of an
infinite afterlife—or an eternal undeadness, at least—in the digital archives,
a notion that has more recently become concretized via the development of
automated software that allows the dead to maintain an active presence on
social media, and the launch of services such as eterni.me, which uses artificial
intelligence and digital footprints to create lifelike avatars of the deceased.

These practices, like *Chinese Holocaust Memorial*, attempt to harness the
digital uncanny to enable the "persona of the dead" to "maintain meaningful
posthumous relationships with the living" (Meese et al., 2015, 408). All make
heavy use of photographs, recalling Gordon's point that "for the Mothers, the
photographs were a spirit guide to the *desaparecidos*" (1997, 109). Not coin-
cidentally, then, Bian Zhongyun's page on the site is one of the very few with
a photographic portrait. This was not a deliberately exclusive move: Wang
Youqin informed me that other photographs were simply very hard to come
by, and that it was her personal relationship with Bian's husband, Wang Jing-
yao, that gave her access to the image (personal communication, 2016). But the
presence of the portrait on Bian's page inevitably intensifies its impact. Wang
Jingyao has many photographs of his wife, as viewers discover in the course of
the documentary. His choice of this particular portrait, with its serenity and
gentleness, recalls in part Barthes's famous line, "this photograph collected all
the possible predicates from which my mother's being was constituted" (2000,
70). But the portrait also served as Bian's altar image behind the false-fronted
bookcase, a status that the layout of the online memorial replicates as it places
the photograph high and centered on the page, though this time in a space of
publicness. From there, it becomes a kind of photo-altar, which reaches out
to spectators not just in its hauntingness, but because it aspires toward the
numinous. By this I refer to the notion, first popularized by Rudolf Otto in
1923, of a mental state "perfectly *sui generis* and irreducible to any other" in the
presence of that which is "entirely other": the nonrational aspects of spiritual
or religious experience, experienced in equal parts as awe, fascination, and
majesty (Otto 1958, 7).

Numinous Objects

The notion that museum artifacts can vouchsafe numinous experience has
become a lively scholarly topic, particularly for ethnologists as they try to
theorize why, on the plane of affect, people seek out encounters with a partic-

ular past. Cameron and Gatewood were among the first to explore this idea, arguing in 2003 that certain heritage and historic objects have the power to carve open deep, if momentary, channels of "spiritual communion with the people or events of the past" (57), creating what Kiersten Latham later dubs a "deeply connective, transcendental encounter" with history (2007, 247). Writing against Adorno's influential description of museums as "the family sepulchers of works of art," which house "objects to which the observer no longer has a vital relationship and which are in the process of dying" (1983, 175), these scholars argue that it is precisely the lure of transcendental communion that draws visitors to some sites and artifacts. Cameron and Gatewood dub their desire the "numen-seeking impulse" (2003, 57), in which numen denotes "a nod or beckoning from the gods" (Latham 2007, 248). The vessels that enable it are items of material culture that "tell stories that can be personal, national, or social in nature" and that speak to us because of "their association, real or imagined, with some person, place, or event endowed with special sociocultural magic" (Maines and Glynn 1993, 10). Perhaps the most famous example in the field of numen-seeking studies is Abraham Lincoln's stovepipe hat, which moved around the U.S. as part of a traveling Smithsonian exhibit in the late 1990s and frequently reduced visitors to tears, ambushing them with an unbidden emotionality (Kurin 1997, 37). As with many numinous objects, the hat functioned as a portal to the past because it was imbued with the physical, almost tactile residues of personhood.

Although unreferenced in the literature thus far, photo-forms are predictably numinous objects, in large part because of that notion of the human trace. Most evidently, photo-forms re-version the often famous faces of the dead, thereby administering an instant jolt of connection. But they are also tied by metaphorical cords to those same people thanks to their photographic source material: their remediated relationship with what Barthes called "the necessarily real thing which has been placed before the lens" (2000, 76), their status as a trace of a trace, as it were, of the person who once stood in front of the viewfinder. Although vigorously undone by thinkers from Benjamin to Susan Sontag and John Tagg, photography's supposed tie to the real gets something of a new lease on life in the photo-form as an aesthetic category. For sure, a re-purposed photograph reinforces on one level the dissolution between photo-chemical image and some mythic "real" thanks to its openly constructed and representational nature. Yet at the same time, these works, with their repetitive return to the photograph as privileged referent, also invite the spectator to buy back into the illusion that the image enjoys a rapport with tangible personhood. Cumulatively, this open-ended character gives the photo-form

a faint sentient charge. These are artifacts that hum imperceptibly with vital signs, as the human charge of the numen-seeker, the human charge of the repurposer, and the human charge of the depicted are brought into dynamic encounter with one another. This special phenomenology of the photo-form, the *sotto voce* pulse of life that flows through these image-works, intensifies further when their makers expressly set out to create mobile museums.

All of the artist-activists who have repurposed Bian Zhongyun's image are driven by curatorial impulses. Thus Wang Jingyao's very home is a museum (*jinianguan* 纪念馆) dedicated to preserving and displaying his wife's artifacts. His role as custodian is intently performative (Feng Jicai 2014), and *Though I Am Gone* is a documentary with self-professed museological intentions.[14] As director Hu Jie puts it, "the Chinese authorities do not want us to remember history, [so] we non-official people should remember on our own" (quoted in Shen Rui 2005). Or to put this another way, so long as Ba Jin's (1987, 819–23) call to build a "Cultural Revolution Museum" in every town goes unheeded, artist-activists will necessarily improvise with semi-clandestine curatorial projects of their own.[15] But the decision of these artist-activists to create mobile museums for Bian Zhongyun also suggests an understanding of the numinous power that museum objects can project in themselves and as they move. Part of the impact of Lincoln's stovepipe hat, after all, came from the fact that the Smithsonian exhibits traveled.[16] More specifically, the decision of these artist-activists, one after another, to create photo-altars betokens a desire to make the encounter with Bian a numinous one—and the notion of network is instrumental to this. Numen-seeking, as Latham (2007) argues, is often a communal experience: many of the respondents she surveyed spoke of how their encounter with the object projected them into a sense of connected-ness, a holistic humanity into which the self dissolves. As a network of artifacts that take Bian's portrait as their repetitive node, these photo-forms widen the range of this *communitas*, presenting not just a single exhibit but an extended *exhibition* of the numinous whose online movements expand the belonging of spectatorship.

In short, rather than practitioners of photo-bloc, this network of artist-activists are makers of photo-altars, with the connotations of spiritual encoun-ter that term brings. In their numinous labor, these artist-activists harness the cultural weight of the single portraiture genre in China: its "long history in ancestral worship," its status as an altar object, and its evolution into a politico-religious icon (Lei Feng 雷锋, Mao Zedong) during the revolutionary period (Oyobe 2016, 12). Furthermore, this distinction between photo-bloc and photo-altar sharpens the points made earlier about secret insurgency and

secret activism, for the simple reason that the numinous overlaps so richly with secrecy. Their intersection is especially well attested in the realm of religion, which has always drawn power from the notion of arcane and cloistered knowledge. Yet "even in its most secular and mundane aspects, [secrecy] may take on the shimmer of the numinous, the *mysterium tremendum* that most definitely also *fascinans*" (Mathewes 2006, 274). Both rulers and practitioners of political secrecy often cultivate this idea of "the unknowable, the religious or cultic secret," not only to induce awe but also to veil their operations in a haze of the auratic and the unimpeachable (Horn 2011, 108). Rulers who stay secluded and pronounce only infrequently are playing this game. What better way, then, to pressurize the public secret than to gather to the revelation of the minor secret a "shimmer of the numinous"? In an economy of secrecy, asserting the affirmative powers of the clandestine can be a strong countermove, as Bratich (2007) notes. But more effective still is to make revelation an experience that glows with some of the power of *mysterium*. This idea of numinous revelation, which stands in contrast to the grubbiness of the political cover-up, is what several artist-activists in the network realize in their repurposings of Bian Zhongyun's portrait.

Opening the Crypt

In *Though I Am Gone*, that which is hidden is made numinous by drawing out its hauntedness, most particularly the specter as Derrida (1994) defined it in his writings on secrecy. Derrida's specter rejects the idea that secrecy can be tamed within the realm of knowledge. His notion of the ghost holds tight to its unknowable otherness, and via that refusal to be apprehended it opens up an encounter with secrecy as a force that shakes at our certainties and makes us "interrogate our relationship with the dead [and] examine the elusive identities of the living" (Davis 2005, 379). This makes its common ground with the numinous clear: both are unknowable and thus incite not just reverence but also fear. This was Mircea Eliade's point when he observed in *The Sacred and the Profane* that the numinous "presents itself as something 'wholly other' (*ganz andere*), something basically and totally different" (1967, 9–10). In Hu Jie's documentary, this relationship between the numinous and the specter is elaborated with full force in the climactic scene of the film, in which Wang Jingyao reveals the contents of the secret suitcase to Hu Jie and his camcorder. As it films what is effectively the opening of a long-sealed crypt full of human relics, this sequence at first seems to be predicated on the idea that secrets can be disclosed and ghosts thereby exorcised. This is Wang Jingyao's hope when he

speaks about the "cross he has borne" since his wife's killing and the haunting he has endured for years. Ultimately, though, the visual language of the scene articulates "revelation" in all its semantic glosses: shock, fearful wonder, and an intimation of the numinous as something that is, in the end, unknowable.

Prefaced by a brief shot in sudden color of Wang Jingyao's bookcase, the scene proper begins with a shot of his hands pulling the suitcase out of its hiding place. It is wrapped in thick plastic, which crinkles loudly on the soundtrack as he removes it. The suitcase, when it emerges, is locked and sealed with straps, which take some time to unfasten. Hu Jie has to assist, a moment marked by another switch to color, signaling a brief interruption in spectral time back to the present. Wang then clears the bedspread to create a space for revelation while the camcorder cuts to the case, which sits pregnant with expectation. Wang begins cautiously pulling out items: the first is a box, wrapped in paper, which rustles noisily again as he takes out a wristwatch, an ID card, a school badge, a gold pocket watch, and several strands of hair. He lays them out in neat lines on the bedspread, and Hu Jie remarks that the watch stopped at 3:40 p.m.—the moment it was "damaged" and the beginning of ghost time. Hu then asks, "And what's this?" as the camera pans to another paper-wrapped bundle, which Wang is hesitantly unfolding. At Hu's question, Wang's hands—the full focus of the shot—close sharply and protectively over the bundle, as the camera lifts to his face and waits eleven long seconds for his reply. The package, Wang finally tells Hu as he begins to extract the objects one by one, contains blood-stained cotton, gauze, and scraps of handkerchief that were used to bind Bian's wounds. Next he shows the camera the crumpled, muddy trousers she had worn, which were cut from her body at the hospital, then her underwear, stained with urine and excrement, and finally her shirt, scrawled faintly in ink with the characters "Down with" "This is the first time I've opened this bundle in thirty-nine years," he says. The scene ends with photography and Wang's camera. The camcorder slips away from Wang's face to a portrait of Bian, which sits on a shelf nearby, and then intersplices shots of Wang's hands, as they smooth the relics again and again, with other photographs of his wife. Wang then folds away his Seagull in a motion of finality, and the camcorder's gaze comes to rest on that old camera, which gradually blooms into color as the spectral interlude ends.

Secrecy, ghostliness, and photography steep and structure this long scene: Bian's bodily vestiges, entombed in the hidden suitcase for nearly four decades; Wang's hands, hesitant yet also desperate to reveal; the lingering shot of the Seagull camera; the *mise-en-scène* itself, which seems to turn Wang's study into a de facto darkroom. This culminating sequence of the film enacts

"revelation" as shock and fearful wonder, and as such it visibly brings some solace to Wang Jingyao. But this revelation is also insurgent. It aims to act on others, and it does so by invoking the specter as a figure that is numinous because it is "wholly other." This point is starkest when Wang produces the relics directly tinged by the traces and residues of Bian's personhood. Both Wang and Hu assert the visibility of the secrets in the suitcase several times during this part of the scene ("The bloodstains are clear to see"), but for the viewer this is not so. While the sharp outlines of the metallic items (the watches, ID card, and badge) shown first are easy enough to discern, the smudgy, handheld, black-and-white camcorder images make Bian's relics—her hair and the fluids of imminent death that stain her clothes—next to impossible to make out. Secrecy for the viewer, in fact, is less the items that are revealed and more the repeated sounds of rustling—whispering, almost—as layer upon layer of paper is removed, and the equally repetitive gesture of Wang's hands as they peel back bindings that unfold like the petals of a flower but disclose only vague and crumpled grayscale shapes, barely identifiable even as pieces of fabric. Secrecy becomes not denotative here, but a matter of connotation. And although Wang Jingyao is finally able to release Bian's spirit in the scene, for the film's audiences these relics take on spectral form in a more Derridean sense: they are objects whose blurred opacity makes them unknowable. But despite this, or rather because of it, they project a numinous force, drawing spectators into an interrogation of what it means to live with and among ghosts.

Parallel Portraits

"Spectatorship" as I refer to it above is a generalized term because the power of the scene is such that any viewer can feel it. Yet the numinosity of the network of photo-forms explored in this chapter is also more closely specific in its intended reach. More precisely, it is an insurgent force that seeks to place lateral pressure on those who keep the broader public secret surrounding Bian Zhongyun—namely, the identity of her Red Guard murderers within the elite Girls Middle School attached to Beijing Normal University. In 2007, the year after Hu Jie's documentary was made—and banned—the school celebrated its ninetieth anniversary at the Great Hall of the People, which was broadcast live on CCTV. To mark the occasion, it held a competition for the ninety most notable alumnae in its history. Song Binbin put forward her name and was selected as one of the winners. As part of the commemorations, the school exhibited the now notorious photograph of Song presenting a Red Guard armband to Mao Zedong (Wang Youqin 2007, 72), mentioned at the beginning

FIGURE 3.4 No irony intended: image from the photo album produced by the Girls Middle School attached to Beijing Normal University, 2007.

of this chapter. The school also published the same image of Mao and Song Binbin in a photo album commemorating its distinguished graduates. But on the opposite page, in an inexplicably grim irony, the organizers printed the photographic portrait of Bian Zhongyun that not so long ago had dwelled behind the bookcase (figure 3.4). The brief caption notes the date of her death but little else. Wang Jingyao did not hesitate to show his rage. He wrote an open letter to the school's principal denouncing the praise of Song Binbin and stating that the armband she gave Mao more than forty years earlier was "stained with Comrade Bian Zhongyun's blood" (Wang Jingyao 2007).

Over the next few years, parallel portraits of Song Binbin and Bian Zhongyun appeared again, this time in Xu Weixin's photorealist series *Chinese Historical Figures 1966–76*, which was first exhibited in Beijing in 2007 and has toured both nationally and internationally since.[17] In this series, Xu remakes photographic portraits from the Cultural Revolution period, transforming small head-and-shoulders shots of both well-known and obscure personages into giant monochrome canvases, each measuring 2.5 meters by 2 meters, which form an epic sequence now numbering close to one hundred

separate paintings. Xu's painting of Bian Zhongyun repurposes the photograph behind the bookcase once again, although Xu transforms the portrait into something closer to a marital diptych by exhibiting it with a partner canvas of Wang Jingyao. Xu has stated his vision for the series: to harness its photographic source material to "resist amnesia" (Shen Yinghui 沈映辉 2009, 191) and to install consciousness of a suppressed past among the apathetic or forgetful later-born (Shui Tianzhong 水田中 2007, 110). Expanding the point, Stephanie Donald has described his radical memory work as "a file, or a database, which younger people can access, analyze and use for themselves" (2012, 53). There can be no doubt that the series is mnemonically charged, summoning the different temporal registers I discussed in the introduction and generating, in the mind's eye of the spectator, a rippling sense of the past. Once again, though, memory-making is not the sole or most illuminating prism through which to understand these photo-works, which apply a strong sideways pressure on the public secret via a visual language that treads the line between the ghostly and the numinous.

The spectrality of Xu Weixin's series is unmissable. If *Chinese Holocaust Memorial* was a ghostly chorus of voices that ring out from Wang Youqin's textual accounts, then *Chinese Historical Figures* allows the spectator to wander a hall of phantoms. Over sixty portraits, as varied in identity as those commemorated in *Chinese Holocaust Memorial*, were shown at the first major exhibition of the series in 2007, and all work the supple hinge between the spirit world and photorealism as a pictorial mode. These links come largely from the look of the "blur," made canonical by Gerhard Richter, but in fact always immanent in photo-realism. As Allen Feldman puts it, Richter paints "the blur that *is there*—the blur *there is* in photo-realism" (2015, 100). Blurred figures, as Tom Gunning observes, have signaled ghostly presence since the dawn of photography: "Recognition of spirits as identifiable persons now deceased usually depended on either a very blurry photography and a willing imagination, or the fact that, to contact the spirit of a specific deceased, the medium often requested a specific photograph" (2003, 11). Xu Weixin's portraits slow the blur that creates such a sense of velocity in Richter's works (Xu's photo-realism is usually sprucer and sharper), but it is present nonetheless in the smooth haziness of the gray tones.[18] Yet this idea that "motion-blurred images were connected to ghostly apparitions" (Flueckiger 2015, 85–86) is not just about what Richter himself calls "the spectral interplay of . . . presence and absence" (2000, 223). Although barely discussed in treatments of his work, the blur also stands for, and acts out, the fugitive and thus secretive aspect of the ghost. The sense of bleed in his paintings—the grays that disappear into each other—are

also a kind of secretion, in Deleuze and Guattari's terms, in which the human figure, ungraspable in its "flowing transitions" and "dissolve[d] demarcations," exemplifies ghostliness as something occult (Richter 2009, 33).

In the case of Xu's portraits, and particularly that of Bian Zhongyun, size makes a further, more emphatic, point about secrecy. As the small studio photograph that once served as a hidden altar for mourning is massively magnified, it activates the dynamics of scale to perform minor secrecy as an insurgent practice (just as the decision to paint the couple together recognizes Wang Jingyao's role in its revelation). The minor secret provokes the public one via an equally dynamic use of positioning. The diptych of Bian and Wang has hung in some exhibitions within a stone's throw of portraits of a range of other figures associated with the Girls Middle School attached to Beijing Normal University, with the summer of Red Guard violence against educators that followed Bian's killing in August 1966, and with the attempts to bring those responsible to justice in the years since. Unlike the commemorative photo album, which "almost perversely" (Johnson 2014) juxtaposed the altar portrait with the photograph of Mao Zedong and Song Binbin that perhaps more than any other iconizes the violence of that summer, *Chinese Historical Figures* uses proximity as the very definition of lateral pressure. Superficially, the series seems to present the same flattened hierarchy of *Chinese Holocaust Memorial*, with its alphabetic list of victims. Indeed, the portraits are also displayed in alphabetic order, and when Xu crowdsourced old photographs for the series via his blog in 2006, his call for images made this desire for nondiscriminating universality even more explicit: "To all friends of my blog, this is an appeal to you or to your elders, fellow townsfolk, colleagues, and friends: looks, gender, age, and walk of life (Red Guards, Little Red Guards, educated youth, PLA, cadres etc.) do not matter, but the image must have been taken during the period 1966–76 and it must be a clear full-face photograph" (quoted in Cui Junxia 2006, 141).

Yet things look different within the actual parameters of gallery space. When exhibited, the series cannot but pull into immediate and intense propinquity a range of opposing Cultural Revolution actors. In addition to Bian Zhongyun and Wang Jingyao, those with direct connections to the Girls Middle School attached to Beijing Normal University whom Xu has painted include Mao Zedong, Jiang Qing, Liu Shaoqi, Deng Xiaoping, and Song Binbin. Included elsewhere in the series is Wang Qingping 王庆萍, who was beaten badly at a public criticism meeting the day after Song Binbin presented Mao with the red armband and was found dead from defenestration shortly afterward; and also Wang Rongfen 王荣芬, who was imprisoned after writing a bold letter to

Mao Zedong criticizing the Cultural Revolution and who is both a longtime critic of Song Binbin and an advocate of Wang Jingyao's cause. Thus when Xu Weixin stated in a panel discussion that "the immense figurative paintings . . . are aggressive. They force viewers to recall and to think the event" (quoted in Wang Mingxian 王明贤 2018), he was referring in significant part to the word-less confrontations the portraits stage across historical time and exhibitionary space between Cultural Revolution antagonists—and between the insurgent network that has repeatedly re-versioned Bian's once private portrait and the figureheads of the public secrecy, with its vested interests, that still shrouds the identity of her killers. As Michael Taussig puts it, this is "the tenderness of face and of faces facing each other, tense with the expectation of secrets as fathomless as they seem worthy of unmasking" (1999, 3). The power of paral-lelism in portraiture, of the face-off across time and space, has been reaffirmed more recently in Photoshopped versions of these now seminal photographs on Weibo. This is shown in figure 3.5, which juxtaposes Song Binbin's jubilant smile when she met Mao in Tiananmen Square in 1966 with her agonized face on the day of her apology forty-eight years later.

Xu Weixin's painterly aggression, as the artist himself suggests, derives from his decision to magnify the photographs so hugely as he transposes them onto canvas. This move ramps up their rhetorical hyperrealism and helps to lift them from the spectral to the numinous. The mystical power of Xu's photo-realist canvases, and the way they enact secrecy, lateral pressure, and revelation, is mentioned repeatedly in accounts of *Chinese Historical Figures* in Chinese art magazines and journals. "Your pictures give people a feeling of epic solemnity, as they soundlessly disclose the 'secrets of his-tory,'" remarks one interviewer (Shen Yinghui 2009, 91). An art critic reflects that "we can imagine the exhibition once the portraits are completed, when they are arranged in a single space, absorbing the same light from the same moment in time . . . the artist . . . has plucked the first string in the heavy melody of history, [allowing] its true music to unfold" (Shui Tianzhong 2007, 110). Another commentator, meanwhile, states that he had become alien-ated by contemporary Chinese art until a chance encounter with Xu's paint-ings caused him "once again to experience a jolt to his inner being," a charge that stems from all the sound churning "under the solemn silence" of the huge canvases (Wu Wei 吴炜 2012, 95–96). Yet another writes: "Standing in front of these huge portraits, so solemn and still, a strange rumble of the past surges up . . . These silent subjects seem to disclose every secret of his-tory . . . We have no choice but to listen as they pour out their hearts" (Wang Min'an 汪民安 2013, 8). This numinosity holds true across the series. But the

FIGURE 3.5 Then and now, from jubilation to remorse: a Weibo user's take on parallel portraits (ca. July 2016, since removed).

contentious history that links the prime face of the insurgent network, Bian Zhongyun, with that of Song Binbin turns those parallel portraits into its core dialogic axis. Bian's portrait is, of course, an image that has been acquiring a certain recognition quotient since the turn of the century, from *Chinese Holocaust Memorial* through *Though I Am Gone* to the photo album published by the Girls Middle School.[19] But as it faces off against Song Binbin's portrait,[20] much of the charge of that encounter comes from the peculiar character of Xu Weixin's source image, obtained from another alumna of the school (Xu Weixin, personal communication, 2016).

Xu's portrait of Song Binbin, in line with the call for images he sent out in 2006, is based on a "clear full-face photograph" (*zhengmian de qingxi zhaopian* 正面的清晰照片), thus marking an immediate contrast with the notorious photograph of her and Mao, which shows both in profile. This contrast grows starker when the portrait is compared with another major sighting of Song Binbin: her appearance in Carma Hinton's Cultural Revolution documentary of 2003, *Morning Sun*, in which Hinton interviewed Song

in a darkened room with her face blurred (Li Li 2016, 117). Although this concession was apparently made in order to persuade a reluctant Song to take part, shrouding her visage actually has the effect of telegraphing the politics of public secrecy that continue to surround Bian's death. Xu Weixin's portrait of Song, "clear," "full-face," and previously little known, homes in, fully frontal, on its unsmiling subject like a mug shot; it is probably the harshest painting in the series. If so, this is also due to Xu's use of inscription across the canvas. At the outset of the portraiture project, Xu made it his custom to attach to each painting a written biography of its pictorial subject, sourced either from family members or from the public record. As Stephanie Donald notes, though, he later took to etching these epigrams directly onto the canvases (2012, 47). Over time, the vast expanse of the portraits incites increasingly experimentalist, even explosive, kinds of inscription such as we see with the portrait of Song Binbin, in which no fewer than twenty-three lines of Chinese and English script are penned with quiet violence directly over the subject's face (figure 3.6). Tellingly enough, the final line reads, "In September of 2007, Song Binbin was named 'Distinguished Alumna' for the fame she gained from the 'Cultural Revolution' in a celebration event that marked the 90th anniversary of the Girls' High School."

This defacement, which is found on only very few portraits in the series,[21] is also a form of desecration—of undoing the public secret—which, as Taussig notes, is an act that can unleash flows of energy (this is, of course, why portraits of political enemies such as Liu Shaoqi were defaced during the Cultural Revolution). More than energy, even, defacement is an act with numinous force, most particularly when it means the literal spoiling of the human countenance. Taussig calls the face the "ur-appearance . . . of secrecy itself," because it stands "at the magical crossroads of mask and window to the soul" (1999, 3). As he puts it: "Defacement is like Enlightenment. It brings insides outside, unearthing knowledge, and revealing mystery. As it does this, however . . . it may also animate the thing defaced and the mystery revealed may become more mysterious, indicating the curious magic upon which Enlightenment, in its elimination of magic, depends" (3–4). In this sense, the defacement of the portrait is reminiscent of nothing so much as the climactic scene of *Though I Am Gone*, when Wang Jingyao's display of Bian's relics performs another kind of desecration, bringing "insides outside, unearthing knowledge." The power of that scene cannot be fully understood without acknowledging that to reveal Bian's soiled death shroud to the camcorder is a miraculous defacement, a kind of sacrilege whose "negative state can come across as more sacred than 'sacred'" and that stirs "a strange surplus of negative energy" (Taussig 1999, 1).

FIGURE 3.6
Xu Weixin, portrait
of Song Binbin. Speak
no evil: the spidery
inscription covers the
subject's mouth like
a muzzle.

This is why Wang's hands close over the bundle of clothes: his caution is not just protective, but minatory too.

The Hardest Word

It is more than likely that the truth of how Bian Zhongyun died will never be known. And despite much speculation, it is also difficult to establish with solid certainty why Song Binbin, some of her peers, and several other Red Guards began to engage in increasingly intensive retrospection about their revolutionary pasts from 2010 onward. In that year, Song, together with other former schoolmates including Liu Jin 刘进, Ye Weili 叶维丽, and Yu Ling 于 羚 (several of whom have been engaged in their own research into the incident since the late 1990s), took part in a roundtable discussion hosted by *Remembrance* (*Jiyi* 记忆), an unofficial e-journal that has arguably done more than any other Chinese-language forum to foster research and dialogue on the Cultural Revolution period (although its activities have become more

subdued during the Xi era).[22] Two years later, Song published an article in the same venue entitled "The Words I Have Wanted to Say for Forty Years" (*Sishi duo nian lai yizhi xiang shuo de hua* 四十多年来一直想说的话, 2012), which appeared alongside other articles by her supporters. The gist of the piece was that she had no direct hand in the killing of Bian, that she had tried to calm the violence on the school campus, that she had paid a high personal price for being given the name "Yaowu" in the years since 1966, and that she had only reluctantly put herself forward for the Distinguished Alumna honor and was horrified when the photograph of her with Mao ended up featuring so conspicuously in the celebrations. The final section of the four-part article, entitled "My Reflections and Apology" (*Wo de fansi he daoqian* 我的反思和道歉), contains the following statement: "I would like to take this opportunity to express my profound grief to Principal Bian who regrettably passed away in the 'August 5th event,' and my deep apology to her family and to all other school leaders and their families who endured suffering in that same event" (Song Binbin 2012, 15). As a semi-samizdat publication, *Remembrance* has a limited and presumably self-referential circulation. Evidently, Song felt that her 2012 apology was not enough, and in 2014 she joined a group of former classmates and made the pilgrimage to the school to bow in front of Bian's bronze bust and reiterate her regrets in a face-off that took place within a far more public arena.

Song Binbin's apology, like the contrition other Red Guards have expressed since 2010 or so, met with a mixed reception in Chinese media outlets and blogs.[23] Wu Di 吴迪, co-founder and editor of *Remembrance*—which dedicated another special issue to the pilgrimage and its expressions of penitence (Wu 2014a)—set out a complex taxonomy of responses to latter-day Red Guard remorse. In it he identified five kinds of reaction to Song's apology, ranging from suspicious condemnation to optimistic approval (Wu 2014b). His own particular aim in giving a platform to Song and her former schoolmates was to open up discussion, even—especially—when it proved controversial, which it swiftly did. Wang Jingyao and Wang Youqin both emphatically rejected Song's remorse. Wang Jingyao outright accused Red Guards at the school of murdering his wife and stated that "until the truth of the August 5th incident is brought to the light of day, I will never accept [their] sham apologies [*xuwei de daoqian* 虚伪的道歉]" (Wang 2014). Although some commentators were convinced by the apology, vitriol surged from others online and inspired several mordant cartoons. One, by Badiucao, showed a sharp-fanged crocodile clad in Red Guard uniform, shedding a single oversized tear. Fellow cartoonist Jiu'an's satire of the apology is, though,

in some ways more pertinent. It remediates the photograph of Song Binbin standing in front of the bronze bust of Bian Zhongyun, but this time she is prevaricating about the footwear she wore on the day that Bian was kicked and beaten to death. As the cartoon remediates the bust, which itself remediates the altar photograph, it becomes the latest iteration in the network of photo-forms whose insurgent operations I have traced in this chapter. Yet as this new articulation of the minor secret once more exerts pressure on the guardians of the public one, this time via sarcasm, what it really reveals is the inadequacy of knowledge—who did what on that fateful day—as a means of reaching some kind of reckoning about Bian's death. This point was reaffirmed via a different route by the media muzzling of the apology story soon after it broke, thus making knowledge not just inadequate but unlikely for the foreseeable future.

Part of Wang Jingyao's anger, after all, is that Song Binbin's apology is neither confession (I did it) nor exposure (I can tell you who did), and confession and exposure, unlike apology, are both recognized antonyms of secrecy. Yet even if the identity of Bian's killers were one day definitively revealed, and even if those killers were brought to justice (of which, of course, there is no guarantee, as so many failed exposure scandals worldwide have shown), what would this mean against the backdrop of so much other still-unrepented, still-unowned violence during the Cultural Revolution that lives on today, not merely as amnesiac fog, but as public secrecy? By the same token, although it might seem like poetic justice if the lateral pressure applied by the insurgent network of photo-forms had helped to prompt remorse, this is not just unprovable but at best only tangential in its importance. The network of photo-forms, and their re-versionings of Bian's altar image, are insurgent in this sense not simply because their mode of revelation brings itself to bear on the specific cover-up that has protected her killers. They also stand as insurrections because the numinous power they harness has the potential to "unleash energies" on a bigger scale, to bring about what Wang Youqin calls "a crack in the ice" (quoted in Kuhn 2014). The public secrecy that surrounds certain aspects of the Cultural Revolution and its ghosts is a mode of knowledge, a social order in itself, rather than a contingent state that newly released information (confession, exposure) might bring cleanly to an end. It is the divisive and atomizing instrument that has processed those events into history and memory. Dealing with that edifice of secrecy-as-system would therefore require not a procession of individual acts so much as an alternative structure.

Coalition Politics?

What makes the bronze statue at the school significant within the network of photo-forms is that it is the first reiteration of Bian's image that has gone truly viral. And this virality occurred because the statue was commissioned and crowdfunded not by the network of artist-activists who drew Bian's photograph into the light from 2000 onward despite censorship—the "minor activist insurgency"—but by a group who might reasonably be described as core guardians of the public secret: several hundred alumnae of the Girls Middle School attached to Beijing Normal University who were pupils there during the late 1960s and thus belong to the so-called *lao san jie* 老三届 generation of Cultural Revolution actors.[24] The fullest account of how the statue came into being can be found in a 2011 entry on the personal blog of Feng Jinglan, a classmate of Song Binbin, who was at the school on the day Bian was killed and who acted as host for the interviews conducted for the first special issue about her death published by *Remembrance* in 2010 (Feng Jinglan et al. 2010). By all those measures, Feng is what Li usefully describes as a "primary insider" (2016, 119). Feng prefaces her account by stating that the death of Bian is an "indelible stain" on the school that "hangs over the heart of every student with a conscience like a shadow that cannot be exorcised," and that more and more students are afflicted by feelings of guilt for acts that "cannot be indefinitely brushed aside using immaturity and ignorance as our excuses." The time has come for us to "face ourselves squarely" (*zhengshi ziji* 正视自己), she writes, in an echo of Xu Weixin's full-face iconography. Feng goes on to describe how students from the graduating classes of 1965 and 1967 first secured approval from the school management to commission the bust before forming an organizing committee that included former pupils enrolled during the period 1962–67. In total, 490 students from forty-four separate classes in eighteen year groups contributed money for the statue, though in the end sculptor Sun Jiabo only charged for his materials (Feng Jinglan 2011).

Wang Jingyao reportedly gave his blessing to the statue, only to withdraw it a fortnight later (Pedroletti 2014). That doubling back is hardly surprising, since it is easy enough to view the crowdfunding campaign cynically. Actual perpetrators may well sit among the 490 students who contributed money, and for Wang, confession would surely be preferable to an exculpating financial donation. Yet his initial blessing is also telling, and not simply because it hints, however fleetingly, at reconciliation. Ultimately, the crowdfunded statue, rather like the crowdsourced images for Xu Weixin's photo-paintings, moots the emergence of alternative blocs within the politics of Cultural Revolution

commemoration. This particular bloc is alternative in part because it belongs within the confessionary impulse that gripped some Red Guards ca. 2014 and that the state found uncomfortable. More important, though, is that its use of Bian's altar image—the icon of the network—metaphorizes a crossing of political lines, a cracking of the ice. This is not to deny for a second that in many ways the future of Cultural Revolution memory is more precarious than ever. Firsthand witnesses are passing away, Ba Jin's dream of a public museum in every town seems no closer to becoming concretized in bricks and mortar, and at the time of writing, censorship about historically sensitive issues has entered a newly intransigent phase which seems set to last under Xi Jinping.[25] Nor is it to dispute that the bitter politics of apology reveal how divided, and divisive, the legacy of the Cultural Revolution remains.

Yet when the custodians of a public secret pick up the icon of a minor, insurgent one and carve it into a photo-altar, secrecy itself—by which I mean the political law, as described by Elias Canetti, that "secrecy lies at the very core of power" (1984, 290), and that to keep secrets is thus to be on the side of the powerful—is shaken at a symbolic level. The momentous nature of the secret, and the hold it maintains over the initiated precisely because they are insiders and want to remain within their club, is challenged. The journal *Remembrance*—where the "primary insiders," the "carrier group," held their extended forum on Bian Zhongyun's death—also regularly reported on the work of the "out-group" artist-activists as they iconized her image. The custodians of the public secret knew, in other words, what that portrait had come to mean and how disruptively symbolic its use might be. Photo-forms, we might conclude, possess an immanent capacity to carry out this work of disruption. The insurgent network I have described in this chapter demonstrates that images are often the most adept antagonists of secrecy, which maintains silence by relying heavily on a textual world of encryption, codified documents, archives under lock and key, the notion of the arcanum. These wordless image-works, by contrast, repeatedly defy that clandestine script-based world at the same time as they seek, rather like the Cultural Revolution once did itself, to "touch people to their very souls."

As Michael Dutton has observed, the aesthetic "technologies" of the Cultural Revolution "worked to turn the rational cognitive processes that produced a strong intellectual belief in revolution into goosebumps on the surface of the skin, lumps in the back of the throat, tears in the eyes of the believer, and anger in the heart of the revolutionary" (2016, 720). And, as he goes on to point out, it is precisely this "capacity to generate political intensity" that is now "disabled, dismembered, diffused, transformed or repressed" (730) for

fear of what might follow if it were unleashed again and the ice were to fissure. Public secrecy of the kind that surrounds the death of Bian Zhongyun is, in this sense, not merely a cover-up that conceals the identity of a group of well-connected teenage killers who may nor may not hold power today. It is a bulwark against intensity, a suppressive force that keeps the soul—the numinous—out of politics. So it is ironic that the challengers of public secrecy found themselves returning to the "technologies" of back then to ignite intensity once more.

DUCKING THE FIREWALL

Who was it, the one casually photographed
the young lad standing before the tank
waving his arms
moving the whole world
and yet, save for the tank's muzzle
no one could see his face
His name, too,
no one knows
And then . . . and then
his trace disappeared
the world that cried for him
didn't want to keep looking for him
—LIU XIAOBO, "Jiyi" (Memory), 1995

A Tale of Two Oscar Entries

The year 2017 saw a remarkable milestone in Chinese movie history. *Wolf Warrior 2* (*Zhanlang 2* 战狼2, dir. Wu Jing 吴京), a Rambo-esque bullet fest in which a Chinese former special forces agent takes on evil American mercenaries in an unnamed African state, became the highest-grossing release in any single territory. The film made $800 million in China, $1 billion globally, and was the first non-Hollywood film ever to enter the list of the top one hundred box-office earners in history. The success of *Wolf Warrior 2* emboldened China to enter the film as its submission for the best foreign-language

FIGURE 4.1 Screen-grab from *Wolf Warrior 2*, 2017. Tank Man morphs militantly into Rambo.

film category at the 2018 Oscars, despite its extreme divergence from the standard arthouse fare. The film's plotting is thin; its pulse beats instead around metronomically spaced shoot-'em-up set pieces: underwater kung fu, drone fights, cruise missiles launched from a flotilla of Chinese destroyers, and a marathon tank battle set in Zhaochuan Ironworks in Hebei Province. Quite apart from its pyrotechnics, this tank battle is striking for another reason. Partway through the sequence, a standoff unfolds between the hero and one of the tanks deployed to exterminate him (figure 4.1). Filmed in long shot, this scene of confrontation—lone man versus armored leviathan—ripples down the years right back to June 4, 1989, and the visually near-identical moment when a young man in a white shirt and dark trousers, carrying two shopping bags, stopped the tanks just off Tiananmen Square. He faced down the combat vehicles for fifty-two heart-stopping seconds before clambering onto one of them, seemingly in search of dialogue with its driver. Promotional shots for *Wolf Warrior 2* show Wu Jing also leaping atop a tank in a further replay of the 1989 scene, though his intent is violent rather than peace-seeking, and his opponents are white American mercenaries rather than Chinese compatriots in the People's Liberation Army.[1]

The similarities between this scene and the Tank Man photograph are so obvious that we can't miss them. But scant, if any, reference to this return of forbidden history can be found on the Chinese net, despite the film's extraordinary popularity and despite the huge volume of online chatter about it. This almost voluble silence also extends to another distant "sighting" of Tank Man

that occurred in 2017, this time in a South Korean film entitled *A Taxi Driver* (dir. Jang Hoon). This movie tells the story of a cab driver in Seoul who reluctantly agrees to take a German journalist to the city of Gwangju, where students were protesting against the government. The pair bear witness to what became the Gwanju Massacre of May 1980, in which army troops beat, shot, and killed hundreds of unarmed young protestors. *A Taxi Driver* is based on a true story, but the driver himself disappeared from view after the Massacre—just as Tank Man did—and it was only after the film's release that his son finally confirmed his identity. And in another set of telling similarities with *Wolf Warrior 2*, *A Taxi Driver* is both the highest-grossing local film ever released in South Korea and the country's selected submission for the foreign-film category at the 2018 Oscars. These acute parallels proved to be too much for the Chinese state. In October 2017, the Beijing Cyberspace Administration Oversight Center issued an order for its censors to "find and delete all introductions, online encyclopedia entries, film reviews, recommendations, and other articles related to the August 2017 South Korean film *A Taxi Driver*" (China Digital Times 2017). The film, which had been gaining popularity among audiences before the ban, was all at once ghosted from the Chinese net, although self-exiled Chinese cartoonist Badiucao (of whom more below) resurrected it for his many followers on Twitter in a piece of drawn satire that joined the transhistorical dots between Tank Man and Taxi Driver (figure 4.2).

In one sense, it should come as no surprise that the censors wiped all traces of *A Taxi Driver* from the Chinese net. The Chinese Communist Party has a famously troubled relationship with the legacy of the Tiananmen Square protests of 1989, as comparative search enquiries visualize all too plainly. Figure 4.3, for example, shows what a search for "Tiananmen Square" turns up on Google Images.[2] Even without the far more decisive search term "Tank Man," the field of the screen as the user scrolls down is repeatedly dominated by that photograph and its transmedial repurposings. Yet type the same search term into Baidu, China's chief search engine, and the results seem to issue forth from a parallel postsocialist universe: one in which the bloodshed of 1989 did not happen, or at the very least has been whitewashed. That said, "color-graded via Photoshop" might be a better description since the deeply saturated blues and greens and reds have a slightly surreal luster, their propagandizing feel reminiscent of the revolutionary posters of the Maoist era (figure 4.4). In contrast to the dense temporality of "Tiananmen" on Google, whose passing into history is serially figured by the photographic remakes, the Square on Baidu seems to live in an eternal present, without past, without memory. And while Tank Man has been propagated and repropagated endlessly outside China

FIGURE 4.2 Transhistorical, transnational Tank Man: Badiucao uses the iconic protestor to draw a line between Chinese and South Korean democratic movements.

FIGURE 4.3 Screenshot of the results of a Google search for "Tiananmen Square." The 1989 protests ripple insistently across the frame.

FIGURE 4.4 Screenshot of the results of a Baidu search for "Tiananmen Square" (天安门广场). China's political nerve center is restored to tranquil, technicolor glory on the domestic search engine.

over the past twenty-five years—mostly in the form of American political cartoons, memes, posters, YouTube remixes, even a Simpsons parody—his presence in his homeland throughout that same time frame has been fugitive, hunted even.

The extent to which Tank Man—as a photograph, as an icon, as the progenitor of a thousand remakes—has become almost farcically deracinated from his origins in central Beijing is a problem that scholars within the field of Chinese studies have not fully gotten around to confronting in the years after 1989. It fell to the American political scientists Robert Hariman and John Lucaites finally to point out, and with a certain masterly understatement, that "the iconic status of the photo was a product of the Western media elite" (2007, 213).[3] They continue: "From a day when one million people were congregating in the square, this photograph only shows a single person. Instead of noise, sirens, and the smells of food, garbage, and urine, there is silence and a general anesthesia of sensory engagement . . . [through this reductionism] the photograph transforms the event from an episode in Chinese national history into a parable about the future global order . . . on the terms most legible and reassuring within a Western narrative of the continued expansion of modern technologies, open markets, and liberal ideals throughout the world . . ." (2007, 220). To the extent that China itself remained in the discussion of Tank Man, he simply "showed" that the Chinese people wanted out of communism; he offered to Western audiences what Slavoj Žižek (2002, 46) calls a "moment of transparent clarity" about China after Mao and revolution. This drive toward "collapsing complex events into image narratives and delimiting political analysis into a trope of pro-democracy struggles" has come under fire from scholars (Ibrahim 2015, 7; see also Ghosh 2011, 45–46). Rightly so, though we might add that the image narrative, the stasis of the icon, is also continually resisted by the logic of remediation, even if photo-forms of Tank Man have tended to describe a narrowly neoliberal ideological arc. None of these critiques, though, concern themselves with the question of Tank Man's legacy as icon in China.

Effectively airlifted abroad and then often, though not exclusively, pressed into the service of U.S.-led democratic liberalism, Tank Man is a photograph whose afterlives in postsocialist China have been elided and obscured to date, a gap that Hariman and Lucaites note openly enough, even if they do not task themselves with filling it. Anyone familiar with the other side of the story—Tank Man in China after 1989—would know that these afterlives are seemingly wraithlike insofar as they exist at all. Indeed, Tank Man plays the role of Banquo's ghost at the robustly on-message political site that Tiananmen Square has become in China itself since 1989. Just as the identity and fate of

that man who faced down the tanks remains unknown, so has Tank Man the photograph been vigorously policed out of online visibility for most Chinese netizens. Pico Iyer (1998) may be right that Tank Man has "Almost certainly . . . [been] seen in his moment of self-transcendence by more people than ever laid eyes on Winston Churchill, Albert Einstein and James Joyce combined," but not many of those people were born after 1989 in China. As Anne-Marie Brady notes, "in China the image is virtually unknown" (2009, 10), and the view that Tank Man therefore carries "no political meaning in China" (Lotfalian 2013, 1380) is sufficiently established that it borders on truism.

How, then, to explain the state's schizophrenic take on Tank Man in 2017? Why did the censors approve his obvious reincarnation in *Wolf Warrior 2*, only to chase down his faint wraith in *A Taxi Driver*? These split responses stem from that fact that the Tiananmen Square bloodshed—and the Tank Man who is its über-icon—are contemporary China's most restive public secret about the historical past. As artist Qiu Zhijie 邱志杰 has put it, "I think June 4 is the biggest taboo area, the most sensitive, the . . . thing you're really not supposed to discuss" (Johnson 2018). In many ways, the absent legacy of the protests offers an object lesson in how to "do" censorship, as tens of millions of younger people in China do indeed live in ignorance of what happened in 1989 within the hallowed Square and now blithely snap selfies in the same precincts where the tanks rolled. As Louisa Lim has noted, censorship may even have worked less wisely than too well, as younger media workers have sometimes "failed to recognize Tiananmen-related material and thus have neglected to censor it" (2014, 96). Yet for older people, especially those who saw or heard tell of the broadcast on national TV, which showed the lone protestor facing down a long phalanx of tanks that stretched up Chang'an Avenue, Tank Man is an imprint on the mind and eye that is well-nigh indelible. And for that reason, it has the power, just like an afterimage left on the retina by bright sunlight, to linger long after exposure to the glimpsed object has ceased. It is in recognition of that fact, of course, that China's censors were sent out on a search-and-destroy mission against *A Taxi Driver*, a film whose resemblance to Tank Man and Tiananmen is at best only blurred, however suggestive it may be.

In this chapter, I argue that this indelibility has only hardened as the years have passed, as Tank Man has staged a series of returns via photo-form in China since the millennium: in the work of internet cartoonists, an augmented reality artistic collective, a video installation artist, photo-artists, and others. My intention here is not to try to rebut the shibboleth that "Tank Man is meaningless in China" by listing, litany-style, successive examples of his visual presence in Chinese spaces—though the work of these artists and their

audiences in China do unquestionably challenge the notion that Tank Man's image is "unknown" and robbed of all significance. As will become clear, the life spans of these photo-forms are often abruptly cut short, have only a small reach—or both. Such limitations make it absurd to suggest that the cumulative effect of these works has been to endow the Tank Man image with any kind of mass viral visibility at home, let alone the iconic status that the image possesses outside China. I argue instead that these repurposings, in part *because* of their fugitive character, perform a key role within the context of ongoing state suppression of the June 4 protests as memory. Harried by the censors, repurposings of Tank Man have to shape-shift like specters to elude their pursuers: "hiding" the tank, "disguising" the man, dismembering the icon into its component parts in order to smuggle them past the censors. Indeed, these photo-forms operate in necessarily divergent ways as they grapple with the complex affects generated by a public secret that splits the generations. In what follows, I begin by exploring cartoon art that deploys intertextual allusions to reboot the Tank Man icon for those old enough to remember it from 1989, leveraging the unforgettability of the image in order to show how fragile the status quo of public secrecy really is. I then go on to show that photo-forms can also illuminate the deep generational crevasse that state management of this legacy has carved out in contemporary China: between those who know what not to know, and those who know next to nothing.

Ultimately, though, photo-forms of Tank Man are more unified than they are diverse, and spectrality is the core thread that binds them. Tank Man is, after all, a revenant nonpareil whose unknown identity and uncertain fate are an invitation to shape-shifting returns. This ghostliness structures the visual language of his photo-forms and even impinges symbolically on their makers, who often find themselves first ghosted from the net and then cast out from China itself. But spectrality also provides a mechanism through which artist-activists can grapple with the public secret on its terms, using its own ploys, and in ways that shed light not on its content but on its closeted operations. In the remainder of the chapter, I push further at the collectivity of these works by showing that their spectrality has a darkly comic tinge. Photo-forms of Tank Man share a mordant, coded humor as they grapple with the funny but sinister fact of a social world split down the middle into those "in the know" and the "know-nots." And as the forces of censorship have borne down harder on photo-forms of Tank Man, this comic character has turned increasingly playful, as repurposers of his image have either abandoned cyberspace for the prankster practices of augmented reality art or turned the joke on the censors by mangling the shape of Tank Man so that algorithms cannot spot him

even while alert audiences can and do. Both hidden and obvious, encrypted and clear as day, photo-forms of Tank Man mount repeated aggravations to state management of the June 4 legacy and the secret-keeping on which it depends. It is in this context of aggravation that Tank Man's cameo in *Wolf Warrior 2* makes sense. The scene between man and tank could never have been included in the film's final cut without high-level sign-off in the Chinese government—and the patriotic snatching back of this most global icon of civic dissent suggests that the state is not only rattled by Tank Man's returns but also determined to claim him as its own. I conclude by arguing that public secrecy about Tank Man and Tiananmen has effectively drawn the authorities into another zero-sum game in which the state itself is now disrupting the faux tranquillity of a hushed past.

Cartooning Around

For Hariman and Lucaites, the planar linearity of the Tank Man photograph makes it almost "a modernist painting in the tradition of Piet Mondrian" (2007, 216). This might be overstatement, but there is no denying the wondrous setup of the shot. Even without its central confrontation, the exactitude of the photo's diagonal lines, its stark empty spaces, its anonymous human figure, even the tenderness of its shopping bags create a moment of singular visual poesis. Rather than modernist painting, though, it is the political cartoon that has been the chief beneficiary of Tank Man's photogenic power. From the outset, the image cried out to be remediated as political satire, and international cartoonists—those outside China, anyway—have barely let it alone in the years since, producing reams of satirical takes even as Tank Man was "disappeared" from Chinese minds, let alone the nation's graphic arts. Yet the launch of Weibo in 2009 created the conditions under which the lost tradition of political cartoon art could return to China, if only for the briefest interval. As media commentator David Bandurski noted in 2012, the advent of the microblog "dramatically changed the environment for cartoonists. They now have a really good platform to find an audience" (quoted in Langfitt 2012). The novelty of Weibo—at that point still a relatively unknown quantity for the state and so not yet hyperregulated— combined with the medial properties of the political cartoon to create an extended moment for a new cohort of digital satirists. As Chinese cartoonist Crazy Crab observed in an interview, "cartoons are the nightmares of the censorship system because unlike words, the check can't search through drawings. Therefore, it's more difficult to trace drawn satire. A sharp politi-

cal cartoon can spread widely before the internet police figures out its real meaning" (Ploum 2013).

During the brief window between Weibo's launch and the crackdown that prompted most of China's major new cartoonists to evacuate the country, figures such as Badiucao, Rebel Pepper, Crazy Crab, and Kuang Biao 邝飙 built up core followings on the site and similar platforms.[4] All worked powerfully with the Tank Man image, forcefully bringing it back to life for Chinese audiences who might not have seen the image domestically for decades, but who had evidently never forgotten it. Most insistent among these cartoonists is probably Badiucao, born in Shanghai and now based in Australia, who has made the icon a staple of his aesthetic activism. Badiucao's cartoons, starkly lined in black and red—he calls contemporary China a "giant meat grinder," a "vortex of blood and iron" (China Digital Times 2016, 6)—quickly found small but dedicated audiences on Weibo before clampdowns pushed him onto Twitter and out of China. Arguably, the most provocative among Badiucao's many takes on Tank Man are those cartoons that directly address the status of the image, and the suppressed protests it represents, as an egregious instance of the public secret. A standout here is "A Piece of Red Cloth" (*Yi kuai hongbu* 一块红布, 2014), in which the body of the tank is draped with crimson fabric: blood and iron again, as well as the familiar red of the Chinese Communist Party and its cover-up, literally rendered, of the Tiananmen protests in the years since (figure 4.5).

The cartoon's messaging operates intertextually and via the decipherment so common to photo-forms. Its title recalls the famous song by Chinese rock singer Cui Jian 崔健, "A Piece of Red Cloth," which became something of a protest anthem during the 1989 demonstrations in the Square and continued to reverberate for years thereafter. As Nimrod Baranovitch notes, the song alludes to how "Chinese society was blindfolded by the Communist Party during the revolutionary period . . . [It] describes a violent experience of someone who is not only blindfolded, but whose hands are clasped and whose mouth is blocked by someone else so he cannot see, speak, drink, escape, or even cry. The speaker in the song turns into a subjugated creature" (2003, 238). Yet when he sang the song on stage at subsequent concerts, Cui Jian would often blindfold himself with a red cloth, turning his performance into a staging of the complicity—the pact of silence—that was also necessary for that subjugation.[5] Threading Tank Man into this rich seam of intertextuality,[6] in which motifs of forced but also voluntary blinkering coalesce, gives the cartoon a layered set of significations for those with memories of 1989: it uses allusion to reroot, and reboot, the icon. In recent years, Badiucao has returned to the scarlet cloth

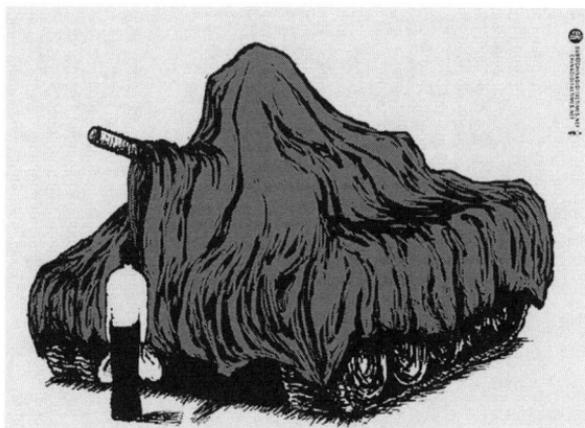

FIGURE 4.5
Badiucao, "A Piece of
Red Cloth," 2014. Once
again, public secrecy
is at its most potent
when it makes a faux
show of concealment.

repeatedly: in figure 4.6 as a visual salute to the Hong Kong umbrella move-
ment in 2014, and again in figure 4.7, which shows Xi Jinping using it as face
mask to muzzle Yang Shuping 杨舒平, the University of Maryland student who
caused an uproar in her homeland when she declared that the air in the U.S.
was freer than that in China. As Geremie Barmé puts it, "as we consider the
long tail of Maoism . . . we should be alert to the abiding allure and uses of the
crimson blindfold" (2012, 40). Barmé calls the cloth a "blindfold" here, but
Badiucao is careful to show its function as an object that blocks cognition
across multiple senses and in ways that can be phony. In his cartoon art, wear-
ing the cloth ultimately becomes code for selective nonacknowledgment as
much as for state suppression. The keepers of the public secret use the cloth to
perform the various acts of not-seeing, not-speaking, not-hearing, even while
their other senses stay attuned but inert to action.

Ultimately, the cartoon skewers the vested pretenses of concealment—and
this for any viewer of the image, whether or not she has personal memories
of what the red cloth means. Wiping traces of Tiananmen from China today
produces nothing other than a rag soaked in blood, and by "hiding" the tank
in this same cloak of redness—which leaves the outlines of the combat vehicle
farcically obvious—Badiucao finds a metaphor for the fragility of the consen-
sus that keeps the Tiananmen crackdown out of public discourse. The tank
gun, which protrudes from the cloth like a half-obscene provocation, height-
ens the mockery. But the refusal of the gun to be covered also shows how men-
acingly unforgettable the suppressed past remains, and the action of cloaking
may even heighten the threat it poses. This point emerged strikingly during a
performance of Cirque du Soleil at a Beijing theater in 2013, when the image of
Tank Man was flashed up for four seconds as part of a montage, after having

FIGURES 4.6–4.7
Badiucao, "Go Hong
Kong," 2014; and
"Yang Shuping," 2017.
The ever-adaptable
red cloth becomes a
metonym for voices
that struggle for
utterance.

somehow eluded the prescreening eyes of the Chinese Ministry of Culture. Media outlets outside China noted that the audience gasped in shock (Wong 2013), but presumably they gasped in recognition, too, or even fright. If, as I suggested in the preface, the Tiananmen crackdown is an event that hovers between taboo and totem, then Tank Man is the figure within whom that fearful tension is made incarnate. His appearance, like an angry ghost in the midst of earthly festivities, does not simply pull the 1989 protests back into the here and now. As much a portent of disorder as a revenant from the past, Tank Man threatens the sureties of the present because he suggests the fallibility of state power even as the rarity of his returns ostensibly testifies to its strength. He shows the cracks in the carapace.

Hiding It from the Kids

Something rather similar occurred in 2009 when American artist and designer Michael Mandiberg, by way of curious experiment, contacted several copyist-artists in Dafen Painting Village in Shenzhen and asked them to produce replicas of the Tank Man photograph. Mandiberg displayed the varied results on his blog, titling "each image with a snippet of dialogue from the negotiations for each painting" (Mandiberg 2009). While some went ahead and fulfilled the commission per the specs, others fudged, rejected, or simply ignored it. One version paints the tanks but omits the man; the painter tells Mandiberg, "You can add the person to painting when you get it." Another queries, "the man . . . will be painted or not?" A third paints the man but inclines his head and upper body slightly so that he appears to be bowing to the tanks. The most telling comment comes from the final communication Mandiberg posts. This last artist turned down the commission, stating that painting such images is "illegal" in China. "When I was in high school in 1989, I once devote my passion to that event," the email continues, but "now most Chinese people forgot the history while I [do] not" (Mandiberg 2009). Yet mass amnesia, with its suggestion of involuntary mnemonic fail, is an imperfect take on the problem. As Badiucao put it in an email interview with me:

> The group who lived through the Tiananmen killings, particularly those who participated in the events, is now middle-aged and forms the core stratum of contemporary society, the key constituents of the middle-class. They know this history all too well. What's more, the image of Tank Man was broadcast on news networks at the time as a way of displaying the humanity of party bosses and the army, who refrained from crushing

Tank Man to a bloody pulp [*niancheng roubing* 碾成肉饼]. So although the authorities now tightly control information about June 4th and Tank Man, this is nothing more than the emperor's new clothes: middle-aged people all have a tacit knowledge of what happened; it's a secret closely kept by both sides. (Personal communication, 2016)

In short, Mandiberg's curious experiment shows not merely the aura of fear that surrounds Tank Man as taboo-totem, but also its intergenerational, interfamilial implications. For a large chunk of China's population—those born before the mid-1970s or so—the Tiananmen protests are an exemplary case of the public secret, whose faux clandestine character at least two generations conspire to maintain.[7] This collective effort relies precisely on what Taussig calls an "active not-knowing" or "knowing what not to know" (1999, 6–7). Or as Bourdieu puts it, nailing the complicity even more sharply, it is all about "the rule of the game which is to act as if one did not know the rule" (2000, 192). For those born later, by contrast, June 4 is passive nonknowledge, which explains the split among the Dafen copyists between those who readily copied the image in its entirety and those who doctored or declined to do so altogether. Indeed, the disjuncture is such that when filmmaker Antony Thomas quizzed a quartet of students at Beijing University, the epicenter of the protests, about Tank Man in preparation for his eponymous documentary in 2005, they responded by asking politely if the image showed a military parade (Gavett 2012). Contemporary Chinese society has been fascinated in recent years by the idea of so-called "hidden rules" from how to bribe an official to how to get ahead in the entertainment industry, which determine status, power, and advantage in the PRC. Yet the carefully maintained nonlegacy of the Tiananmen protests illustrates—perhaps more vividly than any other episode in this book—the extent to which its partner term, the public secret, helps to structure China's socioaffective relations today, reinstating the state in the home, and in ways that have been overlooked.

On one level, of course, not-telling is simply protective, as the artist Sheng Qi has made clear in his personal-political practice. After the Tiananmen protests, he chose to remember the pain of June 4 in a uniquely radical way: he sliced off his little finger and buried it in a flower pot. In the years since, he has repeatedly used this mutilated hand in his work, most notably in a series called—what else?—*Memories* (*Jiyi* 记忆, 2000), in which tiny black-and-white family photographs nestle poignantly in its traumatized palm (figure 4.8). Yet Sheng has never told his son why he has no finger: "Whenever his son asks him what happened, he jokes that he lost his finger on a bus. His son knows that

FIGURE 4.8 Unity and severance: Sheng Qi's meditations on the Chinese family.

he's lying, Sheng Qi admits, but he has decided not to tell him the truth" (Lim 2014, 96). When asked why, Sheng responds, "I want to protect him." Yet secrecy, as a form of power, always segregates, and not telling about Tiananmen aligns those who do not speak and share alongside the selfsame authorities from whom they expressly seek to protect their young. Badiucao observed in our interview that June 4 is a "secret closely kept by both sides." But maintaining that silence also draws the state and its secret-keepers together in alliance against China's younger generations. As such, silence becomes a form of extracted loyalty, a form of moral hostage-taking in which keeping the state's secrets—the price paid for a quiet life—brings not simply complicity but a siding against one's own kin. More than just the kind of inevitable experiential chasm that divides the generations—such as memories of war and famine in China—public secrecy is, in this sense, an active wedge driven between family members, a little-noted reinstallation of the party in the space of the home just at a time when the state's presence is supposedly in steady retreat from private life in China.

Getting Ghostly

On one level, then, we might argue that by repurposing an image that everyone who saw it back then has "agreed" to forget, China's political cartoonists are intent on confronting this disavowal in all its affective distortions, motivated by the desire to disrobe it. This is the notion, by now familiar, that exposure might offer itself as a solution to the reluctant collusiveness of the public secret. Yet to think in terms of the big reveal is to overlook the fact that Tank Man is a fundamentally phantasmal figure. Wraithlike from the very outset as he vanished like smoke from the scene of his insurgency, Tank Man has emerged in recent years as a revenant who haunts through repeated returns. This spectrality, with its play of absence, presence, and mutation, lays its marks on virtually all the photo-forms that repurpose his image. It draws these works into a connected corpus despite their aesthetic diversity and despite the contrastive aspects of the public secret they call to account. Spectrality is the basic syntax that structures the visual language of Tank Man's photo-forms, and a repeated feature of this grammar is the ghost as shape-shifter who can flip identity to suit satirico-political need.

A decisive example of this can be seen in figure 4.9, a reworking of Tank Man from 2011 by Crazy Crab. Rather like a cinematographer who films in 360 degrees instead of the 180 decreed by classic Hollywood continuity editing, Crazy Crab "crosses the line" here and provides a disorienting but revelatory

FIGURE 4.9 A man of many faces: Tank Man becomes the blind activist Chen Guangcheng. Illustration by Crazy Crab, 2011.

inversion of the standard Tank Man framing: at last we see his face. As Badiucao (personal communication, 2016) has noted, what Tank Man "left the world was a figure seen from behind" (*beiying* 背影; literally a "back shadow,"[8] an expression with a faint ghostly resonance in Chinese). And Crazy Crab's inversion reveals yet another spectral morphing: Tank Man has been reincarnated as Chen Guangcheng, the famous civil rights activist and "barefoot lawyer," who is immediately recognizable to Chinese audiences because of his dark glasses (as noted earlier, Chen is blind).[9] The text in the bubble reads "Dammit! Another case of organizing a mob to disturb traffic," which on one level refers to the trumped-up charge of "damaging property and organizing a mob to disturb traffic," for which Chen was handed a jail term of four years and three months in 2006. The Chinese term for "dammit," though, is *jiangui* 见鬼, which literally means "to see a ghost," thus lexically reinforcing the spectral connection between the two disappearing—or forcibly disappeared—dissidents.

In this sense, Crazy Crab's work follows the logic of substitution that helped Tank Man ascend into iconicity right from the start: the lone protestor, as a

faceless figure caught serendipitously in back view, can become Mark Zuckerberg, Vladimir Putin, Donald Trump—whosoever the spoof requires. Both Crazy Crab and Badiucao have riffed in rich ways on this logic, swapping Tank Man for a Buddhist monk to protest the CCP's policies in Tibet, or for a young Uyghur girl in a gesture of support for Xinjiang separatism. But the cartoon in figure 4.10, again by Badiucao and entitled "Sacred Vestments" (Shengyi 圣衣, 2013), puts a sharper gloss on the shape-shifting revenant at the same time as it parlays directly with Crazy Crab's earlier image in which Tank Man reliveth as a latter-day opponent of party power. As Badiucao put it to me, "the flesh may perish, but clothing and personal effects do not, and these items seem to support the spirit after the body has decayed; thanks to them, the spirit can be preserved and transmit itself to later generations . . . Tank Man was a hero who dressed in this most ordinary of shirts and trousers; perhaps one day others can put on these ordinary clothes and step bravely onto the street" (personal communication, 2016). Tank Man, as a dissident identity, can shuffle off this mortal coil (suggested by the bloodstain on his shirt) yet return in different guises, like the reincarnated revenant he is, to the scene of other standoffs with the state. "Being" Tank Man is a set of accoutrements, in other words, a portable persona that can be slipped or inked on at will by those minded to dissidence. Badiucao has showed this himself when using cosplay performance art to bring the lone protestor to the streets of Sydney on June 4 in 2018 (figures 4.11 and 4.12),[10] or when he had the image of Tank Man tattooed on his upper arm to commemorate the twenty-fifth anniversary of the crushed Tiananmen protests. "I wanted to use my body to record the memory of Tank Man," he told me.

These cartoons and performances also use the figure of the revenant—particularly the ghost of futures past, since Chen Guangcheng and others postdate Tank Man—to foretell a time when different histories will be written, when the unsayable will be spoken. For now, though, simply repurposing Tank Man, let alone becoming him, is an action that can lead its practitioners to become "ghosted" themselves, as the case of the cartoonists shows plainly enough. As the internet police steadily came to grips with Weibo, China's political cartoonists found themselves resorting to a practice known as "reincarnating" (zhuanshi 转世) in order to get their work into the ether. "Zhuanshi" is originally a Buddhist term meaning the "transmigration of souls," but in Chinese internet lingo it refers to the creation of a new social media account after an earlier one has been shut down by the provider, usually because the user has breached the bounds of political acceptability. Badiucao was forced to reincarnate thirty times, sufficient frustration for him to state that "the Chinese space for

political cartoonists in the mainland has already closed" (China Digital Times 2016, 7). Kuang Biao has been reborn closer to fifty times, though his WeChat account was closed in 2016, as the authorities began to clamp down on re-registration. The practice of reincarnation on social media lends itself most readily to the critique of censorship in China, a long-standing red-button issue in the Western media. Yet *"zhuanshi"* can also be read linguistically, as a term that connotes the otherworldly, the shape-shifting, the uncanny, even. To re-incarnate successfully on social media required the user to reincarnate *recognizably*, to adopt a new avatar that allowed him or her to be identified by fans while remaining, for a short while at least, elusive to the agents of authority. Thus Kuang Biao once reincarnated as "Uncle Biao Fountain Pen Drawings 47." In other words, just as Tank Man mutates from photograph to pen-and-ink re-versionings of that image, so, too, do his repurposers morph and migrate in order to slip into the online interstices that can give them a short-lived platform for their work. Remediating Tank Man is, in this sense, a multiply spectral practice: it turns all whom it touches into shadows of themselves.

This abundance of spectrality, much of it self-reflexive, does not entirely square with the idea that these cartoons simply seek to shout out the secret that dare not speak its name in the hope that this cry will end the phony performance of amnesia. In fact, as Jack Bratich has pointed out, the operations of public secrecy undermine "a fundamental assumption among oppositional forces, namely the belief that the revelation of secrets is inherently a progressive force" (2006, 502). On the contrary, a simple process of denuding only plays into the hands of the public secret, which "has built-in protection against exposure, because exposure, or at least a certain modality of exposure, is what, in fact, it thrives upon" (Taussig 1999, 216). In other words, Tank Man can be unmasked, just as the red cloth can be whipped off the tank. Yet he will duly pop up again in altered guise because what he represents is not a true secret but one of Slavoj Žižek's "unknown knowns." These cannot be exorcised through mere unveiling because what they stand for is the socialized complicity of the secret rather than its content. Indeed, rather than remind people of an event they have never actually forgotten, oppositional forces would do better to come up with what Taussig elsewhere calls "a set of tricks, simulations, deceptions, and art or appearance in a continuous movement of counterfeint and feint strangely contiguous with yet set against those weighing on us" (1998, 246). Although Taussig does not really specify what these moves might be, nor how this revelatory justice might be done, a suggestion comes when he writes that public secrecy first caught his attention in Colombia during the early 1980s, "when there were so many situations in which people dared not

FIGURE 4.10
Badiucao, "Sacred Vestments." The Tank Man persona is broken down into portable parts so that others can slip on his mantle.

HANDBOOK OF THE PERFORMANCE

When:

Any time on the 4th of June 2018 for your local time.

Where:

Downtown in your city or anywhere you feel meaningful and comfortable, even at your home.

What to Wear:

a. Classic outfit of the tankman with white shirt, black pants and black shoes.

b. Wear a mask if you want to keep anonymous.

c. Carry two Badiucao designed bags (see article below).

How to do the performance:

a. Bring a chair to the location of your choice.

b. Stand on the chair as the pose of the tank man.

c. Chair helps you stand taller and also echos meme of LiuXiaobo.

d. Print the introduction of the performance and share on the site. Click here to download the introduction.

Record:

Make sure you bring a friend with you to take photos and videos as well.

It is even better to stream the performance online with a smart phone.

Share: Tweet Like 8

Use hashtags #tankmen2018 & #坦克人2018 to share your performance on social medias.

Email your images and video to tankmen2018@protonmail.com or DM @tankmen2018 on twitter

If you can not make the performance, please share this project or others people post to support us. THANKS

FIGURES 4.11–4.12 The photo-form as performance art: Badiucao follows the logic of his own "Sacred Vestments" and role-plays the lone protestor on a Sydney street corner.

state the obvious, thus outlining it, so to speak, in the spectral radiance of the unsaid" (1999, 6).

The spectrality that so defines Tank Man, his repurposers, and their work is, of course, in part about the righteous anger of the wrongfully buried. Whether dead or "disappeared," Tank Man is a figure in search of justice. Yet the ghostliness in which he now has his being is also what Taussig calls a "movement of counterfeint and feint" (1998, 246), a means of parrying the thrusts of state power, as those who are suppressed reappear, on repeat, to haunt the guilty. And as Tank Man becomes Chen Guangcheng, or as his repurposers acquire new avatars, the restiveness of the public secret about 1989 is aptly metaphorized. Rather than revealing the already known or reminding people of the entirely unforgotten, these spectral apparitions show that the price of shared silence is a

constant nervy tension that the "peace" will one day be broken. The recent pro-
liferation of spectral voices speaking truth to power about the Tiananmen crack-
down puts the state on repeated notice that public secrecy is only ever as robust
as the fear and awkwardness that hold it in place, and that the possibility of
emboldenment always exists, however remote it may seem. If it does crystallize
into mass articulation, then what follows is not some needless exposé about the
falsified past but rather a threat to the contemporary social order that the public
secret is so instrumental in propping up. The ghost, then, is ultimately a figure of
candor. Dead or disappeared already, and with nothing left to lose, specters can
incite the living to speak from the digital margins with an impunity that shakes
the fearful scaffolding of silence: the very premise that it is too risky to speak.

Moreover, it is crucial to recognize at this juncture that if the 1989 protests
are China's most restive public secret, this is because they are also its most
conspicuous one. In this sense, they also function as a broader metonym for
all the many other things that are unsayable in China today, such as the huge
shadow population of migrant workers who have built megacities within which
they have no real rights to housing, health, or education, and whose ubiquitous
presence on the streets and at construction sites is thus only partially visible; or
the even more fraught matter of whether widespread and well-understood cor-
ruption within the CCP should disqualify it for rule. If the crushed protests of
1989 were to enter into sayability, so, too, might these many other matters—and
not just the verboten things discussed in this book—on whose status as public
secret the state depends for its continued control. Perched at the top of China's
pyramid of public secrets, Tank Man and the crushed Tiananmen protests
show that this tight structure is also a house of cards: should they be toppled
from their apex, the killings-as-secret would bring down much more with them
besides. As arch-metonym for public secrecy in China, then, the 1989 protests
emblematize the extent to which public secrecy is a hard but brittle form of
social management. It cannot be unmasked, but it can perhaps be shaken if its
architecture—its workings—are better understood or even borrowed. Indeed,
once we put aside the notion that exposure has any hope against public secrecy,
further options for "feint and counterfeint" swim into view. Or as Bratich puts it:
"What can be learned from the secret, not just about it?" (2006, 502)—which is
to say, formulating an aesthetic response to public secrecy may usefully involve
assimilating its "dissimulations." This is especially true in cryptocratic environ-
ments, where more overt jibes at the unsayable can carry risks, as the fate of the
exiled cartoonists shows clearly enough.

An example of a work that takes ghostly shape in order to poach the public
secret's own tricks is Chen Shaoxiong's *Ink History* (*Moshui lishi* 墨水历史, 2010),

a three-minute video that traverses China's past from the late Qing period to the present day. Described by the artist as a combination of ink, animation, and installation, *Ink History* consists of dozens of terse but fluid drawings based on famous photographs of Chinese history that have been "scavenged" entirely from the internet and set in propulsive motion to a soundtrack of political speeches, propaganda songs, and a loudly ticking clock. As such, *Ink History* is most evidently a work of search engine art. Yet it is one that offers an alternative look to the frozen collage of the Google image search, which delivers static, silent screenshots of countless multimedial remakes of one and the same iconic shot. Chen Shaoxiong has a professed "distrust of single-image photographs" (Wang Xin 2012, 214), even though he is possessed of a strong repurposing drive. Thus *Ink History* presents the complementary inverse of "Tank Man" on Google Images: multiple photographic icons re-versioned by the same artist in a single medium and made highly audible and judderingly kinetic (staggered zooms in and out are a particular feature). Approaching the photographic icon against the grain of Google Images and its algorithmic aesthetic, the video couples the expressivity of ink with the flow of animation in order to liberate history from the frame even as it relies very openly on a photographically composed vision of the past.

Ink History would be arresting for this reason alone, but it also offers a skilled staging of the public secret as art. The video strings together ink re-versionings of, *inter alia*, Sun Yat-Sen 孙中山 seated with his wife, Soong Ching-Ling 宋庆龄; writer Lu Xun; the "killing contest" of the Nanjing Massacre; the Long March; Chiang Kai-Shek 蒋介石 on the cover of *Time* magazine; Mao Zedong declaring the founding of the People's Republic on October 1, 1949; Mao with Stalin; the well-known propaganda poster "We Must Liberate Taiwan"; the denunciation of counterrevolutionaries during the Cultural Revolution; Richard Nixon shaking hands with Zhou Enlai 周恩来 upon his arrival in Beijing in 1972; Mao's body lying in state in 1976; the trial of the Gang of Four; Deng Xiaoping greeting Margaret Thatcher; the handover of Hong Kong to the mainland; China's triumphal space program; the Sichuan Earthquake; and the Beijing Olympics. The iconography is overwhelmingly propagandistic, and in many cases overbearingly familiar, particularly for older Chinese people. Furthermore, all the images are easily accessible via Baidu, even when the history shown strays slightly into the controversial. But then, at 2:29 minutes, Tank Man appears (figure 4.13). The camera cuts in with a staccato thrust five times over the next two seconds—more times than it performs this move at any other point in the video. The image, which is unmistakably Tank Man at 2:29, becomes by 2:31 noticeably less defined under this zooming,

even as the motion jolts the image out of calcified inertness. The camera tries to pin him down by peering closer, but the shapes loosen and the fluidity of the ink strokes asserts itself (figure 4.14). The jerkiness of the camera movement, which also jumps slightly back and forth over the space of the image, emphasizes the sense that, for all his iconicity, Tank Man remains elusive, outlined in a "spectral radiance."

All the sketches in *Ink History* feel ghostly. This is the effect of ink-as-animation: the flickering motion as the images segue into each other, the centrality of chiaroscuro and shadowing to the sketching process. But the sudden appearance of Tank Man amid all the hypersanctioned state imagery has the shocking feel of an apparition, as the very processes of hiding in plain sight become Chen's artistic subject. How better to aestheticize the notion of a public secret? Like the inverse of stealth or subliminal propaganda, in which key words or images flash by so swiftly that only the unconscious mind registers them, *Ink History* uses Tank Man to interrupt, for two full seconds, the flow of the excessively familiar with a dip below the radar into the taboo.[11] Yet at the same time, incorporating Tank Man into this photographic roll call of China's modern history also performs, and at the selfsame moment, the extent to which the protestor is totemic too. He is a keystone in the edifice of China's modern past, and the day will come, the video declares, when his definitional role will be as known, and as acknowledged, as that of Lu Xun, Lei Feng, and all the other figures whom Chen animates in ink. Meanwhile, as the integrity of Tank Man dissolves under the camera's zoom, the video prompts not "blind" seeing but the kind of closer gaze—crucial to the logic of the photo-form— that discerns the outlines of the unsayable precisely at the moment when they are defamiliarized as ghostly, half-graspable forms. Mirroring the public secret as *ploy*, Chen's work articulates in visual language not merely the thing we all know anyway, but the process whereby it comports itself brazenly in the open. This is not the public secret *per se*, but rather how it works.

Dead Funny

But where does this leave what is arguably the most famous reiteration of Tank Man to break the Chinese internet (figure 4.15)? Created in 2013 by designer Miller Yu in Hong Kong, from where it went viral in China for a short while until the censors banned all searches for "big yellow duck," this Photoshopped Tank Man seems, if anything, deliberately anti-spectral even as it mocks the public secret. Indeed, if ghost had an antonym, it might well be rubber duck: the *unheimlich* versus the über-homely. The meme was inspired by a fifty-four-foot

FIGURES 4.13–4.14 Tank Man steals into view in a pen-and-ink video otherwise dominated by the iconography of state propaganda. From Chen Shaoxiong, *Ink History*, 2010.

FIGURE 4.15 Ducks in a row: the near-sublime power of the original shot turns ridiculous.

tall inflatable sculpture of a rubber duck designed by the Dutch artist Florentijn Hofman, which floated in Hong Kong's Victoria Harbor during 2013. Hofman created the sculpture, and others like it, "to amplify the healing power of the classic bath buddy" (Berthelsen 2013), and its cheery, primary-color innocence caused a minor mania in Hong Kong. This backdrop gives the meme its political charge, as the tense standoff near the Square is soothed into reconciliation courtesy of an intervention from Hong Kong.

Discussions of the duck patrol, whether academic or in the media, have focused on this plastic retooling of the image as a tactic for dodging the censors: ducking the firewall (to make the obvious pun). In a context where search terms as apparently innocuous as "today" are blocked on sensitive anniversaries, it is only by taking on the guise of something quintessentially bathetic—a plastic yellow duck—that the image of man-versus-tank can do the virtual rounds, for a while at least. In other words, the price of being seen is the possibility of provoking a more meaningful kind of encounter with the events at Tiananmen in 1989. Yet this censorship argument feels incomplete, and not just because toys, comics, and cartoon characters recur everywhere in memes or mutations that base themselves on iconic photographs, as an online search for, say, "flags at Iwojima" quickly reveals. For some, no doubt, there may be a desire to democratize the icon for the amateur user or even to tame it by

using the signifiers of childhood, monetizing memory as they go. For others, the shibboleth status of these master images is a kind of aggravation, a gift to the saboteur in the age of Web 2.0 and beyond. This is Boudana, Frosh, and Cohen's point when they note that the "old mass media regime . . . tended to preserve the iconic photo as a socially responsible form whose appropriation was undertaken by identifiable authors in 'good faith': either indexical faithfulness to the 'auratic' uniqueness of those depicted or thematic faithfulness to the moral seriousness of its emblematic meanings" (2017, 16). Now, by contrast, certain memes—often anonymous—threaten via their humor "to elevate ridicule and provocation to the degree that it constitutes a form of insult to the dignity of the depicted" (16).[12]

These arguments, however, overlook the vital powers of laughter within a suppressive environment. In a way, this point has been hovering at the edges of my discussion for some time now, and before any mention of the duck patrol. Humor is a core currency of the political cartoon, evidently animating the works referenced above. But laughter reaches further than the medium of graphic art alone in remediations of Tank Man. These photo-forms as a collective are gravely humorous: they are conjoined by the comic/spectral character they share. On one level, this laughter is about poking fun at power-holders and their censoring excesses, a kind of satirical shakedown that is important in its own right. Yet simple spoof does not capture the full picture, which has a telling structural dimension. In this more operational sense, humor can be seen as the final component of an aesthetic practice that seeks to square up to public secrecy, a role it can play because comedy shares odd and little-discussed space both with the spectral and with the secret that hides in plain sight. All three are modes that often dwell in liminal spaces and gain their power from doing so, and all three, for that same reason, find fitting aesthetic representation in photo-forms. The logic of the repurposed photograph is, after all, that of the double who is almost the same. An object re-versioned is one mutated in such a way that we can recognize both its origin and its new incarnation. And as Freud famously noted nearly a century ago, *doppelgängers* such as these are uncanny; their creepiness emerges from the cracks. Yet what Freud did not choose to acknowledge, while Shakespeare showed it in play after play, is that doubles can also be funny, which no doubt explains why one of the meanings of the term "canny" is "sly humor."[13] Doubles (and double entendres) amuse because they stake out fecund ground for miscommunication, dissembling, and double-cross—all of it, though, transparently obvious to the audience, which gestures clearly toward the relationship between humor and public secrecy. Gallows humor, the grimly comic: ultimately, these companions

in doubleness and oxymoron do justice to the public secret because they suggest that the joke is sinister and that it is also on us—the people—for seeing that the emperor is naked and praising his outfit nonetheless. Or as Crazy Crab puts it, "the political cartoon is a 'laugh bullet' that can penetrate through lies and fear . . . When people laugh, they will think too, in a new perspective" (Ploum 2013).

Just as pertinently, humor is often coded or even encrypted. Indeed, the etymology of this latter term gestures powerfully not just to the keeping of secrets (encryption as the creation of a cipher text that requires a key) but also to spectrality (the crypt as a concealed and subterranean burial place). Thus when the "duck patrol" slips beneath the radar, it does not simply entertain its viewers; it also transmits to them "taboo information" (Attardo 1994, 330). Humor can, at times, be a tool of secrecy that uses its doubleness—this time manifested in the gap between the "raw" forbidden information and its encrypted form—to evade detection and bolster a sense of belonging within the in-group, which is primed to get the joke, and thus receive the contraband data. This is the argument made by Flamson and Bryant, who argue that a little-observed aspect of humor is its role as a means of "signaling compatibility within local groups by relying on the detection of 'encrypted' information" (2013, 50). Cryptography in humor, they suggest, relies on "informational complexity to ensure both the secrecy and the authenticity of a message" (52). Or to paraphrase for the case in hand, the duck patrol amuses in part because, as Orwell put it, "every joke is a tiny revolution . . . Whatever destroys dignity, and brings down the mighty from their seats, preferably with a bump, is funny" (2019, 284). This is never truer than in totalitarian societies, and what better than a plastic yellow duck to exemplify the point that clowns can topple kings? Yet at the same time, the "in-group"—those who see it, those who laugh—understand that the meme is also using encryption to play the public secret at its own game. It covertly slips the ducks past the censors to create a meme that is all about the absurdity of hiding the obvious.[14]

If so, Tank Man and his repurposings may be becoming a joke too far for the authorities in China. Like all doppelgängers, these images retain their power to provoke both fear and laughter precisely because of their fugitive character: no one outside China audibly gasps in shock at a four-second glimpse of Tank Man, after all. Why would they, when that image has been used to market not just the free world but Chick-fil-A chicken sandwiches too (Hariman and Lucaites 2007, 241)? In China, though, Tank Man remains a spectral talisman, presenting an object lesson of the truism that censorship merely serves to sacralize the objects it bans—and can duly become a laughingstock itself because

of it, as the duck patrol shows rather too tartly. One might suppose that the authorities get this point all too well, and they have the choice of at least two possible responses: to lift the taboo and let the image run free and headlong into banality, or to attempt an exorcism, a publicly stage-managed casting out of Tank Man's wayward spirit. That they have taken steps toward the latter was suggested by news reports in 2016 that Visual China Group had purchased from Bill Gates the copyright to one of the few original photographs of Tank Man. As Xiao Qiang 萧强, founder of *China Digital Times*, puts it, we should not be surprised if "a Chinese media company's decisions and actions were aligned with the policies and practices of the Chinese government" (quoted in McPhate 2016). Or as Wang Dan (2016), former protestor in the Square, argued much more bluntly, "once the copyright of that image falls into the hands of the CCP, I fear it will be sealed up for safekeeping." Just as likely is that the CCP will exercise any rights it might sooner or later manage to procure over the image in order to try to restrict its use abroad, too, thus avenging the endless critiques of Chinese disregard for intellectual property at the same time as turning the exorcism of Tank Man into a global spectacle.

On the one hand, then, Tank Man exemplifies to a ridiculous degree Wendy Chun's argument that digital media, despite "its ever-increasing archive in which no piece of data is lost," is in practice "degenerative, forgetful, erasable" (2008, 154, 160). At the same time, however, the sporadic accessibility of Tank Man, and of his multimedia photo-form progeny, to most netizens in China does not limit their impact as absolutely as we might suppose. The one-third of China's population who were born after 1989 may indeed have only the haziest awareness of Tank Man, if they are cognizant of him at all. But he lives on in China as the grit in the clam of the public secret for the very reason that his remakes are more or less unsearchable (and because when the ghost does surface, he typically makes people laugh). We see this process in reverse with the now almost tediously abundant free-market remediations of Tank Man outside China. These have certainly ensured his memorability—yet what kind of legacy is this when "a Chinese citizen taking a stand in China . . . becomes the incarnation of something American" (Hariman and Lucaites 2007, 237)? In an era of search engine optimization and spamdexing, in which online ubiquity supposedly keeps an item fresh and in mind, Tank Man's untrack-ability in China has become, paradoxically, his special stock. Always ghostly from the moment he slipped the scene in 1989, Tank Man's elusiveness has allowed him to become not a searchable object on Baidu but something closer to a roving digital quest—and one that spurs his repurposers to ever more playful action.

Obviously, there is no greater testament to Tank Man's unforgottenness than the purchase, for an undisclosed sum, of a vast image bank in order to obtain the copyright to one (and only one!) of his original images. Provoked into trying to exorcise a ghost—the equivalent of exposing a public secret, and ultimately every bit as pointless—the authorities deployed proxy interests to restrict his presence on the global internet. Much the same thing happened when lateral pressure forced the closure in 2016 of the June 4th Museum (*Liusi jinianguan* 六四纪念馆) in Hong Kong, the only site on Chinese soil that has ever commemorated the protests (and that contained an important memorial to Tank Man).[15] Summoned briefly back to life by China's political cartoonists, Tank Man under Xi Jinping's rule seems to be going to ground again. Where, then, might we go to find him, now and in the future? A work by the anonymous artistic collective 4Gentlemen suggests something of an answer.[16] Entitled *Tiananmen Squared*, it uses the smartphone technology of augmented reality to allow Tank Man's spirit to return to Beijing and stalk his former haunts (4Gentlemen 2011).

More commonly associated with military or gaming applications, augmented reality has recently shaped up as a potent tool for use by conceptual artists. Its high-water mark so far is probably Amir Baradaran's *Frenchising Mona Lisa* (2011), an app that allows users to train their phones on any version of Da Vinci's painting and watch as the enigmatic one miraculously removes her featherlight veil and wraps the Tricolore flag around her head as if it were a hijab. French secularism, sartorial hypocrisy (why are some scarves okay and others not?), curatorial control, the whims of iconography, and the shifting status of the artist all coalesce as targets within the frame in Baradaran's work. Criticized by some as a self-promoting prankster, Baradaran himself argues for the value of augmented reality as a "legitimate installation art medium" (Hube 2014). He seeks, as he puts it, to "bring AR-as-art into the museum" (Hube 2014). Indeed, his abiding gripe is with the Louvre as a stuffily sacrosanct institution that he debunks via invasionary attacks, essentially breaking into the museum to make his mischief. These notions of appropriate use of space, and how to violate it, have been crucial to augmented reality as an art form, as interventionist installations such as Sander Veenhof and Mark Skwarek's 2010 AR exhibition at MoMA showed very clearly. More than thirty artists took part in the "art invasion" exhibition, showing their works all over the building and effectively annexing the museum space for any visitor who had the app installed.

This idea of spatial pranking has broader implications. These have been provocatively mapped by 4Gentlemen, who use the AR application Layar to

FIGURE 4.16 4Gentlemen, *Tiananmen Squared*. Tank Man goes home, courtesy of an AR app.

invade the space of Tiananmen Square and its surrounds with *verboten* image-making. Once downloaded onto a smartphone, the app activates geolocation software to superimpose a computer-generated icon of Tank Man, sized to the original scale, at the exact GPS coordinates—on Chang'an Avenue just off the Square in Beijing—where the face-off between man and machine took place (figure 4.16). In keeping with the photo-form nature of this enterprise, the app also allows users to take pictures of the scene with the Tank Man icon overlaid. On one level, then, the *Tiananmen Squared* project shares space with the work of Baradaran, Veenhof, and Skwarek, infiltrating consecrated ground with below-the-radar visual messaging—but with a sharper twist. *Tiananmen Squared* is not simply iconoclastic (*Frenchising Mona Lisa*) and anti-establishment (squatting in MoMA). It does not merely work on or alongside existing canonical works. Its impulse is also recuperative, as it reinstates at the original flashpoint of its occurrence a virtual icon that state censorship has attempted to wipe from the public "hard drive." Tank Man—the wraith, the disappeared, the deleted—thus stages a defiant return to the Square, commandeered from U.S. liberalist discourse and installed once more in the highly localized site of his political agency, while also cheekily mimicking, through his hidden presence in the open air of central Beijing, the very machinations of the public secret.

Like most AR technologies, *Tiananmen Squared* merges public space with sudden and secretive computer-generated icons. But here publicness is both more municipal and more ideological than in *Frenchising Mona Lisa*, which takes the rarified air of the Louvre as its stage. *Tiananmen Squared*, by contrast, launches from the backdrop of air pollution, traffic noise, and the locale, which, more than any other in China, denotes and connotes public space as state power and is, for that reason, highly surveilled. The app user, surrounded by a mass of vehicles, pedestrians, sightseers, and armed police, connects with the forbidden image of Tank Man in a move that echoes Chen Shaoxiong's *Ink History* in its staging of the public secret. Yet it heightens the sense of raw, risky theater through its outdoor performance and the way it turns user into embodied actor. The public secret as drama also plays out within the app's visual field. The ambient street scene is viewed in two planes on the smartphone until the Tank Man graphic—the secret—appears, sleekly contoured, pinpoint-sharp, and rendered along three axes so that its dimensionality "steps out" from the rest of the pictorial field. It is chromatically and perspectively compelling, despite being invisible to all around, like a grail in its sudden onscreen materialization. Ultimately, then, the effect of *Tiananmen Squared* is to combine the spectral and the playfully subversive with the notion of a digital quest that leaves the internet behind.

Indeed, although 4Gentlemen call Tank Man reloaded a "virtual monument," it might be truer to argue that the project exemplifies Lev Manovich's (2006) point that if the 1990s were about the virtual, "it is quite possible that this decade of the 2000s (and beyond) will turn out to be about the physical— that is, physical space filled with electronic and visual information." Taking Tank Man out of the ether and into the street is, in this sense, entirely of a piece with other shifts in Chinese digital culture, which, as Michel Hockx (2015) has pointed out, has been making the move from the World Wide Web to the freer climes of the app format. Hockx describes how online literary superstar Han Han 韩寒 created an app for accessing his work, which makes use of "the functionalities of Internet connectivity [while] entirely bypassing the browser-based media of the World Wide Web" (106). Although Han Han explicitly denied that his aim is to avoid censorship, the app format certainly opens up "new, independent avenues" (107) for digital expressivity. Rendering Tank Man as an app fits neatly within this rationale. It chases down further the notion that in the face of conspiracies to silence, which now focus almost obsessively on controlling the internet (as shown by the Baidu search results for Tiananmen, the crackdown on cartoonists, the purchase of the Tank Man photograph), web-inflected physical space may emerge as an agile zone for performing playful rituals of revelation. The app is preeminently a practice

that allows users to embody in physical space and corporeal movement the keyboard commands of "find" and "search," though the term "questing" may indeed be more apposite here because it captures better the extent to which the pursuit of Tank Man in contemporary China fuses the mischievous with something almost ceremonial. After all, it is through pilgrimage and the ritual of focused looking that the lineaments of the public secret are held up for scrutiny amid the CCTV and the traffic.

In this sense, it is not surprising that the underlying logic of *Tiananmen Squared* reiterates the theme of in-betweenness that is immanent to both the public secret and the other photo-forms of Tank Man that seek to do him revelatory justice. The app is both web-driven and yet browser-free, digital and yet grounded in the materiality of the body as it moves. Above all, it exploits again and again the status of the repurposed photograph as an interstitial object. Using the app generates a complex *mise-en-abîme* in which the security cameras record the user who scopes the street with his or her smartphone until the graphic of man and tank appears on screen, the vehicle's guns trained telescopically on the user too. At this point, the user may decide, as mentioned earlier, to take a screenshot of man and tank superimposed over the street scene. In short, the app enables no fewer than five separate camera/photographic operations, an emphatic profusion that begs its own set of questions. On one level, this is just an organic response to the memoryscape all around. Just as power flows from the barrel of a (tank) gun, to paraphrase Mao Zedong, so is history now inescapably filtered through the lens. But as the augmented reality app of Tank Man repeatedly performs this shift—from original photograph to computer graphic, from computer graphic back to mixed-media smartphone photograph, from virtual environment to the Square, and from that physical location back to the screen—it also rehearses the logic of the photo-form, which can stage a reckoning with the public secret because it is an object that re-renders the familiar as materially strange.

Tank Man Redux

What's more, the app is designed to rove and roam from location to location, as we see in figure 4.17, which shows Tank Man in Union Square. In so doing, these iterative journeys, from Square to Square and beyond, parlay directly with Ai Weiwei's well-known *Studies of Perspective* series (*Toushi yanjiu* 透视研究, 1993–2003) in which the artist photographs himself flipping the bird to various landmarks of authority: the White House, the Eiffel Tower, Red Square, the Basilica in the Piazza San Marco, the Reichstag, the Mona Lisa (again) (figure 4.18). In

FIGURE 4.17 4Gentlemen, *Tiananmen Squared*. Tank Man travels.

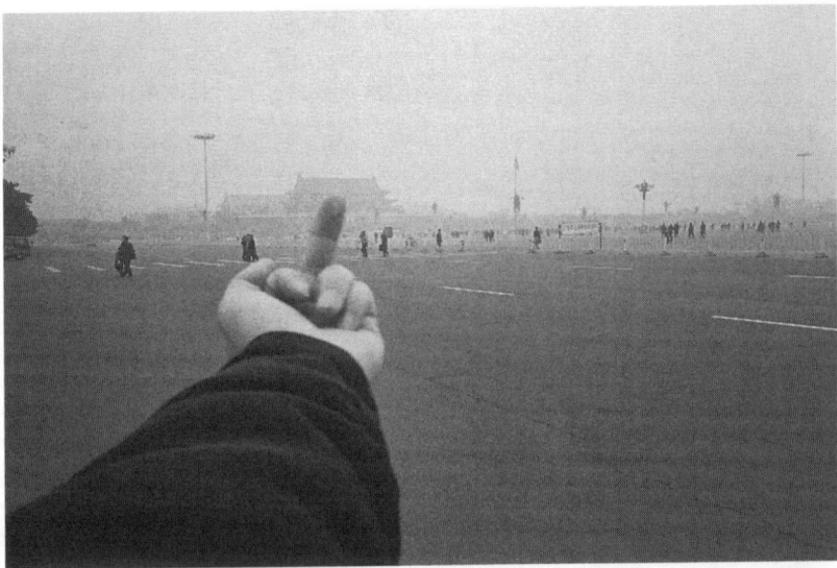

FIGURE 4.18 Giving it the finger: digital art revisited as Ai Weiwei sends state power a message.

naming the series as a whole *Studies of Perspective*, Ai Weiwei's main point of propaganda is to make the middle finger matter more than the monument, to undermine multiple icons of establishment power with an equally iconic gesture of disrespect. Yet the linchpin of the series is *Studies of Perspective: Tiananmen Square*. The power of Ai's semi-selfie snapshot, taken only six years after the crackdown and long before Tank Man's online comeback, derives from its allusive and politically aggravating geometric similarity to that iconic image. Ai's insurgent middle finger, in the central foreground, stands in for the lone protestor, while the Gate of Heavenly Peace, adorned with Mao's huge portrait—and which Ai's finger obliterates—becomes the tanks. In both images, the standoff occurs across the same bottom-left/top-right diagonal axis in the midst of emptied public space. But the crushing downward momentum of Tank Man, in which the tanks have "advanced across most of the pictorial field along the lines and vectors on the street indicating the forward direction of the traffic" (Hariman and Lucaites 2007, 217), is reversed as Ai's finger protrudes as an aggressive *repoussoir*. It takes the place of the tanks and bears down, not on the protestor, but on the site of state power. The planed patterning of the road markings in the original Tank Man shots, which tamely follows the convoy of vehicles, is undone in Ai's photo, which scatters these narrow white lines across the visual field.

In other words, *Studies of Perspective: Tiananmen Square* is Tank Man redux, with a vengeance. If so, it is ultimately predictive about the remixing of icons in digital times, and in China most particularly. Already with Ai's photograph—a gelatin silver print and thus an analog object par excellence despite its prophetic use of digits—we witness a process at work that has revved up noticeably in online space. Even as echoes of Tank Man richochet left and right across Ai's photo, *Tiananmen Square* also testifies to the partial dissolution of that source image, or rather, to its capacity to absorb intrusive adaptation while retaining its strong recognition quotient. As an über-image, Tank Man may twist and bend. Yet the center can still hold in much the same way that an aesthetic remediation of the black-and-white photograph of the gate at Auschwitz, emblazoned with the infamous words "Arbeit macht frei," could be composed of matchsticks and still refer unmissably back to its photographic point of origin. Under digitality—within the universe of memes—remakes and remixes of photographic icons have proliferated for the obvious reason that the speed, profusion, and plasticity of the online environment vastly multiply the opportunities for re-versioning. On a non-censored web, though, these repeated remediations tend, in practice, to belong quite tightly within the same genus. They are clear scions of their photographic patriarch, as we see with Global Tank Man, whose remakes—for all their quantity—are remarkably alike. Their purpose,

after all, is to keep memory refreshed and to harness it within cognate politico-mercantile projects, so it scarcely behooves such remediations to stray too far from the master image.[17] This "family resemblance," to borrow Wittgenstein's (2009, 67–77) term, typically breaks down when Tank Man is remediated in Chinese online spaces. This is for the simple reason that secrecy, not forgetfulness, is the core antagonist against which the remix is battling—and battling secrecy requires clandestine tactics. Just as Ai Weiwei's *Studies of Perspective* shows that Tank Man never really went away, so does it also suggest—and in ways that complement his incarnation as AR art—that his wandering ghost will withstand future attempts at exorcism. Even on China's increasingly censored web, Tank Man can live on for those canny enough to spot him.

In an article on China's new documentarians, Ying Qian lays out the toolkit of tactics that these filmmakers use to "out" secrets, in particular the regime of opacity that the state and local governments created in the wake of the Sichuan Earthquake to conceal bad practice in the construction of public school buildings that led to the deaths of thousands of children. Qian uses the term "re-tweet" to describe how Ai Weiwei and fellow artist-activist Ai Xiaoming 艾晓明 serially reference each other's work as means of getting hidden information out and then keeping it in play. As she puts it, Twitter has "influenced the cinematic form," inducing a quick-fire intertextual responsiveness that can parry attempts at containment (Qian 2014, 192). More important than the specifically Twitter-esque form of this referencing, though, are its seriality and the way it creates a visual in-language whose powers are enhanced by the fact that the internet police want to suppress it. Precisely because these speech acts are prohibited, their audiences listen all the more carefully for them, whatever their guise. For Tank Man watchers, this sense of being on the *qui vive* is never stronger than when the anniversary of June 4 looms—as a feature in the *South China Morning Post* that went online on June 4, 2013, shows (n.a. 2013). The article consists of a live feed that updated readers throughout the day by "re-tweeting" the various photos, memes, and veiled references to the events of 1989 that were circulating in virtual climes. A photograph of Ai Weiwei appears halfway down the page. The image is familiar because it riffs on one of the artist's best-known works, *Dropping a Han Dynasty Urn* (1995), in which Ai was photographed in a slow-motion triptych smashing an ancient ceramic vase. Here, though, the vase has been Photoshopped out in favor of a tank in a deft piece of serial-style visual shorthand that connotes both Tank Man and Ai Weiwei's single-finger salute to the Chinese state in *Studies of Perspective* (figure 4.19). In a work entitled "Duang" (2015), Badiucao brings the chain of allusion full circle by making Ai smash to smithereens the Gate of Heavenly Peace (figure 4.20).

FIGURE 4.19 Tank smashing: an anonymous prankster's take on Ai Weiwei's subversive photo series.

FIGURE 4.20 Badiucao ups the ante: the smashed object shapeshifts into the Gate of Heavenly Peace itself.

Rather like the inventive ways in which netizens have exploited the many homophones in the Chinese language in order to reference keywords banned by the censors, remediations of Tank Man murmur to each other through coded spectral "re-tweets" morph as the message moves step by step along the chain.[18]

In short, these latter remediations of Tank Man exemplify the digital icon at large within censored space and in protean and phantasmagorical form. On China's web, where he is so fugitive and spectral, repurposings of his image can stray further than ever from the original photographs and yet remain instantly, effortlessly identifiable to those in the know. Indeed, to be unlike Tank Man, and yet to be recognized *as him* nonetheless, lies at the core of his necessary ghostliness in a society split by secrecy, just as devising his off-kilter reincarnations is what propels the creativity of his re-makers. Appropriately, Tank Man's ability to disassociate himself from his primary incarnation, and to be reborn in cognate guises, gives his spectrality a mobile, lingering character that is in some ways more poignant than any high-fidelity remediations. In this sense, Tank Man may be more iconic in the nooks and crannies of digital China, the place that has supposedly "forgotten" him, than anywhere else. Rather than "the elephant in the room"—the familiar metaphor for a public secret known to everyone and for that reason never manifest as anything other than an elephant—Tank Man is the shape-shifting symbol of what we might call the partially public secret. He is entirely invisible to some, yet always conspicuous to others, even when sometimes he barely resembles himself—or may not be there at all.[19]

Icons: Dead, Alive, Stolen

We may already be witnessing the law of diminishing returns at work with memes that riff on photographic icons. This is Boudana, Frosh, and Cohen's point when they suggest that even as repurposing canonizes such images, it can also "corrode their intensity and uniqueness" to the point of desacralization as these photographs slip from the grasp of institutional mass media and into the hands of users (2017, 4). "For iconic photographs," they argue, repurposing is both "a definitional condition and a potential death threat . . . [because] the spreading of memes may kill the host" (6, 18). And even when icons do not outright expire, their meaning can narrow into triviality and reductionism as they undergo indefatigable, irreverent recycling. On one level, nothing could be further from the case with Tank Man in China, whose many photo-forms actively resist the logic of *reductio ad absurdum*. As his repurposers battle inventively to

keep Tank Man in play, they have no choice but to push and pull at the structural integrity of his image, disguising it so carefully as to make him incognito to all but the cognoscenti. They warp his image out of all normative shape and even violently dismember it.[20] Equally to the point, Tank Man's struggle for visibility on the Chinese web, frustrating as it may be for those who want to see him, also has the effect of inoculating this particular icon—in China, at least—against the virus of banality that would kill its host.

These necessary distortions are possible in part because of Tank Man's iconicity: the cruel beauty of the shot and the extreme visual stickiness that it gave the protestor in a networked world so unforgiving that most images slip instantly through the cracks. But his longevity is also abetted by the fact that he stands as one of perhaps only two visual symbols of the 1989 protests that has any residual traction at all in contemporary China (the other being the Goddess of Democracy, the statue that dominated the Square in 1989). Works such as Xu Yong's *Negatives*, discussed in the preface, may broaden the repertoire over time, as might the release in 2017 of another remarkable cache of images from the Square, this time taken by photographer David Chen (Luo 2017). Like Xu Yong's images, the photographs that Chen took restore intensity, movement, and animation to the protests, so long freeze-framed in the figure of Tank Man. But both of these collections remain inaccessible in China. So for now, Tank Man rules virtually without challengers, operating as a mythic "condensation" of multiple political meanings (Sonnevend 2016, 84–98)—and utterly incapable of capturing the complexity of several weeks of protest that shook China to its core. In chapter 1, I discussed this selfsame process in relation to the Nanjing Massacre, arguing that the photographic record of those atrocities has been codified into an ocular shorthand, a set of logos engineered to produce synaptic patriotic rage. It would be disingenuous to suggest that Tank Man is any less the engine of fixed meanings simply because he belongs to the iconography of dissidence, even though his image is repurposed far more freely than the catalogue of atrocities showing raped women and decapitated men. Precisely because of their radical difference, in fact, the two imagistic traditions demonstrate with only heightened acuity the bond that pertains between public secrecy and well-known historic photographs—a point I revisit in the conclusion. Public secrets, whether they are upheld or braved down, find themselves defaulting back to the visual, and the visual extreme of an über-photograph, because the embargos placed on speech within suppressive societies give those images that are noisy enough to break the silence an especially plangent voice. But as they speak, such images, via their photo-forms, inevitably create visual regimes that privilege the singular photograph. They enshrine

the image that apparently needs no caption and for that reason has little time or space for nuance.

This is not to deny Tank Man his agency in contemporary China all over again. On the contrary, this chapter shows that the spectral/playful mode that his photo-forms exploit so keenly has the capacity to rub more friction-ally against partial public secrecy than any faux threat of exposure, a danger against which open secrets have their own "built-in protection" (Taussig 1999, 216). Public secrecy, after all, is everywhere and inescapable, as are its off-shoots in the strategic silences that prevail in communities, in families, in our most intimate relationships. They are hardly a postsocialist, propaganda-state phenomenon. In this sense, these remixes of Tank Man show that we need to live intuitively and creatively with the well-known but papered-over facts that permit a given social order to continue in the absence of a collective will to candor. These remakes are incitements to truth, but they do this talking gently from the sidelines. They are complementary objects that, via their very struc-ture, call attention to the sinister yet ridiculous character of the shared failure to speak. As such, they represent the distortions—to repurpose is, after all, on some level to distort—that an antagonistic complicity with public secrecy requires. Banishing Tank Man can only ever be the bluntest of instruments against him, because it merely serves to sharpen the creativity of his repur-posers and the alertness of his audiences, whose eyes stay peeled for his next apparition. The point here is not the risk of overinterpretation, of seeing Tank Man where he does not exist, but rather the long shadow cast by his forbidden specter, which actively stimulates ghost-hunting.

But nature also abhors a vacuum, and it would seem that the authorities in China, and their media agents, have begun to realize that as Tank Man is forced into ever more obscure disguise, the original contours of his image are up for grabs. Earlier I suggested that neutralizing the threat Tank Man poses might take two forms: letting the image run free and burn itself out, or staging some kind of exorcism. But there is, of course, another surely smarter way, and *Wolf Warrior 2* would suggest that the state is giving it serious consideration. In a step-change from the reactive, quasi-paranoid purchase of one of the original Tank Man photographs, the inclusion of the man-versus-machine stand-off in *Wolf Warrior 2* marks an unprecedented attempt to appropriate Tank Man by the political orthodoxy in China. This move, which is possible in significant part because of Tank Man's forced evacuation from Chinese media spaces, exploits the selfsame singularity—immunity from the informative demands of the caption—that iconic images by their very nature enjoy. After all, if Tank Man can be Donald Trump, he can also morph into an operative of the militar-

ily resurgent Chinese state that has run out of patience with the aggravations that the eternal protestor poses to the sociopolitical order, and now wishes to ensure that subsequent repurposings will evoke—for the post-1989 generation, at least—*Wolf Warrior 2* instead, thus serving as patriotic propaganda. As the film's tagline runs, "anyone who offends China will be hunted down, no matter how far the target is." And how better to vanquish an opponent than to cannibalize him—even if no one in China dares to comment on the fact online? In short, rather than censorship, the most imminent danger faced by Tank Man, China's little boy of legend, is that the emperor will laugh back and steal his thunder. But in doing so, the emperor must also admit that he is naked, that the public secret exists, and that it vexes him deeply. It is in this sense that Tank Man and the state are likely to stay mired in impasse, locked in a zero-sum game in which neither can conclusively prevail.

Conclusion. Out of the Darkroom

What cannot be said . . . is what has to be done.
—ANTHONY GIDDENS, *Central Problems in Social Theory*, 1979

Nested Secrets

"A photograph is a secret about a secret. The more it tells you the less you know" (Arbus 1972, 64). So famously reflected Diane Arbus, the American photographer who spent her career taking pictures of "freaks" and forbidden things. Her aphorism on the photograph, as an image whose seeming disclosures actually thwart knowledge, is important in part because it rejects the cliché of candor that even now so often accompanies the camera and its works. Yet in a sense that point is always there with photography. It shapes the medium's very lexicon, poised as it is on the hinge between concealment and openness. This paradox is most paradigmatic in the notion of the darkroom, which is both a "chamber of secrets" and the place where those secrets are lifted from the acid into clarity. But it is also there in the vocabulary of exposure, transparency, filter, candid pictures, wide angle, shutter, capture, fogging, close-up, lens shade. Arbus, though, also departs from this quite familiar ground in the sharper point she makes about the nested nature of photography's relation to the clandestine: "a photograph is a secret about a secret." Here she recognizes that although taking photographs may often trespass on secrets and threaten their exposure, the image thus obtained is also deceptively encrypted—by framing, lighting, tone, color, circuits of spectatorship, and so on. Rather than a technology of the transparent, what Barthes called "a message without a

code" (1977, 17), photography is among the most secretive of visual practices, however stridently it seems to disown its powers of occlusion.

Throughout this book, I have argued that the objects I call photo-forms take the photograph, which is "a secret about a secret," and encrypt it further still. In so doing, they enjoin spectators to the task of decipherment, as it is through this labor that a kind of justice can be done to the thing that dare not speak its name. Unlike the photograph *per se*, in other words, the less that photo-forms expose the more they harbor the power of revelatory justice—which is why Walter Benjamin's words have functioned as a kind of guiding refrain here. Indeed, a broader determining idea shaping the book has been the notion that aesthetic objects are key sites where public secrecy and our relation to it happen. This is not any notion that representation is a smooth mirror for social phenomena, nor Oscar Wilde's claim that "life imitates art far more than art imitates life" (2007, 936). To put this more categorically: photo-forms are not mere illustrations—how could they be, when public secrecy prides itself on being impervious to mere visibility? Rather, in environments where secrecy is ambient and at large, these cultural forms generate a communality—even when their audiences are small—that can be capacious enough to stage a reckoning with the things that society professes not to know. Communality also contains within it the subsense of communing. This relates to the point just made that photo-forms use structures of codedness to pull us into an encounter whose phenomenology is akin to the experience of the shared secret. That is to say, photo-forms give their spectators a code to crack, and this carves out conduits of solidarity between the artwork and its audiences, and among those audiences themselves.

The Labor of the Negative, Revisited

I have referred to this shadowy solidarity, made up of code-makers and code-breakers, as a parallax world, an ambit that exists alongside the world of "unknown knowns," quietly calling out the absurdity of the naked emperor. This notion of a parallax world finds a keen exposition in an extended archival project by contemporary artist Zhang Dali, entitled *A Second History* (*Di'er lishi* 第二历史, 2003–6). In this work, Zhang curates a series of paired images—one "original," the other manipulated—to show how the Chinese Communist Party repeatedly doctored the photographic record of the Revolution in its secret photo labs. The photographs range from official portraits of Mao Zedong to images of model soldier Lei Feng, the writer Lu Xun, other CCP leaders, foreign dignitaries, and ordinary Chinese as they experienced the revolution. The

targets for the airbrush also vary. Sometimes people are wiped entirely from the frame; on other occasions a portrait of Mao is added to a bare wall in an ordinary home, a slogan is rewritten, a propaganda button is removed, or the trees in the backdrop to a photograph are switched miraculously from barren to blossoming. And the motives for manipulation oscillate from the strategic to the almost inexplicable to the faintly absurd.

Commentators have noted *A Second History*'s relationship to secrecy. Wu Hung describes it as the "detective enterprise of an impassioned sleuth," which takes the iconic photographs of China's revolution and "lays bare their secrets in the open" (2016, 114). In the main, though, it is the perfected revolutionary "look" sought by the manipulators that has interested critics most keenly. As Chang Tan puts it, the touched-up photographs create "a distinctive aesthetic that defines the proper representation of heroism, leadership and virtue" (2012, 181). In this coda to the book, I push further at the secrecies in which *A Second History* is steeped, showing its status as a serial photo-form that exemplifies the interactions between the unsayable and the spectral that I have sketched across the preceding pages. But more than this, *A Second History* also crystallizes the notion that photo-forms are objects of heightened agency that bind their makers and viewers together into fluid coalitions of solidarity. For Zhang Dali, the "second history" of his title refers to the falsified world of idealized revolution, where the targets of political purges are scissored out and the deep creases on ancient faces are smoothed away. But to view—really view—this "second history" is also to be drawn into a parallax world. Within it, the once imperceptible outlines of public secrecy suddenly materialize like the imprints on a photographic negative as it is lifted out of acid, or like the tank, so long unseen in China, that the draped red cloth in Badiucao's cartoon—like the opposite of an invisibility cloak—outlines with such mordant force. To enter this world and its epiphanies involves a transactional exchange, and it is one based on acts of labor, both artistic and spectatorial.

Zhang Dali sourced the images for *A Second History* variously. The doctored versions were culled from pictorials, posters, publishing houses, and news media; their originals he located through luck, ingenuity, contacts, and, above all, hard graft in the archives. In some ways, his method is akin to the "garbology" discussed in the introduction: as Zhang put it in an interview with Wu Hung, "I have found these materials in heaps of old papers" (2016, 128). Like the new breed of grassroots historians, Zhang had to sift through daunting stacks of faded documents, honing his skills for two full years until he acquired a knack for detecting the hand of the forger (Zhang Dali, personal communication, 2017). Weng Xiaozhu 翁小筑 calls *A Second History* "a work

in pure archival form" (2010, 75), and for his finds, Zhang had to travel widely: "To obtain the original negatives, [he] went to almost every archive in China, even managing to get hold of some classified film through some sympathetic connections" (Peng 2009). Pushing this point further, Maurizio Marinelli suggests that Zhang "acts like a historian" more than an artist (2009, 47), a point Zhang confirms when he states that his archival labors were a far cry from the "untrammeled inspiration of an artist" (Weng 2010, 75). If so, this is because the obdurateness of China's cryptocracy forces him into a reverse engagement with his aesthetic calling. Instead of riffing on original photographs, as do the other artists, writers, and filmmakers I discuss in this book, Zhang actually undoes the artistic remediation of others. Rather than repurpose historic photographs, he depurposes them. Doctoring a photograph pre-Photoshop was lengthy, painstaking work performed with tiny brushes, subtle pigments, and an artist's sensibility.[1] In a profound sense, then, the stripping away of all that transmedial work that *A Second History* performs is counteraesthetic. Its logic of unmaking goes against the very grain of what an artist is supposed to be and do. This is particularly true of an artist such as Zhang, whose work has repeatedly sought to bring media and materials together, rather than sunder them: from the silhouetted self-portraits he graffitied on walls all over Beijing to his resin and fiberglass casts of migrant workers to his recent photographic experiments with cyanotype prints on cotton. Going back to Taussig (1999), Zhang Dali's defacement of secrecy is indeed what the former called a "labor of the negative"—in both senses of that word—and thus it is not enough, as some have done, to call his work curatorial as opposed to normatively creative. Grappling with secrecy has made him an anti-artist, an un-creator; it is a tough kind of graft.

These efforts, which turn Zhang from artist into historian, archivist, detective, and finally anti-artist, also require a reciprocal outlay of effort from viewers of the series. Zhang calls this spectatorial labor, somewhat facetiously, "Spot the Difference" (quoted in Peng 2009). On one level, this is precisely what *A Second History* is all about, as some of the doctored images are modified only minutely, and Zhang refrains from providing textual exegesis, thus forcing viewers to look hard and long. But "spot the difference" refers only to the first stage of what can either be an epiphanic process or one in which that incipient revelation goes no further. What's more, the game of "spot the difference" does not capture that moment when the scales fall from viewers' eyes as they divine, or think they have divined, the "why" of photographic erasure, tampering, and finesse. In some cases, that "why" is self-evident, as in figure C.1, which shows the fall of Liu Shaoqi in "before and after" mode. In other

cases, it is ambivalent, as in the white cuff that disappears from Lei Feng's sleeve in figure C.2. The jury is out on whether the cuff vanishes because it was scruffy or because it denoted bourgeois class background.[2] Yet in figure C.3, entitled "Clean Village," the "why" of the deleted woman who dominates the central plane of the original photograph remains unbendingly opaque. Zhang Dali has pointed out the multiplicity of motives behind photographic doctoring. These modifications were never just political; they also responded to the "aesthetic concepts of the Cultural Revolution period and theories of artistic direction" (Zhang Dali, personal communication, 2017). One might also speculate that quota-filling among the photo-lab technicians—who were, after all, bureaucrats with jobs to justify—may lie behind some of the apparently pointless alterations.[3] But these explanations still do not fully decode the mystery of the "disappeared" woman, whose cheery face should fit well within the spruced-up rural scene. Returning to shirt cuffs, a similar kind of indeterminacy marks figure C.4. Mao's cuff has been minutely shortened in the doctored photograph; but why?

On one level, resistant images such as these force a frustrated kind of labor from viewers, who—to paraphrase Alain Robbe-Grillet (1989, 83)—prise open the long-locked drawer only to discover that it is empty. But in refusing to deliver up their secrets, such images also bequeath a stronger sense of the entanglements that pertain between photography as a political practice and the public secrecy on which every social order depends for its smooth running. In the interviews Zhang has given about *A Second History*, he emphasizes his sense of shock at discovering that the hyperfamiliar images that wallpapered socialist life were faked—a shock that spectators of the work have also reported. Yet Zhang also tells journalists, directly against this grain, that he first heard about the doctoring of photographs as a young boy in the 1970s: "His father showed him a calendar. There used to be four leaders in the photo, his father said: Liu Shaoqi, Zhu De, Zhou Enlai and Mao Zedong. Liu had gone" (Peng 2009).[4] We might also argue in this connection that the Chinese people presumably knew that Mao Zedong did not possess the elixir of eternal youth and that the images of the leader that appeared in the 1960s and 1970s, showing his face unpocked, unlined, and with a persistently lustrous sheen, must have been idealized incarnations. And above all, they knew from personal experience that the revolution was not golden and flawless, less still "a dinner party," to quote Mao's own famous dictum. But what does "knowing" mean in this context?

Presumably, it is a kind of knowing similar to our current awareness that airbrushed images of the famous, or even of people we know personally on social media, are not "real": it is a more passive version of what I referred to earlier as

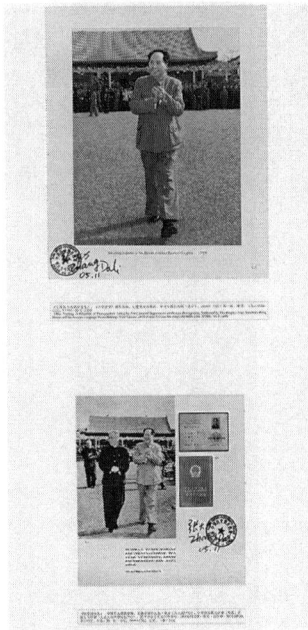

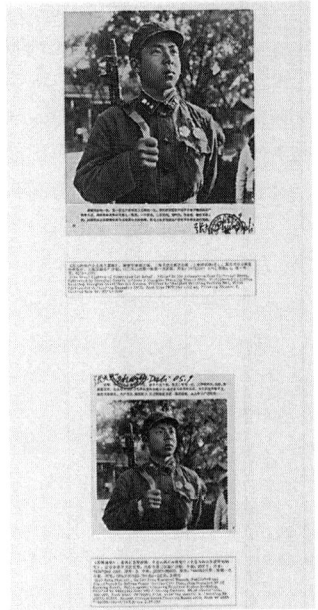

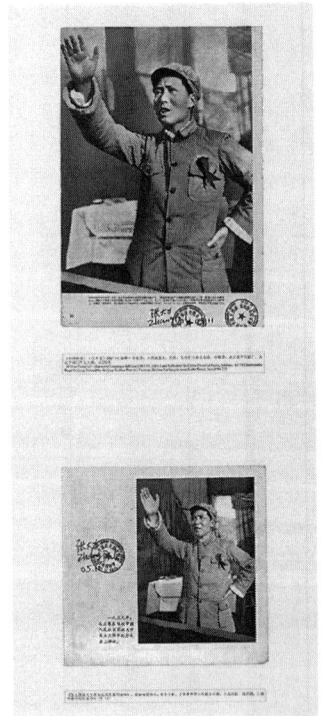

FIGURES C.1– C.4
Elisions and exci-
sions, both petty
and outrageous,
make Zhang Dali's
A Second History
a showcase for the
operations of the
public secret.

"willed opacity." This widespread acceptance of photographic doctoring—or at least the failure to object very strenuously to it—can only occur because those who view have learned to prefer the gentle fake. In this sense, it is not "spotting the difference" that matters most in the spectatorship of *A Second History*, less still the sense of having been tricked. Rather, it is the keener epiphany the series offers—namely, that we the people have collectively decided *not to notice*. This, of course, is the most brilliant of the many heists staged by the public secret: its ability to make subjects collude in the process of knowing what not to know without being especially vexed by the fact. After all, what propaganda state does not cosmeticize its iconography? Under what entirely implausible circumstances would any such government refrain from using all tools available to burnish its image? And only the innocent would dare to hope that other forms of state power—Western democracies, for example—consistently abjure similar tactics: for example, one of the most viewed photographs of Abraham Lincoln was a notorious composite image. *A Second History*, in short, is as much about public secrecy, and our acceptance of it, as it tells the story of the clandestine darkrooms in which the immaculate visuality of the Chinese revolution was manufactured.

This is why ghosts stalk *A Second History* more doggedly than any other work I have discussed in this book. In chapter 3, I discussed the photographs of Hai Bo and his project to reunite the pictorial subjects of yesterday in a present radically diminished by personal loss. The inevitable gaps that register the dead or gone make the series spectral—how could they not?—but these vanishings are also part of time's natural passing, and sometimes they mark nothing more than biological attrition. *A Second History*, by contrast, deals not with those no longer here, but more typically with the "disappeared": the violently deleted people and things whose excision in the darkroom often mirrors their fate outside the picture. The juxtaposition of original and manipulated photographs in Zhang's series grasps at the eeriness of "disappearance," the rent that is ripped in the real when people lose their corporeal visibility while suffering a fate that is egregiously obvious. That uncanniness, and the way it pushes at the meaning of the seeable and the sayable, is registered in the logic of the doppelgänger that structures *A Second History*. Contrary to the gloss often put on this term, which suggests an identikit twin spirit, the uncanniness of the ghostly double comes from its slight "off-ness," from the almost undetectable quirk of difference that makes the alter ego ripe with threat.

In this sense, the ghostliness the doppelgänger embodies has little to do with the paranormal. Rather, as Fredric Jameson puts it, all that its spectrality can ever tell us is that "the living present is scarcely as self-sufficient as it claims to

be; that we would do well not to count on its density and solidity, which might under exceptional circumstances betray us" (1999, 39). The doppelgänger is ultimately a figure of that always imminent betrayal. The photographic doubles that Zhang arrays in close juxtaposition across *A Second History* serve, with an intensity that builds from pair to pair, as reminders that social reality is a constructed myth that is dependent on our compliance. And as such, these doubles reveal the brittle character of public secrecy, which is always vulnerable, not to exposure, but to the fracturing of the consensus that holds it in place. Once a crack appears in the surface of the unsayable, the emperor risks absurdity as his nakedness—or in Mao's case, the myth of his eternal youth—becomes suddenly all the more glaring for having been so studiously overlooked. Something similar occurs when it dawns on viewers, as it sometimes does, that a photograph has been doctored for reasons that seem capricious, petty, or even ridiculous.

The Lures of Encryption

I conclude my study of public secrecy and the photo-form with *A Second History* because Zhang Dali's project vibrates with emblematic value for the arguments made here. The case studies of this book have shown that the photo-form is a core site wherein public secrecy finds trackable form, and that the labor of artistic repurposing opens up an antagonistic dialogue with the hard social facts that would prefer to remain under their carapace of silence. This dialogue is threatening, which is why the guardians of public secrecy repeatedly shut it down, censoring the photo-form in its specific capacity as a speech act and harrying or muffling those who do the repurposing. *A Second History* is revelatory here because it sheds a different light on why the photo-form has emerged as an object of such agency within the domains ruled by public secrecy. As already suggested, the doctored photographs are expressions of aesthetic labor, artworks of a kind. As such, they emblematize Bourdieu's point that public secrecy is "based on a collective labor devoted to maintaining misrecognition with a view to perpetuating collective faith" (1997, 232). More than this, the images are photo-forms themselves. They are artistic riffs on historic photographs that—ideological investments aside—are morphologically identical to the works discussed elsewhere in this study. Indeed, they may even exemplify the photo-form in its purist manifestation, as the "artists" who produced them worked intensively on the photographic negative itself, on the very root of the image. As such, *A Second History* shows that if photo-forms are sites where the unsayable emerges as material form, this is partly because photo-forms were

also key mechanisms through which the public secrecy that shrouds parts of China's past came into being in the first place. The photo-form and its relationship with public secrecy was there already. It had a socialist genealogy; it was subcutaneously familiar.

In short, photography and the creative practices it spawns are locked in tight interplay with that which is "generally known, but cannot be articulated," because photography's status as at once candid and always potentially deceitful makes it both the accomplice and the nemesis of the oxymoron that is the public secret. How much easier the task of hiding power in plain sight must have become with the advent of the photographic apparatus, which had the capacity not merely to render perfect and then propagate the iconography of political regimes, but to do so via image-making, which flaunted its outrageous plausibility even as it proved that the earth was flat, the revolution a thing of utopian wonder, and the Chairman ageless. No wonder the images that served public secrecy grew brazen over time. Some images of Mao exhibited in *A Second History* barely even pretend to look like photographs anymore, resembling instead gently tinted pastel portraits. Yet by the same token, photography and its offspring always harbored the promise of revenge, and those who have shadowboxed with public secrecy in China during the reform and post-reform eras have turned again and again to the photo-form as their mode of murmuring truth to power.

A striking example of this shadowboxing as a corporealized practice occurred in 2015 among supporters of the so-called Feminist Five, a group of activists who had carried out performance art protests against sexual harassment in public spaces earlier that same year. After the authorities detained the activists, supporters in Beijing and Guangzhou began appearing on the streets wearing masks made from headshots of the Five; they posted a picture of themselves, one per day, until the women were released. In chapter 3, I discussed how Chinese netizens changed their profile pictures to images of human rights lawyer Pu Zhiqiang as a kind of social media variant of black bloc, reclaiming the power plays practiced by state secrecy that flaunts itself in public. The supporters of the "Feminist Five" acted out something similar. At a time of body imaging, fingerprinting, retina scans, and facial recognition, when the surveillant powers of government can scan our very tissue for its secrets, and when the practice of "human flesh search engines" (*renrou sousuo* 人人搜索)—internet vigilantes who track down faces glimpsed online—is rife in China, wearing a clumsily made photo-mask becomes a piece of performance art provocation, a means of photo-forming the streets. As the supporters moved through urban space, disguised by the headshots of the Five and posing ever more playfully, they sparred with the media blackout that tried to

FIGURES C.5–C.7
Supporters of the
Feminist Five perform
slapstick photo-bloc
on the streets of
urban China.

cover up the story of the arrests even as it was ricocheting across the world via social media (figures C.5–C.7).

Seen alongside *A Second History*, these masked demonstrations—the use of photo-bloc on city streets seem to mock the public secrecy that the darkroom manipulators helped to forge. Unlike the images of Mao, which were doctored into improbable flawlessness, the photo-masks are almost comically crude—much like the Xi Jinping photo-masks worn by Hong Kong protestors after the authorities expressly banned the use of face masks in October 2019. They articulate a different mode of secrecy, not the apparent seamlessness of the public variety, but the sort of rough disguise favored by those who do indeed have to hide their identities, yet who also want to make that process of concealment satirically performative. The masks are as blatant in their clumsiness as the doctored images are in their idealized perfection, and this is because they, too, enact the operations of secrecy out in the open. What's more, their sarcasm may also be indicative of a mounting awareness of how photography has served a long agenda of dissimulation in modern China. As such, the photo-masks are oddly reminiscent of a Weibo photo-storm that occurred in 2011, when netizens spotted that the local government website of Huili County in Sichuan Province had posted a preposterously faked photograph on its website showing three officials levitating above a newly laid tarmac road in Lihong Town (figure C.8). The county government swiftly issued an apology, explaining that the original photographs of the men inspecting the road had looked substandard, hence the manipulation. But this did nothing to quell the torrent of mockery on social media. The officials were subjected to revenge-via-Photoshop on energized repeat: rocketed to the surface of the moon, parachuted into Obama's war room and onto pornographic film sets, juxtaposed with rutting dogs and dinosaurs, the three men took the hit for a piece of doctoring so shoddy that it threatened the consensus on which public secrecy, in its photographic expressions, entirely depends.[5] Or to rephrase things: if you're going to fake a photo in China, don't flaunt it too far.

Clare Birchall argues that today's public is "unified in and constituted by its bid to uncover secrets" (2011, 143), and with the rise of Google Earth, one might wonder where people and things can go to hide nowadays. Yet as Sarah Nuttall and Achille Mbembe note, secrecy is very far from dead; it is simply changing: "The paradox is that this new age of secrecy is unfolding at a time when the world has the means to know more than ever before: the means for openness, for transparency. And yet opacity seems to be expanding even as the invocation and metaphors of secrecy's death proliferate" (2015, 323). The public secrecy about certain pasts that qualitatively textures the shape of Chinese

© Huili County Government

FIGURE C.8 Accidental levitation: floating government officials set off a cascade of memes.

society today prompts more than just a predictable call for secrecy studies to expand its remit beyond the scope of Western democracies (though that call should, of course, be heeded). It also shows that in an era when "the world has the means to know more than ever before," there is a certain prescient logic to the fact that secrecy about China's troubled histories operates in public. The opacity that expands as the means for transparency multiply has no more natural environment in which to dwell than out in the open, where it becomes both more diffuse yet also more cloaking. In this sense, the public secrecy that is social fact in contemporary China shows that if a "new age of secrecy is unfolding," it is one that China knows all too well already. It was modish in certain policy circles a few years back to suggest that, rather than China becoming democratic, the "West" might usefully find itself following the "China model" one day (Bell 2015). The rise of Xi Jinping and his ultra-authoritarianism put the brakes on that discussion, but the public secrecy that operates widely in China today will likely become a much more widespread climactic phenomenon as opacity looks for ways to expand. Even as secrecy studies have diversified in new and necessary ways, mostly in response to the intensified capacities of covert technologies, what Taussig calls the most fundamental form of anthropological awareness, "knowing what not to know," will become more, not less, dominant among the norms and forms of the clandestine, and thus ever more in need of analysis.

Some time before Taussig, Hannah Arendt wrote of Eichmann's trial, and various points of evidence that were not directly addressed within it, as follows: "The facts I have in mind are publicly known, and yet the same public that knows them can successfully, and often spontaneously, taboo their public discussion and treat them as though they were what they are not—namely, secrets" (1993, 236). Arendt's claim, made over fifty years ago, bears directly on the contention that we may be entering an epoch of renewed public secrecy. It does so because of her emphasis on two mutually imbricated points: the collective and the unprompted. As secrecy responds to the technologies of transparency by becoming ever more open itself, our shared acceptance of that state of willful ignorance will grow in tandem. There are often solid, sympathetic reasons for this, from the self-defensive to the pragmatic to the palliative. Yet however sound these rationales may be, they calcify over time into a collective mind-set that would prefer not to receive reminders about the accommodations that the law of *omertà* demands. A social order is precisely that—an order— and disruptions to it threaten to bring about its opposite. Hence Arendt's other point: the spontaneity of the public secret. It will never be sufficient to say that people stay quiet simply because the state tells them to, even in places such as China where the government can be punitively silencing. Zhang Dali acknowledges this himself when he notes that the doctored images spoke to a collective mind-set, rather than simply articulating the whims of propagandists. And by the same token, staging a reckoning with the unsayable cannot simply be categorized as a state-oppositional stance. In this sense, public secrecy is a further challenge to what Xiaobing Tang has called the "dissidence hypothesis": the prevalent tendency of media, even academic opinion, in "the West" to assume that "any expression of criticism in China [amounts] to an act of political dissidence subversive . . . to the repressive regime" (2015, 178). Knowing what not to know suits and obliges many constituencies, and this is why antagonists of the public secret have to build their countercommunities in intuitive ways.

Visitors to *A Second History* reportedly pored over the images. Some even made notes, took photographs, and sought explanations from Zhang Dali himself as they tried to "crack" the secret of the photographs (Zhang Dali, personal communication, 2017). As they did so, they illustrated the intuitiveness of the photo-form in action. Its encryptedness—the artistic labor of encoding and the spectatorial labor of decoding—functions as a kind of bait; it beguiles those already in thrall to the magic of the public secret into shrugging off the latter's cloak. It uses secrecy to get at secrecy, labor to undercut the labor that keeps the consensus of silence in place. And just as public secrecy creates a

community of those who work together in agreeing to see no evil, the photo-form generates its own micro-groupings of secret-sharers, which is why Zhang Dali has stressed the importance of viewing the series in public (Weng 2010, 75). Sometimes, these groups are aesthetic collectives, such as the network of artist-activists who shared Bian Zhongyun's photograph between themselves and repurposed it one after another until their shared labor reached a kind of critical mass. Yet just as importantly, these groups also comprise minor publics: spectators whose coalitions naturally ebb and flow and may only be short-lived, but who nonetheless cohere as blocs that experiment, for a while at least, with being honest about the things that they know well but do not usually discuss.

It would be foolish to suggest that photo-forms might one day bring an end to public secrecy in China. In part, this is because they are frequently suppressed (*A Second History* was shut down by the municipal authorities when Zhang showed it in Shanghai after successful exhibitions elsewhere in China, and Zhang reports that the authorities vetted his mail when he exhibited the series abroad [personal communication, 2017]). But mostly, the impact of the photo-form must be limited because its audiences are typically small—or so the argument tends to run in discussions about art with activist intent. Gauging impact numerically in this way, however, is to take the photo-form as a terminal artifact, one whose impact derives solely from the brief encounter that occurs between artwork and spectator in a closed physical setting. Writing of activist documentary film and its capacity to effect hard change, David Whiteman argues that to look at a "*finished* film's effects on *individual* citizens within the *dominant* public discourse . . . provides us with only a very limited understanding of the complex and multifaceted ways in which film enters the political process" (2004, 54; emphasis in the original). He suggests instead a "coalition model": one that takes in the processes of production and distribution, that recognizes the "extensive opportunities for interaction among . . . producers, participants, activists, decision makers, and citizens" that documentary-making creates, and that gives due weight to the role that film can play "in educating and mobilizing activists outside the mainstream" as they work to create parallax arenas (54).

Likewise, the photo-form often functions less as a terminal artifact than as a continuous event, as exemplified by *A Second History*, an essentially ongoing and serialized work. As Zhang Dali put it to me, "one might actually say that the work remains unfinished to this day" (personal communication, 2017). It shares this feature with Xu Weixin's *Chinese Historical Figures*, Sheng Qi's repeated returns to Tank Man, Zhang Xiaogang's *Bloodline* works, Hai Bo's *They*, and the family photo-texts that to this day appear in the pages of *Old*

Photographs. It is no accident that photo-forms so routinely take the series as their manifest aesthetic ontology (Ai Weiwei, Li Zijian, Song Yongping, and Liu Xinwu serve as other examples). Refuting finishedness and emphasizing process, the series works to perpetuate spectatorship; it constitutes a continuing endeavor of parallax world-making. Matching this is the shared labor of the production, and preproduction, processes. This occurs with both civilian partners—Zhang Dali's installations took years of collaborative preparation with members of the public, as did Bian Zhongyun's crowd-funded statue and Xu's crowdsourced series of paintings—and also other aesthetic makers, as we see in the numerous forms of artistic baton-passing I have traced in this book. Photo-forms trigger, too, complex forms of post facto engagement, from the homework assignments produced by schoolchildren after visits to the Nanjing Massacre Memorial Hall to the notetaking reported by visitors to *A Second History* to the augmented reality art of *Tiananmen Squared* and the photo-masks discussed above, which move things into the streets. The photo-form is thus an object whose political agency is as much processual as strictly artifactual, and this broader ambit, rooted in the phenomenology of the shared secret, is what enables these image-works to create parallax spaces in which unsayable yet unforgotten knowledge can begin to be owned. Ultimately, it may not matter that speaking more openly about the past is a fleeting thing, practiced only briefly or sporadically with like-minded others. Public secrets, as I have stressed throughout this book, are a sometimes necessary way of managing the burden of the past. But insofar as silence is also stifling, small acts of speech may bring their own vital relief.

PREFACE

1 *Negatives* was first published by New Century Press in Hong Kong, a small and controversial press that specializes in works about Chinese politics. The book was banned in China but then republished by the German art press Verlag Kettler.
2 See, for example, Lee 2015; and Wei 2016.

INTRODUCTION

1 When asked, my Chinese colleagues and friends are ready to improvise translations of the term (examples are *zhouzhi de mimi* 周知的秘密, *gongkai mimi* 公开秘密, *bu neng shuo de mimi* 不能说的秘密, *gongzhong mimi* 公众秘密, and *gonggong mimi* 公共秘密), but they also issue reminders that the concept lacks theoretical traction in China, however keenly its muting effects are sensed.
2 An exception in cultural studies is the spy thriller, a film and novelistic genre that thrived during the Maoist period and offers oblique insights into China's security climate. See Dai 2010.
3 It should be noted, though, that commentary outside China on the social credit system is sometimes inflammatory in its eagerness to ascribe entirely sinister powers to this emergent mode of governance. For a critique of this tendency, see Daum 2017. Daum is right to point out that the notion of trust—building it, keeping it—lies at the core of the social credit system; but it may also be the case that this system, over time, will breed a greater sense of vigilance over individual speech acts.
4 The text of the Rumsfeld briefing is available online: "DoD News Briefing—Secretary Rumsfeld and Gen. Myers," news transcript, U.S. Department of Defence, February 12, 2002, http://archive.defense.gov/Transcripts/Transcript.aspx?TranscriptID=2636/.

5 Earlier studies that dealt with public secrecy tended to focus on sexuality, the closet, and the silent accommodations reached by those who do not declare their sexual identities within their familial and social circles. See, for example, Barbara Ponse's (1976) discussion of "counterfeit sexuality" in lesbian lives.

6 See, for example, Bratich 2006; Mookherjee 2006; and A. Young 2011.

7 Braester argues that certain characters in post-Tiananmen fiction participate in a failure to recall the past that is "playful, noncommittal, but perhaps the only way to cope with an absurd reality" (2016, 442).

8 See, for example, Yang 2002; Braester 2003; B. Wang 2004; and Berry 2008.

9 Some exceptions to this rule, several of which predate the growth of secrecy studies as a defined field, can be found in the fields of literary and visual studies. Examples include Kermode 1979; Long 2004; François 2008; Pionke and Millstein 2010; Nair 2012; and McCall, Roberts, and Fiorenza 2013.

10 Belinda Kong calls this the "hermeneutics of evasion": the strategies of "metaphor or metonymy, catachresis or ellipses" that artist-activists use to engage the secret-keeping society on its own terms (2012, 27).

11 Unsurprisingly, little has changed during the reform and postreform periods. As Geremie Barmé puts it, "the atmospherics of plots and conspiracies are still central to the way that the CCP channels and responds to the specters of the past . . . to this day its internal protocol and behavior recall all too frequently its long history as a covert, highly secretive, and faction-ridden organization" (2012, 31).

12 As Zi Hui 子慧 notes, "almost overnight these fusty, pock-marked old photographs were ubiquitous right across the publishing world" (1998, 33).

13 This notion that "old photos" reveal folk-oriented microhistories is well established. Zhao Jingrong 赵静蓉 argues that the images most commonly anthologized "record the daily life, fashions, folk customs, marriage ceremonies, and funeral rites of ordinary people in China's towns and cities" (2005, 14). Photographs depicting "major historical events, historical figures, or historical scenes" are scant by contrast, because the "old photo" vogue is a reaction against "standard history" (*zhengshi* 正史) (14).

14 See Zhongyang dang'anguan 中央档案馆, Zhongguo di er lishi dang'anguan 中国第二历史档案馆, and Jilinsheng shehui kexueyuan 吉林省社会科学院 1995.

15 An exhaustive list of these would run to several pages, but examples include Cao Juren 曹聚仁 and Shu Zongqiao 舒宗侨 2011; Feng Tianyu 冯天瑜 and Zhang Duqin 张笃勤 2011; and Liu Ni 刘妮 2012. As Edward Krebs notes, "a comparison of books published today with those of ten years ago would surely reveal a great increase in the use of illustrations, especially photographs" (2004, 88–89).

16 Key examples include the essays by Yomi Braester, Andrew F. Jones, and Nicole Huang in a special issue of *positions: asia critique* 18, no. 3 (2010); those by James Hevia (2009) and Carlos Rojas (2009); and the book-length studies by Claire Roberts (2012) and Wu Hung (2016).

17 A vivid example of this came with the publication in 2017 of a photobook by Wang Qiuhang 王秋航 entitled *1966–1976 Wo de zipaixiang* 我的自拍像

(*Cultural Revolution Selfies*), which showed long-hidden images of the author-photographer drinking, gambling, and dressing up in bourgeois outfits during the austere peak of Maoist revolution.

18 As James Gao has argued, photography in China has "become an important terrain for the cultural representation of aspects of China's social suffering: famines, war atrocity, the Cultural Revolution and the 'pathology of modernity'" (2011, 100).

19 This is Zhao Jingrong's point when she notes that "as far as the more established social pattern of using script-based means to record the past is concerned, the (photographic) vogue marks a turning-point: people have begun to 'read images' as a means of understanding history afresh" (2005, 15).

20 In part, the origins of this photographic blackout can be traced back to the pre-Communist period. Hard-hitting photojournalism took longer to establish itself as a professional calling in China, and the first photographers to shoot social suffering in China were Westerners, whose images of victims were usually shipped home for domestic publication. Chinese cameramen, meanwhile, dedicated most of their efforts to artistic portraits and to recording exuberant urban life. This dearth of tough image-making was not just a matter of custom, however. Almost as soon as important Republican-era photographers began to claim photojournalism as a *métier*, the Nationalist government clamped down on photography that revealed social malaise. It was only during the Sino-Japanese War that cameramen such as Sha Fei 沙飞, Sun Mingjing 孙明经, and Wang Xiaoting 王小亭 could practice their craft in earnest. The Communist takeover, however, put new strictures on vanguard photojournalism of this kind.

21 As Claire Roberts notes, "photographs of Mao Zedong and other Communist officials were taken as they admired 'bumper harvests' during the Great Famine, but few images have come to light that record the devastating reality that gripped much of China during the period" (2013, 108).

22 For example, a pictorial history of the Nanjing Massacre, melding text with photographs of atrocity, arguably reproduces those images rather than repurposes them; yet this assumption comes under threat with genres such as the photomemoir in China, which illustrates Liliane Louvel's point that the text "'illustrates' the photograph and not the other way around," leaving both transfigured (2008, 38–39).

23 See, for example, Beckman and Ma 2008; Hughes and Noble 2003; Bryant 1996; Marcoci 2010; and Jacobs 2006.

24 David Perlmutter (1998, 11–20) offers a useful set of definitional criteria for the icon, enumerating these as the celebrity status of the photograph, the prominence of its display, the quantitative frequency of its media appearances, the profit it can engender, the importance of the event it depicts, its ability to generate a resonant theme that exceeds the referential meaning of that event, and its striking composition.

25 As they put it, "forms of appropriations are a crucial sign of iconicity, and more so than we realized at first" (Hariman and Lucaites 2007, 37), a recognition

whose belatedness plays out practically in the more limited attention that the study gives to photo-forms.

26 An example is the infamous photograph of a baby wailing on the tracks at Shanghai South Railway Station in the aftershock of Japanese aerial bombardment, taken by "Newsreel" Wong, or Wang Xiaoting, in 1937. That picture is, on one level, a testament to the barbarism of the Japanese. But Wong's image also acquired an energetic life history of its own: it traveled to the U.S. and was exhibited in movie theaters, printed in newspapers, and featured in *Life* magazine, reportedly picking up 126 million viewers along the way (n.a. 1937, 102). This exposure embarrassed Japanese nationalists, who put a price on Wong's head and have periodically attempted to discredit the photograph as a fake (Higashinakano, Kobayashi, and Fukunaga 2005, 79–81)—efforts that remind us of the image's place within a more expressly photographic history. Is it genuine photojournalism or a ramped-up propaganda shot? Is it significant for the look of the image that Wong used a Leica camera, with its pinpoint-sharp glassware that enhances the camera's already "perverse noticingness" (Malcolm 1989, 89), to create an image of remarkable recessional depth and detail? And what of the patina of the photograph as viewers today most often see it, reproduced and reproduced again so that its once spruce contours blur?

27 See Landsberg 2004; Hirsch 2012; Zeitlin 1998; and Young 2000. Behind all of this is the notion of false memory creation; as Linda Haverty Rugg puts it, "the line between memory and photographs blurs, with photographic-era children uncertain as to whether their memories of childhood are memories of events they witnessed or photographs they have seen" (1997, 23). In a psychiatric study from 2002, Wade et al. corroborate this point, noting that photographs provide a cognitive "springboard" (598) that can generate "memories" of unexperienced events.

28 The statues were cast a decade earlier, but protests from Crimean Tatars, many of whom were persecuted by Stalin, prevented the work from being exhibited in Yalta itself until Russia's seizure of the peninsula from Ukraine in 2014 finally led to its public display.

29 For photographic nomenclature in China, see also Gu Yi 2013.

30 This clearly evokes Derrida's (1994, 10) much-referenced idea of hauntology as the bane of ontological surety, since re-versioning performs the fluidity of medial states.

CHAPTER 1. DON'T LOOK NOW

1 See, for example, Yin Jijun 尹集钧 and Shi Yong 史咏 1999; Zhu Chengshan 2002b; Qinhua Rijun Nanjing datusha yunan tongbao jinianguan 侵华日军南京大 屠杀遇难同胞纪念馆2005; Zhang Xianwen 张宪文2006; and an updated edition of *A Photographic Catalogue of the Nanjing Massacre*, published in 2015.

2 Significantly, Number Two China Historical Archives, Nanjing Municipal Archives, and the Nanjing Massacre Memorial Hall did produce an earlier

photographic collection in 1985, entitled *A Collection of the Massacre and Violence Committed in Nanjing by the Japanese Military* (*Qinhua Rijun Nanjing datusha baoxing zhaopian ji* 侵华日军南京大屠杀暴行照片集), but it was designated for "internal circulation" only (*neibu faxing* 内部发行).

3 As Mark Eykholt notes, a key exception to this absence occurred during the Korean War, when "the Chinese government used the Massacre to stir up patriotism against the United States" (2000, 24). Joshua Fogel also points out that the atrocities were invoked again during the struggles over the U.S.-Japan security treaties in the early 1960s as part of a pattern whereby the PRC "strategically exploits history against international enemies, and deploys it to inspire shame in potential trading partners," while keeping the atrocities below the radar domestically (2007, 270).

4 An example of this is *A Chronological Biography of Mao Zedong* (*Mao Zedong nianpu* 毛泽东年谱, 2002). The entry for December 13, 1937 reads simply: "Nanjing falls" (*Nanjing xianluo* 南京陷落). The Massacre itself is not mentioned, despite the fact that the entire facing page is devoted to describing a meeting of the Political Bureau of the CCP Central Committee that took place during the same week (40–41).

5 This absence was noted by a blogger named Fu Ningke 福宁客 in an article entitled "Why Did Mao Zedong Keep the History of the Nanjing Massacre out of School Textbooks?" (Mao Zedong weihe bu rang Nanjing datusha lishi shang keben? 毛泽东为何不让南京大屠杀历史上课本) in 2014. The piece was reposted multiple times, in particular on sites with a reputation for opposing the Chinese Communist Party, such as epochtimes.com and secretchina.com, both of which have links to Falun Gong (Menchen-Trevino and Mao 2015, 188). As Rui Gao and Jeffrey C. Alexander note, it was not until 1992 "that the massacre entered into the required reading for elementary schools in post-Maoist China" (2012, 589).

6 Fogel (2007, 269) has noted this of the Massacre, whereas Arthur Waldron (1996, 949) observes it of the entire Sino-Japanese War during the Maoist period.

7 Jungmin Seo argues in this connection that "the fall of Nanjing by the advancing Japanese Imperial Army in December 1937 was associated with a series of images that proves the corrupt and incapable nature of the KMT . . . [thus] the narration of the Nanjing Massacre was not about the tragedy of China, but about the failed morality and irresponsibility of the KMT" (2008, 384).

8 The major literary works are Zhou Erfu's 周而复 novel *The Fall of Nanjing* (*Nanjing de xianluo* 南京的陷落, 1987) and Xu Zhigeng's reportage work *The Great Nanjing Massacre* (*Nanjing datusha*, [1987] 2014).

9 Key works by the deniers published during the 1990s include Fuji Nobuo 富士信夫 1995; Higashinakano Shûdô 東中野修道 1998; and Suzuki Akira 鈴木明 1999.

10 See n.a. 2016; and n.a. 2017. This deficit occurred despite the fact that information about the atrocities was well circulated during their immediate aftermath and extensively recounted in the war crimes trials and military tribunals. For

coverage of the Massacre in Chinese print media in the late 1930s, see Gao and
Alexander 2012, 588.

11 Gao and Alexander reveal similar findings about the period between 1946 and
1982, when the sparse mentions of the Massacre that did occur "were mostly
not *about* the massacre, but, rather, arose in response to international conflicts"
(2012, 590).

12 A search on Weibo for "Nanjing Massacre Memorial Day" (*Nanjing datusha
gongjiri* 南京大屠杀公祭日) turns up a range of posters and videos that deploy
images from the photographic record from both personal and institutional
accounts.

13 Eykholt argues that while "Chinese documentation is overwhelming," this histo-
riography continues to orbit in ever decreasing circles around the fixed point of
patriotism (2000, 12). In the same vein, Chi observes that the Massacre "revival"
is overly historicized, monopolized by scholars who have treated it "as a solid
object for historical comprehension," viewed through a restrictively empirical
lens (2001, 58).

14 A compelling example of this is the move toward viewing the Massacre as an
untreated psychoanalytic trauma, pioneered by the work of Zhang Lianhong.
Zhang notes that the drive to use survivor testimony for its "empirical value"
(*shizheng jiazhi* 实证价值) has led to a neglect of psychological scarring both as
an area of academic inquiry and as a focus for social concern. See Zhang Lian-
hong 2006. For a survey-based analysis of traumatic memory amongst survi-
vors, see Zhang Lianhong 2003.

15 A notable example is Tiexue.com, a popular website for military fans and
People's Liberation Army enthusiasts (*junmi* 军迷), whose title (literally "blood
and iron") is itself already indicative. The site's features on the Nanjing Massacre
routinely use the phrase *tiezheng* in connection with the photographic record of
the atrocities.

16 As Nicolai Volland puts it, "Access [to *neibu* publications] was usually restricted
to readers with privileges, such as those in work units related to press and
propaganda, scientific personnel, or ranking party cadres . . . with specialized
training or higher political consciousness who were supposedly immune to the
corrupting influences these works contained. Such readers could access special
sections in libraries storing *neibu* editions, or had cards entitling them to pur-
chase *neibu* editions from bookstores. The exact distribution key might be more
or less narrow, and was occasionally stated in the publications themselves . . .
The realm of limited-access publications created a sphere of privileged readers,
a 'restricted public,' narrower than the population at large, yet clearly not private
either" (2017, 192).

17 Paola Iovene notes that neither of the chief distribution outlets for *neibu* publi-
cations in Beijing "had any sign on the door," and that access to the *neibu* section
of bookshops was only "from a side or back entrance" (2014, 74).

18 Or as Callahan puts it, the Massacre revival has produced "the unity of China's
body politic . . . through the mutilation of specific Chinese bodies" (2012, 166).

19　For the killing contest, see Wakabayashi 2000.

20　See Zhongguo shehui kexueyuan jindaishi yanjiusuo 中国社会科学院近代史研究所 1992; and Sun Zhaiwei 1995.

21　For other examples of book jackets that deploy photo-logos, see Zhu Chengshan 1994, 1998, 2004; Cheng Zhaoqi 程兆奇 2002; Zhang Xianwen 张宪文 and Lü Jing 吕晶 2007; Xu Zhigeng 2014; and Sun Zhaiwei and Li Deying 李德英 2012.

22　A telling instance of this can be found in *A Photographic Catalogue of the Nanjing Massacre*, which splices the images together almost in the manner of an animated film (2015, 69–70). See also Zhongguo di er lishi dang'anguan 中国第二历史档案馆 et al., 1997, 81–85.

23　See http://neverforget.sina.com.cn/. Other websites that make copious use of atrocity photographs include Patriotic Youth Online (*Qingshaonian aiguozhuyiwang* 青少年爱国主义网), http://agzy.youth.cn; and the National Memorial (*Guojia gongjiwang* 国家公祭网), http://www.cngongji.cn/index_cn.html.

24　This process is telegraphed more self-reflexively in the Memorial Hall, where original photographs sit side-by-side with their plaster mock-ups, such as a figure of John Rabe making a telephone call or a reproduction of an air-raid shelter.

25　A number of recent studies have addressed this point and, to a lesser extent, the role the photographic record has played in producing China's self-flagellating, self-motivating discourse of patriotic shame. See Wang Zheng 2012; and Callahan 2009.

26　See, for example, the 1,830 furious posts prompted by a feature about the photographs first published on a *Tianya* 天涯 bulletin board on December 13, 2010, available at http://bbs.tianya.cn/post-no04–1468288–16.shtml.

27　The volume brings to visual life the wartime diary of Azuma Shirô 东史郎, a former soldier in the Imperial Army who served for four years with the troops that invaded mainland China and took part in the sacking of Nanjing. Initially published in 1987 as *Our Nanjing Platoon* (*Waga Nankin puratôn* わが南京プラトーン), and later as a fuller version entitled *The Diary of Azuma Shirô* (*Azuma Shirô no nikki* 東史郎の日記, 2001), Azuma's diary has met with mixed fortunes. Many in Japan have queried its authenticity, and Azuma was sued for libel by one of the superior officers whom he had named as a perpetrator in the text. In China, however, the diary has been applauded as a rare and precious act of contrition.

28　See, for example, Xu Zhigeng 2005.

29　Michael Berry has already argued that some of Zhu's data on the Massacre is polemically skewed, and he wonders why Sun Zhaiwei, "a respected historian," would elect to write an account of the Massacre that is so openly fictional in its narrative apparatus (2008, 139). Zhu is well aware that some people mock him as a "keeper of the flame," and his rejoinder is simple: "What's wrong with that?" (Lu Peifa 陆培法 2014). Yet the role of "massacre specialist," a pedagogical identity that supersedes that of historian or museologist, is precisely what has prompted both Zhu Chengshan and Sun Zhaiwei to step outside the realm of documentary fact.

30 These films bring to life historical figures such as Luo Jin 罗瑾 (the photo shop employee who made a secret booklet of photographs taken by Japanese soldiers) and John Magee (the American missionary whose footage of the atrocities was core evidence in the Tokyo War Tribunal).

31 The wailing baby, positioned in a triangular equidistant pattern between the soldiers and the Buddhist monk in the bottom right-hand corner, also invokes Newsreel Wong's photograph of the aerial bombardment of Shanghai South Railway Station in 1937, though fully frontal rather than in silhouette. This figure, with its top-central presence, uses that iconic image to pull the painting into the framework of the broader Sino-Japanese War, while also making the Massacre a synecdochal sign for that conflict.

32 During 2010–2013, the painting toured twenty-four cities in China on a journey that took in Yunnan in the south and Gansu in the north (n.a. 2012).

33 When one of the paintings from the series was put on permanent display in the National Museum of China, Lü Zhangshen 吕章申, the museum's director, described the import of this move in media interviews: "The enshrinement and formal display of *Nanjing Massacre* has two meanings. Firstly, it affirms the artistic accomplishments of its painter; and secondly, at a time when the right wing in Japan is still waxing strongly, the fact that this painting—which they hate and fear, and whose exhibition abroad they have attempted to block in every way possible—will be on permanent display in the National Museum of China, a grand cultural temple for the Chinese people, is also a symbolic victory" (quoted in Chen Wei 陈薇 2014).

34 See, for example, n.a. 2014b, an interview with Tang Chongnan 汤重南 of the Institute of World History, Chinese Academy of Social Sciences. Tang, who is also head of the China Japanese History Association, states that "this kind of violence is terrifying. When we teach it to pupils in the classroom, we need to emphasize how it relates to the serious destruction of humanism, mankind's consciousness of peace, and human rights. Specific details and scenes would not necessarily be shown to children."

35 Similarly, a "Nanjing Massacre lesson plan" featured on the website of the respected Beijing-based educational publishing house Yuwen chubanshe (Language and Culture Press) includes the stark instruction: "Display photographs of the Massacre" (n.a. 2010).

36 To explore these pedagogical patterns further, a Chinese colleague and I designed a survey about the teaching of the Nanjing Massacre, which my colleague then distributed among four hundred students aged between twelve and sixteen at a junior high school in Shandong Province. We received 399 responses: 92 percent reported that they learned about the atrocities in primary school or earlier; 95 percent had seen violent photographs of the Massacre, and the most common sources of these images were school textbooks and presentations by teachers; 49 percent of these students had seen the photographs before the age of ten; and 43 percent had seen films about Massacre at school, including Lu Chuan's *City of Life and Death*, which contains scenes of rape. Overall,

93 percent of the respondents reported that learning about atrocities at school had stirred their patriotic feelings.

37 In November 2014, for example, the following query was posted on the question-and-answer site Zhihu 知乎: "Does it damage the health of China's young people to look at photographs and films about the Nanjing Massacre?" Some of the respondents opposed the proliferation of these images, but debate of this kind remains scant and hard to find on the Chinese web, and the vast majority of Massacre-related topics on Zhihu itself are unquestioningly patriotic in tone. See https://www.zhihu.com/question/26761161.

38 The mandatory character of photographic looking in China stands in contrast to the energetic debates elsewhere over public access to atrocity images. Crane, for example, has claimed that the time has come to "repatriate" photographs of Nazi atrocity to the archives (2008, 329), whereas Susie Linfield has argued that such images should be viewed because they "sabotage their own intent": they are "scalding self-accusations" that make viewers aware of the savagery of the photographer (2010, 52).

39 Daqing Yang notes elsewhere that "the outpouring of Chinese publications on the Nanjing Massacre . . . has appeared without a lively internal debate" (1999, 847).

40 See note 12 and also Zhang 2009.

41 See, for example, Lee 2014, 106–7.

42 See Lu Xun 1981.

43 See http://www.weibo.com/1757842035/DF14No8cN?type=comment#_rnd1495035222876/.

CHAPTER 2. KEEPING IT IN THE FAMILY

1 Liu's photo-essays in *Harvest* were assigned their own taxonomical space within the contents list of the journal, clearly demarcated from "standard" essays, which appeared under the heading *Sanwen* 散文 (meaning prose, sketch, or essay).

2 These hybrids had an average length of about seventeen pages and initially featured a small number of photographs (seven in the first photo-essay). As the series got going, however, the volume of images increased, reaching a peak of twenty-seven in the seventh photo-essay.

3 It could be argued, however, that the precedents for these photo-texts were already well established in Chinese visual culture. Frank Dikötter points out that "the use of calligraphy was unique to photographic practice in China: in a country where mastery of the written language was a sign of social distinction, the educated would often add a verse onto a *carte-de-visite*, while artists adorned sepia-toned photos of landscapes with entire poems and added red chop and signature" (2008, 76–77).

4 This stands in contrast with traditional Chinese notions of privacy (*si* 私), which was often designated as the realm of the selfish, underhand, or illicit (McDougall 2002, 6).

5 For Red Guard house searches and their impact on privacy, see Thurston 1984–85, 606; and Li 2014, 110–29. For "forbidden books" and their secret circuits of consumption, see Mittler 2012, 130–35; and Song 1997. For state dossiers and the information they held on intellectuals in particular, see Li 2016a.

6 For the complexities of the term "post" in China's transition away from social-ism, see McGrath 2008, 13–14. For a collection of essays that articulate these residues as expressly spectral forms, see Rojas and Litzinger 2016.

7 As late as 1990, for example, Immanuel Hsu (1990, vii–xi) wondered whether China would yet follow a capitalist path, a query whose answer seems self-evident with hindsight but that speaks keenly of the uncertainty of the period.

8 This is borne out by the multiple reprints of the text that have appeared since its first publication in 1988: new editions came out in 1997, 1998, 2000, 2007, and 2012.

9 As Gu Lijian 顾礼俭 notes, "in recent years, bestselling and culturally rich publications such as *Old Photographs* and *Old Albums* have received a great deal of hype, so it is rather unfair that we have barely seen a word from critics on Liu Xinwu's pioneering and profound work which appeared a full ten years earlier" (1998, 142). As the popularity of *Old Photographs* took off, moreover, its principal editor Feng Keli (2000, 37) was quick to argue that the periodical had pioneered the photo-text format, making no mention of Liu Xinwu's earlier innovations.

10 In this sense, I echo Nicole Huang's call that the "history of contemporary Chinese visual cultures will have to come to terms with this body of private artifacts" (2010, 686).

11 He Qinglian 何清涟 (1998, 6) describes the "collective amnesia" (*jiti jianwang-zheng* 集体健忘症) that shrouded Chinese society a full two decades after the end of the Cultural Revolution; see also Wu 2014, 5. The amnesia argument reaches an apotheosis in Anastasio, Ehrenberger, Watson, and Zhang (2012, 181–202), whose study fuses neuroscience with humanistic disciplines to argue that state management of Cultural Revolution memory damaged the "social hip-pocampus" in China and induced "collective retrograde amnesia."

12 In some ways, Liu's short story "Milky Way" (Yinhe 银河, 1980) is more perti-nent here because it directly explores the connection between photo studios, portraiture, and the suppressed legacy of Red Guard guilt. See Liu 1981, 109–36.

13 In his study of post-Mao cinematic culture, Chris Berry identifies no fewer than eighty-nine films produced between 1976 and 1981 in which "all or part of each film is set during what is known as the Cultural Revolution decade of 1966–1976" (2004, 1).

14 Tellingly, 1986—the year when Liu's series of essays was launched—also saw the publication of Ba Jin's essay, "A Cultural Revolution Museum" (Wenge bowu-guan 文革博物馆), in which he calls for an honest searching of souls about the events of those years.

15 Liu's line here parallels the distinction between privacy and secrecy drawn by Carol Warren and Barbara Laslett, who suggest that "privacy is consensual; the behavior it protects is socially legitimated and seen as nonthreatening to others. Secrecy is nonconsensual; the behaviors it protexts are seen as illegitimate" (1977, 50).

16 For precise statistics on the print runs of the periodical from 1996 until the end of the millennium, see Wang Jiaming 2000, 20.

17 These publications include Wang Fang 王芳 and Shi Ren 石仁 1997; Lu Ye 路野 1997; Qin Feng 秦风 1998; Xue Yanwen 薛炎文 and Zhang Xueshan 张雪杉 1998; and the *Old Cities* (*Lao chengshi* 老城市) series published by the Jiangsu Art Press from the late 1990s onward.

18 As Edward S. Krebs puts it, "the editors sought and developed an unusual rapport with readers, inviting them to send their own photographs with accompanying essay or comment, and also encouraging letters in response to these contributions. Thus this small publication offered a periodic workshop in print" (2004, 88).

19 An important precursor for the efforts made by *Old Photographs* to visualize Cultural Revolution experience was Yang Kelin's 杨克林 two-volume *Cultural Revolution Museum* (*Wenhua dageming bowuguan* 文化大革命博物馆), published in Hong Kong in 1995. This work envisions the period in mostly public ways, however, and its separate chapters, divided into different "halls," contain little in the way of personal photography.

20 The only substantial English-language studies are those by Wu (2008, 119–34) and Krebs (2004). See also Li Zeng's (2008) unpublished dissertation.

21 For image-text relations, see Wu Weihua 吴炜华 1998. For nostalgia, see Zhao 2005, 124–25; Wang Desheng 王德胜 1998; and He 2003, who also explores how the periodical promoted vernacular forms of narration.

22 As early as the thirteenth issue of *Old Photographs*, readers were already beginning to send in contributions that questioned whether the true mission of the periodical was to stoke nostalgic feeling. A reader called Li Ziyang 李子旸 (2000) suggests that a desire for information about the past was its key driver.

23 This echoes Krebs's point that *Old Photographs* enabled "people to probe their own memories as well as their individual consciences in ways that, if not unprecedented in modern China, have not been exercised for many decades" (2004, 88).

24 Insofar as family photo-texts flip the telescope around to explore the pain of those left behind, they challenge some assumptions of the "educated youth" memoir genre.

25 Gentz argues that memoir writing after the 1980s demonstrated an "astonishing conformity . . . Most of the autobiographical recollections by young Red Guards or prominent victims resemble Scar Literature in mode and tone . . . we look in vain for much in the way of individual voice, diversity, or ambiguity" (2014, 4, 13). Fictional voices, by contrast, were a good deal more varied.

26 Writing in 2006, Xu Ben 徐贲 argues that the Cultural Revolution memoryscape was by this later point shaped by three major formations: virtual museums; storytelling; and recreational, commercialized nostalgia.

27 My particular focus here is on family photo-texts from the period 1996–2004. Although such image-works still continue to appear to this day, 2004 marks a natural end point for my analysis because the mid-2000s saw such a surge in online discussion of the Cultural Revolution that the role played by the photo-texts as a counternetwork of revelation was to an extent superseded (Yang 2007, 310–12). Unsurprisingly, *Old Photographs* itself acquired an online presence, launched in 2009. See http://www.lzp1996.com/srxb/20131031/877.html.

28 See Xiao Bo 晓博 2000; Shi Yaozeng 史耀增 2000; A Ling 阿玲 2002; and Wei Desheng 魏德胜 2004.

29 Schoenhals makes a related point about the website Oldbeijing.net, a link to which was "prominently displayed" on the front page of the online Beijing Municipal Archive when Schoenhals was writing (it has since been removed). This link was striking because the Oldbeijing.net contained, "deep down in the blog bowels" of the site, such items as a list of "Already Investigated Deaths in the Cultural Revolution at Beijing University and Qinghua University," compiled by Wang Youqin (Schoenhals 2008, 169). As Schoenhals puts it, the website was "a *virtual* 'Heimatmuseum' located 'below the radar' of Communist Party politics and providing room for activities . . . that neither quite fit the label official, nor belong comfortably in the sphere of the 100 percent unofficial/oppositional" (2008, 156).

30 For examples, see Xia 2000; and Gao Yulin 高玉琳 2003.

31 The essays are collected in Feng Jicai 2014. The appendix contains an essay entitled "The Origins of this Book" (Guanyu ben shu xiezuo de yuanqi 关于本书写作的缘起), in which Feng explains his mission to record personal stories of the Cultural Revolution and the secret practices via which he conserved the accounts he wrote during the late 1960s: "Secretly I began to write down the stories and fates of the people around me. I knew that such writing might be a crime punishable by death, so at first I changed all the names of people and places to foreign names and I moved the time to the last century. Then I signed them with names of foreign writers, such as Thomas Mann, Kuprin, Gide, and Steinbeck. If by chance they were discovered, I would say that I had copied them long ago from foreign novels. I also wrote on small scraps of paper that were easy to hide. As soon as I had completed a story, I would immediately hide it underneath a brick, inside a crack in the wall, in a flower pot, or in between some quilts. Or I would paste sheets of paper together, cover them with a page of Chairman Mao's quotations or a Cultural Revolution propaganda poster, and hang them on the wall . . . But for a person who has something to conceal, the more adroit you are and the better your hiding place, the more you feel that you will be found out. So I would turf these scraps out and hide them all over again. For a long time, I wrote and hid, dug out and then ferreted away again" (2014, 328–29). Later, Feng describes rewriting his accounts on thinner papers, rolling them up, and inserting them into his bicycle tube before memorizing and then burning them. In this sense, he practiced what Chen Sihe 陈思和 (1999) has called "drawer literature" (*chouti wenxue* 抽屉文学): works that could not be

published during the Maoist era and were tucked away in desk drawers or the recesses of the mind until a later date.

32 In an essay on Zhang Xiaogang, Zhang Lei 张蕾 and Li Jing 李静 note that family photography, although it was *prima facie* a private medium, functioned in practice as the "microcosm of an age" because of its adherence to "collective ideology" (2011, 220).

33 To an extent, these pressures were an effect of studio portraiture itself, which was the sole access to image-making for many families at a time when camera ownership was limited. Liu Rongsheng 刘荣胜 (2000, 6) notes, for example, that domestic camera production stood at about 3.7 million units for the entire period from 1957 to 1979.

34 Ba Jin might almost have been referring to the ideological camouflage of family photography when he writes the following lines at the end of his essay "A Cultural Revolution Museum": "Let each person consider his or her actions during those ten years: masks will fall, we will delve into our consciences, expose our true faces, and repay the debts of the past, great and small" (1987, 823).

35 Yan Yi 阎义 (2015, 14) notes that demand for commemorative photography in Beijing during 1966–67 was so intense—especially among the Red Guards who had flooded to the capital—that customers had to wait for days for an appointment at a studio.

36 See also Gu Zheng 顾铮 2006, 119; and Duan Yan 段彦 2009, 109. As one writer of a family photo-text in *Old Photographs* put it, "the only person in the whole of China at that time who was not wearing a Mao badge was Mao Zedong himself" (A Ling 2002, 139).

37 For examples of family photo-texts that recount plights such as these, see Gao 1999, 94–96; Jiang Weiping 姜维平 2001; Xia 2000; Yao Liren 姚里人 2002; Liu Ning 刘宁 2002; Xu Ming 徐明 2004; and Zhu Yingyin 朱映茵 2004.

38 As another writer whose father was sentenced to reform through labor put it, "in our family photograph from 1969, each of us looks calm . . . but actually our hearts all held hidden troubles too hard to mention. Some of us siblings had been sent down to the countryside, others were doing manual labor or were at school, but we had all gone our separate ways. Our parents were beset with worry" (Liu Boming 刘伯明 2004, 72).

39 Family portraiture constitutes a core case of what Xiaobing Tang (2016, 145–49) calls the enduring presence today of "socialist visual experience." Particularly relevant is Tang's discussion of how artist Wang Guangyi deploys Ernst Gombrich's theory of "schemata": the familiar perceptual patterns that painters inherit from their forebears and then revise in their own work. The fixed family tableau that so many artists in the 1990s repeatedly refashioned is a core exemplar of the schemata.

40 This was the notion that rights and privileges should naturally accrue to those who came from "born red" revolutionary families, whereas those whose class backgrounds were "reactionary" should inherit the sins of the fathers.

41 See, for example, Ding You 丁佑 1998.

42　The same before-and-after format also structures a photo-book of "educated youth" memoirs entitled *Paths out of Youth: Portraits of 100 Educated Youths and Their Fates* (*Zouguo qingchun: 100 ming zhiqing de mingyun xiezhao* 走过青春: 100 名知情的命运写照), which appeared in 2006. These photo-texts, however, are both expressly named and mostly individualized, veering away from the poignant familial meanings of Hai Bo's work.

43　To an extent, the artist backs up the amnesia argument: his follow-up series to *Bloodline* is entitled *Amnesia and Memory* (*Shiyi yu jiyi* 失忆与记忆, 2001–).

44　In an article about sites of Maoist memory in China today, Jie Li sets out "curatorial proposals"—most of them of a grassroots nature—for how such remembrance might be safeguarded for the future. Noting that memories of the Mao era "rarely transgress generational boundaries," Li suggests reinventing the Maoist practice of "speaking bitterness" in order to spark "intergenerational dialogue" (2016b, 346–48). It is difficult to dispute the value of such an endeavor, but it does not broach the more intractable problem that such silences are not just enforced but sometimes also voluntary.

45　Textual sources on this topic are scant, presumably because of its taboo status, although linked picture books (*lianhuanhua*) from the Cultural Revolution period itself sometimes told approving accounts of children whose ardent love for Chairman Mao led them to report on family members. See Lü Jingren 吕敬人 and Mou Huaike 牟怀柯 1976.

CHAPTER 3. CRACKING THE ICE

1　For accounts of Bian's death, some of them very much at odds with each other, see Wang Youqin 1995; Ye 2006; Song 2012; Chen Chuangchuang 陈闯创 2016; and Weigelin-Schwiedrzik and Cui 2016. As Weigelin-Schwiedrzik and Cui point out, the evolving historiography on Bian's death is striking for the fact that many, if not most, of the accounts thus far have been scripted by "authors involved in the event" (2016, 735).

2　Wang Youqin's use of the English term "holocaust," not a direct translation of the website's Chinese title (which refers to "victims" [*shounanzhe* 受难者]), is a controversial choice. See Schwarcz 1996, 1–7.

3　Wang Youqin also brought out her research into Cultural Revolution victimhood in book form, published by a Hong Kong press in 2004.

4　Xu Weixin has also painted Lin Zhao 林昭, the subject of *Searching for Lin Zhao's Soul* (*Xunzhao Lin Zhao de lingyun* 寻找林昭的灵魂, 2004), another pioneering documentary by Hu Jie about buried histories of the Cultural Revolution.

5　An article written by Song Binbin entitled "I Presented a Red Armband to Chairman Mao" (Wo gei Mao Zhuxi daishang le hong xiuzhang 我给毛主席戴上了红袖章) appeared in *Guangming ribao* 光明日报 on August 20, 1966, and was reprinted in the *People's Daily* the following day.

6　This phrase is Song Binbin's (2014).

7　Lundunke 2014.

8 As Susanne Weigelin-Schwiedrzik noted in 2006, "At present the leadership of the CCP is dominated by the so-called Red Guard generation. Hu Jintao and Wen Jiabao are both members of it, with Hu Jintao participating in the so-called '414' faction at Qinghua University, one of those places in Cultural Revolution China where armed fighting was extremely fierce. Other members of the leadership who are said to have been actively involved in factional fighting were gradually reintegrated into the political elite without having gone through any investigations related to their Cultural Revolution activities" (2006, 1081).

9 These injunctions are gagging orders used in privacy cases in order to prevent the names of the parties, the details of the case, and even the very existence of legal proceedings from being released into the public domain.

10 Zhang Xiaoliang 张晓良 notes that four portraits—those of Chen Yinke 陈寅恪, Feng Youlan 冯友兰, Jian Bozan 翦伯赞, and Gu Zhun 顾准—were removed from a 2009 show of Xu's work in Beijing at the behest of the censors for no specified reason, and that publicity for the Wuhan exhibition was extremely low-key (2010, 60).

11 The memo read: "Because online public sentiment is complicated, all websites must cool the story 'Song Renqiong's Daughter Song Binbin Apologizes.' First, remove the article from homepages. Interactive platforms must not promote related topics." A copy of the memo can be found at the *China Digital Times* website, http://chinadigitaltimes.net/chinese/2014/01/国信办：宋任穷之女宋彬彬道歉/.

12 For a study of the disappeared in China, see Caster 2017.

13 Online memorials are now so well established in China (partly because of shrinking cemetery space) that virtual grave sweeping is now a social craze: users can buy virtual flowers and, with a mouse-click, make an avatar bow before a digital tomb.

14 Jie Li, for example, refers to *Though I Am Gone* as a "virtual museum" (2009, 538) that does commemorative work difficult to carry out in offline spaces.

15 Such projects also derive significance from the fact that, as James Robson has noted, "museums in Asia function in religious ways and religious sites, such as temples, have come to function as museums" (2010, 121). Robson points out, in particular, that state suppression of religion in China has led museums to become clandestine sites of worship, "surreptitiously reviving religious practices under the guise of culture" (126).

16 The portability of numinous objects was also important with Buddhist relics, as John Kieschnick has noted: "Rulers were attracted to relics both because of the widespread belief in their power and because of their portability: encased in impressive reliquaries, tiny bits of teeth and bone could be sent off to distant provinces . . . with a powerful political-religious message" (2003, 44).

17 The series has been shown in China as part of single-artist exhibitions at Beijing's Today Art Museum in 2007 and at Wuhan Art Museum in 2010, and as part of solo international shows at ChinaSquare Gallery, New York, in 2008 and University of Michigan Museum of Art (UMMA) in 2016. Portraits from the series have also been shown as part of group exhibitions in Beijing, Shanghai,

Shandong, Guangzhou, and Chengdu (Xu Weixin, personal communication, 2016).

18 Xu Weixin himself suggests that his work is closer in tone to that of Chuck Close than Richter (personal communication, 2016). Like Close, Xu is a consistent portraitist who paints photo realist "heads" (Close's term) on a massive scale and often inclines toward well-known subjects.

19 As Feng Xiang 冯翔 (2014) notes, in fact, Bian Zhongyun has in some ways achieved an unusual commemorative status among victims of the Cultural Revolution: "A memorial service was held for her at the Babaoshan Revolutionary Cemetery, and her ashes were placed in the Memorial Hall for Revolutionary Martyrs."

20 The two portraits were hung in the same show at Wuhan Art Museum in 2010 and UMMA in 2016. See Zhang Xiaolang 2010; and Oyobe 2016, 34–35, 48.

21 The other examples of invasive defacement I have identified are Xu's paintings of Huang Shuai 黄帅 (2006–7) and Nie Yuanzi 聂元梓 (2007). In both cases, Xu performed the calligraphic defacement some years after completing the portrait itself.

22 *Remembrance* was founded in 2008 and is edited by film historian Wu Di; the complete catalogue is housed at prchistory.org/remembrance. Its initial mission statement read: "to aggregrate research results, provide scholarly information, set up platforms for exchange, and promote research on the Cultural Revolution" (Wu Di 2008). The death of Bian Zhongyun has been a core and repeated focus of its activities since 2010.

23 For a discussion of responses to the apologies of Song Binbin and Chen Xiaolu 陈小鲁, another well-known Red Guard penitent, see Yang 2016, 184–86; and Xu Ben 2014. For an analysis that interprets the vehement rejection of Red Guard contrition as a strategy for promoting positive recuperation of the Cultural Revolution and Mao's role in it, see Weigelin-Schwiedrzik and Cui 2016.

24 This term refers to the cohort of middle school students who graduated during the years 1966–68. See Dittmer 1996, 18.

25 This new toughened stance is well illustrated by the troubles of the monthly magazine *China Annals* (*Yanhuang chunqiu* 炎黄春秋), a long-standing bastion of relatively liberal political thought and historical reflection in China. In the summer of 2016, the authorities moved to replace its editorial team with a new lineup tasked with bringing the journal, and its heterodox ideas, to heel. A standoff between the editors and the Chinese National Academy of Arts followed, which resulted in the closure of the magazine. *Remembrance*, meanwhile, has not publicly posted a new issue since December 2016. For an analysis of "semiofficial and unofficial journals" during this period, see Veg 2019, 112–19.

CHAPTER 4. DUCKING THE FIREWALL

1 I am grateful to Jason McGrath for drawing my attention to this scene.

2 I captured the screenshots shown in figures 4.3 and 4.4 on April 22, 2016. I used an anonymous browser to search Google and Baidu from a public computer

with an IP address owned by the University of Oxford. Subsequent searches have inevitably produced slightly altered results, but the overall ideological pattern—Google searches dominated by images of the 1989 protests, and Baidu searches by brightly hued pictures of the Square itself—retains its constancy.

3 For a more extended discussion of the deployment of the Tiananmen protests as a news icon in the U.S., see Lee, Li, and Lee 2011.

4 As already indicated, Badiucao is essentially self-exiled from China, as are Rebel Pepper (real name Wang Liming 王立铭), another subversive cartoonist who has also repurposed Tank Man several times in his work and who moved under duress to Japan in 2014, and Crazy Crab, who now lives in Finland and has stopped drawing cartoons in recent years. Until the early 2010s, all three of these cartoonists still lived, and drew, in China.

5 The draping of the tank in a large swathe of red also recalls Cui Jian's later album *Balls under the Red Flag* (*Hongqi xia de dan* 红旗下的蛋, 1994), whose cover shows an embryo blindfolded with a red cloth again but is more upbeat in tone.

6 As Carlos Rojas notes, Cui Jian's songs have always assumed "a dynamic, protean existence, wherein their political significance often lies not so much in what is explicitly contained within the lyrics themselves, but rather in how the works are being cited and used" (2013, 313).

7 A notable challenge to the general silence is presented by the "Tiananmen Mothers" (*Tiananmen muqin* 天安门母亲): women who lost children in the crackdown and have campaigned determinedly for greater public discussion about 1989 in the years since.

8 The Other of faceless Tank Man is full-frontal Mao, whose portrait, also reversioned repeatedly over the years in response to changes in both the political and physical weather, has dominated the vast visual field of Tiananmen since 1949. The openness, benevolence, and hyper-public positioning of Mao's countenance, however, serve to mask the fact that the very design of the gates and walls of Tiananmen has always manifested "the political tenet that power could be maintained only by keeping it secret . . . What was displayed, then, was the 'concealment' of power" (Wu 2005, 57–58). Mao's face symbolically "fronted" state secrecy (even after the Tiananmen site had been extensively remodeled), which is no doubt why three young men vandalized his portrait a few days before the Tank Man photographs were taken in 1989. As Taussig (1999) elaborates at length, defacement is a major strategy against secrecy as a mode of domination.

9 While active, Crazy Crab demonstrated a long-standing commitment to supporting Chen Guangcheng in his work. For an analysis of his vibrant online works about Chen, see Mina 2014.

10 In 2018, Badiucao sought to turn his Sydney performance art global by linking the banned Tank Man totem to a range of memes related to core political issues from that year, such as the Me Too movement and the abolition of China's presidential two-term limit under Xi Jinping. The 2018 project encouraged supporters to download meme-emblazoned plastic bag designs from Badiucao's website and use them as props for Tank Man street art.

11 Wang Shuo, China's most successful novelist of the late 1980s and 1990s, does something similar when he sneaks an ekphrastic reference to Tank Man (a "column of enemy tanks . . . rumbled toward [the protagonist] at a snail's pace") into his otherwise bawdy and irreverent novel *Please Don't Call Me Human* (*Qianwan bie ba wo dang ren* 千万别把我当人, 1989), written just weeks after the crackdown.

12 As Limor Shifman notes, in such cases "the utterly serious keying of the original photograph has been transformed in the process of memetic uptake, which involves explicit playfulness," but she distinguishes between "political oriented versions," which are "mainly sardonic," and the "amused and humorous" tone of "pop-culture-oriented ones" (2014, 53).

13 In one of the few discussions to explore the link between humor and the uncanny, Robert Pfaller (2006, 206) argues, citing Ernst Lubitsch's *To Be or Not to Be* (1942), that the double is crucial to their space of structural sameness. I am grateful to K. C. Lo for drawing this reference to my attention.

14 In this sense, the duck patrol bears interestingly on Ethan Zuckerman's "Cute Cat Theory" of digital activism. Zuckerman (2008) argues that "with web 2.0, we've embraced the idea that people are going to share pictures of their cats, and now we build sophisticated tools to make that easier to do. As a result, we're creating a wealth of tech that's extremely helpful for activists. There are twin revolutions going on—the ease of creating content and the ease of sharing it with local and global audiences." Inevitably, images—harder to detect and delete, quicker to go viral—have a special valence here, as the duck patrol seems to show clearly enough. Yet as An Xiao Mina (2011) has argued in response to Zuckerman, in the case of political memes in China, where contentious speech acts must avail themselves of comic disguise, "the cute cats [or duck patrols] *are* the activist message." Another example of cutesy humor with a razor edge is the recent "toad worship" subculture (*moha wenhua* 膜蛤文化) that has grown up around former Chinese leader Jiang Zemin. Jiang's faintly amphibian look, enhanced by the so-called frog spectacles that he wears, has spawned online chatter that seems affectionate but has a sharply critical undertone in the social media feeds of some Chinese netizens. This critique either targets Jiang himself or, more commonly, takes oblique aim at current leader Xi Jinping.

15 The museum has since reopened at a new site in Mong Kok.

16 The Lily and Honglei art studio uses this as a pseudonym.

17 In their study of memes that play on "Girl Fleeing Napalm," Boudana, Frosh, and Cohen (2017, 8–16) argue that three core strategies commonly reconfigure the iconic image: overlaying it with different elements, extracting the figure of the girl and relocating it in different settings, and implanting new figures that sometimes usurp her presence. Yet these strategies, some of which Boudana et al. call "radical," actually cleave quite closely to the compositional format of the original photograph and thus retain a straightforward recognizability. As such, they contrast strongly with the coded mutations of Tank Man in Chinese online space.

18 This process can be seen in another photographic series, *Mirrors* (*Jingzi* 镜子), by Li Wei, in which the disembodied head of the artist is made to float in ambient

space—thanks not to Photoshop but to Li's use of a specially designed mirror with a hole in the center, which reflects the surrounding scene in reverse. Picking up—mirroring—Ai Weiwei's refrain in *Studies of Perspective*, the series moves transnationally from site to iconic site, but reaches its climactic point at the square in a photo-work at Tiananmen. Li's head, facing the camera against the backdrop of the square, in which the familiar shapes of vehicles, road markings, and street lights are discernible, hovers in the lower left quadrant of the image like a decapitated Tank Man who has finally turned round to show himself. On a narrative level, the image once again rebukes the conspiracy of silence: "the ghostly head is the only 'real' object . . . [while] the tidy square, which reveals no trace of the violence committed there, turns out to be the illusion, a mere reflection" (Berry 2008, 305). But its own visual language is no less in thrall to secrecy as it loops back to Tank Man via a self-referential aesthetic code that covers its tracks.

19 A photo-performance by Beijing-based artist Song Dong 宋冬, entitled "Breathing" (Haqi 哈气, 1996), offers an example of this latter point. On a winter's day, the artist laid for forty minutes on the cold concrete of Tiananmen Square, exhaling onto the pavement until a thin layer of ice formed. The trace left behind was ghostly, of course, but it also breathed life back into Tank Man, whose passing was intimated by Song Dong's supine position.

20 Lily and Honglei speak directly to this genealogical disintegration in a video work about June 4 entitled *Forbidden City* (*Zijincheng* 紫禁城, 2008), which melds digital animation with traditional Chinese paper cuts. The piece opens with an image of an old-fashioned tea shop window, in which is hung a red paper-cut decoration of the character *fu* 福, meaning prosperity and happiness. A flower has been cut out in each corner of the decoration, at face value a reference to the "Four Gentlemen" of Chinese artistic and botanical tradition (plum blossom, orchid, bamboo, and chrysanthemum)—but also an encrypted allusion to the so-called Four Gentlemen of the Tiananmen Square protests: a quartet of activists including Nobel Laureate Liu Xiaobo, who went on hunger strike in June 1989 (and after whom the conceptual art collective is named). As a *guqin* 古琴 (Chinese zither) plays on the soundtrack, the paper cut disintegrates into falling petals until only five tiny red marks remain. The camera then closes in on these shapes, revealing them to be the lone protestor, three tanks, and the Forbidden City itself. For the next two minutes, the tanks and the protestor—the component parts of the original Tank Man photograph—abandon their assigned places to move disjointedly and at random across the screen, until the inevitable hard collision between man and machine occurs and a spectral swirl of blood is superimposed across the visual field. It drifts like a fractal for several seconds before floating away, just as the falling petals reassemble into the character *fu*, the swirl of blood melts into steam from a teacup, and the scene returns to the tea shop as if the bloodshed had never happened. By dismembering the Tank Man photograph, the video acts out the process of creative redux—stripping down to barest bones and then aesthetically recoding key parts—that icons

must undergo if they are to maintain some kind of visibility in suppressive environments.

CONCLUSION. OUT OF THE DARKROOM

1 For a study of the techniques of photographic manipulation, see Fineman 2012.
2 As Wendy Larson notes, Lei Feng stood as "a flawless model of negotiation between the spiritual, material, and social worlds" (2008, 109), a state of perfection that made his iconography a sensitive business.
3 I am grateful to Chow Yiu Fai for sharing this insight with me.
4 See also Zhang Ce 张策 2010, 77.
5 For a selection of the spoofs, see https://www.chinasmack.com/floating-chinese -government-officials-stun-netizens.

References

n.a. 1937. "The Camera Overseas: 136,000,000 People See This Picture of Shanghai's South Station." *Life*, October 4.

n.a. 2010. "'Nanjing datusha' jiaoan" (Nanjing Massacre Lesson Plan). Yuwenchuban-she.com. Accessed April, 10, 2017. http://www.ywcbs.com/article.do?contentid =5568.

n.a. 2012. "210 yu fu zuopin zucheng daxing xunhui gezhan. Li Zijian youhua zuopin zai Lanzhou zhanchu" 210 余幅作品组成大型巡回个展: 李自健油画作品在兰州展出 (Large-Scale Solo Exhibition on Tour with over 210 Artworks. Li Zijian's Oil Paintings Are Exhibited in Lanzhou). Gs.xinhuanet.com, June 11. Accessed May 22, 2017. http://www.gs.xinhuanet.com/news/2012–06/11/content_25377699 .htm.

n.a. 2013. "Chinese Evade Censors, as HK Journalists Stopped at Tiananmen." *South China Morning Post*, June 4. Accessed August 2, 2016. https://www.scmp.com /comment/blogs/article/1253135/chinese-evade-censors-hk-journalists-stopped -tiananmen.

n.a. 2014a. "Beishida nüfuzhong bufen canyu wenge xuesheng daoqian" 北师大女附中部分参与文革学生道歉 (Some Students Involved in the Cultural Revolution at the Girls Middle School Attached to Beijing Normal University Make an Apology). *Xinjing bao* 新京报 (Beijing News), January 13.

n.a. 2014b. "Nanjing datusha zhuanshi yinggai zai quanguo zhongxiaoxue puji. Fang Zhongguo shekeyuan shijie yanjiusuoyuan Tang Chongnan" 南京大屠杀专史应该在全国中小学普及—访中国社科院世界所研究员汤重南 (The Specific History of the Nanjing Massacre Should Be Taught in Primary and Middle Schools Nationwide: An Interview with Tang Chongnan of the Institute of World History, Chinese Academy of Social Sciences). *Zhongguo qingnianbao* 中国青年报 (China Youth Daily), November 18. Accessed December 10, 2016. http://zqb.cyol.com/html /2014–11/18/nw.D110000zgqnb_20141118_2–10.htm.

n.a. 2016. "Nanjing datusha, weihe xuwu le 30 nian?" 南京大屠杀，为何虚无了30年? (Why was the Nanjing Massacre Consigned to Nothingness for 30 Years?) *Wenxuecheng* 文学城 (Literature City), December 23. Accessed February 10, 2017. http://bbs.wenxuecity.com/memory/1084457.html.

n.a. 2017. "Zhonggong weihe 30 duo nian bu ti Nanjing datusha?" 中共为何30多年不提南京大屠杀? (Why Didn't the CCP Mention the Nanjing Massacre for More than 30 Years?) *Abuoluowang*, March 23. Accessed May 4, 2017. http://www.aboluowang.com/2017/0323/900831.html.

A Ling 阿玲. 2002. "Qinqing suiyue" 亲情岁月 (Family Love down the Years). *Lao zhaopian* 老照片 (Old Photographs) 25: 139–40.

Adorno, Theodore W. 1983. *Prisms*. Translated by Samuel and Shierry Weber. Cambridge, MA: MIT Press.

Ai Weiwei 艾未未. 2017. "How Censorship Works." *New York Times*, May 6. Accessed June 7, 2017. https://www.nytimes.com/2017/05/06/opinion/sunday/ai-weiwei-how-censorship-works.html.

Anastasio, Thomas J., Kristen Ann Ehrenberger, Patrick Watson, and Wenyi Zhang. 2012. *Individual and Collective Memory Consolidation: Analogous Processes on Different Levels*. Cambridge, MA: MIT Press.

Arbus, Diane. 1972. *Diane Arbus: An Aperture Monograph*. New York: Aperture Foundation.

Arendt, Hannah. 1993. *Between Past and Future: Eight Exercises in Political Thought*. New York: Penguin.

Ariès, Philippe. 1981. *The Hour of Our Death*. Translated by Helen Weaver. New York: Knopf.

Attardo, Salvatore. 1994. *Linguistic Theories of Humor*. Berlin: Mouton De Gruyter.

Ba Jin 巴金. 1987. *Suixiang lu* 随想录 (Random Thoughts). Beijing: Sanlian shudian.

Baer, Ulrich. 2005. *Spectral Evidence: The Photography of Trauma*. Cambridge, MA: MIT Press.

Baetens, Jan. 2001. "*Going to Heaven*: A Missing Link in the History of Photonarrative?" *Journal of Narrative Theory* 31 (1): 87–105.

Bal, Mieke. 1997. *The Mottled Screen: Reading Proust Visually*. Translated by Anna-Louise Milne. Palo Alto, CA: Stanford University Press.

Bao Kun 鲍昆. 2010. "Yingxiang shi lishi de mima" 影像是历史的秘密 (Images Are the Secrets of History). In *Poyi lao zhaopian mima* 破译老照片密码 (Cracking the Code of Old Photographs), edited by Yang Lang 杨浪, 365–67. Beijing: Sanlian shudian.

Baranovitch, Nimrod. 2003. *China's New Voices: Popular Music, Ethnicity, Gender, and Politics, 1978–1997*. Berkeley: University of California Press.

Barmé, Geremie. [1987] 2011. "My Friend the Memory Hole: A Comment on Living with Deng Xiaoping's 'Anti-bourglib' Campaign." *China Heritage Quarterly*, no. 25 (March). Accessed July 26, 2017. http://www.chinaheritagequarterly.org/features.php?searchterm=025_memory.inc&issue=025.

Barmé, Geremie. 2012. "Red Allure and the Crimson Blindfold." *China Perspectives* 2:29–40.

Barmé, Geremie. 2017. "Memory Holes, Old and New." *China Heritage.* Accessed July 27, 2017. http://chinaheritage.net/journal/memory-holes-old-new/.

Barthes, Roland. 1977. *Image, Music, Text.* Translated by Stephen Heath. London: Fontana.

Barthes, Roland. 1978. *A Lover's Discourse: Fragments.* Translated by Richard Howard. New York: Hill and Wang.

Barthes, Roland. 2000. *Camera Lucida.* Translated by Richard Howard. London: Vintage.

Bartlett, John. 1980. *Familiar Quotations.* Boston: Little, Brown.

Baudrillard, Jean. 1983. *Simulations.* Cambridge, MA: MIT Press.

Baudrillard, Jean. 1998. *Photographies: Car L'Illusion ne s'Oppose pas a la Réalité.* Paris: Descartes and Cie.

Beckman, Karen, and Jean Ma, eds. 2008. *Still Moving: Between Cinema and Photography.* Durham, NC: Duke University Press.

Bell, Daniel. 2015. *The China Model: Political Meritocracy and the Limits of Democracy.* Princeton, NJ: Princeton University Press.

Benjamin, Walter. 1977. *The Origin of German Tragic Drama.* Translated by John Osborne. London: New Left Books.

Berlant, Lauren. 2008. *Supervalent Thought.* Accessed August 5, 2016. https://supervalentthought.com/tag/secrecy/.

Berman, Marshall. 1989. "Can These Ruins Live?" *Parkett* 20:42–55.

Berry, Chris. 2004. *Postsocialist Cinema in Post-Mao China: The Cultural Revolution after the Cultural Revolution.* New York: Routledge.

Berry, Michael. 2008. *A History of Pain: Trauma in Modern Chinese Literature and Film.* New York: Columbia University Press.

Berthelsen, John. 2013. "Love, Thy Name is Ducky." *Asian Correspondent,* 24 May. Accessed July 11, 2017. https://asiancorrespondent.com/2013/05/love-thy-name-is-ducky/#K559QyIr8t5BY41P.97.

Birchall, Clare. 2011. "'There's Been Too Much Secrecy in this City': The False Choice between Secrecy and Transparency in US Politics." *Cultural Politics* 17 (1): 133–156.

Birchall, Clare. 2016a. "Managing Secrecy." *International Journal of Communication* 10:152–63.

Birchall, Clare. 2016b. "Shareveillance: Subjectivity between Open and Closed Data." *Big Data and Society* 3 (2): 1–12.

Birchall, Clare. 2016c. "Six Answers to the Question 'What is Secrecy Studies?'" *Secrecy and Society* 1 (1): 1–13. Accessed November 10, 2016. http://scholarworks.sjsu.edu/cgi/viewcontent.cgi?article=1003&context=secrecyandsociety.

Blanco, Maria del Pilar, and Esther Peeren, eds. 2013. *The Spectralities Reader: Ghosts and Haunting in Contemporary Cultural Theory.* London: Bloomsbury.

Bland, Ben. 2017. "China Rewrites History with New Censorship Drive: Whitewashing of Archives Part of Wider Ideological Crackdown by Xi Jinping." *Financial Times,* September 4. Accessed November 20, 2017. https://www.ft.com/content/4ffac53e-8ee4–11e7–9084-d0c17942ba93.

Bok, Sissela. 1989. *Secrets: On the Ethics of Concealment and Revelation*. New York: Vintage Books.

Boudana, Sandrine, Paul Frosh, and Akiba A. Cohen. 2017. "Reviving Icons to Death: When Historic Photographs Become Digital Memes." *Media, Culture and Society*. Epub ahead of print, February 3. https://doi.org/10.1177/0163443717690818.

Bourdieu, Pierre. 1997. "Marginalia—Some Additional Notes on the Gift." In *The Logic of the Gift: Towards an Ethic of Generosity*, edited by Alan D. Schrift, 231–44. New York: Routledge.

Bourdieu, Pierre. 2000. *Pascalian Meditations*. Translated by Richard Nice. Palo Alto, CA: Stanford University Press.

Bourriaud, Nicolas. 2006. "Relational Aesthetics." In *Participation*, edited by Claire Bishop, 160–71. London: Whitechapel.

Braester, Yomi. 2003. *Witness Against History: Literature, Film, and Public Discourse in Twentieth-Century China*. Palo Alto: Stanford University Press.

Braester, Yomi. 2010. "Photography at Tiananmen: Pictorial Frames, Spatial Borders, and Ideological Matrixes." *positions: asia critique* 18 (3): 633–70.

Braester, Yomi. 2016. "The Post-Maoist Politics of Memory." In *A Companion to Modern Chinese Literature*, edited by Yingjin Zhang, 434–51. Oxford: Wiley-Blackwell.

Brady, Anne-Marie. 2009. "The Beijing Olympics as a Campaign of Mass Distraction." *China Quarterly* 197:1–24.

Bratich, Jack. 2006. "Public Secrecy and Immanent Security: A Strategic Analysis." *Cultural Studies* 20 (4–5): 493–511.

Bratich, Jack. 2007. "Popular Secrecy and Occultural Studies." *Cultural Studies* 21 (1): 42–58.

Brown, Jeremy, and Matthew D. Johnson, eds. 2015. *Maoism at the Grassroots: Everyday Life in China's Era of High Socialism*. Cambridge, MA: Harvard University Press.

Bryant, Marsha, ed. 1996. *Photo-Textualities: Reading Photographs and Literature*. Newark: University of Delaware Press.

Burgin, Victor, ed. 1982. *Thinking Photography*. Basingstoke, U.K.: Palgrave.

Callahan, William A. 2007. "Trauma and Community: The Visual Politics of Chinese Nationalism and Sino-Japanese Relations." *Theory and Event* 10 (4).

Callahan, William A. 2009. "The Cartography of National Humiliation and the Emergence of China's Geobody." *Public Culture* 21 (1): 141–73.

Callahan, William A. 2012. *China: The Pessoptimist Nation*. Oxford: Oxford University Press.

Callahan, William A. 2015. "Textualizing Cultures: Thinking beyond the MIT Controversy." *positions: asia critique* 23 (1): 131–44.

Cameron, Catherine M., and John B. Gatewood. 2003. "Seeking Numinous Experiences in the Unremembered Past." *Ethnology* 42 (1): 55–71.

Canetti, Elias. 1984. *Crowds and Power*. New York: Farrar, Straus and Giroux.

Cao Juren 曹聚仁, and Shu Zongqiao 舒宗侨, eds. 2011. *Zhongguo kangzhan huashi* 中国抗战画史 (An Illustrated History of the Sino-Japanese War). Vols. 1 and 2. Beijing: Zhongguo wenshi chubanshe.

Caster, Michael, ed. 2017. *The People's Republic of the Disappeared: Stories from Inside China's System for Enforced Disappearance*. N.p.: Safeguard Defenders.

Chan Koonchung 陈冠中. 2009. *Shengshi: Zhongguo 2013* 盛世: 中国 2013 (The Fat Years: China, 2013). Hong Kong: Oxford University Press.

Chang, Iris. 1997. *The Rape of Nanking: The Forgotten Holocaust of World War II*. New York: Basic Books.

Chang, Tsong-zung. 1996. *Reckoning with the Past: Contemporary Chinese Painting*. Edinburgh: Fruitmarket Gallery.

Chen Chuangchuang 陈闯创. 2016. "Bian Zhongyun shi bei hongweibing dasi de ma? Jiantan Song Binbin de daoqian" 卞仲耘是被红卫兵打死的吗? 兼谈宋彬彬的道歉 (Was Bian Zhongyun beaten to death by Red Guards? A discussion of Song Binbin's apology). In *Honghuo: Wenge wushi zhounian xueshu lunwenji* 红祸: 文革五十周年学术论文集 (Red Disaster: A Collection of Academic Papers on the 50th Anniversary of the Cultural Revolution), edited by Wu Chenmou 吴称谋, 236–50. N.p.: World Chinese Publishing.

Chen Minjie. 2009. "From Victory to Victimization: The Sino-Japanese War (1937–1945) as Depicted in Chinese Youth Literature." *Bookbird: A Journal of International Children's Literature* 47 (2): 27–35.

Chen Qinggang 陈庆港. 2015. *Zui manchang de shisi tian: Nanjing datusha xingcunzhe koushu, shilu yu jishi* 最漫长的十四天: 南京大屠杀幸存者口述实录与纪实 (The Longest Fourteen Days: Testimonies and Records from Survivors of the Nanjing Massacre). Nanjing: Jiangsu fenghuang wenyi chubanshe.

Chen Shaoxiong 陈绍雄. 2010. *Moshui lishi* 墨水历史 (Ink History). Accessed January 28, 2016. https://www.youtube.com/watch?v=piAeMViAEVE.

Chen Sihe 陈思和. 1999. "Shilun dangdai wenxue shi (1949–1976) de 'qianzai xiezuo'" 试论当代文学史 (1949–1976) 的"潜在写作" (The 'Invisible Writing' inside Contemporary Literary History [1949–1976]). *Wenxue pinglun* 文学评论 (Literary Review) 6:104–13.

Chen Tao 陈涛. 2011. "Huaijiu yu zhaohun: dangdai Zhongguo guannian sheyingzhong de jiating jiyi" 怀旧与招魂: 当代中国观念摄影中的家庭记忆 (Nostalgia and Calling Back the Spirits of the Dead: Family Remembrance in Contemporary Chinese Conceptual Photography). *Wenyi yanjiu* 文艺研究 (Research on Literature and Art) 6:25–33.

Chen Wei 陈薇. 2014. "Li Zijian youhua 'Nanjing datusha' chenlie guojia bowuguan" 李自健油画《南京大屠杀》陈列国家博物馆 (Li Zijian's painting *Nanjing Massacre* Is Exhibited in the National Museum of China). *Fenghuang Hunan* 凤凰湖南, May 2. Accessed December 10, 2016. http://hunan.ifeng.com/news/fghx/detail_2014_05/02/2206182_0.shtml.

Cheng Zhaoqi 程兆奇. 2002. *Nanjing datusha yanjiu: Riben xugoupai pipan* 南京大屠杀研究: 日本虚构派批判 (Research on the Nanjing Massacre: A Critique of the Japanese Deniers). Shanghai: Shanghai cishu chubanshe.

Chi, Robert. 2001. "Picture Perfect: Narrating Public Memory in Twentieth-Century China." PhD diss., Harvard University.

China Digital Times. 2016. *Watching Big Brother: Political Cartoons by Badiucao.* Ebook. Berkeley: China Digital Times.

China Digital Times. 2017. "Minitrue: Delete References to Korean Film 'A Taxi Driver.'" *China Digital Times*, October 4. Accessed December 19, 2018. https://chinadigitaltimes.net/2017/10/minitrue-delete-articles-related-korean-film-taxi-driver/.

Chinese Communist Party. 1981. "Guanyu jianguo yilai dang de ruogan lishi wenti de jueyi" 关于建国以来党的若干历史问题的决议 (Resolution on Certain Questions in the History of Our Party since the Founding of the People's Republic of China). Adopted at the Sixth Plenary Session of the Eleventh Central Committee of the Chinese Communist Party, Beijing, June 27.

Chinese Students and Scholars Association. 2006. "Chinese Students Association Offended by Homepage Art," letter to the editor, *The Tech*, 126 (21), April 28. Accessed March 2, 2017. http://wwwtech.mit.edu/V126/N21/letters21.html.

Christensen, Thomas. 1996. "Chinese Realpolitik." *Foreign Affairs* 75 (5): 37–52.

Chun, Wendy H. K. 2008. "The Enduring Ephemeral, or the Future is a Memory." *Critical Inquiry* 35:148–71.

Coelewij, Leontine, ed. 2014. *Marlene Dumas: The Image as Burden.* London: Tate Publishing.

Cohen, Stanley. 2000. *States of Denial: Knowing About Atrocities and Suffering.* Cambridge: Polity Press.

Collins, Daniel L. 1992. "Anamorphosis and the Eccentric Observer: Inverted Perspective and Construction of the Gaze." *Leonardo* 25 (1): 73–82.

Crane, Susan A. 2008. "Choosing Not to Look: Representation, Repatriation, and Holocaust Atrocity Photography." *History and Theory* 47 (3): 309–30.

Cubitt, Sean. 1996. "Supernatural Futures: Theses on Digital Aesthetics." In *Future Natural: Nature, Science, Culture*, edited by George Robertson, Melinda Mash, Lisa Tickner, Jon Bird, Barry Curtis, and Tim Putnam, 235–52. Abingdon, U.K.: Routledge.

Cui Junxia 崔君霞. 2006. "Xu Weixin: qianxin 'Wenge zhongshengxiang' chuangzuo" 徐唯辛: 潜心《文革众生相》创作 (Xu Weixin: A Focused Look at the Making of *Cultural Revolution Figures*). *Dongfang yishu* 东方艺术 (Eastern Art) 21:140–45.

Dai Jinhua 戴锦华. 2010. "Dieying chongchong. Jiandiepian de wenhua chuxi" 谍影重重: 间谍片的文化初析 (Spy Shadows Everywhere: A Preliminary Cultural Analysis of the Espionage Movie). *Dianying yishu* 电影艺术 (Film Art) 1:57–63.

Dan Hansong. n.d. "From Oral History Performance to Political Apology Performance: a Case Study of Wang Youqin and Song Binbin," working paper, Academia.edu. Accessed October 31, 2016. http://www.academia.edu/18639623/From_Oral_History_Performance_to_Political_Apology_Performance_A_Case_Study_of_Wang_Youqin_and_Song_Binbin.

Daum, Jeremy. 2017. "China through a Glass, Darkly: What Foreign Media Misses in China's Social Credit." *China Law Translate.* Accessed June 17, 2018. https://www.chinalawtranslate.com/seeing-chinese-social-credit-through-a-glass-darkly/?lang=en.

Davies, David J. 2005. "Old Zhiqing Photos: Nostalgia and the Spirit of the Cultural Revolution." *China Review* 5 (2): 97–123.

Davis, Colin. 2005. "Hauntology, Spectres and Phantoms." *French Studies* 59 (3): 373–79.

Debord, Guy. 1998. *Comments on the Society of the Spectacle*. Translated by Malcolm Imrie. London: Verso.

Deleuze, Gilles, and Félix Guattari. 1986. *Kafka: Towards a Minor Literature*. Translated by Dana Polan. Minneapolis: University of Minnesota Press.

Deleuze, Gilles, and Félix Guattari. 2004. *A Thousand Plateaus: Capitalism and Schizophrenia*. Translated by Brian Massumi. London: Continuum.

Denton, Kirk. 2014. *Exhibiting the Past: Historical Memory and the Politics of Museums in Postsocialist China*. Honolulu: Hawai'i University Press.

Derrida, Jacques. 1986. "Shibboleth." In *Midrash and Literature*, edited by Geoffrey Hartman and Sanford Budick, 307–48. New Haven, CT: Yale University Press.

Derrida, Jacques. 1989. "How to Avoid Speaking: Denials." In *Languages of the Unsayable: The Play of Negativity in Literature and Literary Theory*, edited by Sanford Budick and Wolfgang Iser, 3–70. New York: Columbia University Press.

Derrida, Jacques. 1994. *Specters of Marx, the State of the Debt, the Work of Mourning, and the New International*. Translated by Peggy Kamuf. Abingdon, U.K.: Routledge.

Derrida, Jacques. 1995. *The Gift of Death*. Translated by David Wills. Chicago: University of Chicago Press.

Derrida, Jacques. 1996. *Archive Fever: A Freudian Impression*. Translated by Eric Prenowitz. Chicago: University of Chicago Press.

Derrida, Jacques. 2005. *Sovereignties in Question: The Poetics of Paul Celan*. Edited by Thomas Dutoit and Outi Pasanen. New York: Fordham University Press.

Derrida, Jacques. 2016. *On Grammatology*. Translated by Gayatri Chakravorty Spivak. Baltimore: Johns Hopkins University Press.

Derrida, Jacques, and Maurizio Ferraris. 2001. *A Taste for the Secret*. Cambridge: Polity Press.

Dikötter, Frank. 2008. *The Age of Openness: China Before Mao*. Hong Kong: Hong Kong University Press.

Ding You 丁佑. 1998. "Wengezhong de longya ren" 文革中的聋哑人 (A Deaf Person during the Cultural Revolution). *Lao zhaopian* 老照片 (Old Photographs) 7:25–29.

Dittmer, Lowell. 1996. "Reconstructing the Cultural Revolution." *China Information* 11:1–20.

Donald, Stephanie Hemelryk. 2000. *Public Secrets, Public Spaces: Cinema and Civility in China*. Lanham, MD: Rowman and Littlefield.

Donald, Stephanie Hemelryk. 2012. "Monumental Memories: Xu Weixin's *Chinese Historical Figures, 1966–1976*." *New Formations* 75:45–62.

Duan Yan 段彦. 2009. "Yi zuo zhaoxiangguan de 60 nian sheying jiyi" 一座照相馆的 60年摄影记忆 (60 Years of Photographic Memories from a Photography Studio). *Yingxiang shijue* 影像视觉 (Image Vision) 10:98–109.

Durkheim, Emile. 1982. *The Rules of Sociological Method: And Selected Texts on Sociology and its Methods*. Edited by Steven Lukes and translated by W.D. Halls. New York: Free Press.

Dutton, Michael. 2005. *Policing Chinese Politics: A History*. Durham, NC: Duke University Press.

Dutton, Michael. 2016. "Cultural Revolution as Method." *China Quarterly* 227:718–33.

Eaglestone, Robert. 2017. *The Broken Voice: Reading Post-Holocaust Literature*. Oxford: Oxford University Press.

Eliade, Mircea. 1967. *The Sacred and the Profane*. Translated by W. R. Trask. New York: Harcourt Brace Jovanovich.

Eykholt, Mark. 2000. "Aggression, Victimization, and Chinese Historiography of the Nanjing Massacre." In *The Nanjing Massacre in History and Historiography*, edited by Joshua A. Fogel, 11–69. Berkeley: University of California Press.

Fang Fang 方方. 2016. *Ruan mai* 软埋 (Bare Burial). Beijing: Renmin wenxue chubanshe.

Fang Lizhi. 1990. "The Chinese Amnesia," translated by Perry Link. *New York Review of Books*, September 27. Accessed March 3, 2015. http://www.nybooks.com /articles/1990/09/27/the-chinese-amnesia/.

Fauna. 2011. "Floating Chinese Government Officials Inspect New Road." *China-Smack*. Accessed June 6, 2019. https://www.chinasmack.com/floating-chinese -government-officials-stun-netizens.

Feldman, Allen. 2015. *Archives of the Insensible: Of War, Photopolitics, and Dead Memory*. Chicago: University of Chicago Press.

Feng Jicai 冯骥才. 2014. *Yibai ge ren de shinian* 一百个人的十年 (A Decade in the Lives of a Hundred People). Beijing: Wenhua yishu chubanshe.

Feng Jinglan 冯敬兰. 2011. "Muqinjie: Bu xunchang de jinian" 母亲节: 不寻常的纪念 (Mother's Day: An Unusual Memorial). *Wangjian beishan de boke* 望见北山的博客 (Gazing at the Northern Hills: A Blog). Accessed June 10, 2016. http://wenku .baidu.com/view/c9b35e0dbb68a98271fefa52.

Feng Jinglan. 2014. "Xiaozhang shi zenme si de? Yuan Beijing shida nü fuzhong wenge chuqi 'bawu shijian' zongshu" 校长是怎么死的？原北京师大女附中文革初期 "八五事件"综述 (How Did the Principal Die? A Summary of the "August 5 Event" Which Occurred at the Girls Middle School Attached to Beijing Normal University in the Opening Stages of the Cultural Revolution). *Jiyi* 记忆 (Remembrance) 106:8–12. Accessed April 30, 2016. http://prchistory.org/wp-content/uploads/2014 /05/REMEMBRANCE_No106.pdf.

Feng Jinglan et al. 2010. "Ye tan Bian Zhongyun zhi si" 也谈卞仲耘之死 (A Discussion about the Death of Bian Zhongyun). *Jiyi* 记忆 (Remembrance) 47:19–55. Accessed August 8, 2016. http://prchistory.org/wp-content/uploads/2014/05 /REMEMBRANCE-No-47–2010年4月28日.pdf.

Feng Keli 冯克力. 2000. "*Lao zhaopian* de chuangban" (The Founding of *Old Photographs*).《老照片》的创办 *Chuban guangjiao* 出版广角 (Broad Views on Publishing) 5:35–37.

Feng Tianyu 冯天瑜 and Zhang Duqin 张笃勤, eds. 2011. *Xinhai geming tuzhi* 辛亥革命图志 (The 1911 Revolution in Pictures). Beijing: Zhonghua shuju.

Feng Xiang 冯翔. 2014. "Wang Jingyao: wo, meiyou wangji lishi" 王晶垚: 我, 没有忘记历史 (Wang Jingyao: I Have Not Forgotten History). *Nanfang zhoumo* 南方周末 (Southern Weekly), March 13. Accessed January 8, 2016. http://www.infzm.com/content/98889.

Fineman, Mia. 2012. *Faking It: Manipulated Photography Before Photoshop*. New York: Metropolitan Museum of Art.

Flamson, Thomas J., and Gregory A. Bryant. 2013. "Signals of Humor: Encryption and Laughter in Social Interaction." In *Developments in Linguistic Humour Theory*, edited by Marta Dynel, 49–73. Amsterdam: John Benjamins.

Flueckiger, Barbara. 2015. "Photorealism, Nostalgia, and Style: Material Properties of Film in Digital Visual Effects." In *Special Effects: New Histories/Theories/Contexts*, edited by Dan North, Bob Rehak, and Michael S. Duffy, 78–97. London: British Film Institute.

Fogel, Joshua A. 2007. "The Nanking Atrocity and Chinese Historical Memory." In *The Nanking Atrocity, 1937–38: Complicating the Picture*, edited by Bob Tadashi Wakabayashi, 267–84. New York: Berghahn Books.

4Gentlemen. 2011. "Tiananmen Square Augmented Reality." *Diary in Exile*, January 31. Accessed February 1, 2016. http://fourgentlemen.blogspot.co.uk/2011/01/tiananmen-square-augmented-reality.html.

Frampton, Hollis. 2009. *On the Camera Arts and Consecutive Matters: The Writings of Hollis Frampton*. Edited and with an introduction by Bruce Jenkins. Cambridge, MA: MIT Press.

François, Anne-Lise. 2008. *Open Secrets: The Literature of Uncounted Experience*. Palo Alto, CA: Stanford University Press.

Freud, Sigmund. 2005. *The Essentials of Psycho-Analysis*. Introduction by Anna Freud, translated by James Strachey. London: Vintage.

Fu Ningke 福宁客. 2014. "Mao Zedong weihe bu rang Nanjing datusha lishi shang keben?" 毛泽东为何不让南京大屠杀历史上课本 (Why Did Mao Zedong Keep the History of the Nanjing Massacre out of School Textbooks?). *Fu Ningke de boke* 福宁客的博客 (Fu Ningke's blog). Accessed November 14, 2016. https://www.secretchina.com/news/gb/2014/01/17/527326.html.

Fuji Nobuo 富士信夫. 1995. "*Nankin daigyakusatsu*" wa kôshite tsukurareta 「南京大虐殺」はこうして作られた (This Is How the "Great Nanjing Massacre" Was Made Up). Tokyo: Tentensha.

Galison, Peter. 2004. "Removing Knowledge." *Critical Inquiry* 31 (1): 229–43.

Gao, James Z. 2011. "Shooting Social Suffering: Photography and China's Human Disasters." *Chinese Historical Review* 18 (2): 99–124.

Gao, Rui, and Jeffrey C. Alexander. 2012. "Remembrance of Things Past: Cultural Trauma, the 'Nanking Massacre,' and Chinese Identity." In *The Oxford Handbook of Cultural Sociology*, edited by Jeffrey C. Alexander, Ronald N. Jacobs, and Philip Smith, 583–611. Oxford: Oxford University Press.

Gao Shen 高先觉. 1999. "Bu kan huishou de suiyue" 不堪回首的岁月 (A Past That I Cannot Bear to Look Back On). *Lao zhaopian* 老照片 (Old Photographs) 12:94–96.

Gao Xingzu 高兴祖. 1997. "Du *Nanjing datusha tuzheng*" 读《南京大屠杀图证》 (Reading *Photographic Evidence of the Nanjing Massacre*). *Kangri zhanzheng yanjiu* 抗日战争研究 (Studies on the War of Resistance Against Japan) 23:22–99.

Gao Yulin 高玉琳. 2003. "Fuqin shi yi ben shu" 我父亲是一本书 (My Father Is Like a Book). *Lao zhaopian* 老照片 (Old Photographs) 32:113–20.

Gavett, Gretchen. 2012. "Revisiting Tiananmen Square: 'It Might be a Parade or Something.'" *Public Broadcasting Service*, June 5. Accessed May 10, 2017. https://www.pbs.org/wgbh/frontline/article/revisiting-tiananmen-square-it-might-be-a-parade-or-something/.

Gentz, Natascha. 2014. "Negotiating the Past: Narratives of the Cultural Revolution in Party History, Literature, Popular Media, and Interviews." In *Landscapes of the Chinese Soul: The Enduring Presence of the Cultural Revolution*, edited by Tomas Plankers, 1–34. London: Karnac.

Ghosh, Bishnupriya. 2011. *Global Icons: Apertures to the Popular*. Durham, NC: Duke University Press.

Giddens, Anthony. 1979. *Central Problems in Social Theory: Action, Structure and Contradiction in Social Analysis*. Berkeley and Los Angeles: University of California Press.

Goodman, David S. G. 1994. *Deng Xiaoping and the Chinese Revolution: A Political Biography*. Abingdon, U.K.: Routledge.

Gordon, Avery. 2008. *Ghostly Matters: Haunting and the Sociological Imagination*. Minneapolis: University of Minnesota Press.

Gries, Peter Hays. 2005. *China's New Nationalism: Pride, Politics, and Diplomacy*. Berkeley: University of California Press.

Gu Lijian 顾礼俭. 1998. "Chongdu *Siren zhaoxiangbu*" 重读《私人照相簿》 (Rereading *My Private Photograph Album*). *Wenxue ziyoutan* 文学自由谈 (Free Literary Discussions) 3:142–45.

Gu Yi. 2013. "What's in a Name? Photography and the Reinvention of Visual Truth in China, 1840–1911." *Art Bulletin* 95 (1): 120–38.

Gu Zheng 顾铮. 2006. "Wengezhong de sheying" 文革中的摄影 (Photography in the Cultural Revolution). *Ershiyi shiji* 二十一世纪 (Twenty-First Century) 93:117–22.

Gunning, Tom. 2003. "Haunting Images: Ghosts, Photography, and the Modern Body." In *The Disembodied Spirit*, edited by Alison Ferris, 8–19. Brunswick, ME: Bowdoin College Museum of Art.

Gunning, Tom. 2004. "What's the Point of an Index? Or Faking Photographs." *Nordicom Review* 1 (2): 39–49.

Hariman, Robert, and John Louis Lucaites. 2007. *No Caption Needed: Iconic Photographs, Public Culture, and Liberal Democracy*. Chicago: University of Chicago Press.

Harrison, Mark. 2004. "Why Secrets? The Uses of Secrecy in Stalin's Command Economy." University of Warwick: PERSA Working Paper 34.

He Qinglian 何清涟. 1998. *Zhongguo xiandaihua de xianjing* 中国现代化的陷阱 (The Pitfalls of China's Modernization). Accessed March 5, 2017. http://heqinglian.net/wp-content/uploads/2013/01/何清涟：中国现代化的陷阱德文版.pdf.

He Qun 何群. 2003. *"Lao zhaopian*: yi zhong dazhonghua de lishi xushu" 《老照片》: 一种大众化的历史叙述 (*Old Photographs*: A Popularized Form of Historical Narrative). *Qilu yiyuan* 齐鲁艺苑 (Qilu Realm of Arts) 3:68–71.

He Ping 何平. 1997. "Zhengui de shizheng: Ping *Qinhua Rijun Nanjing datusha tuzheng*" 珍贵的实证: 评侵华日军南京大屠杀图证 (Precious Evidence: A Review of *A Collection of Photographs of the Massacre Committed in Nanjing by the Japanese Military*). *Kangri zhanzheng yanjiu* 抗日战争研究 (Studies on the War of Resistance Against Japan) 23:206–12.

He, Yinan. 2007a. "History, Chinese Nationalism and the Emerging Sino-Japanese Conflict." *Journal of Contemporary China* 16 (50): 1–24.

He, Yinan. 2007b. "Remembering and Forgetting the War: Elite Mythmaking, Mass Reaction, and Sino-Japanese Relations, 1950–2006." *History and Memory* 19 (2): 43–74.

Hei Ming 黑明. 2006. *Zouguo qingchun: 100 ming zhiqing de mingyun xiezhao* 走过青春: 100名知情的命运写照 (Paths out of Youth: Portraits of 100 Educated Youths and Their Fates). Xi'an: Shaanxi shifan daxue chubanshe.

Herzog. 2012. "Tantan weishenme Mao shidai 'Nanjing datusha' meiyou chengwei redian huati" 谈谈为什么毛时代南京大屠杀没有成为热点话题 (Why the Nanjing Massacre Never Became a Hot Topic during the Maoist Period). MITBBS.com, February 22. Accessed January 27, 2017. https://www.mitbbs.com/article_t /Military/37295537.html.

Hevia, James L. 2009. "The Photography Complex: Exposing Boxer-Era China (1900–1901), Making Civilization." In *Photographies East: The Camera and Its Histories in East and Southeast Asia*, edited by Rosalind Morris, 79–120. Durham, NC: Duke University Press.

Higashinakano Shûdô 東中野修道. 1998. *"Nankin gyakusatsu" no tettei kensho*「南京虐殺」の徹底検証 (A Thorough Assessment of the "Nanjing Massacre"). Tokyo: Tendensha.

Higashinakano Shûdô, Kobayashi Susumu 小林進, and Fukunaga Shinjirô 福永慎次郎. 2005. *Nankin jiken "shôko shashin" o kenshô suru* 南京事件「証拠写真」を検証する (Appraising the "Photographic Evidence" of the Nanjing Incident). Tokyo: Soshisha.

Hiranuma Takeo 平沼赳夫, ed. 2009. *Han'nichi kinenkan. Futô na shashin no kekkyo o motomeru* 反日記念館:不当な写真の撤去を求める (Anti-Japanese Memorial Halls. Demanding the Removal of Improper Photographs). Tokyo: Tendensha.

Hirsch, Marianne. 1997. *Family Frames: Photography, Narrative, and Postmemory.* Cambridge, MA: Harvard University Press.

Hirsch, Marianne. 2012. *The Generation of Postmemory: Writing and Visual Culture after the Holocaust.* New York: Columbia University Press.

Hockx, Michel. 2015. *Internet Literature in China.* New York: Columbia University Press.

Horn, Eva. 2011. "Logics of Political Secrecy." *Theory, Culture and Society* 28 (7–8): 103–22.

Hsu, Immanuel. 1990. *China without Mao: The Search for a New Order*. Oxford: Oxford University Press.

Hu Jie 胡杰, dir. 2006. *Wo sui si qu* 我虽死去 (*Though I Am Gone*).

Hu Jie, dir. 2004. Xunzhao *Lin Zhao de linghun* 寻找林昭的灵魂 (*Searching for Lin Zhao's Soul*).

Hu Jurong 胡菊蓉. 1995. "Shoubu qinhua Rijun Nanjing datusha daxing tupian ji *Nanjing datusha tuzheng* gongkai chuban" 首部侵华日军南京大屠杀大型图片集《南京大屠杀图证》公开出版 (On the Publication of *Photographic Evidence of the Nanjing Massacre*, the First Large-scale Photographic Album of the Massacre Committed in Nanjing by the Japanese Military). *Minguo dang'an* 民国档案 (Republican Archives) 3:120–21.

Huang, Nicole. 2010. "Locating Family Portraits: Everyday Images from 1970s China." *positions: asia critique* 18 (3): 671–93.

Hube, Eva Marie. 2014. "Artist Amir Baradaran Talks Technology, Marina Abramovic, and Defacing Mona Lisa." *FourTwoNine*, October 28. Accessed April 12, 2016. http://fourtwonine.com/2014/10/28/5354-amir-baradaran-talks-with-us-about-futurism-technology-and-the-mona-lisa/.

Hughes, Alex, and Andrea Noble, eds. 2003. *Phototextualities: Intersections of Photography and Narrative*. Albuquerque: University of New Mexico Press.

Hüppauf, Bernd. 1997. "Emptying the Gaze: Framing Violence through the Viewfinder." *New German Critique* 72:3–44.

Ibrahim, Yasmin. 2015. "Tank Man, Media Memory and Yellow Duck Patrol: Remembering Tiananmen on Social Media." *Digital Journalism*. Epub ahead of print, July 17. https://doi.org/10.1080/21670811.2015.1063076.

Iovene, Paola. 2014. *Tales of Futures Past: Anticipation and the Ends of Literature in Contemporary China*. Palo Alto, CA: Stanford University Press.

Iyer, Pico. 1998. "The Unknown Rebel." *Time*, April 13.

Jaar, Alfredo, and David Levi Strauss. 2012. "The Lament of Images." In *Picturing Atrocity: Photography in Crisis*, edited by Geoffrey Batchen, Mick Gidley, Nancy K. Miller, and Jay Prosser, 275–281. London: Reaktion Books.

Jacobs, Karen, ed. 2006. *Photography and Literature*. Special issue, *English Language Notes* 44 (2).

Jameson, Fredric. 1999. "Marx's Purloined Letter." In *Ghostly Demarcations: A Symposium on Jacques Derrida's* Spectres of Marx, edited by Michael Sprinker, 26–67. London: Verso.

Jay, Martin. 1998. *Cultural Semantics: Keywords of Our Time*. London: Athlone Press.

Jelin, Elizabeth. 2003. *State Repression and the Labors of Memory*. Minneapolis: University of Minnesota Press.

Jenkins, Henry, Sam Ford, and Joshua Green. 2013. *Spreadable Media: Creating Value and Meaning in a Networked Culture*. New York: New York University Press.

Jiang Fenglin 姜凤林. 2012. "Mao Zedong weishenme yinman Nanjing datusha?" 毛泽东为什么隐瞒南京大屠杀? (Why Did Mao Zedong Cover Up the Nanjing Massacre?) *Tianxia luntan* 天下论坛, December 23. Accessed May 5, 2017. http://bbs.creaders.net/politics/bbsviewer.php?trd_id=806753&language=bigs.

Jiang, Jiehong. 2007. "Burden or Legacy: From the Chinese Cultural Revolution to Contemporary Art." In *Burden or Legacy: From the Chinese Cultural Revolution to Contemporary Art*, edited by Jiang Jiehong, 1–32. Hong Kong: Hong Kong University Press.

Jiang Weiping 姜维平. 2001. "Yi zhang quanjiafu"—张全家福 (A Family Photograph). *Lao zhaopian* 老照片 (Old Photographs) 17:84–87.

Johnson, Ian. 2015. "China's Brave Underground Journal—II." *New York Review of Books*, December 18. Accessed June 2, 2016. http://www.nybooks.com/articles /2014/12/18/chinas-brave-underground-journal-ii/.

Johnson, Ian. 2018. "'The Biggest Taboo': An Interview with Qiu Zhijie." *New York Review of Books*, January 6. Accessed February 2, 2018. http://www.nybooks.com /daily/2018/01/06/the-biggest-taboo-an-interview-with-qiu-zhijie/.

Jones, Andrew F. 2010. "Portable Monuments: Architectural Photography and the 'Forms' of Empire in Modern China." *positions: asia critique* 18 (3): 599–631.

Jünger, Ernst. 2008. *On Pain*. Translated and with an introduction by David C. Durst. New York: Telos Press.

Kecheng jiaocai yanjiusuo 课程教材研究所 and Lishi kecheng jiaocai yanjiu kaifa zhongxin 历史课程教材研究开发中心, eds. 2010. *Zhongguo lishi: ba nianji* 中国历史: 八年级 (Chinese History for 8th Grade Students). Vol. 1. Beijing: Renmin jiaoyu chubanshe.

Kermode, Frank. 1979. *The Genesis of Secrecy: On the Interpretation of Narrative*. Cambridge, MA: Harvard University Press.

Kermode, Frank. 1980. "Secrets and Narrative Sequence." *Critical Inquiry* 7 (1): 83–101.

Kershaw, Ian. 1983. *Popular Opinion and Political Dissent in the Third Reich: Bavaria 1933–1945*. Oxford: Clarendon Press.

Kieschnick, John. 2003. *The Impact of Buddhism on Chinese Material Culture*. Princeton, NJ: Princeton University Press.

King, Gary, Jennifer Pan, and Margaret E. Roberts. 2013. "How Censorship in China Allows Government Criticism but Silences Collective Expression." *American Political Science Review* 107 (2): 1–18.

Klein, Naomi. 2000. *No Logo*. Toronto: Vintage Canada.

Kleinman, Arthur. 1995. *Writing at the Margin: Discourse between Anthropology and Medicine*. Berkeley: University of California Press.

Kleinman, Arthur, and Joan Kleinman. 1997. "The Appeal of Experience; The Dismay of Image: Cultural Appropriations of Suffering in Our Times." In *Social Suffering*, edited by Arthur Kleinman, Veena Das, and Margaret Lock, 1–25. Berkeley: University of California Press.

Kohli, Chiranjeev, and Rajneesh Suri. 2002. "Creating Effective Logos: Insights from Theory and Practice." *Business Horizons* 45 (3): 58–64.

Kong, Belinda. 2012. *Tiananmen Fictions outside the Square*. Philadelphia: Temple University Press.

Kracauer. Siegfried. 1993. "Photography," translated by Thomas Y. Levin. *Critical Inquiry* 19 (3): 421–36.

Krauss, Rosalind. 1979. "Sculpture in the Expanded Field." *October* 8:30–44.

Krebs, Edward S. 2004. "Old in the Newest New China: Photographic History, Private Memories and Individual Views of History." *Chinese Historical Review* 11 (1): 87–116.

Kuhn, Anthony. 2014. "Chinese Red Guards Apologize, Reopening a Dark Chapter." "Parallels," NPR, February 4. Accessed March 21, 2016. http://www.npr .org/sections/parallels/2014/01/23/265228870/chinese-red-guards-apologize -reopening-a-dark-chapter.

Kuper, Simon. 2013. "Interview: John Morris on His Friend Robert Capa." *Financial Times*, May 31. Accessed January 10, 2017. https://www.ft.com/content/3d37a03e -c8be-11e2-acc6-00144feab7de.

Kurin, Richard. 1997. "From Smithsonian's America to America's Smithsonian." *Museum Anthropology* 21 (1): 27–41.

Kutz, Christopher. 2016. *On War and Democracy*. Princeton, NJ: Princeton University Press.

Lacan, Jacques. 1998. *The Four Fundamental Concepts of Psychoanalysis: The Seminar of Jacques Lacan, Book XI*. Edited by Jacques-Alain Miller, translated by Alan Sheridan. New York: W.W. Norton.

Lai Jianhong 赖建泓. 2001. "Qiantan lao zhaopian de guanli he baohu" 浅谈老照片的管理和保护 (A Brief Discussion on the Management and Preservation of Old Photographs). *Wenwu chunqiu* 文物春秋 (Annals of Cultural Relics) 2:44–6.

Landsberg, Alison. 2004. *Prosthetic Memory: The Transformation of American Remembrance in the Age of Mass Culture*. New York: Columbia University Press.

Langfitt, Frank. 2012. "Provocative Chinese Cartoonists Find an Outlet Online." NPR, March 16. Accessed May 10, 2016. https://www.npr.org/2012/03/16 /148695679/provocative-chinese-cartoonists-find-an-outlet-online.

Lao Zhaopian 老照片. 2009–. Old Photographs (website). Accessed May 5, 2017. http://www.lzp1996.com/srxb/20131031/877.html.

Larson, Wendy. 2008. *From Ah Q to Lei Feng: Freud and Revolutionary Spirit in 20th Century China*. Palo Alto, CA: Stanford University Press.

Lary, Diana. 2015. *China's Civil War: A Social History, 1945–1949*. Cambridge: Cambridge University Press.

Latham, Kiersten F. 2007. "The Poetry of the Museum: A Holistic Model of Numinous Museum Experiences." *Museum Management and Curatorship* 22 (3): 247–63.

Lee, Chin-Chuan. 1998. "Press Self-Censorship and Political Transition in Hong Kong." *International Journal of Press/Politics* 3 (2): 55–73.

Lee, Chin-Chuan, Hongtao Li, and Francis L. F. Lee. 2011. "Symbolic Use of Decisive Events: Tiananmen as a News Icon in the Editorials of the Elite U.S. Press." *International Journal of Press/Politics* 16 (3): 335–56.

Lee, Vivian. 2014. "The Chinese War Film: Reframing National History in Transnational Cinema." In *American and Chinese-Language Cinemas: Examining Cultural Flows*, edited by Lisa Funnell and Man-Fung Yip, 101–16. New York: Routledge.

Lee, Wei-I. 2015. "Interview: Xu Yong's *Negatives*." *Voices of Photography* 15. Accessed November 24, 2017. http://www.vopmagazine.com/xu-yong/.

Li Fang 李舫. 2009. "*Nanjing! Nanjing!* Gongying bantian piaofang jin 900 wan" 《南京!南京!》公映半天票房近900万 (First Half Day of Box Office Takings for *Nanjing! Nanjing!* Approaches 9 Million Yuan). *Renminwang* 人民网 (The People's Web), April 24. Accessed May 17, 2017. http://culture.people.com.cn/GB/42223/163562/163563/9718178.html.

Li, Jie. 2009. "Virtual Museums of Forbidden Memories: Hu Jie's Documentary Films on the Cultural Revolution." *Public Culture* 21 (3): 538–49.

Li, Jie. 2014. *Shanghai Homes: Palimpsests of Private Life*. New York: Columbia University Press.

Li, Jie. 2016a. "Dossier Literature." In *Oxford Handbook of Modern Chinese Literatures*, edited by Carlos Rojas and Andrea Bachner, 275–95. Oxford: Oxford University Press.

Li, Jie. 2016b. "Museums and Memorials of the Mao Era: A Survey and Notes for Future Curators." In *Red Legacies in China: Cultural Afterlives of the Communist Revolution*, edited by Jie Li and Enhua Zhang, 319–54. Cambridge, MA: Harvard University Asia Center.

Li Li. 2016. *Memory, Fluid Identity, and the Politics of Remembering: The Representations of the Chinese Cultural Revolution in English-speaking Countries*. Brill: Leiden.

Li Ziyang 李子旸. 2000. "Zhende shi zai huaijiu ma" 真的是在怀旧吗 (Is It Really Nostalgic)? *Lao zhaopian* 老照片 (Old Photographs) 13:151–53.

Lily and Honglei. 2008. *Forbidden City*. Accessed August 29, 2016. http://lilyhonglei.com/forbiddenCity/.

Lim, Louisa. 2014. *The People's Republic of Amnesia*. Oxford: Oxford University Press.

Linder, Alex. 2018. "Nordstrom Removes Hoodie Depicting Nanjing Massacre Following Online Uproar." *Shanghaiist*, May 5. Accessed July 2, 2018. http://shanghaiist.com/2016/11/14/nordstrom_nanjing_massacre_hoodie.php.

Linfield, Susie. 2010. *The Cruel Radiance: Photography and Political Violence*. Chicago: University of Chicago Press.

Link, Perry. 2002. Preface to *Nanking 1937: Memory and Healing*, edited by Feifei Li, Robert Sabella, and David Liu, ix–xx. Armonk, NY: M.E. Sharpe.

Liu Boming 刘伯明. 2004. "Wo fuqin de qingyuan" 我父亲的情缘 (My Father's Destiny in Love). *Lao zhaopian* 老照片 (Old Photographs) 37:68–73.

Liu Ni 刘妮, ed. 2012. *Qinli Yan'an suiyue. Yan'an dianyingtuan sheying jishi* 亲历延安岁月：延安电影团摄影纪实 (Experiencing the Yan'an Years: A Photographic Record from the Yan'an Film Studio). Beijing: Renmin chubanshe.

Liu Ning 刘宁. 2002. "Nainai yu laoshu" 奶奶与老叔 (My Grandma and My Uncle). *Lao zhaopian* 老照片 (Old Photographs) 24:139–41.

Liu Rongsheng 刘荣生. 2000. "Zhongguo zhaoxiang shichang de fazhan gaikuang" 中国照相市场的发展概况 (An Overview of the Development of the Photography Industry in China). *Ganguang cailiao* 感光材料 (Photosensitive Materials) 2:3–8.

Liu, Xiao. 2016. "Magic Waves, Extrasensory Powers, and Nonstop Instantaneity: Imagining the Digital beyond Digits." *Grey Room* 63:42–69.

Liu Xiaobo 刘晓波. 2012. *June Fourth Elegies: Poems*. Translated by Jeffrey Yang. Minnesota: Graywolf.

Liu Xinwu 刘心武. 1981. *Da yan mao* 大眼猫 (Big-Eyed Cat). Hangzhou: Zhejiang renmin chubanshe.

Liu Xinwu. 2012. *Siren zhaoxiangbu* 私人照相簿 (My Private Photograph Album). Nanjing: Jiangsu renmin chubanshe.

Lo, Clifford. 2015. "Hong Kong Police Hunt 'Black Bloc': Anarchist Gang Blamed for Legco Bin Blast." *South China Morning Post*, December 15. Accessed June 8, 2018. http://www.scmp.com/news/hong-kong/law-crime/article/1891375/black-bloc -protesters-targeted-hong-kong-police-seek.

Long, Pamela O. 2004. *Openness, Secrecy, Authorship: Technical Arts and the Culture of Knowledge from Antiquity to the Renaissance*. Baltimore: Johns Hopkins University Press.

Lotfalian, Mazyar. 2013. "Aestheticized Politics, Visual Culture, and Emergent Forms of Digital Practice." *International Journal of Communication* 7:1371–90.

Louvel, Liliane. 2008. "Photography as Critical Idiom and Intermedial Criticism." *Poetics Today* 29 (1): 31–48.

Louvel, Liliane. 2011. *Poetics of the Iconotext*. Edited by Karen Jacobs, translated by Laurence Petit. Abingdon, U.K.: Routledge.

Lu, Hanchao. 2002. "Nostalgia for the Future: The Resurgence of an Alienated Culture in China." *Pacific Affairs* 75 (2): 169–86.

Lü Jingren 吕敬人 and Mou Huaike 牟怀柯. 1976. *Zhidou: Women shi Mao zhuxi de hongxiaobing* 智斗: 我们是毛主席的红小兵 (A Battle of Wits: We Are Chairman Mao's Little Red Soldiers). Shanghai: Shanghai renmin chubanshe.

Lu Peifa 陆培法. 2014. "'Xuduo putong Ribenren dou bei Rijun de baoxing jingdai le.' Shouge guojia gongjiri Nanjing jishi" "许多普通日本人都被日军的暴行惊呆了." 首个国家公祭日南京纪事 ("Many Ordinary Japanese Were Shocked by the Violence of the Japanese Troops." A Chronicle of the First National Nanjing Memorial Day). *Renmin ribao haiwaiban* 人民日报海外版 (People's Daily Overseas Edition), December 13. Accessed March 23, 2017. http://paper.people.com.cn/rmrbhwb /html/2014–12/13/content_1509679.htm.

Lu Xun 鲁迅. 1981. "Nahan zixu" 呐喊自序 (Preface to *A Call to Arms*). In Lu Xun, *Lu Xun quanji* 鲁迅全集 (The Collected Works of Lu Xun), vol. 1, 415–21. Beijing: Renmin wenxue chubanshe.

Lu Ye 路野, ed. 1997. *Lao xiangce: jingtou shuxie de lishi* 老相册: 镜头书写的历史 (Old Albums: History Written through the Lens). Vol. 1. Hohhot, China: Nei Menggu renmin chubanshe.

Luckhurst, Roger. 2008. *The Trauma Question*. New York: Routledge.

Lundunke 伦敦客. 2014. "Shengyuan 93 sui de Wang Jingyao! Jianping Song Binbin de xuwei daoqian" 声援93岁的王晶垚! 简评宋彬彬的虚伪道歉 (In Support of 93-Year-Old Wang Jingyao! An Assessment of Song Binbin's False Apology). Blog .wenxuecity.com, February 5. Accessed March 10, 2016. http://blog.wenxuecity .com/myblog/61670/201402/3595.html.

Luo Siling. 2017. "Hidden Away for 28 Years, Tiananmen Protest Pictures See Light of Day." *New York Times*, June 1. Accessed December 2, 2017. https://www.nytimes.com/2017/06/01/world/asia/china-tiananmen-1989-photographs.html.

Ma Jian. 2008. *Beijing Coma*. Translated by Flora Drew. New York: Farrar, Straus, and Giroux.

Maines, Rachel P., and James J. Glynn. 1993. "Numinous Objects." *Public Historian* 15 (1): 8–25.

Malcolm, Janet. 1989. "Pink Roses." *New Yorker*, June 26, 89–90.

Mandiberg, Michael. 2009. "Tiananmen Square Paintings (20 Years Later)." Mandiberg.com. Accessed August 10, 2016. http://www.mandiberg.com/in-memory-of-the-man-in-front-of-the-tanks-tiananmen-20-years-later/.

Manovich, Lev. 2006. "The Poetics of Urban Media Surfaces." Special issue, "Urban Screens: Discovering the Potential of Outdoor Screens for Urban Society," *First Monday* 4. Accessed April 29, 2016. http://www.firstmonday.org/ojs/index.php/fm/article/view/1545/1460.

Marcoci, Roxana, ed. 2010. *The Original Copy: Photography of Sculpture, 1839 to Today*. New York: Museum of Modern Art.

Maret, Susan. 2011. "Introduction." In *Government Secrecy*, edited by Susan Maret, xi–xxx. Bingley, UK: Emerald Group Publishing.

Maret, Susan. 2016. "The Charm of Secrecy: Secrecy and Society as Secrecy Studies." *Secrecy and Society* 1 (1): 1–28. Accessed February 17, 2017. http://scholarworks.sjsu.edu/cgi/viewcontent.cgi?article=1014&context=secrecyandsociety.

Marinelli, Maurizio. 2009. "Negotiating Beijing's Identity at the Turn of the Twentieth Century." In *Dissent and Cultural Resistance in Asia's Cities*, edited by Melissa Butcher and Selvaraj Velayutham, 33–52. Abingdon, UK: Routledge.

Massey, Doreen. 2007. *World City*. Cambridge: Polity Press.

Mathewes, Charles T. 2006. "Religion and Secrecy." *Journal of the American Academy of Religion* 74 (2): 273–74.

Mazur, Mary G. 1999. "Public Space for Memory in Contemporary Civil Society: Freedom to Learn from the Mirror of the Past?" *China Quarterly* 160: 1019–35.

McCall, Timothy, Sean Roberts, and Giancarlo Fiorenza, eds. 2013. *Visual Cultures of Secrecy in Early Modern Europe*. Kirksville, MO: Truman State University Press.

McDougall, Bonnie S. 2002. "Particulars and Universals: Studies on Chinese Privacy." In *Chinese Concepts of Privacy*, edited by Bonnie S. McDougall and Anders Hansson, 3–24. Leiden: Brill.

McDougall, Bonnie S. 2004. "Privacy in Modern China." *History Compass* 2:1–8.

McGoey, Linsey. 2012. "Strategic Unknowns: Towards a Sociology of Ignorance." *Economy and Society* 41 (1): 1–16.

McGrath, Jason. 2008. *Postsocialist Modernity: Chinese Cinema, Literature, and Criticism in the Market Age*. Palo Alto, CA: Stanford University Press.

McPhate, Mike. 2016. "With Corbis Sale, Tiananmen Protest Images Go to Chinese Media Company." *New York Times*, January 27. Accessed March 5, 2016. https://www.nytimes.com/2016/01/28/business/media/with-corbis-sale-tiananmen-protest-images-go-to-chinese-media-company.html.

Meese, James, Bjorn Nansen, Tamara Kohn, Michael Arnold, and Martin Gibbs. 2015. "Posthumous Personhood and the Affordances of Digital Media." *Mortality* 20 (4): 408–20.

Menchen-Trevino, Ericka, and Yuping Mao. 2015. "Online Political Discussion in English and Chinese: The Case of Bo Xilai." In *Networked China: Global Dynamics of Digital Media and Civic Engagement: New Agendas in Communication*, edited by Wenhong Chen and Stephen D. Reese, 175–96. New York: Routledge.

Middleton, Paul. 2014. "Marks, Signs, and Images: The Sense of Belonging and Community Which Pre-dates History but Has Now Become a Powerful Global Language." In *Semiotics and Visual Communication: Concepts and Practices*, edited by Evripides Zantides, 310–21. Newcastle: Cambridge Scholars.

Mina, An Xiao. 2011. "Social Media Street Art: Censorship, China's Political Memes and the Cute Cat Theory." *An Xiao Studio*, December 28. Accessed August 9, 2016. http://anxiaostudio.com/2011/12/28/social-media-street-art-censorship -chinas-political-memes-and-the-cute-cat-theory/.

Mina, An Xiao. 2014. "Batman, Pandaman and the Blind Man: A Case Study in Social Change Memes and Internet Censorship in China." *Journal of Visual Culture* 13 (3): 359–75.

Mishima Yukio 三島由紀夫. 1968. *Hanazakari no mori: Yûkoku* 花盛りの森・憂国 (Forest in Full Flower: Patriotism). Tokyo: Shinchosha.

Mitchell, W. J. T. 2013. *What Do Pictures Want? The Lives and Loves of Images.* Chicago: University of Chicago Press.

Mitter, Rana. 2003. "Old Ghosts, New Memories: China's Changing War History in the Era of Post-Mao Politics." *Journal of Contemporary History* 38 (1): 117–31.

Mittler, Barbara. 2012. *A Continous Revolution: Making Sense of Cultural Revolution Culture*. Cambridge, MA: Harvard University Press.

Mookherjee, Nayanika. 2006. "'Remembering to Forget': Public Secrecy and Memory of Sexual Violence in the Bangladesh War of 1971." *Journal of the Royal Anthropological Institute* 12:433–50.

Nair, Sashi. 2012. *Secrecy and Sapphic Modernism: Writing* Romans à Clef *Between the Wars*. Basingstoke, U.K.: Palgrave Macmillan.

Nietzsche, Friedrich. 1989. *On the Genealogy of Morals and Ecce Homo*. Edited by Walter Kaufman, translated by Walter Kaufmann and R. J. Hollingdale. New York: Vintage.

North, Michael. 2005. *Camera Works: Photography and the Twentieth-Century Word*. Oxford: Oxford University Press.

Nuttall, Sarah, and Achille Mbembe. 2015. "Secrecy's Softwares." *Current Anthropology* 56 (12): 317–24.

Olivier, Marc. 2015. "Glitch Gothic." In *Cinematic Ghosts: Haunting and Spectrality from Silent Cinema to the Digital Era*, edited by Murray J. D. Leeder, 253–70. London: Bloomsbury.

Orwell, George. 2019. *The Collected Essays, Journalism and Letters of George Orwell*. Vol. 3, *As I Please, 1943–1945*. Edited by Sonia Orwell and Ian Angus. London: Secker and Warburgh.

Otto, Rudolf. 1958. *The Idea of the Holy: An Inquiry into the Non-Rational Factor in the Idea of the Divine and Its Relation to the Rational.* Translated by John W. Harvey. New York: Oxford University Press.

Oyobe, Natsu. 2016. *Xu Weixin: Monumental Portraits.* Ann Arbor: University of Michigan Museum of Art.

Paglen, Trevor. 2014. "New Photos of the NSA and Other Top Intelligence Agencies Revealed for First Time." *The Intercept,* February 10. Accessed September 20, 2017. https://theintercept.com/2014/02/10/new-photos-of-nsa-and-others/.

Pang Xianzhi 逄先知, ed. 2002. *Mao Zedong nianpu, 1893–1949* 毛泽东年谱, 1893–1949 (A Chronological Biography of Mao Zedong, 1893–1949). Vol. 2. Beijing: Zhongyuan wenxian chubanshe.

Pfaller, Robert. 2006. "The Familiar Unknown, the Uncanny, the Comic: The Aesthetic Effects of the Thought Experiment." In *Lacan: The Silent Partners,* edited by Slavoj Žižek, 98–216. London: Verso.

Picard, Max. 1952. *The World of Silence.* Translated by Stanley Godman. Chicago: Henry Regnery.

Pedroletti, Brice. 2014. "China's Former Red Guards Turn Their Backs on Maoism." *Guardian,* May 4. Accessed July 10, 2017. https://www.theguardian.com/world/2014/may/05/mao-cultural-revolution-china-red-guard.

Peng Yining. 2009. "Pictures Expose Peculiar Prejudices of the Propagandist." *Global Times,* August 23. Accessed May 4, 2016. http://www.globaltimes.cn/content/460300.shtml.

Perlmutter, David D. 1998. *Photojournalism and Foreign Policy: Icons of Outrage in International Crises.* Westport, CT: Praeger.

Pionke, Albert D., and Denise Tischler Millstein, eds. 2010. *Victorian Secrecy: Economies of Knowledge and Concealment.* Abingdon, U.K.: Routledge.

Ploum, Julia. 2013. "The Power of Cartoons 1—Crazy Crab from China." *Cartoon Movement* blog, March 4. Accessed 28 April, 2016. http://blog.cartoonmovement.com/2013/03/the-power-of-cartoons-1-crazy-crab-from-china.html.

Ponse, Barbara. 1976. "Secrecy in the Lesbian World." *Urban Life* 5 (3): 313–38.

Prieur, Christophe, Dominique Cardon, Jean-Samuel Beuscart, Nicolas Pissard, and Pascal Pons. 2008. "The Strength of Weak Cooperation: A Case Study on Flickr." arXiv.org, February 16. Accessed December 2, 2017. http://fr.arxiv.org/abs/0802.2317v1.

Qian, Ying. 2014. "Working with Rubble: Montage, Tweets and the Reconstruction of an Activist Cinema." In *China's iGeneration: Filmmakers, Films and Audiences in a New Media Age,* edited by Matthew D. Johnson, Keith B. Wagner, Kiki Tianqi Yu, and Luke Vulpiani, 181–96. London: Continuum.

Qin Feng 秦风, ed. 1998. *Ni mei jianguo de lishi zhaopian* 你没见过的历史照片 (Historic Photographs You've Never Seen). Jinan, China: Shandong huabao chubanshe.

Qinhua Rijun Nanjing datusha yunan tongbao jinianguan 侵华日军南京大屠杀遇难同胞纪念馆, ed. 2005. *Nanjing datusha tulu* 南京大屠杀图录 (A Photographic Catalogue of the Nanjing Massacre). Beijing: Wuzhou chuanbo chubanshe.

Qinhua Rijun Nanjing datusha yunan tongbao jinianguan 侵华日军南京大屠杀遇难同
胞纪念馆, ed. 2015. *Nanjing datusha tulu* 南京大屠杀图录 (A Photographic Cata-
logue of the Nanjing Massacre). Beijing: Wuzhou chuanbo chubanshe.

Rancière, Jacques. 2011. *The Emancipated Spectator*. London: Verso.

Reilly, James. 2004. "China's History Activists and the War of Resistance against
Japan: History in the Making." *Asian Survey* 44 (2): 276–94.

Rev, Istvan. 1987. "The Advantages of Being Atomized: How Hungarian Peasants
Coped with Collectivization." *Dissent* 34 (3): 335–50.

Richter, Gerhard. 1995. *The Daily Practice of Painting: Writings 1962–1993*. Edited by
Hans-Ulrich Obrist. London: Thames and Hudson.

Richter, Gerhard. 2000. *Walter Benjamin and the Corpus of Autobiography*. Detroit:
Wayne State University Press.

Richter, Gerhard. 2009. *Gerhard Richter: Writings 1961–2007*. Edited by Hans Ulrich
Obrist and Dietmar Elger. New York: Distributed Art.

Rittel, Horst W. J., and Melvin M. Webber. 1973. "Dilemmas in a General Theory of
Planning." *Policy Sciences* 4(2): 155–69.

Robbe-Grillet, Alain. 1989. *For a New Novel: Essays on Fiction*. Translated by Richard
Howard. Evanston, IL: Northwestern University Press.

Roberts, Alasdair. 2006. *Blacked Out: Government Secrecy in the Information Age*.
Cambridge: Cambridge University Press.

Roberts, Alasdair. 2012. "WikiLeaks: the Illusion of Transparency." *International
Review of Administrative Sciences* 78 (1): 116–33.

Roberts, Claire. 2012. *Photography and China*. London: Reaktion Books.

Robson, James. 2010. "Faith in Museums: on the Confluence of Museums and Reli-
gious Sites in Asia." PMLA 125 (1): 121–28.

Rojas, Carlos. 2009. "Abandoned Cities Seen Anew: Reflections on Spatial Speci-
ficity and Temporal Transience." In *Photographies East: The Camera and Its Histo-
ries in East and Southeast Asia*, edited by Rosalind Morris, 207–28. Durham, NC:
Duke University Press.

Rojas, Carlos. 2013. "Return of the Vagabond: Cui Jian and China's Democracy
Movement." In *Sounds of Resistance: The Role of Music in Multicultural Activism*,
vol. 1, *Activism in the United States*, edited by Eunice Rojas and Lindsey Michie,
311–28. Santa Barbara, CA: Praeger.

Rojas, Carlos. 2016. "Introduction: Specters of Marx, Shades of Mao, and the Ghosts
of Global Capital." In *Ghost Protocol: Development and Displacement in Global
China*, edited by Carlos Rojas and Ralph Litzinger, 1–12. Durham, NC: Duke
University Press.

Rojas, Carlos, and Ralph Litzinger, eds. 2016. *Ghost Protocol: Development and
Displacement in Global China*. Durham, NC: Duke University Press.

Rubinstein, Daniel, and Katrina Sluis. 2008. "A Life More Photographic: Mapping
the Networked Image." *Photographies* 1 (1): 9–28.

Rugg, Linda Haverty. 1997. *Picturing Ourselves: Photography and Autobiography*.
Chicago: University of Chicago Press.

Rumsfeld, Donald. 2002. "DoD News Briefing—Secretary Rumsfeld and Gen.
Myers." U.S. Department of Defense, news transcript, February 12. Ac-

cessed August 7, 2017. http://archive.defense.gov/Transcripts/Transcript.aspx
?TranscriptID=2636.

Schneider, Florian. 2016a. "China's 'Info-web': How Beijing Governs Online Political
Communication about Japan." *New Media and Society* 18 (11): 2664–84.

Schneider, Florian. 2016b. "Studying Digital China's Networks and Media Objects."
China Policy Institute: Analysis, June 3. Accessed July 15, 2016. https://cpianalysis
.org/2016/06/03/studying-digital-chinas-networks-and-media-objects-the
-promises-and-challenges-of-digital-data/.

Schoenhals, Michael. 1996. *China's Cultural Revolution. 1966–69: Not a Dinner
Party*. Armonk, NY: M.E. Sharpe.

Schoenhals, Michael. 2008. "A Chinese Virtual '*Heimatmuseum*'—Old Beijing.net."
In *The Poetics of Memory in Post-Totalitarian Narration*, edited by Johanna Lind-
bladh, 155–71. Lund, Sweden: Centre for European Studies, Lund University.

Schoenhals, Michael. 2013. *Spying for the People: Mao's Secret Agents, 1949–1967*.
Cambridge: Cambridge University Press.

Schwarcz, Vera. 1996. "The Burden of Memory: The Cultural Revolution and the
Holocaust." *China Information* 11 (1): 1–13.

Schwarcz, Vera. 2002. "The 'Black Milk' of Historical Consciousness: Thinking about
the Nanjing Massacre in Light of Jewish Memory." In *Nanking 1937: Memory and
Healing*, edited by Robert Sabella, Feifei Li, and David Liu, 183–204. New York:
Routledge.

Sebald, W. G. 2001. *Austerlitz*. Translated by Anthea Bell. London: Penguin.

Seo, Jungmin. 2008. "Politics of Memory in Korea and China: Remembering the
Comfort Women and the Nanjing Massacre." *New Political Science* 30 (3): 369–92.

Shakespeare, William. 2011. *Richard II*. Edited by Anthony B. Dawson and Paul
Yachnin. Oxford: Oxford University Press.

Shao Changbo 邵长波. 2003. "Zhaoxiang" 照相 (Taking Photographs). *Lao zhaopian*
老照片 (Old Photographs) 27:124–27.

Shen Rui. 2005. "To Remember History: Hu Jie Talks about His Documentaries."
Senses of Cinema 35. Accessed March 2, 2016. http://sensesofcinema.com/2005
/conversations-with-filmmakers/hu_jie_documentaries/.

Shen Yinghui 沈映辉. 2009. "Yishu duikang yiwang: Zhuanfang Zhongguo Renmin
Daxue Yishu Xueyuan fuyuanzhang Xu Weixin" 艺术对抗遗忘: 专访中国人民大学艺
术学院副院长徐唯辛 (Art Battles Amnesia: An Exclusive Interview with Xu Weixin,
Associate Dean of the Art Institute at Renmin University). *Xibu guangbo dianshi*
西部广播电视 (West China Broadcasting TV) 8:190–91.

Shi Yaozeng 史耀增. 2000. "'Mao xuan' yinyuan" 《毛选》姻缘 (Brought Together by
Mao's *Selected Works*). *Lao zhaopian* 老照片 (Old Photographs) 14:143–45.

Shifman, Limor. 2014. *Memes in Digital Culture*. Cambridge, MA: MIT Press.

Shui Tianzhong 水田中. 2007. "Lishi jiyi yu xianshi zhuiwen: Xu Weixin de *Lishi
zhongguo zhongshengxiang: 1966–1976*" 历史记忆与现实追问: 徐唯辛的《历史中
国众生相》1966–1976 (Historical Memory and the Interrogation of Reality. Xu
Weixin's *Chinese Historical Figures: 1966–1976*). *Dongfang yishu* 东方艺术 (Eastern
Art) 6:110.

Siegworth, Gregory J., and Matthew Tiessen. 2012. "Mobile Affects, Open Secrets, and Global Illiquidity: Pockets, Pools, and Plasma." *Theory, Culture and Society* 29 (6): 47–77.

Silverman, Jason. 2012. "*Ai Weiwei: Never Sorry* Documents Artist's Social-Media Dissent." Wired.com, January 27. Accessed April 4, 2016. http://www.wired.com /2012/01/ai-weiwei-documentary-sundance/.

Simmel, Georg. 1906. "The Sociology of Secrecy and of Secret Societies." *American Journal of Sociology* 11 (4): 441–98.

Simmons, Christopher. 2011. *Just Design: Socially Conscious Design for Critical Causes*. Cincinnati, OH: How Books.

Smith, Damon. 2011. "Lu Chuan, *City of Life and Death*." *Filmmaker Magazine*. Accessed November 24, 2017. https://filmmakermagazine.com/23862-lu-chuan-city-of-life -and-death/#.XQZLEy3MxBx.

Song Binbin 宋彬彬. 2012. "Sishi duo nian lai yizhi xiang shuo de hua" 四十多年来一直想说的话 (The Words I Have Wanted to Say for 40 Years). *Jiyi* 记忆 (Remembrance) 80:3–15.

Song Binbin. 2014. "Zai bu daoqian jiu mei jihui le" 再不道歉就没机会了 (If We Do Not Apologise Now, There Will Be No Further Chances). *Xinjing bao* 新京报 (Beijing News), January 13. Accessed March 15, 2016. https://wxn.qq.com/cmsid /CUL201401130021460A.

Song Yongping. 2016. "Photographing My Parents (Text to Accompany Photos by Song Yongping)." Art Express, March 15. Accessed September 16. http://artist .artron.net/20160315/n822312.html.

Song Yongyi 宋永毅. 1997. "Wengezhong de huangpi shu he huipi shu" 文革中的黄皮书和灰皮书 (Yellow Books and Grey Books during the Cultural Revolution)." *Ershiyi shiji* 二十一世纪 (Twenty-First Century) 42:59–64.

Song Yongyi. 2004. "The Enduring Legacy of Blood Lineage Theory." *China Rights Theory* 4:13–23. Accessed August 21, 2017. http://www.hrichina.org/sites/default /files/PDFs/CRF.4.2004/EnduringLegacy4.2004.pdf.

Sonnevend, Julia. 2016. *Stories without Borders: The Berlin Wall and the Making of a Global Iconic Event*. Oxford: Oxford University Press.

Sontag, Susan. 1979. *On Photography*. Harmondsworth, U.K.: Penguin.

Sontag, Susan. 2004. *Regarding the Pain of Others*. London: Penguin.

Spence, Jonathan. 1988. "Introduction." In *China: A Photohistory, 1937–1987*, edited by W. J. F. Jenner, 7–18. New York: Pantheon.

Sun Zhaiwei 孙宅巍. 1995. *1937 Nanjing beige: Rijun tucheng lu 1937* 南京悲歌: 日军屠城录 (Nanjing Elegy 1937: An Account of the Massacre of the City by the Japanese Military). Taipei: Taiwan xianzhi chuban shiye gufen youxian gongsi.

Sun Zhaiwei. 2008. "Gaige kaifang gei Nanjing datusha shi yanjiu dailai boboshengji" 改革开放给南京大屠杀研究带来勃勃生机 (Reform and Opening Up Have Invigorated Research into the History of the Nanjing Massacre). *Dang'an yu jianshe* 档案与建设 (Archives and Construction) 9:34–36.

Sun Zhaiwei and Li Deying 李德英. 2015. *Nanjing datusha quanjilu* 南京大屠杀全记录 (A Complete Record of the Nanjing Massacre). Beijing: Zhongguo wenshi chubanshe.

Suzuki Akira 鈴木明. 1999. *Shin "Nankin daigyakusatsu" no maboroshi* 新「南京大虐殺のまぼろし」(The Illusion of the New "Great Nanjing Massacre," new edition). Tokyo: Asuka Shinsha.

Tai, Mikala. 2010. "Branded and Planted: The Globalised Chinese Body." *Intersections: Gender and Sexuality in Asia and the Pacific* 23. Accessed June 4, 2017. http://intersections.anu.edu.au/issue23/tai.htm.

Tan, Chang. 2012. "Art for/of the Masses: Revisiting the Communist Legacy in Chinese Art." *Third Text* 26 (2): 177–94.

Tang, Xiaobing. 2015. *Visual Culture in Contemporary China: Paradigms and Shifts.* Cambridge: Cambridge University Press.

Tang Yuankai. 2009. "Searching for Truth." *Beijing Review*, May 25. Accessed June 8, 2018. http://www.bjreview.com.cn/quotes/txt/2009–05/25/content_197183.htm.

Tatlow, Didi Kirsten. 2016. "Fate Catches Up to a Cultural Revolution Museum in China." *New York Times* (China Edition), October 8. Accessed June 22, 2016. https://cn.nytimes.com/china/20161008/china-cultural-revolution-shantou -museum/en-us/?mcubz=3.

Taussig, Michael. 1998. "Viscerality, Faith, and Skepticism: Another Theory of Magic." In *In Near Ruins*, edited by Nicholas B. Dirks, 221–56. Minneapolis: University of Minnesota Press.

Taussig, Michael. 1999. *Defacement: Public Secrecy and the Labor of the Negative.* Palo Alto, CA: Stanford University Press.

Thurston, Anne F. 1984–1985. "Victims of China's Cultural Revolution: The Invisible Wounds: Part I." *Pacific Affairs* 57 (4): 599–620.

Tian Zhuangzhuang 田壮壮, dir. 1994. *Lan fengzheng* 蓝风筝 (*The Blue Kite*). Beijing: Beijing Film Studio/Longwick Film Production.

Ting, Vivian 丁颖茵. 2014. "Shijian liudong de xingxiang: dangdai yishu zhanlan de lishi sikao" 时间流动的形相: 当代艺术展览的历史思考 (The Shape of Temporal Flow: On the Historical Thinking of Contemporary Art Exhibitions). *Ershiyi shiji* 二十一世纪 (Twenty-First Century) 144:90–102.

Tomas, David. 1991. "Old Rituals for New Spaces: *Rites de Passage* and William Gibson's Cultural Model of Cyberspace." In *Cyberspace: First Steps*, edited by Michael Benedikt, 31–47. Cambridge, MA: MIT Press.

van Dijck, José. 2011. "Flickr and the Culture of Connectivity: Sharing Views, Experiences, Memories." *Memory Studies* 4 (4): 401–15.

Veg, Sebastian. 2014. "Creating a Literary Space to Debate the Mao Era: The Fictionalisation of the Great Leap Forward in Yan Lianke's *Four Books*." *China Perspectives* 4:7–15.

Veg, Sebastian. 2019. *Minjian: The Rise of China's Grassroots Intellectuals.* New York: Columbia University Press.

Vittinghoff, Natascha. 2005. "Cankao xiaoxi (Reference News) and Neibu (Internal) Publications." In *Encyclopedia of Contemporary Chinese Culture*, edited by Edward L. Davis, 85. New York: Routledge.

Volland, Nicolai. 2017. "Clandestine Cosmopolitanism: Foreign Literature in the People's Republic of China, 1957–1977." *Journal of Asian Studies* 76 (1): 185–210.

Wade, Kimberley A., Maryanne Garry, J. Don Read, and D. Stephen Lindsay. 2002. "A Picture Is Worth a Thousand Lies: Using False Photographs to Create False Childhood Memories." *Psychonomic Bulletin and Review* 9:597–603.

Wakabayashi, Bob Tadashi. 2000. "The Nanking 100-Man Killing Contest Debate: War Guilt Amid Fabricated Illusions, 1971–75." *Journal of Japanese Studies* 26 (2): 307–40.

Wakeman, Fredric. 2003. *Spymaster: Dai Li and the Chinese Secret Service*. Berkeley: University of California Press.

Waldby, Catherine. 2000. *The Visible Human Project: Informatic Bodies and Posthuman Medicine*. Abingdon, U.K.: Routledge.

Walder, Andrew. 2012. *Fractured Rebellion: The Beijing Red Guard Movement*. Cambridge, MA: Harvard University Press.

Waldron, Arthur. 1996. "China's New Remembering of World War II: The Case of Zhang Zizhong." *Modern Asian Studies* 30 (4): 945–78.

Wang, Ban, 2004. *Illuminations from the Past: Trauma, Memory, and History in Modern China*. Palo Alto, CA: Stanford University Press.

Wang Dan 王丹. 2016. "Na zhang zhaopian shi bajiu minyun de daibiao tuxiang, banquan luodao Zhonggong shouli, wo danxin jiang hui bei fengcun" 那张照片是八九民运的代表图像, 版权落到中共手里, 我担心将会被封存 (That Photograph Is a Representative Image of the People's Movement of 1989, and Once the Copyright Falls into the Hands of the Chinese Communist Party, I Fear It Will Be Sealed up for Safekeeping). Facebook status update, January 26. Accessed April 29, 2016. https://www.facebook.com/permalink.php?story_fbid=10153354994373027&id=105759983026.

Wang, David Der-Wei. 2004. *The Monster That Is History: History, Violence, and Fictional Writing in Twentieth-Century China*. Berkeley: University of California Press.

Wang Desheng 王德胜. 1998. "Liuxing 'huaijiu'" 流行 "怀旧" (The Vogue for Nostalgia). *Zhongguo qingnian yanjiu* 中国青年研究 (Research on Chinese Youth) 2:37–39.

Wang Fang 王芳 and Shi Ren 石仁, eds. 1997. *Bainian lao zhaopian* 百年老照片 (A Century of Old Photos). Vol. 1. Beijing: Jingji ribao chubanshe.

Wang Jiaming 王家明. 1996. "Yi zhong meihao de qinggan" 一种美好的情感 (A Beautiful Feeling). *Lao zhaopian* 老照片 (Old Photographs) 1:126.

Wang Jiaming. 2000. "*Lao zhaopian* yinshu tongji" 《老照片》印数统计 (Statistics on the Print Runs of *Old Photographs*). *Chuban guangjiao* 出版广角 (Broad Views on Publishing) 1:20.

Wang Jingyao 王晶垚. 2007. "Bian Zhongyun zhangfu Wang Jingyao gei Beishida fushu shiyan zhongxue xiaozhang Yuan Aijun de gongkaixin" 卞仲耘丈夫王晶垚给北师大附属实验中学校长袁爱俊的公开信 (An Open Letter from Bian Zhongyun's Husband Wang Jingyao to Yuan Aijun, Principal of the Experimental Middle School Attached to Beijing Normal University). Accessed August 9, 2016. http://www.edubridge.com/erxiantang/12/wangjingyao.htm.

Wang Jingyao. 2014. "Guanyu Song Binbin, Liu Jin xuwei daoqian de shengming" 关于宋彬彬刘进虚伪道歉 的声明 (On the Subject of the Fake Statements of Apology

from Song Binbin and Liu Jin). *Zonglan Zhongguo* 纵览中国 (China in Perspective). Accessed February 15, 2016. http://www.chinainperspective.com/ArtShow.aspx?AID=24468.

Wang Min'an 汪民安. 2013. "Jinianxing, sumu yu diankuang" 纪念性, 肃穆与癫狂 (Monumentality, Solemnity and Frivolity). In *Zhongguo lishi zhongshengxiang: 1966–1976* 中国历史众生相: 1966–1976 (Chinese Historical Figures: 1966–1976), edited by Xu Weixin 徐唯辛, 7–10. Beijing: Yishujia duli chuban.

Wang Mingxian 王明賢 et al. 2008. "*Lishi zhongshengxiang* xueshu yantaohui" 《历史众生相》学术研讨会 (Panel Discussion of *Chinese Historical Figures*). Xuweixin.artron.net. Accessed June 16, 2014. http://xuweixin.artron.net/news_detail_41970.

Wang Qiuhang 王秋航. 2017. *1966–1976 Wo de zipaixiang* 1966–1976 我的自拍像 (Cultural Revolution Selfies 1966–1976). Hong Kong: New Century Press.

Wang, Shaoguang. 1995. "The Politics of Private Time: Changing Leisure Patterns in Urban China." In *Urban Spaces in Contemporary China: The Potential for Autonomy and Community in Post-Mao China*, edited by Deborah Davis, 149–72. New York: Cambridge University Press.

Wang Shuo 王朔. 2011. *Qianwan bie ba wo dang ren* 千万别把我当人 (Please Don't Call Me Human). Tianjin: Tianjin renmin chubanshe.

Wang Xiaoshuai 王小帅, dir. 2014. *Chuangruzhe* 闯入者 (*Red Amnesia*). China: Dongchun Films/Herun Media/Edko Films/Chongqing Film Group/Shanghai Inlook Media Group.

Wang Xin. 2012. "Seeing and Disbelieving: Chen Shaoxiong's Ink Animation Videos." In *Modern Art Asia Selected Papers*, issues 1–8, edited by Majella Munro, 213–24. West Sussex: Enzo Arts and Publishing.

Wang Youqin 王友琴. 1995. "1966: xuesheng da laoshi de geming" 1966: 学生打老师的革命 (1966: The Revolution in Which the Students Beat Up their Teachers). *Ershiyi shiji* 二十世纪 (Twenty-first Century) 30:33–46.

Wang Youqin. 2000. *Zhongguo wenge shounanzhe jinianyuan* 中国文革受难者纪念园 (Chinese Holocaust Memorial). Accessed June 21, 2016. http://www.chinese-memorial.org.

Wang Youqin. 2004. *Wenge shounanzhe: guanyu pohai, jianjin yu shalu de xunfang shilu* 文革受难者: 关于迫害, 监禁与杀戮的寻访实录 (Victims of the Cultural Revolution: An Investigative Account of Persecution, Imprisonment and Murder). Hong Kong: Kaifang zazhishe.

Wang Youqin. 2007. "Finding a Place for the Victims: The Problem in Writing the History of the Cultural Revolution." *China Perspectives* 4:65–74.

Wang, Zheng. 2012. *Never Forget National Humiliation: Historical Memory in Chinese Politics and Foreign Relations*. New York: Columbia University Press.

Warren, Carol, and Barbara Laslett. 1977. "Privacy and Secrecy: A Conceptual Comparison." *Journal of Social Issues* 33 (3): 43–51.

Wei Desheng 魏德胜. 2004. "Jiuying mohu le ru meng" 旧影模糊了如梦 (Old Photographs as Blurred as Dreams). *Lao zhaopian* 老照片 (Old Photographs) 37:84–66.

Wei Hui 卫慧. 1999. *Shanghai baobei* 上海宝贝 (Shanghai Baby). Shenyang: Chunfeng wenyi chubanshe.

Wei, Lilly. 2016. "Xu Yong: 'Negatives Act as Witness.'" Studio International, August 31. Accessed December 21, 2017. http://www.studiointernational.com/index.php/xu-yong-video-interview-negatives-china.

Weigelin-Schwiedrzik, Susanne. 2006. "In Search of a Master Narrative for 20th-Century Chinese History." China Quarterly 188:1070–91.

Weigelin-Schwiedrzik, Susanne, and Cui Jinke. 2016. "Whodunnit? Memory and Politics before the 50th Anniversary of the Cultural Revolution." China Quarterly 227: 734–51.

Wendell Holmes, Oliver. 1859. "The Stereoscope and the Stereograph." Atlantic Monthly 3:738–48.

Weng Xiaozhu 翁小筑. 2010. "Zhang Dali he ta de Di'er lishi: zhuanfang yishujia Zhang Dali" 张大力和他的《第二历史》：专访艺术家张大力 (Zhang Dali and His A Second History: An Interview with the Artist Zhang Dali). Yanhuang shijie 炎黄世界 (The World of the Yan and Yellow Emperors) 107 (3): 74–6.

Whiteman, David. 2004. "Out of the Theaters and into the Streets: A Coalition Model of the Political Impact of Documentary Film and Video." Political Communication 21 (1): 51–69.

Wilde, Oscar. 2007. Collected Works of Oscar Wilde: The Plays, the Poems, the Stories and the Essays Including De Profundis. Ware, U.K.: Wordsworth Editions.

Wittgenstein, Ludwig. 2009. Philosophical Investigations. Translated by G. E. M. Anscombe, P. M. S. Hacker, and Joachim Schulte. Oxford: Wiley-Blackwell.

Wong, Edward. 2009. "Showing the Glimmer of Humanity Amid the Atrocities of War." New York Times, May 22. Accessed June 7, 2018. https://www.nytimes.com/2009/05/23/world/asia/23iuchuan.html.

Wong, Edward. 2013. "Amid Tribute to King of Pop, an Echo of Tiananmen Square." New York Times, August 15. Accessed April 24, 2016. http://www.nytimes.com/2013/08/16/world/asia/amid-tribute-to-king-of-pop-an-echo-of-tiananmen-square.html.

Wu Di 吴迪, ed. 2008. Jiyi 记忆 (Remembrance) 1. Accessed August 7, 2016. http://prchistory.org/wp-content/uploads/2014/05/REMEMBRANCE-No-1-2008年9月13日.pdf.

Wu Di 吴迪, ed. 2014a. "Shida nüfuzhong wenge zhuanji" 师大女附中文革专辑 (Special Issue on the Girls Middle School Attached to Beijing Normal University during the Cultural Revolution). Jiyi 记忆 (Remembrance) 108. Accessed January 24, 2016. http://prchistory.org/wp-content/uploads/2014/05/REMEMBRANCE_No108.pdf.

Wu Di 吴迪. 2014b. "Song Binbin daoqian zhi hou" 宋彬彬道歉之后 (After Song Binbin's Apology). New York Times (Chinese edition), July 17. Accessed December 4, 2015. https://cn.nytimes.com/china/20140717/cc17sbb/.

Wu Guangyi 吴广义. 1995. "Nanjing datusha de tiezheng" 南京大屠杀的铁证 (Ironclad Evidence of the Nanjing Massacre). Liaowang xinwen zhoukan 瞭望新闻周刊 (Outlook Weekly) 28:31.

Wu Hung. 2005. Remaking Beijing: Tiananmen Square and the Creation of a Political Space. Chicago: University of Chicago Press.

Wu Hung. 2008. *Making History: Wu Hung on Contemporary Art*. Hong Kong: Timezone 8.

Wu Hung. 2016. *Zooming In: Histories of Photography in China*. London: Reaktion.

Wu Wei 吴炜. 2012. "Rang lishi laidao 'xianchang': ji youhuajia Xu Weixin de yishu tansuo zhi you" 让历史来到 "现场": 记油画家徐唯辛的艺术探索之旅 (Let History Arrive "On the Scene": Charting the Artistic Explorations of Oil Painter Xu Weixin). *Zhongguancun* 中关村 (Zhongguancun) 1:95–100.

Wu Weihua 吴炜华. 1998. "Lao zhaopian de dujie" 《老照片》的读解 (Reading *Old Photographs*). *Xiandai chuanbo* 现代传播 (Modern Communication) 2:82–83.

Wu, Yiching. 2014. *The Cultural Revolution at the Margins: Chinese Socialism in Crisis*. Cambridge, MA: Harvard University Press.

Wu Yonggang 吴永刚 and Wu Yigong 吴贻弓, dir. 1980. *Bashan yeyu* 巴山夜雨 (*Night Rain at Bashan*). Shanghai: Shanghai Film Studio.

Wu Zhenghua 伍正华, Sang Linfeng 桑林峰, and Tian Yawei 田亚威. 2015. "Laoji renlei haojie, hanwei shijie heping. Zhuanfang qinhua Rijun Nanjing datusha yunan tongbao jinianguan guanzhang Zhu Chengshan" 牢记人类浩劫捍卫世界和平: 专访侵华日军大屠杀遇难同胞纪念馆馆长朱成山 (Remember Humanitarian Disaster and Protect World Peace: An Interview with Zhu Chengshan, Director of the Nanjing Massacre Memorial Hall). *Xinxiang pinglun* 新湘评论 (New Hunan Review) 17:15–17.

Xia Liqun 夏立群. 2000. "Fuqin de lao xiangji" 父亲的老相机 (My Father's Old Camera). *Lao zhaopian* 老照片 (Old Photographs) 13:120–27.

Xiao Bo 晓博. 2000. "1975 Nian: jiejie gege yu wo" 1975 年: 姐姐哥哥与我 (The Year 1975: My Sister, My Brother, and Me). *Lao zhaopian* 老照片 (Old Photographs) 16:148–49.

Xie Jin 谢晋, dir. 1982. *Muma ren* 牧马人 (*The Herdsman*). Shanghai: Shanghai Film Studio.

Xie Zhihai. 2013. "Chinese Democracy Gets Help." *Japan Times* (online edition), August 25. Accessed May 1, 2016. http://www.japantimes.co.jp/opinion/2013 /08/25/commentary/world-commentary/chinese-democracy-gets-help/# .WBiYznecZUN.

Xu Ben 徐贲. 2006. "Bianhuazhong de wenge jiyi" 变化中的文革记忆 (Changing Memories of the Cultural Revolution). *Ershiyi shiji* 二十一世纪 (Twenty-First Century) 93:19–28.

Xu Ben. 2014. "Weishenme you de 'wenge daoqian' buneng bei jieshou" 为什么有的 "文革道歉" 不能被接受 (Why Some Cultural Revolution Apologies Cannot be Accepted). *China Digital Times*, 16 February. Accessed June 17, 2019. https:// chinadigitaltimes.net/chinese/2014/02/徐贲-为什么有的文革道歉不能被接受/.

Xu Ming 徐明. 2004. "Muqin zai wo xinzhong" 母亲在我心中 (My Mother's Place in My Heart). *Lao zhaopian* 老照片 (Old Photographs) 37:74–83.

Xu Weixin 徐唯辛. n.d. "Wang Jingyao." Xuweixin.artron.net. Accessed October 31, 2016. http://xuweixin.artron.net/works_detail_BRT000000025517.

Xu Xiaohong and Lynn Spillman. 2010. "Political Centres, Progressive Narratives and Cultural Trauma: Coming to Terms with the Nanjing Massacre in China,

1937–1979." In *Northeast Asia's Difficult Past: Essays in Collective Memory*, edited by Mikyoung Kim and Barry Schwartz, 101–28. New York: Palgrave MacMillan.

Xu Yong. 2015. *Negatives*. Dortmund: Kettler Verlag.

Xu Zhigeng 徐志耕. 2005. *1937: Tucheng: Qinhua Rijun Nanjing datusha* 屠城: 侵华日军南京大屠杀 (Massacred City: The Nanjing Massacre Carried out by the Invading Japanese Army). Hangzhou: Zhejiang shaonian ertong chubanshe.

Xu Zhigeng. [1987] 2014. *Nanjing datusha* 南京大屠杀 (The Nanjing Massacre). Beijing: Xianzhuang shuju.

Xue Yanwen 薛炎文 and Zhang Xueshan 张雪杉, eds. 1998. *Zhiqing lao zhaopian* 知青老照片 (Old Photographs of Sent-Down Youth). Tianjin: Baihua wenyi chubanshe.

Yan Lianke. 2013. "On China's State-Sponsored Amnesia." *New York Times*, April 1. Accessed July 20, 2017. http://www.nytimes.com/2013/04/02/opinion/on-chinas -state-sponsored-amnesia.html.

Yan Yi 阎义. 2015. "Dabei zhaoxiangguan lishi zai women de yanzhong: jiangshu Dabei zhaoxiangguan de qianshijinsheng" 大北照相馆历史在我们的眼中: 讲述大北照相馆的前世今生 (The History of Dabei Photography Studio through Our Eyes: A Discussion of the Dabei Photography Studio Past and Present)." *Gonghui bolan* 工会博览 (Trade Union Survey) 2:11–17.

Yang, Daqing. 1999. "Convergence or Divergence? Recent Historical Writings on the Rape of Nanjing." *American Historical Review* 104 (3): 842–65.

Yang, Daqing. 2001. "The Malleable and the Contested: The Nanjing Massacre in Postwar China and Japan." In *Perilous Memories: The Asia-Pacific War(s)*, edited by T. Fujitani, Geoffrey M. White, and Lisa Yoneyama, 50–86. Durham, NC: Duke University Press.

Yang, Guobin. 2005. "Days of Old Are Not Puffs of Smoke: Three Hypotheses on Collective Memories of the Cultural Revolution." *China Review* 5 (2): 13–41.

Yang, Guobin. 2007. "'A Portrait of Martyr Jiang Qing': The Chinese Cultural Revolution on the Internet." In *Re-envisioning the Chinese Revolution: The Politics and Poetics of Collective Memories in Reform China*, edited by Ching Kwan Lee and Guobin Yang, 287–316. Palo Alto, CA: Stanford University Press.

Yang, Guobin. 2016. *The Red Guard Generation and Political Activism in China*. New York: Columbia University Press.

Yang Kelin 杨克林, ed. 1995. *Wenhua dageming bowuguan* 文化大革命博物馆 (Cultural Revolution Museum). Vols. 1 and 2. Hong Kong: Dongfang chubanshe.

Yang, Xiaobin. 2002. *The Chinese Postmodern: Trauma and Irony in Chinese Avant-Garde Fiction*. Ann Arbor: University of Michigan Press.

Yang Yanjin 杨延晋, dir. 1979. *Kunao ren de xiao* 苦恼人的笑 (Bitter Laughter). Shanghai: Shanghai Film Studio.

Yao Liren 姚里人. 2002. "Yi fu quanjiafu" 一幅全家福 (A Family Photograph). *Lao zhaopian* 老照片 (Old Photographs) 24:137–38.

Ye Weili. 2006. "The Death of Bian Zhongyun." *Chinese Historical Review* 13:203–40.

Ye Zhaoyan 叶兆言. 2017. *Yijiusanqi nian de aiqing* 一九三七年的爱情 (1937: A Love Story). Beijing: Renmin wenxue chubanshe.

Yin Jijun 尹集钧 and Shi Yong 史咏. 1999. *Nanjing datusha. Lishi zhaopianzhong de jianzheng* 南京大屠杀：历史照片中的见证 (The Nanjing Massacre: An Undeniable History in Photographs). Haikou: Hainan chubanshe.

Yong bu wangque: Nanjing datusha shishi 永不忘却: 南京大屠杀史实 (*Never Forget: The Historical Facts of the Nanjing Massacre*). n.d. Accessed December 13, 2016. http://neverforget.sina.com.cn/.

Yoshida, Takashi. 2009. *The Making of the "Rape of Nanking": History and Memory in Japan, China, and the United States.* Oxford: Oxford University Press.

Young, Alison. 2011. "The Art of Public Secrecy." *Australian Feminist Law Journal* 35 (1): 57–74.

Young, James E. 2000. *At Memory's Edge: After-Images of the Holocaust in Contemporary Art and Architecture.* New Haven, CT: Yale University Press.

Zeitlin, Froma. 1998. "The Vicarious Witness: Belated Memory and Authorial Presence in Recent Holocaust Literature." *History and Memory* 10 (2): 5–42.

Zelizer, Barbie. 1998. *Remembering to Forget: Holocaust Memory Through the Camera's Eye.* Chicago: University of Chicago Press.

Zeng, Li. 2008. "The Past Revisited: Popular Memory of the Cultural Revolution in Contemporary China." PhD diss., Northwestern University.

Zerubavel, Eviatar. 2006. *The Elephant in the Room: Silence and Denial in Everyday Life.* Oxford: Oxford University Press.

Zhang Ce 张策. 2010. "Bei xiudiao de lishi" 被修掉的历史 (A Doctored History). *Shijue* 视觉 (Lens) 18:76–107.

Zhang Lei 张蕾 and Li Jing 李静. 2011. "Shehui xinlixue jiaodu fenxi: dongfang yishujia Zhang Xiaogang" 社会心理学角度分析：东方艺术家张晓刚 (Analyzing the East Asian Artist Zhang Xiaogang from a Socio-Psychological Perspective). *Dongfang qiye wenhua* 东方企业文化 (Eastern Entreprise Culture) 6:220.

Zhang Lianhong 张连红. 2003. "Nanjing datusha yu Nanjing shimin de chuangshang jiyi" 南京大屠杀与南京市民的创伤记忆 (The Nanjing Massacre and the Traumatic Memories of the City's Citizens). *Jianghai xuekan* 江海学刊 (Jianghai Journal) 1:147–52.

Zhang Lianhong. 2006. "Nanjing datusha de houyizheng: xingcunzhe de chuangshang" 南京大屠杀的后遗症: 幸存者的创伤 (The Medical After-effects of the Nanjing Massacre: Survivor's Trauma). *Jianghai xuekan* 江海学刊 (Jianghai Journal) 3:139–43.

Zhang Lianhong. 2007. "Zhong-Ri liangguo Nanjing datusha yanjiu de huigu yu sikao" 中日两国南京大屠杀研究的回顾与思考 (Research into the Nanjing Massacre in China and Japan: Some Retrospective Thoughts). *Nanjing daxue xuebao* 南京大学学报 (Journal of Nanjing University) 1:95–109.

Zhang Sheng 张生. 2009. "Nanjing datusha shouhaizhe PTSD chubu yanjiu" 南京大屠杀受害者PTSD 初步研究 (Preliminary Research into PTSD among Victims of the Nanjing Massacre). *Kangri zhanzheng yanjiu* 抗日战争研究 (Studies on the War of Resistance Against Japan) 4:23–32.

Zhang Xianwen 张宪文. 2006. *Nanjing datusha shiliaoji* 南京大屠杀史料集. Vol. 28, *Lishi tuxiang* 历史图像 (Historical Materials of the Nanjing Massacre. Vol. 28, Historical Photographs). Nanjing: Jiangsu renmin chubanshe.

Zhang Xianwen and Lü Jing 吕晶, eds. 2007. *Nanjing datusha zhenxiang* 南京大屠杀
真相. Vol. 1, *Zhongfang shiliao* 中方史料 (The Truth about the Nanjing Massacre.
Vol. 1, Chinese Materials). Nanjing: Jiangsu renmin chubanshe.

Zhang Xiaogang 张晓刚 and Ouyang Jianghe 欧阳江河. 2009. "Zhang Xiaogang yu
Ouyang Jianghe duitan" 张晓刚与欧阳江河对谈 (A Conversation between Zhang
Xiaogang and Ouyang Jianghe). ArtsBj.com, April 30. Accessed October 2, 2016.
http://www.artsbj.com/Html/interview/wyft/msj/95118_6.html.

Zhang Xiaolang 张晓良. 2010. "Xu Weixin de wenge renwu xiaoxiang zai Wuhan
zhanchu" 徐唯辛的文革人物肖像在武汉展出 (Xu Weixin's Cultural Revolution por-
traits go on show in Wuhan). *Jiyi* 记忆 (Remembrance) 49:59–60. Accessed July 2,
2016. http://prchistory.org/wp-content/uploads/2014/05/REMEMBRANCE-No-4
9-2010%E5%B9%B45%E6%9C%88-23%E6%97%A5.pdf.

Zhang Yimou 张艺谋, dir. 1994. *Huozhe* 活着 (*To Live*). Taiwan: ERA International/
Shanghai: Shanghai Film Studio.

Zhang Yuhong 张玉洪. 2003. "Nanbao san chunhui" 难报三春晖 (Debts of Loving
Care That Cannot Be Repaid). *Lao zhaopian* 老照片 (Old Photographs) 27:128–31.

Zhao Jingrong 赵静蓉. 2005. *Dida shengming de dise*: *Lao zhaopian xianxiang yanjiu*
抵达生命的底色: 老照片现象研究 (Reaching for the Background Colors of Life: A
Study of the Old Photographs Phenomenon). Guilin, China: Guangxi shifan daxue
chubanshe.

Zhao, Suisheng. 1998. "A State-Led Nationalism: The Patriotic Education Campaign
in Post-Tiananmen China." *Communist and Post-Communist Studies* 31 (3):
287–302.

Zhongguo di er lishi dang'anguan 中国第二历史档案馆, Nanjing shi dang'anguan 南京
市档案馆, Qinhua Rijun Nanjing datusha yunan tongbao jinianguan 侵华日军南京
大屠杀遇难同胞纪念馆, eds. 1985. *Qinhua Rijun Nanjing datusha baoxing zhaopian
ji* 侵华日军南京大屠杀暴行照片集 (A Collection of Photographs of the Massacre
and Violence Committed in Nanjing by the Japanese Military). For internal circu-
lation only.

Zhongguo di er lishi dang'anguan 中国第二历史档案馆, Nanjing shi dang'anguan 南京
市档案馆, Qinhua Rijun Nanjing datusha yunan tongbao jinianguan 侵华日军南京
大屠杀遇难同胞纪念馆, eds. 1997. *Qinhua Rijun Nanjing datusha tuji* 侵华日军南京
大屠杀图集 (A Collection of Photographs of the Massacre Committed in Nanjing
by the Japanese Military). Nanjing: Jiangsu guji chubanshe.

Zhongguo shehui kexueyuan jindaishi yanjiusuo 中国社会科学院近代史研究所, ed.
1992. *Riben qinhua qishinian shi* 日本侵华七十年史 (Seventy Years of Japanese
Aggression toward China). Beijing: Zhongguo shehui kexue chubanshe.

Zhongyang dang'anguan 中央档案馆, Zhongguo di er lishi dang'anguan 中国第二历史
档案馆, Jilinsheng shehui kexueyuan 吉林省社会科学院, eds. 1995. *Nanjing datusha
tuzheng* 南京大屠杀图证 (Photographic Evidence of the Nanjing Massacre). Chang-
chun, China: Jilin renmin chubanshe.

Zhou Erfu 周而复. 1987. *Nanjing de xianluo* 南京的陷落 (The Fall of Nanjing). Beijing:
Renmin wenxue chubanshe.

Zhu Chengshan 朱成山. 1994. *Qinhua Rijun Nanjing datusha xingcunzhe zheng-yanji* 侵华日军南京大屠杀幸存者证言集 (Testimonies by Survivors of the Nanjing Massacre Carried Out by the Invading Japanese Army). Nanjing: Nanjing daxue chubanshe.

Zhu Chengshan. 1998. *Qinhua Rijun Nanjing datusha waiji renshi zhengyanji* 侵华日军南京大屠杀外籍人士证言集 (Testimonies by Foreigners about the Nanjing Massacre Carried Out by the Invading Japanese Army). Nanjing: Jiangsu renmin chubanshe.

Zhu Chengshan. 2002a. *Dong Shilang xiezui* 东史郎谢罪 (Azuma Shirô Atones for His Sins). Shanghai: Shanghai cishu chubanshe.

Zhu Chengshan. 2002b. *Nanjing datusha yu guoji dajiuyuan tuji* 南京大屠杀与国际大救援图集 (A Photographic Collection of The Nanjing Massacre and the International Rescue Efforts). Nanjing: Jiangsu guji chubanshe.

Zhu Chengshan. 2004. *Qinhua Rijun Nanjing datusha baoxing rizhi* 侵华日军南京大屠杀暴行日志 (A Journal of the Violence Carried Out by the Invading Japanese Troops during the Nanjing Massacre). Nanjing: Nanjing chubanshe.

Zhu Yingyin 朱映茵. 2004. "Wo jia de liang zhang jiu zhaopian" 我家的两张旧照片 (Two Old Photographs of My Family). *Lao zhaopian* 老照片 (Old Photographs) 37:87–90.

Zi Hui 子慧. 1998. "Lao zhaopian xianxiang de qishi" 老照片现象的启示 (Inspired by the Old Photographs Phenomenon). *Beijing dang'an* 北京档案 (Beijing Archives) 5:33.

Žižek, Slavoj. 2002. *Welcome to the Desert of the Real.* London: Verso.

Žižek, Slavoj. 2004. "What Rumsfeld Doesn't Know That He Knows about Abu Ghraib," Lacan.com, May 21. Accessed January 28, 2017. Available at http://www.lacan.com/zizekrumsfeld.htm.

Zuckerman, Ethan. 2008. "The Cute Cat Theory Talk at ETech." *My Heart's in Accra,* March 8. Accessed August 8, 2016. http://www.ethanzuckerman.com/blog/2008/03/08/the-cute-cat-theory-talk-at-etech/.

Index

secrecy and, 6, 19–21, 31; in *A Second History* (*Di er lishi*) (Zhang Dali), 216

espionage, 8, 92, 209; disinformation and, 22

ethnic cleansing, as euphemism, 17–18

euphemisms, public secrecy and, 17–18

exclusionary sociality, secrecy as, 57–58

exposure: Nanjing Massacre and, 49, 57, 71; public secrecy and, 136–37, 140–43, 164, 182, 185, 188, 206

ex-secrecy, Nanjing Massacre and, 45, 51–52, 58

EyeWitness (*Jianzhengzhe*), 74

Eykholt, Mark, 55, 229n3, 230n13

Facebook, 86, 100, 133

false memory creation, photography and, 228n27

family photographs: Chinese art, Cultural Revolution and, 119–29; formality of, during Cultural Revolution, 110–12, 237n32; *hejiahuan* (photograph of entire family), 118; intra-family violence and betrayal and, 128–30, 238n45; lack of camera ownership and, 237n33; memory and, 89–90; as photo-texts, 41, 94, 104–19, 123, 138, 222, 235n24, 236n27, 237n37; privacy and, 89–91; *quanjiafu* (photograph of entire family), 110–14, 118–19; spectrality in, 94, 112–19, 155–62

family resemblances, Wittgenstein's concept of, 4–5, 202

Family Tree (*Jiapu*) (Zhang Huan), 124–25

Family Tree (*Jiazu tupu*) (Shao Yinong and Mu Chen), 123–24

Fan Jianchuan, 84–85

The Fat Years (*Shengshi: Zhongguo 2013*) (Chan Koonchung), 16

Feldman, Allen, 116, 128, 157

Feminist Five, 217–19

Feng Jicai, 109, 236n31

Feng Jinglan, 165

Feng Keli, 105, 234n9

Feng Mengbo, 94, 119–20

Feng Xiang, 240n19

Feng Youlan, 239n10

film: Cultural Revolution in, 96, 106, 234n13; Nanjing Massacre in, 49–50, 74–75, 84–88, 232n36; Tank Man images in, 169–71

Flamson, Thomas J., 194

Flickr, 101

Fogel, Joshua, 229n3, 229n6

Forbidden City (*Zijincheng*) (Lily & Honglei), 243n20

Ford, Sam, 136

"The Forgotten Holocaust" (Chang), 50

"414" faction (Cultural Revolution), 239n8

4Gentlemen artistic collective, 196–99

Four Gentlemen of Tiananmen Square protests, 243n20

Frenchising Mona Lisa (Baradaran), 196–98

Freud, Sigmund, 179, 193, xvi

Frosh, Paul, 193, 204, 242n17

Fu Ningke (blogger), 229n5

Galison, Peter, 11

Gang of Four, 95, 108, 126, 189

Gao, James, 227n18

Gao, Rui, 229n5, 229n10, 230n11

Gao Shen, 116

Gao Xiaohua, 96

Gao Xingzu, 55

garbology, PRC historiography and, 22, 211

Gates, Bill, 195

Gatewood, John B., 151

Gentz, Natascha, 235n25

geopolitics, Nanjing Massacre in context of, 48

ghostliness. *See* haunting; spectrality

Giddens, Anthony, 209

"Girl Fleeing Napalm" image, 242n17

Girls Middle School attached to Beijing Normal University: commemorative album produced by, 156, 160; commemorative crowdfunding activities by former pupils at, 165–66; former pupils and *Remembrance* (*Jiyi*) journal and, 162; most distinguished alumnae competition to mark ninetieth anniversary of, 155, 161, 163; murder of Bian Zhongyun at, 41–42, 131; politically elite status of pupils during Cultural Revolution, 138; portraits of figures by Xu Weixin linked to school, 158, 161; reflection about summer of 1966 by former pupils, 136, 162–63; Song Binbin and, 134–35, 155, 161; statue of Bian Zhongyun at, 42, 135–26, 145, 163–64, 165–67; Wang Youqin and, 133

Goddess of Democracy statue, 205
"Go Hong Kong" (Badiucao), 178
Gombrich, Ernst, 237n39
Google search engine, 219; Bian Zhongyun on, 132; Tank Man on, 170–71, 139, 240n2; Tiananmen Square on, 170–71, 240n2
Gordon, Avery, 6, 39, 146–47, 150
Great Famine of 1958–61, 4, 13, 26, 227n21
Green, Joshua, 136
Guattari, Félix, 7, 99, 104, 131–32, 136–37, 143, 146, 158
Gu Lijian, 234n9
Gunning, Tom, 53, 157
Gu Zhun, 239n10
Gwangju Massacre of May 1980, 170

Hai Bo, 32, 94; *They (Tamen)*, 39, 119, 126–28, 215, 222
Halebian, Olivia, 22
Hanchao Lu, 105
Han Han, 198
Hariman, Robert, 30, 172, 175, 227n25
Harvest (Shouhuo), 90, 102–3, 233n1
haunting: Bian Zhongyun murder and, 147–55; *Chinese Holocaust Memorial (Zhongguo wenge shounanzhe jinianyuan)* (Wang Youqin) and, 149–50; *desaparecidos* in Argentina and, 146–47, 150; in family photographs, 126–30; historic photographs and, 37–38; internet and, 148; media and, 147–49; photo-form as an aesthetic category and, 5–6, 38–39; Nanjing Massacre and, 84–88; public secrecy and, 39–40; Tank Man icon and, 182–91, 195, 202, 204; in *Though I Am Gone (Wo sui si qu)* (Hu Jie), 153–55. *See also* spectrality
hejiahuan, 118
He Qinglian, 234n11
The Herdsman (Muma ren) (Xie Jin), 96
Herring, Oliver, 28
"Herzog" (blogger), 51
"hidden rules" (*qian guize*), 9, 180
Hinton, Carma, 160–61
Hirsch, Marianne, 34, 38, 111
Historical Documents on the Nanjing Massacre (Nanjing datusha shiliaoji), 62–64
Hockx, Michel, 92, 198
Hofman, Florentijn, 192

Holbein, Hans, 19–21, 31
Holmes, Oliver Wendell, xv–xvi
Holocaust: art works about, 32; Cultural Revolution contrasted with, 238n2; images of, 78–79; memory studies and, 34; Nanjing Massacre contrasted with, 74, 233n38; photographic representation of, 82
Holofcener, Lawrence, 32–34
Hong Kong: "big yellow duck" meme and, 190, 192; handover of, 189; June 4th Museum in, 196; state power and secrecy in, 141–42, 239; umbrella movement in, 177–78
"How Censorship Works" (Ai Weiwei), 14–15
"How to Take a Photograph" (Ruci zhaoxiang) (Jiang Kun & Li Wenhua), 111
Hsu, Immanuel, 234n7
Huang, Nicole, 90, 110, 118–19, 226n16, 234n10
Huang Shuai, 240n21
Hu Jie, 32; *Searching for Lin Zhao's Soul (Xunzhao Lin Zhao de lingyun)*, 238n4; on state management of memory, 152; *Though I Am Gone (Wo sui si qu)*, 131, 133–34, 138, 145, 152–55, 238n4
Hu Jintao, 239n8
"human flesh search engines" (*renrou sousuo*), 217
humor, censorship and, 192–95
Hüppauf, Bernd, 79–80

iconicity: Bian Zhongyun and, 166; definitions of, 227nn24–25; doctored photography of the Communist revolution and, 42; of "Girl Fleeing Napalm," 232n17; of Newsreel Wong's photograph of wailing baby at Shanghai South Station, 232n31; online environment and, 201–2; photography and, 29–30; 227n24; of Tank Man, 40, 171–76, 183, 190, 205, 243n20
Ink History (Moshui lishi) (Chen Shaoxiong), 188–91, 198
Instagram, 100, 103–4
internet: Ai Weiwei, celebrity and, 144–45; Chinese censorship of, 5, 13, 142, 173, 176, 184–85, 196, 198, 202, 239n11; Cultural Revolution and, 92, 97–98, 129, 149–50, 236n27; historic photographs in online spaces, 25;

iconic photographs and, 201–2; memorials and mausolea on, 133, 145, 149–50, 239n13; nationalism on, 71, 86–87, 231n23; network of photo-forms of Bian Zhongyun and, 132–36, 145–46, 149–50, 152; online activism, Crazy Crab and, 142, 241n9; photo-sharing on, 100–103, 147; photo-spoofing memes on, 190, 192, 217–20, 242n14; search engine art, 189; secrecy studies and, 100; secrets and, 103–4, 143–44; spectrality of, 148; vigilantes in China, 217

The Invention of Solitude (Auster), 110

Iovene, Paola, 230n17

iron-clad proof *(tiezheng)*, Nanjing Massacre and, 53, 67, 73, 230n15

Iyer, Pico, 173

Jaar, Alfredo, 82–83

Jameson, Fredric, 215–16

Jang Hoon, 170

Jelin, Elizabeth, 17

Jenkins, Henry, 136

Jian Bozan, 239n10

Jianchuan Museum cluster, 85

Jiang Qing, 107, 138, 158

Jiangsu People's Press, 55

Jiang Zemin, 14–15, 242n14

Jilin People's Press, 45

Jiu'an, 32; cartoon of Song Binbin's apology, 135, 164

June 4th Museum *(Liusi jinianguan)*, 196, 242n15

Jünger, Ernst, 79

justice: limitations of public exposure in the pursuit of, 140–44, 164; public secrecy, humor and, 193–94; public secrecy, photo-forms and, 6–7, 37, 39–40, 136–37, 140, 143, 199, 210; revenant and, 7, 37, 39–40, 86, 185, 186; Tank Man and, 187, 199; Walter Benjamin and revelatory justice, x, 6, 136, 143, 210

Kermode, Frank, 19

Kershaw, Ian, 3

Kieschnick, John, 239n16

"killing contest" (Nanjing Massacre), 61, 67, 189, 231n19

Kinoshita Yûka, 86–87

Klayman, Alison, 144

Klein, Naomi, 59

Kleinman, Arthur, 26, 97

Kleinman, Joan, 26

Kohli, Chiranjeev, 58–59

Kong, Belinda, 226n10

Korean War, PRC propaganda during, 229n3

Krauss, Rosalind, 29–30

Krebs, Edward, 226n15, 235n18, 235n23

kuailei (indignation and depression), 92, 109

Kuang Biao, 176, 185

Kuomintang (KMT), Nanjing Massacre and, 48, 229n7

Kutz, Christopher, 98

Kwan, Stanley, 31

"The Lament of Images" (Jaar & Strauss), 82–83

Landsberg, Alison, 34

Lan Yu (Stanley Kwan), 31

lao san jie (Cultural Revolution generation), 165, 240n24

Lary, Diana, 96

Laslett, Barbara, 235n15

Latham, Kiersten, 151–52

laughter, censorship and, 193–94

Lei Feng, 152, 190, 210, 213, 244n2

Li, Jie, 238n44, 239n14

Lily & Honglei, 32, 38, 242n16, 243n20

Lim, Louisa, 17, 173

Li Na, 138

Lincoln, Abraham, 151–52, 215

Linfield, Susie, 233n38

Link, Perry, 83

Lin Zhao, 238n4

Liu, Xiao, 101

Liu Jin, 162

Liu Shaoqi, 138, 149, 158, 212–13

Liu Xiaobo, 145, 168, 243n20

Liu Xinwu, 32; *My Private Photograph Album (Siren zhaoxiangbu)*, 41, 90–94, 96–104, 109–10, 119–20, 123, 125, 129, 222, 233n1, 234n9; serialized works and, 222

Li Wei, 32, 38; *Mirrors (Jingzi)*, 242n18

Li Zijian, 32; *Nanjing Massacre: Slaughter, Rebirth, Buddha (Nanjing datusha: tu-sheng-fo)*, 60, 75–78, 222, 232n33; serialized works and, 222